JOSEPH BEUYS

The Reader

JOSEPH BEUYS
The Reader

Edited and translated by

Claudia Mesch and Viola Michely

with a Foreword by Arthur C. Danto

Additional translation by
Nickolas Decarlo, Kayvan Rouhani
and Heidi Zimmerman

I.B. TAURIS
LONDON · NEW YORK

Published in 2007 by I.B.Tauris & Co Ltd
6 Salem Road, London W2 4BU
175 Fifth Avenue, New York NY 10010
www.ibtauris.com

ISBN 978 1 84511 363 6

A full CIP record for this book is available from the British Library

Typeset in Stone Serif by Steve Tribe, Andover
Printed and bound in Great Britain by TJ International Ltd,
Padstow

CONTENTS

List of Illustrations viii

Acknowledgements xi

Foreword: Style and Salvation in the Art of Beuys
Arthur C. Danto xiii

Editors' Introduction 1

I. Beuys and his 'Challengers'

1. Breaking the Silence: Joseph Beuys on his
 'Challenger', Marcel Duchamp (1995)
 Antje von Graevenitz 29

2. Beuys, Haacke, Broodthaers (1988)
 Stefan Germer 50

3. Beuys and Broodthaers:
 Dialectics of Modernity between 'Analytic Geometry
 and the Belief in an Unbelieving God' (2001)
 Dorothea Zwirner 66

4. Letters as Works of Art:
 Beuys and James Lee Byars (2000, excerpt)
 Viola Michely 88

II. Critics' Perspectives

5. Beuys: The Twilight of the Idol (1980)
 Benjamin Buchloh 109

6. Discontinuous Notes on and after a Meeting of
 Critics, by One of the Artists Present (1981, excerpt)
 Vera Frenkel 127

7. Joseph Beuys, or the Last of the Proletarians (1988)
 Thierry de Duve 134

III. Beuys and the Limits of Iconography

8. Beuys and Romanticism (1986, excerpt)
 Theodora Vischer 151

9. No to... Joseph Beuys (1997)
 Rosalind Krauss 170

IV. Beuys, Art and Politics

10. 'Questions? You have Questions?'
 Joseph Beuys' Artistic Self-Presentation in *Fat
 Transformation Piece/Four Blackboards*, 1972 (1996)
 Barbara Lange 177

11. Every Man an Artist: Talks at Documenta V
 by Joseph Beuys (1972, excerpt)
 Clara Bodenmann-Ritter 189

12. Institutionalizing Social Sculpture:
 Beuys' *Office for Direct Democracy through
 Referendum* Installation, 1972 (1997, excerpt)
 Claudia Mesch 198

13. *Überblick* Series on the Parliamentary
 Election (1983, excerpt) 218

V. Beuys and Postmodernism

14. Performance: Joseph Beuys (1985, excerpt)
 Gregory Ulmer 233

15. In the Shadow of Joseph Beuys:
 Remarks on the Subject of Art and
 Philosophy Today (1987)
 Peter Bürger 250

16. Letter to Jean-François Chevrier (1997, excerpt)
 Peter Bürger 264

17. The Aesthetics of Post-History:
 A German Perspective (1995, excerpts)
 Irit Rogoff 270

VI. Issues of Reception

18. The Reception of Joseph Beuys in the USA,
 and Some of its Cultural/Political and Artistic
 Assumptions (1998, excerpt)
 Dirk Luckow 287

19. Joseph Beuys and the GDR:
 The Individual as Political (1992)
 Eugen Blume 304

20. Joseph Beuys and Surrealism (1997)
 *Roundtable: Benjamin Buchloh, Jean-François Chevrier
 and Catherine David* 320

Appendix: Key Dates and Exhibitions 325

Index 328

ILLUSTRATIONS

1.1 Joseph Beuys, *The Silence of Marcel Duchamp is Overrated*,1964; © 2006 Artists Rights Society (ARS), New York/VG Bild-Kunst, Bonn 32

1.2 Beuys on bicycle at the Academy of Düsseldorf, 1982; © 2006 Artists Rights Society (ARS), New York/ VG Bild-Kunst, Bonn 35

1.3 Marcel Duchamp, *"to have the apprentice in the sun"*, 1914; © 2006 Artists Rights Society (ARS), New York/ ADAGP, Paris/Succession Marcel Duchamp 36

1.4 Joseph Beuys, *Thermisch/plastisches Urmeter* ('Thermal/ plastic Primeval Meter'); © 2006 Artists Rights Society (ARS), New York/VG Bild-Kunst, Bonn 37

1.5 *VieW* cover, 1945; © 2006 Artists Rights Society (ARS), New York/ADAGP, Paris/Succession Marcel Duchamp 42

1.6 Duchamp, 'Eau & gaz à tous les étages', 1958; © 2006 Artists Rights Society (ARS), New York/ADAGP, Paris/ Succession Marcel Duchamp 43

3.1 Joseph Beuys, *Das Schweigen* ('The Silence'), 1973; © 2006 Artists Rights Society (ARS), New York/ VG Bild-Kunst, Bonn 75

3.2 Marcel Broodthaers, *Pense-Bête*, 1964; © 2006 Artists Rights Society (ARS), New York/SABAM, Brussels 75

3.3 Joseph Beuys, *Freier demokratischer Sozialismus* ('Free Democratic Socialism'), 1972; © 2006 Artists Rights Society (ARS), New York/VG Bild-Kunst, Bonn 78

3.4 Marcel Broodthaers, *Il n'y a pas des structures primaires*,
 1968; © 2006 Artists Rights Society (ARS), New York/
 SABAM, Brussels 79

4.1 James Lee Byars, Documenta Archiv, Kassel
 Photo: Heyne, Neusüss, Pfaffe 91

4.2 Joseph Beuys, Documenta Archiv, Kassel
 Photo: Heyne, Neusüss, Pfaffe; © 2006 Artists Rights
 Society (ARS), New York/VG Bild-Kunst, Bonn 92

4.3 James Lee Byars and Joseph Beuys with *The Pink Silk
 Airplane*, Düsseldorf 1969; Photo: Katharina Sieverding 96

4.4 James Lee Byars and Joseph Beuys at the opening of
 the Speck collection, Haus Lange, Krefeld 1983;
 Photo: Benjamin Katz; © 2006 Artists Rights Society
 (ARS), New York/VG Bild-Kunst, Bonn 100

6.1 Joseph Beuys (*c.*1981), Photograph by Wolfgang Isle;
 © 2006 Artists Rights Society (ARS), New York/VG
 Bild-Kunst, Bonn 128

8.1 C.D. Friedrich, *Verschneite Hütte*, 1827, Alte
 Nationalgalerie, Berlin 150

8.2 Joseph Beuys, *Schneefall*, 1965 (view, Guggenheim,
 New York); © 2006 Artists Rights Society (ARS), New
 York/VG Bild-Kunst, Bonn 150

8.3 Joseph Beuys, *Doppelfond*, 1954/1974 (Staatisches
 Museum Mönchengladbach; Photo U. Klophaus);
 © 2006 Artists Rights Society (ARS), New York/
 VG Bild-Kunst, Bonn 156

8.4 Beuys, *Fond II*, 1961–1967 (centre), and *Fond III*,
 1969 (right; Beuys Block, Hessisches Landesmuseum,
 Darmstadt); © 2006 Artists Rights Society (ARS),
 New York/VG Bild-Kunst, Bonn 157

10.1 Joseph Beuys, *Four Blackboards*, 1972, Tate Gallery,
 London; © 2006 Artists Rights Society (ARS),
 New York/VG Bild-Kunst, Bonn 176

10.2 Joseph Beuys, *Ich versuche dich freizulassen (machen)* ('I
 try to set (make) you free') (27 February 1969, Berlin,
 Akademie der Künste), poster for the exhibition *Seven
 Exhibitions*, 1972, Tate Gallery, London; © 2006 Artists
 Rights Society (ARS), New York/VG Bild-Kunst, Bonn 180

10.3 Verso of Fig. 10.2, features the English translation
 of informational flyers from the Office for Direct
 Democracy by Referendum; © 2006 Artists Rights
 Society (ARS), New York/VG Bild-Kunst, Bonn 181

10.4 Joseph Beuys, *Fat Transformation Piece*, 1972, Tate
 Gallery, London; © 2006 Artists Rights Society (ARS),
 New York/VG Bild-Kunst, Bonn 183

11.1 Photograph, Beuys in *Documenta Office for Direct
 Democracy*, Kassel, 1972; © 2006 Artists Rights
 Society (ARS), New York/VG Bild-Kunst, Bonn 190

12.1 Joseph Beuys, *ohne die Rose tun wir's nicht* (1972),
 multiple; © 2006 Artists Rights Society (ARS), New York
 /VG Bild-Kunst, Bonn 205

12.2 Joseph Beuys, *Rose für direkte Demokratie* (1973),
 multiple; © 2006 Artists Rights Society (ARS),
 New York/VG Bild-Kunst, Bonn 205

12.3 Joseph Beuys, *So kann die Parteidiktatur überwunden
 werden* ('This is how the dictatorship of (political)
 parties can be overcome'), multiple, 1971; © 2006
 Artists Rights Society (ARS), New York/VG
 Bild-Kunst, Bonn 207

12.4 Joseph Beuys, *Dürer, ich führe persönlich Baader und
 Meinhof durch die Documenta V* (Dürer, I personally
 conduct Baader-Meinhof through Documenta V);
 Museum Ludwig, Cologne 1972; © 2006 Artists
 Rights Society (ARS), New York/VG Bild-Kunst, Bonn 209

15.1 René Magritte, *The Museum of a Night* (1928); © 2006
 C. Herscovici, Brussels/Artists Rights Society (ARS),
 New York 256

17.1 Joseph Beuys, *Tram Stop*, 1976 (Kröller Müller
 Museum, Otterlo); © 2006 Artists Rights Society
 (ARS), New York/VG Bild-Kunst, Bonn 282

ACKNOWLEDGEMENTS

THE EDITORS ARE GRATEFUL for the assistance and support that numerous individuals and institutions have given us while we worked on this volume over the course of many years. This collection could not otherwise have been completed.

We thank in particular Dr Antje von Graevenitz for her unwavering support at every stage of our project.

We acknowledge the consistent support provided to us by the Herberger College of the Arts at Arizona State University, facilitated by its then-director, Dr Jon Sharer (now emeritus).

We also thank the translators and editors who worked with us in preparing the English texts included in this collection: ASU graduate students Heidi Zimmerman and Nickolas Decarlo, as well as Sonia I. Hanson; and, in Berlin, Kayvan Rouhani.

In preparing this volume we benefited from the holdings of the Erhard Klein Archive at the Kunstmuseum Bonn.

Finally we thank Mrs Eva Beuys and the Beuys Estate for extending the necessary permissions to us.

FOREWORD

Style and Salvation in the Art of Beuys
Arthur C. Danto

JOSEPH BEUYS, TOGETHER WITH Marcel Duchamp and Andy Warhol, are the artists one must turn to in order to understand the present shape of art – the Founding Fathers of contemporary sensibility. But whereas Duchamp and Warhol are widely discussed and frequently shown, Beuys has somewhat faded from contemporary awareness, and seems to belong to an earlier era. Perhaps this is because the subject of his art, not to mention his own personal myth, seem internally related to the Second World War and the period of German reconstruction afterward. Or with the particular political unrest and protest that defined the German *mentalité* of the 1960s and the politics of the cold war. His politics and to some degree the ritual aura that invests his art somewhat distance us from him. Duchamp was apolitical, and while Warhol had definite political convictions, his art is anchored to the popular culture that continues to define present consciousness. The two of them remain as presences in the art scene of today. This is a good time, accordingly, that Beuys be summoned from the shadows through a fresh set of essays like the ones that have been gathered here, and to which I offer this as a foreword.

Beuys is often thought of as if he were someone influenced by Beuys. In 1992–1993 he was identified, for example, as 'the most prophetic voice' for the public art programme of

Sculpture Chicago, called 'Culture in Action', which consisted of eight distinct undertakings by groups remote indeed from the institutional world of art professionals and their typical audiences: people in public housing, or on welfare, or coming from ethnic communities on whose maps museums and galleries have no location. 'In his concept of "social sculpture",' the critic Michael Brenson wrote, 'everything was art, and every aspect of life could be approached creatively, with a sense of inventiveness and ritual … "Everyone is an artist," he said, in one of his best-known statements.'

Certainly this seems like a self-exemplifying characterization, Beuys being only one of the examples of an artist who makes art out of anything, who approaches every aspect of life creatively, with a sense of inventiveness and ritual. In Chicago, members of the Bakery, Confectionery, and Tobacco Workers' International Union of America, Local No. 552 – how much further can you get from the curatoriat? – produced a candy bar named 'We Got It!' It was art and candy-making was art-making and confectioners were artists. A collaborative group, Haha and Flood, produced, with a group of volunteers, a hydroponic garden, distributing the vegetables to feeding places for the AIDS-afflicted. 'A Coalition of Chicago Women', with the performance artist Suzanne Lacy, evolved a ritual celebration of Chicago women by means of granite markers bearing women's names around the city. A candy bar (emulsified fat, after all); a vegetable garden; a ritual exaltation of women: these could hardly be more in the Beuysian spirit. But nothing done in 'Culture in Action' looked at all as if it could have been done by Beuys. What is overlooked in treating Beuys as if he were an example of someone influenced by Beuys is the unmistakable style of the Beuysian object, so that even an object not made into art by anyone as yet can look unmistakably enough Beuysian that were anyone else to appropriate it as art, they would look derivative, like someone walking around in a fisherman's vest, wearing a felt hat indoors, which constituted Beuys' signature costume.

What makes Beuys an artist, and indeed an artist by the standards of the art professionals to which enterprises such as 'Culture in Action' turn their backs, is his style, whether in his costume, his stories about himself, his language, or the objects out of which exhibitions of his work are made. This is certainly

true of his drawings: they are unmistakably his, blobs and blots in sepia or brown, on throwaway paper, and connected by some desultory scribbled lines. It is consistent with this style that the medium should be such substances as hare's blood or vegetable juices. What would be inconsistent would be if the medium were made of the finest pigment painted on Fabriano-Tiepolo watercolour paper especially ordered. There are dissonances like this in Beuys' make-up: the hats were of the finest quality – Stetsons – always bought in London. His wife recalls that Beuys had been the snappiest dresser in the Academy. Thomas Messer tells us that when Beuys was the Guggenheim's guest in 1979, he rode around in Cadillac limousines driven by chauffeurs, and dined on caviar. These strike a dissonant note in the way the discovery that Heidegger was a connoisseur of *grands crus* is dissonant with his peasant pretensions, even if wine comes from the Earth. I am not out to criticize, merely to indicate the structure of consistency and inconsistency which go with having a style. There would be no dissonance in the fact that Motherwell was devoted to luxury, or that the philosopher Pierce were a connoisseur of fine clarets.

A few summers ago, I visited an installation of Beuys' work at the Guggenheim Museum, given an alcove of its own in an exhibition of post-war art called 'The Tradition of the New'. The wall text at the entryway identified him in his own terms as a 'social sculptor', whose works are in effect 'remains' and 'traces' of lectures and performances. This is true and false. There are remains and traces which are works of art, but many which are not – and there are works of art that are remains or traces in no stronger sense than any work of art. The second gallery of the alcove memorialized a lecture Beuys gave in Vienna in 1980, with blackboards covered with chemical formulae, which we also see in some photographs of Beuys, wearing his unmistakable costume, speaking to rapt students, seated on the floor. There is also a typescript, urgently overwritten, of a discussion between Beuys and some sceptics who evidently attended the performance. The photographs, and even the holograph, for all its overwriting, are not works of art though they are traces and remains: so only certain remains and traces are properly art, even in the extended sense of the term given by Beuys. The blackboards, on the other hand, are remains and traces that qualify as art, I think. The main

formula is for alkali – sodium carbonate – made of the ashes of plants. But Beuys has written, like a good teacher, certain words – base, acid (*Sauer*), soap (*Seife*) – and has drawn a heart. The heart is meant to connote a moral fact, regarding the warmth we feel when we wash with soap, which springs evidently from the fact (Beuys claims) that soap is colloidal, we are colloidal, and hence (the syllogism is incidentally invalid), we are soap. The blackboard is the trace and remains of a curious discourse in mystical chemistry, and, as visitors to the exhibition of Beuys' drawings curated by Bernice Rose and Ann Temkin recall, these blackboards were considered drawings, or even as works which straddled a boundary between drawing and sculpture. One of the blackboards at the Guggenheim, with the same formulae and vocabulary (and heart) is furiously calligraphic and expressionist enough to be art by the narrowest of criteria: it is so elegant as almost to be dissonant with the style.

In truth, the style is partially defined by qualities that fit smoothly with the idea of the trace and the remnant. It is the style of left-over, broken, dated objects, distressed and discarded – objects which have fallen out of what Heidegger calls the *Zeugganzes* of the average everydayness of life, of no use anymore. And Beuys uses them for the expressiveness of their fallen usefulness, I suppose the way Joseph Cornell used objects from the vanished inventories of variety stores for the evocativeness of their fallen banality. Typically (I hasten to acknowledge: not always and not universally) Beuys' *Vitrinen* (of which there were two at the Guggenheim) display objects which appear to be worn fragments of once useful objects, scarred and patinated by grime and time. *La Lotta Continua* – a disabled linotype machine – is an almost monumental example, given that linotype machines, by 1980, had rather little by way of supportive *Zeugganzheit* in the world of electronic data processing: most printing plants had long since abandoned their use, though the powerful printers union in England made them a point of resistance to electronic typesetting, and lost the battle when publishers moved to Wapping. The heavy coat of fat Beuys poured over the keyboard merely underscored the truth that no one was any longer going to hit them to shape lines of type: *La lotta e finita*. There is a question, not to be resolved here, or at least not by me, as to whether the vitrines themselves,

considered apart from their odd contents, are works of art in their own right. What is unmistakable is that they are coherent with the overall Beuysian style. They have, for instance, a certain touching hand-made quality, and seem to be made of left-over lumber by means of rough carpentry, as contrasted with cabinet-making. The window is held in place by screen-door hooks, and the glass is fixed in its frame by thick hand-applied putty on the outside, as if by a not especially skilful hand. Beuys himself, with his wide brimmed hat, his huntsman's garments, his incantatory language, his medieval facial features, seems himself to belong to a forgotten form of life. Embodying the aesthetic of his characteristic objects – 'traces and remains' – Beuys is like the third brother, the simple son of the fairy tale, who keeps picking up and pocketing, as if treasures, objects for which no one has a proper use – the handle of a broken pitcher, for example, or the wing of a dead bird. Indeed their only use, in the fairy story, is the help they give in solving the puzzles of a perverse princess. Displayed as they are in the vitrines, the question for critics is what riddle it is these are to help us solve. Beuys' greatness as an artist perhaps consists in convincing us that there is a riddle for which his works serve as partial solutions.

The Vienna lecture, from what I could gather from the wall texts, seems to have begun with some sort of joke about soap and laundering, which, despite ours being the age of feminism, he characterizes as the work of young women. It then ascended through some natural associations to salvation, for which, I suppose, cleansing is a natural metaphor, and from the young women to someone to whom he refers as *Die Jungfrau* – The Virgin – who will save us. For whatever dark reasons only a virgin will do. *Die Jungfrau* will save us. And I thought at this moment of Heidegger, of his 1966 interview in *Der Spiegel*, in which he says 'only a God can save us'. Here is the passage in full:

> Philosophy will not be able to effect an immediate transformation of the present condition of the world. This is not only true of philosophy but of all merely human thought and endeavor. Only a god can save us. The sole possibility that is left for us is to prepare a readiness, through thinking [*Denken*] and poetic creation [*Dichten*], for the appearance of the god

or for the absence of the god in time of foundering
[*Untergang*], for in the face of the god who is absent,
we founder.

Save us from what for what? There is no simple, certainly no
short answer for Heidegger, but his masterpiece, *Sein und Zeit*
(Being and Time) is dense with allusion to *Gefallenheit*, for
which the 'trace-and-remains' aesthetic of the Beuysian object
is in candidacy for illustration. And Heidegger speaks of the
'Call to Conscience' (*Ruf des Gewissens*) which summons us to
authenticity, which perhaps he had grown pessimistic about that
happening by 1966, and thought only about divine intervention
– an odd idea for what was meant to be a secular theology, a text
on salvation without a saviour.

I have no thesis on influence to offer here: I don't claim that
Beuys read Heidegger, or read philosophy at all. One of the
vitrines at the Guggenheim had what is clearly a mint copy of a
paperback edition of Kant's *Kritik der reinen Vernunft*, on which
the artist had stamped in red: 'BEUYS: *Ich kenne kein week-end'*.
This is a boast, as I read it: 'I have no week-end to spare to read
Kant's book in'. Or: 'I never take time off', which may indeed
be true. In any case, I am speaking in the mode of ascribing
an affinity between German souls, one of which *denkt* and the
other of which *dichtet*, and both of which do this in the spirit of
saving humankind from a crisis for which the crises of politics,
of morality, of economics, of art itself, are but manifestations. It
is a crisis of the human soul, and neither Heidegger nor Beuys
have faith that thought or art will suffice to pull us through.
Rather, thought and art are modes of prayer, appeals to a god or
a *Jungfrau* to do what we at our best – as thinkers and as artists
– are unable unaided to do.

INTRODUCTION

ART HISTORY HAS TAKEN on formidable tasks in the post-war era. Primary among them is a thoroughgoing redefinition of the canon of modern art, made necessary by the appearance in the USA of another distinct direction in art production: *postmodernism.* American critics and art historians have been occupied in delineating these new developments, which are said to extend the development of visual modernism into the critical postmodernism of late-twentieth-century art. Yet, while it connects with modernism, postmodern art is also determined to distinguish itself from the modes and processes of modern art in specific ways. Some modern artists, such as Marcel Duchamp, are now understood to find a better fit in the criteria that have been established for postmodern art. Picasso, on the other hand, is definitively modern. Artists of the historical avant-garde, of the Soviet Union (Constructivism), of Germany (Dada) or of France (Surrealism) have been determined to belong to an historical moment that has irretrievably passed. Canons are reformulated around such shifting definitions of modern art and postmodern art, like sorted with like. Some artists are illuminated in the process; others are relegated to the shadows of neglect. In the meantime, West German art history was also involved in its own revision of the canon of modern art, which was certainly impacted by postmodernism. In addition, revisionist art histories in the post-war Germanys struggled to take into account the course of German history in the twentieth century and the enormous ruptures and losses inflicted by the Nazi regime, many of which also extended into the realm of culture.

In art history's encounter with certain artists, objects or texts, the process of canon revision seems to lose its clarity. These unruly artists or objects seem not to fall neatly into established categories and classifications. They instead fall into a kind of art historical no man's land akin to the optical occurrence of the penumbra, the edge of shadow – or part-shadow – that is observed around full shadow. In this unfocused, grey area, stark categories – of light and dark, of progress or regression, of avant-garde or hoax, of modern or postmodern – are cast into doubt. Certainties are suspended, and an opportunity to reconsider and revise presents itself.

Joseph Beuys (1921–1986) is in this sense an artist of the penumbra. During his lifetime, he was simultaneously celebrated and lampooned by fellow artists and by the international art community; since his death he has been lauded as heroic by some and condemned as a dark figure of German fascism and totalitarian impulses by others. He is among the most controversial artists of the late twentieth century. For these and other cultural-historical reasons, the disciplinary apparatus of art history in the USA has been hesitant to take up Beuys' direct connection with the engaged tradition of the modernist avant-garde. This engagement has made his art difficult and unfashionable. Faced with Beuys' increasingly visible presence in art institutions, from the Düsseldorf Academy to the Documenta exhibitions to German museums, as well as in the German media, German critics and art historians found it more difficult to ignore his art.

Strangely, a number of commentators – critics in West Germany and abroad – found themselves in agreement with the judgements of the West German mass media and even with East German party functionaries in portraying Beuys either as another example of the corrupting influence of the bourgeois dealer-critic system or in dismissing him as a 'charlatan'. (The latter charge was also made by many of Beuys' colleagues at the Düsseldorf Academy.) Furthermore, a common assumption lingers among American commentators that most if not all German writing on Beuys was and is celebratory and largely uncritical.

The contributors to *Joseph Beuys: The Reader* include critics, art historians and artists, some of them influential American and German commentators on Beuys' art; the collection also

includes more obscure critical reviews and art historical studies written in North America. These latter essays point to the early interest in Beuys' practice on the part of many women artists and critics, and not only from those who were his students. This volume foregrounds the complexity and scope of Beuys' oeuvre, which not only encompassed his well-known work in performance, drawing, painting, sculpture and multiples, but also included conversations with visitors in museum installations, media interviews, activist appearances as a German Green Party candidate and his influential encounter with East German artists. We do not, however, claim to offer a complete survey of Beuys' oeuvre, nor an all-inclusive collection of critical writing on Beuys, nor to serve up definitive readings or interpretation. This volume means to mark a widening of, and not the conclusion to, an international discussion of Beuys' art. We do not mean to imply that it is necessary or desirable to reach a critical consensus on Beuys' hyper-ambitious art practice. In introducing readings of Beuys' art that are new to an English-speaking audience, we hope to move beyond the sometimes dismissive readings of Beuys' art that may have squashed further debate.

We also intend to address readers who are not familiar with Beuys' work but have a true curiosity about him, perhaps generated through his mass-culture celebrity. Our intent is also to offer a point of entry into Beuys' difficult art practice. As is often the case with difficult visual art, and especially with Beuys, the most accessible entry point is routed through the methodology of biography. Beuys himself bowed to this. But he also seems to have realized that making his own life story the basis of his art's meaning severely limited its possibilities as art, as Peter Nisbet has convincingly argued.[1] Our strategy in this book is to present Beuys differently, and through more diverse and recent methodologies of art history. Our book is, therefore, a response to Johannes Cladders' call to integrate Beuys within art history, and to place his art within the context of contemporary art practice.[2] The point of entry we offer is through art history's recent and various fashionings of 'Beuys'. We did not want to privilege biography and its limitations in this book. For those readers who desire a more basic introduction, the biography/timeline in the Appendix provides a listing of the key exhibitions and details of Beuys' life.

As we discuss below, for various reasons that include Beuys' own statements, readings of Beuys' art that are biographical in nature have become dominant both in the USA and in Europe. The exact and explicit relevance of Beuys' biography to the meaning of his artworks is, however, still a matter of contention. A number of publications have presented a chronology of key events, exhibitions and dates in the artist's life. One of the best introductions remains Caroline Tisdall's 1979 Guggenheim catalogue, *Joseph Beuys*, though it obviously does not deal with Beuys' late works; Heiner Stachelhaus's *Joseph Beuys* (1991) is a good biography. An old standard, *Joseph Beuys: Life and Works* by Götz Adriani, Winfried Konnertz and Karin Thomas (1979) is poorly translated and not recommended, except in the original German edition. These chronologies are not to be confused with the complex and important document/fiction that Beuys presented as his 'life course/work course' and which recapitulated the basis for his art practice from the late 1950s to 1972. Pamela Kort has foregrounded the 'Life Course' as the document central to unlocking the meaning of Beuys' practice.[3] As is the case with almost all aspects of Beuys' life and art, however, the *Lebenslauf* has been the object of speculation.

Other critics and historians have considered the relation of Beuys' art and biography in a critical manner. Donald Kuspit has read the 'problem' of Beuys' life story in a most sophisticated manner, through a psychoanalytic lens; he has also addressed the particular position occupied by other Beuys critics, including Benjamin Buchloh and Robert Storr.[4] Peter Nisbet's 'Crash Course' traces Beuys' own efforts – and his later decision to steer away from – foregrounding his own life story as a basis for meaning in his practice.

Joseph Beuys: The Reader brings together essays from the distinct and co-existing discourses on Beuys' art as they developed in North America and in both Germanys, dating back to Beuys' emergence to prominence in the key year of 1972 and ending after German reunification in 1990. The volume opens with a foreword by Arthur Danto, who poses the not inconsequential question of what continues to make Beuys significant within twentieth-century culture. Divided into six major sections and an appendix, the texts and investigations of *The Reader* foreground critical discussion of specific artworks by Beuys, the

dialogue these works have created with those of other artists, and how Beuys' art contests the operative assumptions of visual modernism or exceeds its boundaries as they are currently delineated. *The Reader* includes two discussions with Joseph Beuys himself and sixteen significant art historical studies and discussions of the last thirty years on Beuys' art, some well known. In outlining these separate discourses and literatures on the artist, and in recognizing Beuys as a marginalized figure in American discourse, *The Reader* hopes to reinitiate discussion of the work of this artist as a figure who challenges and destabilizes the categories established for modern and postmodern art by American art history since the late cold war.

Art history has generally constructed a secular – and modern – 'Beuys', a position Beuys himself had established in his art by the 1970s and 1980s. In line with the recent sweep of art history that it includes, the Beuys put forward by *The Reader* is secular and modernist. There are most certainly other 'Beuys' that remain to be uncovered or constructed. Another 'Beuys' would have to do with Beuys' engagement with the sacred. This aspect of his work arguably positions him as pre-modern, or at a cultural point before the secularizing thrust of the modern. This is an enormous and rich topic, and it concerns the place of the sacred within modern art, if it can indeed be located there.

Beuys' sustained refashioning of the Duchampian readymade into religious or sacred art in his work of the 1950s and 1960s is a complex chapter in his oeuvre that has not been systematically addressed in English-language art history. It is not coincidental that two Catholic priests as well as a famed art historian of the Byzantine period have all written extensively on Beuys' art. First there is the interest of Monsignor Otto Mauer of the Galerie nächst St. Stephan in Vienna in Beuys, a most interesting chapter in the arguably more Catholic-inflected contemporary art that came out of Vienna in the 1960s (which included the Viennese Actionists, Valie Export and Peter Weibel). Monsignor Friedhelm Mennekes has also put forward sacred readings of Beuys' art (in his 1996 book *Joseph Beuys: Thinking Christ*). In an essay of 1988, the Byzantinist Otto von Simson argued that Beuys broke new ground for Christian art in the post-war world. Further, many of Beuys' performances have been read as engaging with the sacred realm of the shamanistic rite or ritual. Beuys the sacred artist is

a rich and enormous subject. We simply cannot do justice to his complexity here; he will be the subject of a second volume.

The cultural context of post-war Germany and the trajectory of Beuys' tumultuous career remain central to understanding the modernist Beuys that is presented in *The Reader*. In order to clarify the context from which the contributions to this volume – as well as the numerous positions and conflicts of the debate around Beuys – emerged, our introduction sketches the history and art history of Beuys' far-ranging oeuvre, the abrupt starts and stops Beuys experienced in his dealings with German and American art institutions. Finally, we give a brief outline of the reception Beuys and his art received in critical discourse on both sides of the Atlantic.

Beuys' Reception and Post-War Art History in (West) Germany

Beuys' political activism dominated the reception of his work throughout the 1970s and early 1980s. As a result of the organizations and parties he co-founded – the German Student Party and later the Green Party – his field of activism widened, and the group that recognized him as an artist grew. Beuys became famous as an artist who also claimed the role of politician for himself. Yet he simultaneously completed installations and drawings; he continuously produced works of art which were not recognized by a larger public. Beuys instead got recognition as an organizational speaker for the Greens, addressing creativity in the context of schools and universities, science and economics. He thereby brought art back into public discussion. Beuys used this synergy effect for his concept of expanded art. The additive process of combining and linking people from different professions and social circles to an overall reformist picture of society was part of Beuys' success as a public figure. Because he formed organizations for the implementation of reformist ideas – such as the Free International University, which also became a publishing house – Beuys found sympathizers in the Anthroposophical Society and in the field of religion, such as Father Mennekes. Furthermore, there were followers and disciples among his students. This all increased publishing on Beuys, but from the authors' own professional fields. From these positions, they formed bridges to Beuys and his concept of expanded art and less often to his artworks. In all this, Beuys as a person became

more vivid than his artwork; his speeches and outfits were more famous than his individual works of art. The reception was then dominated by clichéd biographical readings of his oeuvre. This is true not only of the reception by the general public, but also within German art history.

Beuys' work as a field of art was not taken up by West German academia before the late 1980s. Before 1980, contemporary art was not part of the curriculum in most West German art history departments. Interestingly Peter Bürger's essay, included in this volume, also dates to this period; it relates to the influential German tradition of critical theory, such as that of Jürgen Habermas. Contemporary art had not been established as a field of art history, and there was major uncertainty as to how to deal with contemporary art methodologically. Iconographical and iconological reading were common approaches, as was stylistic analysis, but they proved less useful in the confrontation with Informel and Concrete Art in post-war West Germany. Adam Oellers has characterized early art historical writing on Beuys as moving from a basis in authenticating texts and statements by Beuys himself to analyses using more classical methods.[5] Matthias Bleyl has, however, also commented on the limitations of classical methods when faced with Beuys' art.[6]

Max Imdahl, professor at the newly founded Ruhr-University of Bochum, was the first to expand the limits of the iconographic method. Imdahl not only lectured on recent art with a focus on non-figurative art; he also established a university collection. In Bochum, works by artists engaged with Concrete Art in Europe and the USA, such as Richard Serra, François Morellet or Günter Fruhtrunk, could be examined in the flesh, a necessity for serious art historical research on contemporary art. In Imdahl's search for new instruments of interpretation, the aesthetic experience of the viewer takes on a major role. The privileging of the study of medieval and contemporary painting enabled him to focus on the process of looking, and he developed the so-called 'Iconic' manner of viewing. The Iconic is not defined as a method but as an attitude of close reading before an original artwork. Panofskian iconology is then transformed into an interpretation based in the present. This philosophical approach to contemporary and medieval art resonated within the renowned interdisciplinary research group Poetics and

Hermeneutics, also at the Ruhr-University of Bochum. While Imdahl was accused of being ahistorical, other scholars such as Matthias Bockemühl actualized the beholder of art as a new theory in his 1985 work *Die Wirklichkeit des Bildes. Bildrezeption als Bildproduktion* (*The Reality of Painting: Reception as Production*). At the same time, another viewer-focused theory emerged with Wolfgang Kemp, *Der Betrachter ist im Bild* (*The Beholder is in the Painting*).

In 1991, the first dissertation on the work of Joseph Beuys by Theodora Vischer, a student of Gottfried Boehm at University of Basel, changed the situation of Beuys within West German art history. Under the title *Joseph Beuys: The Unity of his Work*, Vischer discusses in detail the functional aspect of the various mediums of Beuys' art and his theoretical work. Vischer thereby differentiated, for the first time, the theoretical from the artistic work of the artist. She concluded that discrepancies exist between the two and that it is not possible to explain the one direction of art practice with the other. Her work initiated a new tendency to deal more concretely with Beuys' artworks.

There were also attempts, in museum education, to experience Beuys' works without reference to the artist's theory or even to his activities. Gerd Selle, Professor for Art Pedagogy at the University of Oldenburg, collected his experiments on Beuys in *Betrifft Beuys. Annäherung an Gegenwartskunst* (*Concerning Beuys: Approaching Contemporary Art*), published in 1994. In this book, he collected student work made in conjunction with the *Beuys Block* in Darmstadt, an effort to approach the work through writing and drawing exercises. In 1987–1988, students from the University of Frankfurt also had a course which examined the *Beuys Block*.[7]

There was, however, some reluctance to place Beuys within the history of modern art. Many of the masters and doctoral dissertations that were to follow focused on one aspect of his work, or on one work itself, or used a comparison to place Beuys within the art movements of the twentieth century. Yet there remained the art historical problem of how to deal with the ephemeral aspect of his work: the actions, performances and speeches. Uwe M. Schneede's catalogue raisonné of the actions and performances (1994) and Jörg Schellmann's catalogue raisonné of the multiples (7th revised edition, 1992 in German;

English edition, 1997) appeared before anyone could work out a general catalogue raisonné, which has yet to be completed. No general catalogue raisonné exists, despite the fact that several foundations are working on cataloguing the artist's work and are collecting research material and published literature.

The Museum Schloss Moyland opened in 1997 near Kleve. It features a permanent exhibition of the collection of the van der Grinten brothers and is the site of the Joseph Beuys Archive: a library with publications, research material, the artist's correspondence since 1967, and a photographic archive. Eugen Blume began to archive films by and on Beuys at the Hamburger Bahnhof in Berlin. The estate of Joseph Beuys also has an archive and is a useful source of information. Furthermore, the FIU (Free International University) Foundation still functions as an activist organization and an information and publishing platform. A *Beuys-Stiftung* (foundation) was founded in Basel, which organized and convened the first Beuys-Symposium in 1991, followed by a second Beuys-Symposium organized by the Stiftung Museum Schloss Moyland in 1995, and smaller symposia in Kassel (1998) and Budapest (2000). As the publication of the symposium essays reveals, both Beuys-Symposia show the variety and discrepancies in writing and talking about Beuys, ranging from eyewitness reports to anthroposophical viewpoints to approaches from art history and other sciences. However, the question of how to deal with Beuys' oeuvre in its entirety – that is, with the artist persona, his public performances and the role of art and artists in society – remains a major problem and task for art historians. These questions of course also necessitate reflection on the role of art history and art institutions within this.

But the feminist movement proved even more influential for the social sciences, including art history. It brought the only theoretical and methodological foundation that reacted to the political turn of art since the Second World War and to art's expansion into social realms outside museums or galleries. Feminist art history claimed goal-oriented research within its interests. After decades researching forgotten art production by women, a new generation of art historians focused on gender relations within artworks as well as in society. Here art history is written from a wider perspective without being caught in hermeneutic genealogies, differences and rejections; it instead

looks at the function of art and its production.

The divided reception of Beuys' work amongst artists also needs to be mentioned. In this volume, Barbara Lange continues the tradition of feminist scepticism in regard to Beuys' practice: here we should mention an entire Canadian school of Beuys-critique forwarded by the artists Sturtevant, Clive Robertson, Vera Frenkel (see her essay in this volume) and Jana Sterbak, as well as the widely known critiques by Marcel Broodthaers (discussed throughout this volume) and Terry Atkinson (of Art & Language). These artists have been outspoken critics of Beuys. There is another feminist approach to Beuys as well: the feminist art historian Andrea Duncan has revealed the connection of 'formlessness' – as it had been theorized by feminist philosophers Luce Irigaray and Julia Kristeva – to rust in Beuys' sculptural objects. In contrast to Rosalind Krauss's strictly Bataillian definition of *informe* (in an essay that is included in this volume), Duncan has suggested that Beuys' artworks open to 'a possible birth from the phallic' and share with these feminist theorists a desire 'for an affective state beyond our present condition and for change within the social body'.[8] One can also point to other women artists who worked with Beuys: his numerous students, who included Katherina Sieverding, Rosemarie Troeckel and Ulrike Rosenbach; Shelley Sacks, who continues working in 'social sculpture'; and Mary Kelly and Margaret Harrison, who were both involved in the FIU in its early stages.

The Long March through the Institutions: Beuys in West Germany

The collecting and exhibiting activity of the van der Grinten brothers was most important for the early reception and recognition of the work of Joseph Beuys in West Germany. Born in the same area, Joseph Beuys met Hans and Franz Joseph van der Grinten for the first time in the home of his art teacher in 1946, where Beuys was preparing to study at the art academy in Düsseldorf. Around 1950, the van der Grinten brothers decided to form a joint collection and acquired their first drawings from the artist. In 1953, they organized the first exhibition of drawings, woodcuts and sculptural works in their farmhouse. Amazingly, this exhibition travelled to the Von der Heydt-Museum in Wuppertal, and thus became Beuys' first museum exhibition. In 1961, both their friendship and a larger

collection – mainly drawings – of Beuys' work was secured, and the van der Grintens exhibited it in the civic museum of Kleve, accompanied by a catalogue. Beuys' initial appointment to the Düsseldorf Academy that same year began smoothly enough; some expressed surprise that such a young and relatively unproven artist had been appointed to a professorship of sculpture at the prestigious academy. Beuys became teacher for monumental sculpture, but the sculptural work exhibited by the van der Grintens caused considerable controversy and rejection. The brothers therefore had the idea of mounting an exhibition solely for Beuys' sculptural work. Two years later, they installed an exhibition with mainly sculptural works under the title of 'Fluxus' in the barn of their parents' farm. This exhibition was widely recognized throughout the Rhineland.[9]

Beuys' first breakthrough with a major museum came with his one-man exhibition, *Parallelprozess I* (*Parallel Process I*) at the Mönchengladbach Civic Museum of Art in 1967. One of the tycoons of German reconstruction, the industrialist Karl Ströher, bought up about two-thirds of this exhibition. Ströher's collection of contemporary art, including Beuys, toured West Germany from 1967 to 1970; after this date, the Beuys pieces were given as an indefinite loan to the Hessisches Landesmuseum in Darmstadt – incidentally also a natural history museum – where they remain to the present day as the 'Beuys Block.'

In the 1970s, Beuys did not establish a consistent relation between exhibition and performance. Sometimes Beuys' early gallery exhibitions took place in conjunction with a performance, or only a performance was staged, or Beuys showed objects in the manner of a traditional exhibition. Beuys' final performance (or 'action', as performance was termed in Germany) with Henning Christiansen and Nam June Paik, took place at the School of Fine Arts in Hamburg in 1985. Perhaps as a result, the reception of Beuys' sculptural oeuvre was enormously delayed, and entered into German art history only later, in the early 1990s.

Several European museum curators continuously featured Beuys' work from the 1960s and after in single and group exhibitions: Dieter Koepplin, director of the Kupferstichkabinett in Basel since 1967, who in his first years showed drawings by Beuys; Harald Szeemann, curator of the famed Documenta 5 exhibition and the Beuys retrospective at the Kunsthaus Zürich

in 1993; and Johannes Cladders, director of the civic museum at Mönchengladbach, where the famous Marx Collection was installed until it was transferred to Berlin in the late 1990s. Finally, Armin Zweite, a successor to Werner Schmalenbach, profoundly changed the museum collection and acquisition policies of the Kunstsammlung North-Rhine Westphalia and, as a result, Beuys' work entered the museum collection for the first time with numerous acquisitions and permanent installations of work complexes such as Beuys' final installation, *Palazzo Regale*.

From 1972 until his death in 1986, Beuys exhibitions took place at major West German and international museums in the West, including the Oxford Museum of Modern Art (*The Secret Block for a Secret Person in Ireland*, 1974), the Kunstmuseum Basel, the Guggenheim Museum in New York, the Museum Boymans-van Beuningen Rotterdam, the National Museum of Man in Ottawa, the Busch-Reisinger Museum at Harvard, the Seibu Museum of Art in Japan and the Musée St. Pierre Art Contemporain, Lyon.

Beuys in the German Democratic Republic

Beuys' exhibition record in the German Democratic Republic – which only began in the 1980s – points to a softening of the state's control of art institutions around a strict notion of socialist realist art. As Eugen Blume's contribution to this volume explains, a figurative tradition in visual art under state socialism which began in the Stalinist Soviet Union, socialist realism, was also taken up as a figurative style, primarily within painting, and was promoted by the states of the Soviet Bloc during the cold war. In October 1981, Beuys multiples from the Ulbricht Collection were put on display in the East Berlin 'Ständige Vertretung' ('Permanent Representation') in the Hannoverrschen Strasse, a cultural institute staffed by West Germans, which famously initiated contacts with the so-called 'alternative' scene in the GDR.[10] In his first and only official visit to the GDR, Beuys attended this opening and presented a short performance; it is claimed that some East German artists took considerable risks in even attending this event. While bureaucrat/art historian Hermann Raum's review dismissed Beuys and his art as another example of western decadence, others attest that Beuys' exhibition was discussed widely in official and alternative art circles in East Germany.[11] In 1984, Beuys was turned back by

East Berlin border police (one of whom stated 'You won't get into the GDR for even five minutes, Mr Beuys!') for the second collaborative performance he had planned with the artist Erhard Monden and the art historian Eugen Blume.[12] Eugen Blume's contribution to this volume discusses Beuys' critical reception in East Germany in greater detail. His art and presence solidified the commitment of autonomous artists to performance practice in the GDR's final years.[13]

Beuys in 'America'

Beuys travelled with his Berlin dealer René Block to New York in 1974 for an exhibition and his first US performance, *I Like America and America Likes Me*, a title that may contain the single greatest overstatement in all of twentieth-century art. On the same trip, Beuys delivered 'lectures' at the New School (filmed by Willoughby Sharp) and the Ronald Feldman Gallery; he travelled to Chicago and Minnesota for further lectures, actions (such as *Dillinger*, 1974) and exhibitions.

Beuys continued to show his art in New York at René Block, Ronald Feldman and John Gibson over the next years. Beuys agreed, amidst a swirl of controversy, to his first retrospective exhibition in the USA at the Guggenheim Museum in 1979; he was fifty-eight years old. Unlike his previous exhibitions, the Guggenheim exhibition focused almost exclusively on Beuys' object and sculpture production and had no performance or 'lecture' component. The scope of the New York retrospective was particularly odd given the fact that Beuys' most recent contribution to Documenta in 1977 consisted solely of the Free International University seminars, many hosted by guest lecturers, on a number of political and economic topics. Therefore, many New Yorkers did not understand the connection between Beuys' objects and his performance practice, since the most explicitly political component of Beuys' art was effectively sheared from the objects as they were presented in the USA. Unlike his work in West Germany after 1977, Beuys chose not to bridge objects and performance in the USA. Of course the question remains: why did Beuys settle upon this very American arrangement? Was it, as Clement Greenberg put it, a loss of nerve, or an unwillingness to confront the dominant formalist values of New York art institutions at the time and risk losing a major US exhibition?

Beuys in the Academy

While he rose to prominence in museum-institutions, Beuys fared far worse within the German art academy, where it is no exaggeration to characterize his career as disastrous. The first calls for Beuys' dismissal from his position began in 1968, after he refused to adhere to academy policy regarding student admissions and portfolio review in opening his class to anyone who wanted to study with him. Nine faculty members submitted a letter to the administration accusing Beuys and his students of destabilizing the academy; in a fitting correspondence of destabilization, Beuys' student Jörg Immendorff also staged his own mini-academy 'Lidl-Raum' on the lawn in Düsseldorf. It was also in 1968 that the École des Beaux Arts in Paris was occupied by students.

In 1972, the ongoing dispute between Beuys and the Ministry of Education concerning Beuys' practice of accepting students into his class who had been rejected for admission by other faculty members intensified. Johannes Rau, Minister of Education for the state of North-Rhine Westphalia,[14] ordered Beuys to stop the practice. Beuys and students occupied the administrative offices of the Academy for a week in October 1972, demanding open access to education for all and also protesting against a closed enrolment policy within the arts. Rau then summarily fired Beuys from his tenured position, without pay or recourse. The decision was opposed by students and the German public, and by prominent artists and writers such as Heinrich Böll, Richard Hamilton, David Hockney, Allan Kaprow, Ed Kienholz and Gerhard Richter, all of whom demanded Beuys' reinstatement. Beuys initiated a lawsuit regarding his dismissal, which he won in 1978. In a negotiation/settlement with the Academy, Beuys was allowed to maintain studio space in the Academy building and retain his title, but he no longer had a position on the faculty. Beuys then moved the office of the Free International University to these rooms, where it operated until 1986.

A number of American collectors with ties to American museums proved ready to stage Beuys' art in major exhibitions, and the 'museologizing' of Beuys' work in the USA began in the 1990s. Beuys' artworks entered important American collections such as the Dia Foundation, the Busch-Reisinger Museum at Harvard University and the Walker Art Center; key

Beuys works were also acquired in France by the Centre Georges Pompidou. A resulting wave of exhibitions in the 1990s initiated a reconsideration of Beuys' art, including *Arena: Where Would I Have Got if I Had Been Intelligent!* at the Dia Center for the Arts (New York, 1994), *Joseph Beuys: Drawings after the Codices Madrid of Leonardo da Vinci* (1998), *Thinking is Form: The Drawings of Joseph Beuys* (1990) at the Philadelphia Museum, and the 1997 Walker Art Center exhibition of Joseph Beuys multiples. Organized by former Documenta curator Harald Szeemann, the 1993 Kunsthaus Zurich exhibition (which travelled to Paris and Madrid) is the single most important European Beuys exhibition since the artist's death, as it initiated a new French and Spanish reception of Beuys' art.

Beuys in American Criticism and Art History

Beuys' reception in American criticism and art history is a unique chapter in the history of the visual culture of the post-war era. Beuys' 1974 visit to the USA went almost unnoticed, due in part to the fact that his wide-ranging art practice could not be easily assimilated into the major directions – minimalism and conceptual art – that concerned American art at the time.

American art history of the post-war period has largely followed the careful Kantian formalist logic set out by Clement Greenberg in the 1940s. In reaction to the rise of totalitarian governments in Europe and the USSR, Greenberg famously came to reject the lineage of the modernist avant-garde that had directly engaged itself for the goal of social and political change. For Greenberg, the art that carried western civilization forward eschewed political engagement; on this count Greenberg agreed with the anti-avant-gardist of the Frankfurt School, Theodor Adorno. In the late 1970s, with the rise of the French-inflected discourse on postmodernism in the USA, structuralist and poststructuralist views complicated Greenberg's purely formalist logic; yet his anti-avant-gardism jived nicely with postmodernism's rejection of any cultural mention of 'master narratives' that might set their sights on social and political change. American Minimalist Art as well as certain directions in conceptual art developed another key position of postmodernism in programmatically refusing traces of the artist's subjectivity within the creative process.

Given the emphasis he placed on the moment of human

creativity in his art (and his famous dictum 'every human is an artist'), Beuys celebrated the connection between creativity and subjectivity as a wellspring of human culture. It has been suggested that in this view of art he was closer to the positions of classical modernism than to those of postmodernism. Ever more visible in the media, particularly after he declared his intention of seeking a nomination to represent the new Green Party, Beuys fashioned himself into a media figure – a hybrid of celebrity, art and politics. On this count, he differed dramatically from the persona put forward by Warhol, the other late-twentieth-century artist who engaged most extensively with the mass media. Far from presenting an evacuated subjectivity that celebrated and promoted the consumption process in the manner of Warhol, Beuys used his media appearances to promote specific political causes, sometimes those of the Green Party, or to argue his views on the inadequacy of both capitalism and socialism. As part of his media campaign, Beuys even sought out endorsement possibilities that he argued were means of funding key FIU and Green Party projects.

Little was published in the USA on Beuys in the 1970s until his 1979 retrospective exhibition at the Guggenheim Museum in New York. Generally, American critics and historians who have dealt with Beuys have fallen into two distinct camps: in the wake of Lucy Lippard's important *Six Years*: *The Dematerialization of the Object of Art* (1973), they focused on developments in New York which had been termed 'conceptual' in nature and understand Beuys as having a fraught relationship with this direction in art; a second group of critics around the journal *October* came to position Beuys as the figure against which they defined and analyzed a structuralist-based and mostly American 'postmodern' art practice.

Lucy Lippard's *Six Years* is an early survey of what has come to be called 'conceptual art'. Lippard includes several Beuys performances of the 1960s – *Eurasia* of 1966 is most closely chronicled. In her discussion of *Eurasia*, Lippard quotes Beuys on the political intent powering his work. Lippard continued to point to Beuys' significance in her 1995 essay 'Escape Attempts'. In a discussion that focuses broadly on conceptual art in the 1960s, Lippard contrasts Beuys' work as a teacher with most of conceptual art's concern with language as a medium and

not as a means of communication: 'Verbal strategies enabled Conceptual art to be political through verbal strategies, but not populist. Communication between people was subordinate to communication about communication.'[15] Lippard also uses Beuys' art to offer a revisionist notion of conceptual art which is open to both directions, in taking note of its oppositional quality which is not achieved solely through form but also through content.

Caroline Tisdall's catalogue for the 1979 Guggenheim retrospective, *Joseph Beuys*, was the first major reference and overview of Beuys' work up to that date in English. The other major English-language essay resulting from the 1979 retrospective was Benjamin Buchloh's damning review, 'Beuys: The Twilight of the Idol', published in *Artforum* in 1980 (and included in this volume).[16] Donald Kuspit has analyzed Buchloh's response in his essay 'Joseph Beuys: The Body of the Artist' (1995) as in part based in the generational break the war elicited amongst Germans. (For further European responses to Buchloh's views, see the essays by Stefan Germer, Theodora Vischer, Antje von Graevenitz, and Dorothea Zwirner in this volume.)

One can speak of a specific reception accorded to Beuys by the critics of the New York journal *October* which built on Buchloh's essay. Rosalind Krauss, a founding editor, with fellow editors Annette Michelson and Buchloh, convened a 'roundtable' discussion of Beuys' Guggenheim retrospective in 1980.[17] The discussion determined that Beuys cannot be compared to either Duchamp or Cage. Beuys is seen instead to offer an obsolete, nineteenth-century take on the avant-garde, on modern physics, electricity and 'models of meaning'; similarly, Beuys' citation of the surrealists is without historical relevance. The speakers decide that Beuys has no relation to the most important figures of German art of the 1960s and 1970s (Gerhard Richter, Blinky Palermo, Hanne Darboven, the Bechers). The discussion finally concludes that Beuys stands outside of art history and is largely irrelevant to the situation of international art.

Interestingly, no work or performance by Beuys is considered at any length in this discussion. It should be noted that the major focus of *October* at the time was the articulation of a notion of visual postmodernism, initiated around the New York exhibition *Pictures* (1977). *October* also played a major role in

establishing the influence of French theory in American art discourse. In contrast to the *October* position, Gregory Ulmer's *Applied Grammatology* (1985) argued that Beuys' practice and his theory of art as 'social sculpture' could be read as an application of Derridian 'grammatology'.

In its summer 1988 issue (and possibly as a response to Ulmer), *October* returned to the subject of Beuys in essays by Thierry de Duve and Stefan Germer among others (both are included in this volume). De Duve argues that Beuys drew from a flawed and even false conception of the figure of the proletarian in his theory and practice. Germer points to Beuys' refusal to withdraw from a Guggenheim exhibition in 1972 where Marcel Broodthaers' art was allegedly censored by curators. The event Germer canonizes also led to Broodthaers' 'open' letters to Beuys, which had – as proven in Germer's and several other essays in this volume – a long afterlife in American art history. Krauss again commented on Beuys in 1997, positioning him as the other to a direction in advanced art she constructs around Bataille's notion of *informe* (see the excerpt in this volume).

The anthology *Joseph Beuys: Mapping the Legacy* (DAP, 2001), edited by Gene Ray, primarily featured essays by curators. It cohered around the question of Beuys' position to the Holocaust as revealed in various objects, installations or statements. Max Reithmann's and Ray's essays point to Beuys' unwillingness or inability to confront directly the atrocities committed against Jews during the Nazi period in his artworks or in his statements. However, Beuys is credited for his sustained engagement with the 'project of mourning' in the wake of the Holocaust.

Ray's book also contains Benjamin Buchloh's first commentary on Beuys after his 1980 review. In part because of the sheer scope of his activities, Buchloh concludes that Beuys cannot be accommodated in a history of advanced art after 1945 without altering it drastically, since, in contrast, other (postmodernist) artists' works appear almost inconsequential in their (downsized postmodernist) ambition. (Peter Bürger had earlier pointed to this disparity in the essay he has contributed to this volume.) The key question in this debate also recalls that of the British volume, *Joseph Beuys: Diverging Critiques* – either one accepts the idea of Beuys' (inadequate) exceptionalism in late-twentieth-century art, or one admits to the possible inadequacy of

diachronic models of art history to accommodate or account for his practice and the need to develop others as a result.

Beuys in Art History: The Contents of *Joseph Beuys: The Reader*

The texts and investigations of this reader foreground critical discussion of specific Beuys artworks. Further, these texts foreground the dialogue these Beuys artworks have created with those of other artists, and how Beuys' art contests the operative assumptions of visual modernism or exceeds its boundaries as they are currently understood.

In Section I, 'Beuys and his "Challengers"', contributors reconsider the penumbral space of interaction between the work of post-war artists who challenged Beuys or were challenged by his distinctive notion of art, such as Marcel Duchamp, Marcel Broodthaers, Hans Haacke and James Lee Byars. We define this cultural area as 'penumbral' because it escapes the comfort zone of the singular, determining author and of the self-contained artwork. This section tracks the development of a model of the creative process itself within individual artworks by Beuys and those of other artists who were his colleagues. This dialogic model centres on the action of inter-subjective debate or contestation, and offers a strong contrast to the model of the individual artist creating a hermetic, 'original' artwork.

Of course, the response to Beuys was far broader than this section's shortened list would indicate. For example, Beuys' relation to Fluxus is an issue of central importance not only to Beuys' art but also to a more comprehensive understanding of Fluxus and its activities. Despite the expansive literature on Fluxus, there is not much in the English-language literature that examines Beuys' changing relation to it; this is a subject very much in need of further investigation. Only two authors have addressed it: Hannah Higgins, in her book *Fluxus Experience* (2002); and Thomas Kellein (director of the Kunsthalle Bielefeld). Higgins only mentions Beuys in passing and does not pursue his connection to Fluxus in any detail. Kellein's important essay 'Zum Fluxus-Begriff von Joseph Beuys' ('On Beuys' Fluxus Concept'), published as part of the 1991 *Beuys Tagung* in Basel, gives this connection its first sustained, art historical examination.[18] Kellein argues that Beuys' self-asserted association with Fluxus, beginning in 1963 with his second 'stable exhibition' on the

van der Grinten farm in Kranenburg, served the artist well in launching his own work internationally. In contrast to George Maciunas' notion of 'fluxus', which was to lead to an eventual evaporation of art in society, Beuys developed the elastic term into his own radically expanded notion of art. Kellein also notes an irony in this confrontation: where Fluxus' visibility arguably waned after 1965, Beuys' own work gathered momentum and international recognition.

Other artists or 'challengers' to Beuys have commented critically on his practice. Terry Atkinson's 'Beuyspeak' represents the rather dismissive position of Art & Language in relation to Beuys' conceptual practice (Atkinson's essay was published in *Diverging Critiques*). And while there seems to be widespread agreement that there is some kind of relation to be established between Beuys and Andy Warhol – de Duve comments that 'only Warhol equals Beuys in media-value' – little or nothing has been published on the topic. Without offering any specifics, Robert Storr's essay 'The Idea of the Moral Imperative' (*Art Criticism*, 1991) purports to contrast the two in broad strokes, depicting Beuys as a utopian and Warhol as a cynic. As a means of framing an essay on the contemporary sculptor Thomas Hirshhorn, Buchloh offers a cursory and reductive 'sketch of oppositions' between the concerns of the two artists, arguing a naive belief in autonomy for one which is transcended by the other, without making reference to specific works of art by either.

Like the weirdly anti-climactic photo-op encounters between the two artists staged by West German galleries in 1979 – and which Johannes Stüttgen attempted to immortalize as the 'Beuys/Warhol Event' – the work of each artist remains so far removed from the other that comparison ends up saying little or nothing about the work itself except in the vaguest of generalities. Perhaps on the most fundamental level the two stood at opposite poles in their relation to the media. Both instrumentalized it to project a mass-media persona of celebrity but with entirely different assumptions; it is on this terrain that we can read one as a modernist (Beuys) and the other as a consummate postmodernist (Warhol). Warhol's art investigated the mechanisms behind the media image; Beuys took the media at its word as a communication medium, trusting it to deliver his 'vehicles' for social change unscathed. The media remains

their strongest bond and one that might be more promising for comparative investigation of their artworks – as Christopher Phillips has begun to do.[19] Emerging artists continue to challenge and be challenged by Beuys: Maurizio Cattelan and Keith Tyson's recent statements and artworks, part of the 2005 Beuys exhibition at the Tate Modern, make this plain.[20]

Beuys' reception by *October* critics, or, the New York reception of Beuys' art and the international response to it, forms the basis of Sections II and III. We include key contributions on the Beuys' New York reception by Benjamin Buchloh, Thierry de Duve and Rosalind Krauss, and some responses to them. Some of these early essays had to do with the return of iconographic meaning in Beuys' art and the methodological problems that return posed to art historians, particularly in regard to his references to the philosophy of German Romanticism. The Canadian artist Vera Frenkel considers the role of charisma in Beuys' work. In her response to Buchloh, Theodora Vischer sees the echo of early German Romantic natural history and philosophy in Beuys' critical position toward Enlightenment science.

The fourth section, 'Beuys, Art and Politics', reveals Beuys as a touchstone for a politicized generation of women artists, critics and art historians who would emerge in the 1970s and 1980s, and offers close and competing readings of activist works by Beuys from the key year of 1972. Beuys' increasing involvement as an artist with various political and activist causes, from the 'German Students Party' in the Düsseldorf Academy to environmental actions ('Let us Overcome the Dictatorship of Party Democracy Now', 1972) to campaigning as a candidate for a spot on the Green Party ticket in the parliamentary elections of 1982–1983, came to stretch the sphere of art so that it sometimes directly entered the sphere of politics. To further illuminate Beuys' activism-as-art, two discussions with Beuys, never previously published in English, are included in this section: one is with visitors to his installation at Documenta in 1972; the other is a roundtable discussion on Beuys' failed Green Party candidacy in Düsseldorf in 1982–1983. As the *Überblick* discussion included in this volume states, Beuys is seen as one of the founding members of the German Green Party even though it rejected him as an official candidate in 1983. Some members within the party, most notably Petra Kelly, continued to point to Beuys as 'der grüne

Vordenker', or as the intellectual origin of the party.[21]

Beuys was one of the last western artists to take up the lineage of the engaged modernist avant-garde; this position had become most unfashionable, even taboo, within postmodern art production in the USA. Due to his critical stance toward mechanical law, his insistence on an 'anthropological' notion of art, his absolute anti-formalism, and the basis of his art in an increasingly strident activist politics, Beuys was probably never postmodern. Section V, 'And Postmodernism', focuses on the relation of Beuys' art to philosophical and theoretical developments of the post-war period (echoing Arthur Danto's Foreword). In an important essay, from which an excerpt is presented here, Irit Rogoff points to Beuys' central place within the cultural preoccupation with collective memory, trauma and commemoration in West German art of the late 1980s, part of a shift to 'an alternative discourse of memory'.[22] An extract from Gregory Ulmer's book *Applied Grammatology* in this section offers a deconstructionist reading of Beuys' performance practice: he outlines the point of convergence between Beuys' and Derrida's theoretical systems around the notion of a postmodernist pedagogy. Beuys' relation to postmodernism is a broad topic that cannot be treated exhaustively within one brief section. We also note that Antje von Graevenitz's contribution to *The Reader* deals extensively with Beuys' relation to the proto-postmodernist Duchamp, and therefore also raises important points on his more general relation to the postmodern. Much work remains to be done in this regard; one might envision, for example, a reading of Beuys' art theory through the lens of Deleuze's notions of movement and the Open.[23]

In an essay that precedes the one included in this volume, theorist of the avant-garde Peter Bürger examined Beuys' utopian project.[24] For Bürger, Beuys is an example of a late avant-gardist who assumes both an avant-gardist position and one antithetical to it: Beuys adapts to the institutional frame of bourgeois art while distancing himself from it. Beuys also shifts his production from avant-gardist and anti-auratic forms of art that recall the destructive mode of allegory, to work that is blatantly auratic or 'classical' in nature, a point that Bürger does not take up but that is central to Beuys' work. Beuys' foregrounding of his artistic persona, and his process of distributing relic-like performance

objects and photographs via the multiple and installation, are the divergent paths of the auratic which he revived in his work.

The final section, 'Issues of Reception', includes art historical considerations of the dramatically different receptions Beuys and his art has received in East Germany, West Germany and the USA. Dirk Luckow's essay traces Beuys' US reception within the context of the paradoxical post-war American stance toward Europe. Luckow is not the first art historian to suggest that art criticism and discourse in the USA during the cold-war era displayed a bias against certain artists or national cultures. Gertje R. Utley has traced the rising cultural nationalism of the USA after 1945 and the impact the notion of American exceptionalism had on Picasso's declining US reputation during the final decades of his art production.[25] This cultural situation is the point of departure for Luckow, who considers how American artists in the 1960s and 1970s shared this mindset while nevertheless travelling and in some cases living in Europe for extended periods of time. The East German art historian Eugen Blume tracks Beuys' surprising influence and reception in the final years of the German Democratic Republic. This section concludes with a recent informal exchange between Jean-François Chevrier, Benjamin Buchloh and Catherine David on the question of the modernist avant-garde and the prominent place Peter Bürger had earlier assigned to Beuys within it.

Joseph Beuys: The Reader is an initial step in reopening an international discussion on Joseph Beuys and his art. Beuys continues to pose major challenges for twenty-first-century art and art history. His difficult and divided reception proves that his art is alive with the energies and forces he so often discussed. It continues to provoke.[26] The essays in this collection trace a number of Beuys' specific challenges: the problems inherent in a contemporary artist's established codes of meaning or iconography and the horizon of the art experience they might fix; the new model of dialogic interaction between his art and that of other important artists of his generation; and the new frontier of political engagement he established as an artist; and finally the significance of the lack of consensus on Beuys' work. The import of these challenges, among others, is not yet settled. As Vera Frenkel suggests, we should consider not only what Beuys did but also the significance of the silence that has

grown around his art. In taking the positions of Romanticism – as the Surrealists had also done – Beuys forwarded a model of modernity that rejected Enlightenment aesthetics. Art history and criticism has yet to fully theorize this alternative history of the modern, this enormous challenge Beuys issued to us. The work in this volume begins this task.

NOTES

1. Peter Nisbet, 'Crash Course: Remarks on a Beuys Story', in Gene Ray (ed.), *Joseph Beuys: Mapping the Legacy* (New York: DAP, 2001).

2. Johannes Cladders, 'Joseph Beuys: Origins and Affinities', in David Thistlewood (ed.), *Joseph Beuys: Diverging Critiques* (Liverpool: Liverpool University Press, 1995), pp. 21–6.

3. Pamela Kort, 'Joseph Beuys' Arena: The Way in', in Lynne Cooke and Karen Kelly (eds.), *Arena: Where Would I Have Got if I Had Been Intelligent!* (New York: Dia Center for the Arts, 1994), pp. 18–33; 'Joseph Beuys' Aesthetic', in Thistlewood (ed.), *Joseph Beuys: Diverging Critiques*, pp. 65–80.

4. Of particular interest is Kuspit's essay 'Joseph Beuys: Between Showman and Shaman', in Thistlewood (ed.), *Joseph Beuys: Diverging Critiques*, pp. 27–50. Kuspit has published widely on Beuys over a number of years: 'Beuys: Fat, Felt and Alchemy', *Art in America* (May 1980): 79–88; 'Beuys: The Body of the Artist', *Artforum* 29:10 (Summer 1991): 80–6, reprinted in Thistlewood (ed.), *Joseph Beuys: Diverging Critiques*; and the chapter 'Enchanting the Disenchanted: The Artist's Last Stand – Joseph Beuys', in Kuspit, *The Cult of the Avant-Garde Artist* (Cambridge: Cambridge University Press, 1993).

5. Adam C. Oellers, 'Beuys und … Zur Methodologie der Beuys-Rezeption zwischen Wissenschaftstheorie und Massenwirksamkeit' ('Beuys and … On the Methodology of Beuys Reception, between science and mass media'), in Inge Lorenz (ed.), *Joseph Beuys Symposium Kranenburg 1995* (Bedburg-Hau and Basel: Stiftung Museum Schloss Moyland and Wiese Verlag, 1996), pp. 107–15, especially p. 108.

6. Matthias Bleyl, 'Über den Umgang der universitären Kunstgeschichte mit Joseph Beuys' ('On academic art history's dealings with Joseph Beuys'), in Volker Harlan, Dieter Koepplin and Rudolf Velhagen (eds.), *Joseph Beuys-Tagung Basel 1.-4. Mai 1991 in Hardhof* (Basel: Wiese Verlag, 1991), pp. 221–7.

7. See Matthias Bleyl (ed.), *Joseph Beuys, der erweiterte Kunstbegriff: Texte und Bilder zum Beuys Block im Hessischen Landesmuseum Darmstadt (Joseph Beuys' Expanded Concept of Art: Texts and Paintings of the Beuys Block)* (Darmstadt, 1989).

8. Andrea Duncan, 'Rockets must Rust: Beuys and the Work of Iron in Nature', in Thistlewood (ed.), *Joseph Beuys: Diverging Critiques*, p. 91.

9. On this exhibition, see Hans van der Grinten, 'Joseph Beuys "Stallausstellung" Fluxus 1963 in Kranenburg', in Bernd Klüser and Katharina Hegewisch (eds.), *Die Kunst der Ausstellung* (Frankfurt a.M.: Insel Verlag, 1991).

10. On the Ständige Vertretung (founded in 1974) and Beuys' 1981 visit, see Simone Hain, 'Schwebende über einer Grenze. Kulturelle Begegnungen in der Ständigen Vertretung der Bundesrepublik', in *Klopfzeichen. Kunst und Kultur der 80er Jahre in Deutschland: Mauersprünge* (Leipzig: Verlag Faber & Faber, 2002), pp. 73–5.

11. Hain notes that members and office-holders of the VBK (Union of Visual Artists) were pressured by the organization and even by the secret police (the Stasi) not to attend the Beuys exhibition. Ibid. p. 73.

12. See Eugen Blume, 'Baustellen der Identitäten, Laborismus gegen Kapitalismus und Kommunismus im Dunkeln: Joseph Beuys', in *Klopfzeichen*, pp. 49–51.

13. Karl-Siegbert Rehberg lists the Dresden artists Jürgen Schieferdecker, Wolfgang Petrovsky, the well-known academy teacher Günther Hornig and East Berlin artists Robert Rehfeldt and Stefan Kayser as artists who were influenced by Beuys. Karl-Siegbert Rehberg, 'Verkörperungs-Konkurrenzen. Aktionskunst in der DDR zwischen Revolte und "Kristallisation"', in Christian Janecke (ed.), *Performance und Bild Performance als Bild* (Berlin: Philo & Philo Fine Arts, 2004), p. 121.

14. Johannes Rau served as Federal President of the Federal Republic of Germany from 1999 to July 2004.

15. Lippard, 'Escape Attempts', in Ann Goldstein (ed.), *Reconsidering the Object of Art* (Los Angeles: Museum of Contemporary Art, 1998), p. 31. This emphasis on Beuys as a pedagogical presence first appeared in a doctoral dissertation by Cornelia Lauf. It is a common focus of American writing. Lippard further brackets Beuys' interest in education as specific to European developments in conceptualism.

16. Benjamin Buchloh, 'Beuys: The Twilight of the Idol', *Artforum* XVIII, no. 5 (January 1980), 35ff (reprinted in this volume).

See also the essays in *October* vol. 45 by de Duve and Germer (included in this volume).

17. Benjamin Buchloh, Rosalind Krauss, and Annette Michelson, 'Joseph Beuys at the Guggenheim', *October* 12 (1980): 3–21.

18. Thomas Kellein, 'Zum Fluxus-Begriff von Joseph Beuys', *Joseph Beuys-Tagung Basel* 1.-4. (Mai 1991), 137–42.

19. Christopher Phillips, 'Arena: The Chaos of the Unnamed', in *Arena*, pp. 52–62.

20. See Maurizio Cattelan, 'The Fat is on the Table', and Keith Tyson, 'The Spirit of Change', in *Tate Etc.* (Summer 2005): 80–3.

21. Kelly, who joined the Greens from the FIU, continued her close public affiliation with Beuys even after she had become the party's most well-known politician. See Petra Kelly, 'Joseph Beuys: Beuys war immer schon fort, wenn die anderen kamen!', lecture at *Paralleles Denken*, a symposium of the City of Düsseldorf in conjunction with the exhibition *Joseph Beuys: Natur, Materie, Forms* (18 January 1992), reprinted in Petra Kelly and Joseph Beuys, *Diese Nacht, in die die Menschen...* (Wangen: FIU Verlag, 1994), p. 104. Kelly joined the Greens after working within the FIU. She became a Bundesstag leader for the Greens as a representative from Bavaria in 1983. She continued to serve in the German parliament until she was murdered in October 1992.

22. Irit Rogoff, 'The Aesthetics of Post-History', in Stephen Melville (ed.), *Vision & Textuality* (Durham: Duke University Press, 1995), p. 199.

23. Gilles Deleuze, *Cinema 1: The Movement Image* (Minneapolis: University of Minnesota Press, 1986).

24. Peter Bürger, 'A propos Joseph Beuys – Alltag, Allegorie und Avantgarde' (1986), translated as 'Everydayness, Allegory and the Avant-Garde: Some Reflections on the Work of Joseph Beuys', in *The Decline of Modernism* (Cambridge: Polity Press, 1992), pp. 147–61. Bürger, a scholar of surrealism, is best known for his seminal study *Theory of the Avant-Garde* (Minneapolis: University of Minnesota Press, 1975).

25. Gertje R. Utley, *Picasso: The Communist Years* (New Haven: Yale University Press, 2000).

26. For example, the entry for 'Joseph Beuys' on the collaborative online encyclopaedia *Wikipedia* is one of the few entries for a visual artist to have borne the notations 'The neutrality of this article is disputed' and 'This article or section needs a complete rewrite for the reasons listed on the talk page'. See http://en.wikipedia.org/wiki/Joseph_Beuys.

Section I
BEUYS AND HIS 'CHALLENGERS'

1. BREAKING THE SILENCE

Joseph Beuys on his 'Challenger', Marcel Duchamp*

ANTJE VON GRAEVENITZ

IN LECTURES OR IN recorded conversations with others, Joseph Beuys did not often quote other artists or draw parallels with them in regard to his own work. Those he did mention included Leonardo da Vinci, Raphael, Dürer, Wilhelm Lehmbruck, Wilhelm von Gloeden and Marcel Duchamp. One should not forget Jackson Pollock, whom he constantly brought up when asked which artists he particularly valued, without further explanation as to why the American painter, known for all-over compositions and drip paintings, played an exceptional role for him.[1] Among those mentioned, Duchamp occupies a special place; Beuys made frequent and critical comments about him. Thus one might conclude that he wished to contrast himself with Duchamp, since Duchamp was regarded as responsible for every new direction in art from the 1960s until the 1980s, such as Fluxus, Pop Art and conceptual art. Duchamp was generally honoured as the father or inventor of contemporary art.

At the time, therefore, it was necessary for a young artist to protest such discouragement. If one listens carefully to the discussions with Beuys that are passed down in recordings, reads the interviews and views his works perceptively, then one can no longer describe his critique as merely motivated by competition or small-mindedness. Duchamp mattered much more to him than that.[2]

In 'Entrance to a Living Organism' ('*Eintritt in ein Lebenswesen*'), a lecture on 6 August 1977 at Documenta in Kassel, Beuys spoke to what was generally a lay audience in simple, fairly disparaging words about Duchamp. To begin with, he briefly outlined his

own development as well as his search for possibilities to become active in artistic practice in the face of the 'annihilation of mankind' and the 'destruction of the earth'. He then continued: 'I have also noted in one work of Marcel Duchamp, which is very complex and experimental in nature, that one must pose the question quite differently. That is the question of the critical situation of art itself.' It is not enough, Beuys said, that one turns directly to a picture. One has to allow new experiments and subsequently expand the concepts for the work. And, while Duchamp experimented, he did not draw conclusions from his methods. 'Duchamp was a slacker who completed beautiful and interesting experiments as shocks to the bourgeoisie, and those were done brilliantly in the aesthetic typology of the time' but, for all that, he did not develop a category of thought for it. Duchamp signed an industrially produced urinal with a pseudonym and displayed it in an exhibition so that it would be perceived as art, although it wasn't produced by him but rather by many workers. He did not draw conclusions from this situation. 'If it is possible to transfer the results of human work from the world of the division of labour into the museum, he should also have said, as *I* concluded: therefore everyone is an artist,' and Beuys laughed loudly.[3]

In 1985, he spoke again about Duchamp's urinal, this time with more deference, in an English-language discussion with William Furlong in connection with Beuys' work *Plight* in the Anthony D'Offay Gallery in London; he further contrasted his 'expanded concept of art' to Duchamp:

> So he did not enhance all the work and all the labour to a new understanding of art as necessity … to start everything in order to understand all aspects of human kinds of labour from his view. This would have been of great importance, because since then it could have already become a kind of discussion about existing ideology in society, the capitalistic system and the communistic system: the germ in the right directions practised by Marcel Duchamp. But then he distanced himself from further reflection. So he did not understand his own work completely.[4]

Had he drawn conclusions from his actions instead of wanting to shock the bourgeoisie, as was befitting a dadaist at the time, Duchamp would have transformed art. Beuys continued:

> So in being very modest, I could say: my interest was to make another interpretation of Marcel Duchamp. I tried to fill this most important gap in his work and make a statement, 'the silence of Marcel Duchamp is overrated'. You know, after he stopped working, playing chess, he did not speak any more about art, he was completely silent; he cultivated this kind of silence in a very old-fashioned form. He wanted to become a hero-in-silence or in doing nothing or in resigning from art ... So I principally tried to push this beyond the threshold of modern art into an era of anthropological art, as a beginning in all fields of discussion ... not only of minor problems.[5]

Beuys' declaration is astonishing for two reasons: while on the one hand he saw the seeds of the 'expanded notion of art' in Duchamp's work, on the other he established a view of twentieth-century art history that credited only two artists with the development of art and then created a rift between them. He regarded Duchamp as the terminator of modern art but himself as the initiator of an anthropological art, as he called it.

Already in June of 1984, he had put forward a similar explanation in a discussion published in French and Italian and had similarly defined, by means of his expansion of Duchamp's abandoned work, the 'anthropological material' that remained to be developed: 'The primary anthropological material of mankind is thought, emotion and will.'[6] He mentioned these three concepts, in reverse order, as constituting the stages of his theory of sculpture ('*Plastik*'). He had formulated this for Dieter Koepplin and established them as parallels to the principles of chaos/will, movement/perception, and thought/action.[7] His goal was to encourage the free and active mental creativity of the viewer. To that end, his art should only have a demonstrative and evocative character.

On 11 December 1964, the silence of Duchamp gave Beuys the opportunity to stage a programmatic performance ('action')

with the title *The Silence of Marcel Duchamp Is Overrated* (Fig. 1.1). It took place in the studios of the ZDF North Rhine-Westphalia television station and was broadcast as part of the series *The Potter's Wheel* (*Die Drehscheibe*) under the name 'Fluxus Group'. The nonsensical silence of art in the face of pressing questions

1.1. Joseph Beuys, *The Silence of Marcel Duchamp Is Overrated*, 1964; © 2006 Artists Rights Society (ARS), New York/VG Bild-Kunst, Bonn.

about the future was made doubly apparent through the medium of the broadcast. As a former radio operator in the air force, Beuys knew about the significance of transmission and about how to make use of the broadcast in a meaningful way for his 'anthropological art'.[8] Uwe M. Schneede covered the action itself in his book *Joseph Beuys Die Aktionen*;[9] Schneede claims that Beuys was apparently inspired by Robert Lebel's Duchamp monograph.[10] Felt, fat (margarine cartons), ringing chimes, the colour '*Braunkreuz*' (brown cross, a cross/bandage meant as a healing sign), the walking stick and chocolate (is there a connection to Duchamp's chocolate grinder in the *Large Glass*?) were Beuys' materials. As in all of Beuys' works, their use in the action is meaningful; the materials themselves indicate principles of nature such as chaos, warmth and energy. They

also represent anthropological tasks for mankind: transmission (the chimes, the iron-based colour), preservation, protection and direction (the staff), as well as the 'gift of love', chocolate. The diversity of these substances and the strange carryings-on should be interpreted by their displacements of meaning to existentially human qualities. On the one hand, the shapes are there to be seen; on the other, the material mediates theoretical principles, as in an epiphany. Only an epiphany can bring about recognition in the viewer. For that reason, Beuys' works appear as means of transportation, as vehicles for the spirit.

Diversity, displacement of meaning and interpretation based on analogy were already important in Duchamp's work.[11] Beuys must have particularly enjoyed that Duchamp also began with an emblem appropriate to the vehicular quality of art, his bicycle wheel mounted on top of a kitchen stool of 1913. At the time, Duchamp designated the work 'readymade', in which, according to Zaunschirm, a code is hidden for an erotic emblem of art: 'willing girl'.[12] Duchamp himself explained that he kept it in his studio for amusement and as a vehicle for thoughts about art.[13] Fifty years later, on 1 July 1966, he declared that he had not thought of the artwork in the sense of an object for exhibition. Beuys liked to refer to his art as 'warmth ferry', and repeatedly made use of the vehicle as an emblem for the creative flow of thought. This is not only true of the *Transsibirische Eisenbahn* (Trans-Siberian Railway), but also of the *Urschlitten* (Sled) multiple, and of the VW-transport of *The Pack* (*Das Rudel*).[14] He had already completed a work consisting of a photograph of a bicycle taped onto a sheet of paper that originated from the action of the same title, *The Silence of Marcel Duchamp Is Overrated*.[15] In contrast to Duchamp, Beuys later selected an entire functioning bicycle, which was apparently dedicated to Duchamp, for the exhibition *Quartetto* in a Venetian church that adjoined the *Biennale* exhibition site.[16] The work took up a considerable part of the church's space and consisted of fifteen blackboards, some covered with white and coloured chalk drawings. The gallerist Konrad Fischer had installed them in a line across the floor behind the upright bicycle. The piece is characterized by the question posed in its title, *Is It about a Bicycle?*, with an addition in the catalogue, *From Vehicle-Art*.[17] Otherwise, Beuys did not pose questions in his titles; statements were more suitable to

him as in, for example, his remarkable postcard-slogan '*Ich denke sowieso mit dem Knie*' ('Anyhow I think with the knee').[18]

The Irish art critic Dorothy Walker has offered a possible explanation for the title of *Is It about a Bicycle?* During one of Beuys' stays in Dublin she introduced him to the book *The Third Policeman* by the writer Flann O'Brien. This book is an absurd, philosophical work that has to do with a wild search for a missing 'black box'; a confused policeman poses the completely misguided question, 'Is it about a bicycle?'[19] The answer is 'no!' – always an easier answer than 'yes'. An observant reader may know that, earlier in the book, the italicized command, '*Use Your Imagination*', was stressed.[20] This could in fact have appealed to Beuys, since he always valued the powers of human intuition and imagination. His student Johannes Stüttgen, who was also responsible for the picture- and text-drawings on the fifteen blackboards, does not recall that Beuys ever mentioned O'Brien's name. The title, he said, was decided upon during a drive they had made from Goslar to Düsseldorf. Perhaps Beuys remembered O'Brien on this occasion?

While Bernard Lamarche-Vadel reproduced all fifteen boards in colour, his book never mentioned the fact that the work resulted from an extensive collaboration between teacher and student – incidentally a singular case in Beuys' work – nor did Lamarche-Vadel investigate the relationship with Duchamp's work. Therefore, the factual circumstances of *The Third Policeman* need to be commented upon here.[21]

The work was created in instalments. Since Beuys had already organized lectures or discussions in previous *Documenta* exhibitions, he wished to be represented only with his action *7,000 Oaks* at the 1982 *Documenta*. Therefore he left it to his student, Johannes Stüttgen, to convene fifteen weekly seminars on the work of his teacher in the (Apollo) tent which was erected in front of the Orangerie for that purpose.[22] Beuys himself never appeared there. At every meeting, Stüttgen drew upon a school blackboard to outline commentaries on Beuys' works and theories as well as his own interpretations. All of the boards were finally arranged in a circle. Beuys expressed his enthusiasm and devised a scheme to work with these. On the fifteenth blackboard, which was actually executed first, he drew a round container and, with two arrows, indicated circulation on top of

the existing drawings by Stüttgen. At the top right, he wrote the word '*Gefälle*' (descent). Subsequently, all of the blackboards were stored in Beuys' former studio at the Düsseldorf Academy, where Stüttgen directed the office of the Free International University (FIU).

Somewhat later, Beuys arranged for the boards to be placed one after another in the corridor, and he asked the owner of a red bicycle which had been standing in the same room if he would let Beuys have it for an artwork. He used this bicycle to ride on top of all of the boards, starting with the last one (Fig. 1.2). While cycling, he let paint drip from a wallpaper brush onto the front wheel, and this produced white tracks. He repeated the process two or three times, while Stüttgen assisted him with steering, painting, cycling and staying upright, which was quite an artwork in itself. Nevertheless, Beuys did not consider it to be an action.[23] It more accurately represented a work process in which a student's work was adapted, since this work was dedicated to Beuys and consisted of a catalogue of his works and ideas, even if these took on new pictorial forms.[24] They also served as proof of Stüttgen's continued commitment. Last but not least, Beuys added a curtain rod to the bicycle, for which he had created a brass joint. He attached the rod to the bike diagonally with a piece of chalk at its end. This way, the earlier drawing process could be demonstrated again. Thus the work was completed and Beuys exhibited it in Venice as an artwork in its own right. It was acquired in parts by collectors in Italy and France[25] and was published by Lamarche-Vadel. However, Stüttgen was not cited as the co-author, although the presence of Beuys' student constituted the concept of the work and its meaning.

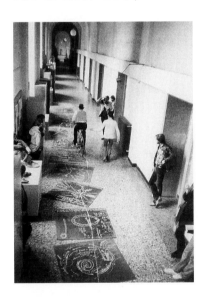

1.2. Beuys on bicycle at the Academy of Düsseldorf, 1982; © 2006 Artists Rights Society (ARS), New York/VG Bild-Kunst, Bonn.

A work by Duchamp was apparently referenced, in which he had compiled a miniaturized form of his oeuvre from 1934 to 1942 in a suitcase.[26] In November of 1984, Lamarche-Vadel asked Beuys if his work in Venice had to do with Duchamp's *Boîte-en-Valise*; Beuys answered affirmatively but evasively, 'Yes, maybe Marcel Duchamp was interested in the vehicle of art because he conceived of that object that integrated a bicycle wheel that spins around itself'.[27] Perhaps Beuys also had in mind Duchamp's small drawing of a bicyclist on notepaper, created in 1914, one year after the bicycle wheel. Duchamp gave the cyclist a track that he created with a special line. In this case, Duchamp's written addition is also important: 'To have the apprentice in the sun'. (Fig. 1.3) Should he ride into the sun to grow? Should he warm himself on Apollo's rays? It is notable that Duchamp never taught and, in 1914, had never had a student. Whether he understood his bicycle in the sense of a 'warmth drive' remains an open question. At any rate, he was occupied with ideas concerning energy, as were many artists of his time. In this regard, Beuys surely agreed with him. He also shared Duchamp's rejection of painting that merely functioned as decorative embellishment and saleable art.[28] Duchamp served as Beuys' model for the expansion of art. Duchamp and Beuys had abandoned the idea to create this type of commodity art. And since Beuys perceived Duchamp as a challenger, one wonders if

1.3. Marcel Duchamp, *"to have the apprentice in the sun"*, 1914; © 2006 Artists Rights Society (ARS), New York/ADAGP, Paris/ Succession Marcel Duchamp.

Duchamp's other works might be connected with Beuys even if Beuys did not refer to them explicitly.

In the 1984 exhibition at the Merianpark in Basel, *Skulptur im 20 Jahrhundert* ('Sculpture in the Twentieth Century'), visitors

descended into a cramped basement in a small leased house. The long room with a barrel vault appeared empty at first. All that was visible was a tiny cloud of steam along the moulding of a front wall – a work by Beuys entitled *Thermisch/plastisches Urmeter* (Thermal/plastic Primeval Meter) (Fig. 1.4). Theodora Vischer and Helmut Leppien interpret Beuys' *Thermal/plastic Primeval Meter* as a measure for the workings of the law of entropy, that is, for how the warmth and energy of objects in the universe is emitted and then decreases until cold sets in, bringing about '*Kältetod*' (Cold-death).[29] Ilya Prigogine received the Nobel Prize for his tabulation of the law of maximum entropy and classification of its structures. Did Beuys actually wish to contradict the meaning of this law? Did he, in contrast to the Napoleonic meter measure, wish to link his *Primeval Meter* to modern philosophy and physics?

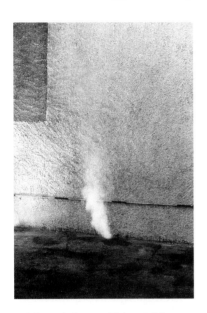

1.4. Joseph Beuys, *Thermisch/plastisches Urmeter* ('Thermal/plastic Primeval Meter'); © 2006 Artists Rights Society (ARS), New York/VG Bild-Kunst, Bonn.

It is unlikely that Beuys had only one eidetic object in mind when referring to modern physics. One comes to the same conclusion in taking Beuys' theory of the 'expanded notion of art' into account, as is customary in the interpretation of his work. The only thing he is recorded to have said about the *Primeval Meter* is, 'It is Heraclitus; it is absolutely Heraclitus'. The famous phrase 'everything is flowing' is attributed to this pre-Socratic philosopher. But the phrase does not render the work unambiguous, as 'flowing' has a concrete as well as a metaphorical meaning. In flow or flux, the process-oriented quality of the work is established – the work can be viewed as a Fluxus-event – as well as its spiritual constitution. Beuys understood that the 'expanded notion of art' was a medium of understanding for the viewer, for whom

creative thought and actions, as well as social conduct and neighbourly love, would be paramount goals for a free life. Would he have disregarded this goal? The concept of the 'cold-death' of the universe sounds melancholic and does not correspond to Beuys' proclaimed intentions, which were always hopeful. His 'warmth-plastic', as he generally referred to his work, was precisely intended to remove 'cold-plastic', since he considered the estrangement of humankind from its primary goals as 'cold'. Beuys and melancholy do not quite fit together. The concept of healing the viewer from every estrangement through art was Beuys' 'hope principle'. Proof that the little steam-cloud was not intended to offer a concrete, material illustration of the laws of thermodynamics is surely to be found in the fact that the steam was constantly renewed. The water was refilled, and the evaporator was constantly fed. Thus Beuys created the impression that evaporation and replacement balanced each other, and that a small, damp warmth-supply existed without interruption. Therefore, one needs to propose another reading in regard to the social aims of the expanded notion of art.

Beuys made use of a rectangular copper kettle soldered with tin at its edges; water was heated in it and the steam subsequently piped through a galvanized iron pipe Beuys ran through a hollow behind the wall of the basement exhibition space. In the metallurgy of the alchemists, copper and iron speak an erotic-spiritual language where material and spirit are, through a causal connection, rendered parallel to concepts found via analogy. Copper is allocated to the female sex and aligned with the planet Venus – the goddess Venus guards beauty. In contrast, iron is male, as is the god Mars and the planet of the same name. If one looks at the forms Beuys chose, erotic components persist: the heated copper vessel corresponds to a womb, the iron pipe to a phallus, steam to the warmth of love. In fact, this part of the sculptural work and with it a possible alchemical reading of its meaning was not accessible to the public, since the small steam-cloud was the only visible part of the work. But it must be meaningful that Beuys later exhibited the vessel and pipe – he retitled the work in switching the word sequence, to *Plastisch/ thermisches Urmeter* – and positioned a video demonstrating the original function of the objects next to it. Beuys could have used a copper pipe but the iron had a particular, spiritual task for him.

With the use of copper and iron, Venus and Mars meet in the Vulcan's forge for the play of love in myth. Vulcan is the artist of the myth, an 'artifex', as the alchemists called artists. Without Mars and Venus, the artist/blacksmith cannot work. He needs both if his work is to be purposeful and beautifully forged. The artist is in fact wed to the goddess of beauty, and so watches her union with jealousy.

But beauty belongs to everyone. Beuys recounts the myth without drama. He seeks reconciliation: the steam, which escapes the Beuysian forge in the erotic unification of Mars and Venus, pushes towards the viewers and warms them as well as their surroundings. Only this event matters to the artist, since only the steam-cloud, which mingles with the breath of the viewer, is visible. Breath had not previously become an artwork; here, life and art are in fact one. The viewer inhales the work, and thereby art supports life. The union gives him or her warmth. With reference to the spiritual, the artwork warms the viewers' thoughts and allows them to ponder this *conjunctio* (Latin for 'union'). This *conjunctio* is precisely one of the most important methods of the 'chemical wedding' – alchemy's meaningful strategy for material and spiritual unification. The smithy Beuys passes on the life-giving seed from the coitus of the open parts of iron and copper, Mars and Venus, to the viewer, who reads it as an act of love. Art gives the breath of life and allows thought – thus the steam-cloud is a *Thermal/plastic Primeval Meter*.

A work by Marcel Duchamp also deals with such a chemical wedding. Presumably, Beuys' *Thermal/plastic Primeval Meter* might also be understood as a continuation of Duchamp's major work, the *Large Glass*, with its enigmatic title, *La mariée mise à nu par ses celibataires, même* ('The Bride Stripped Bare by Her Bachelors, even'). In this work, Duchamp created an allegory for the unattainability of art. The bridal art hovers in the upper portion of the glass plate in the shape of something between a motor and birth-mother, while, on the lower portion of the glass plate, phallic-looking bachelors endeavour to impregnate the bride with their seed, which is sublimated in the chocolate grinder. This is an esoteric story that, as a bachelor-machine, already carries its own myth. Due to the way Duchamp drew the bachelors on the glass, the viewer could imagine himself standing among them. In any case, a second viewer standing

on the other side of the work could regard the first as another bachelor. It is therefore the viewer that will never fertilize art with his gaze, even though the love-gas of the bride has excited him. In his various writings Duchamp describes this philosophical work in this manner.[30] In contrast Beuys very inconspicuously demonstrated the opposite: that the chemical wedding exists between the bride, the groom, and the viewer. A simple, small steam-cloud is evidence of it. The cloud mingles with the viewer's breath, warms them and connects with their lives. The viewers carry the steam-cloud within themselves and it continues on with them.

Thus Duchamp not only wanted to replace the Napoleonic primeval meter with the law of chance through three new standards with his tripartite work *Trois stoppages-étalon*, made in 1913–1914 in Paris; he further intimates that alchemy was also meaningful to his work. We have a record, for example, of his answer on 2 October 1958 to questions from an author (who was researching the book *Les peintres vous parlent* for the publisher L'Oeil du Temps in Paris). The question was whether Duchamp believed contemporary painters were more intellectual than sensitive, and he answered:

> … rational intelligence is dangerous and leads to 'ratiocination'. The painter is a medium that doesn't know what it does. No translation can express the mystery of sensibility, a word that is still obscure but that nonetheless concerns the basis of painting or poetry, like a kind of alchemy.[31]

Beuys would have approved of this. But surely more important in this case is the fact that the motif of the steam- and gas-cloud also occurs in Duchamp's work. First of all, one could state that the absence of the gas-cloud is a particular form of presence in the work: seen on a mythic level, Duchamp's bottle rack served to drive the 'spirit from the bottle', and in fact one has often connected the French concept '*égouttoir*' (for a bottle rack) with '*égoûter*' (absence of taste).[32] If one further interprets the spreading ribs of the rack as referencing the painterly scaffolding of lines of cubist paintings of the time, it might constitute a commentary on the theories of cubists Gleizes and Metzinger,

both friends of Duchamp. A stream of water is also missing from Duchamp's *Fountain*, the scandalous urinal of 1917. Quite naturally, one thinks of it, links to it mentally, thereby making the motif invisibly present. The same holds true for the assemblage *Why not Sneeze Rrose Sélavy?* of 1921, which appears to suggest, through its working title as well as its material (sugar cubes of marble, the genuine, phallic cuttlebone for beak-sharpening, the thermometer in a small birdcage), the innuendo of a healthy sneeze, an erotic liberation: '*Eros c'est la vie*'. Zaunschirm has uncovered the relation to Plato's 'banquet' in that the liberating sneeze is meant to mark the freed Eros.[33] With the thermometer, this puzzling work becomes a warmth sculpture in Beuys' sense, *avant la lettre*.

Moreover, Duchamp's book-cover sketch which has the appearance of an advertisement for an 'Eau de Voilette' (the bottles which he decorated with his own transvestite-like image as 'Belle Haleine', a sister of Rrose Sélavy, photographed by Man Ray) seems to carry the absent cloud of scent with it.[34] But soon the small steam- and gas-cloud was no longer only present in its absence. This can be observed in Duchamp's *50 cc Air de Paris*, a gift to the Arensbergs in an apothecary vial. In his peep-show-like work *Etant donnés*, the viewer is positioned as a voyeur and gets to see, through the two holes of an old Spanish door, a reclining nude in a suggestive pose with parted legs as she holds a gas lamp (Bec Auer) aloft. The waterfall visible behind her and the lamp itself (as '*gaz d'éclairage*') unifies allegories of Eros and spiritual enlightenment in emblematic fashion. Incidentally, Schneede reports that Beuys originally planned a work that could have functioned as a commentary on the *Etant donnés*.[35] Duchamp's half-nude, shop-window mannequin made of wax and intended for André Breton's *Surrealist Exhibition* in the Galerie des Beaux-Arts in 1939 (140 rue du Faubourg Saint-Honoré), also carried a red lamp in her jacket. This again embodies Duchamp's muse and alter-ego, Rrose Sélavy.

Duchamp created a cover in 1945 for the American art journal *VieW* where only a gas bottle and a small cloud are visible (Fig. 1.5). The *VieW* cover presented itself as an advertisement.[36] It could be that Duchamp took inspiration from the photo of the burning Zeppelin (the 'Hindenburg' of 1937), which, like a giant cigar in the sky, emitted a large cloud.[37] More important in

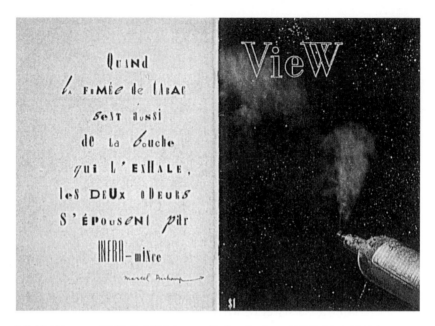

1.5. *VieW* cover, 1945; © 2006 Artists Rights Society (ARS), New York/ ADAGP, Paris/Succession Marcel Duchamp.

connection with Beuys is the relation between the gas-cloud and the word 'view'. This is meaningful for an artist who, instead of focusing on vision alone, tied himself to the invisible and also presented emissions of energy as entities connected with both Eros and spirit. In *VieW*, Duchamp lets the viewer, who was accustomed to 'reading' posters and advertisements at the time, produce analogous connections between words and pictured objects in order to seek the common denominator of an immaterial gift.[38]

The motif continued to concern Duchamp; for the luxury edition of his monograph by Robert Lebel in 1958, he accompanied the twenty-one-copy edition with a small enamelled sign which promises 'Eau & gaz à tous les étages' – akin to an advertisement (Fig. 1.6). Female servants lived in the upper floors of Parisian apartment houses. Therefore, the *'étages'* not only evoke images of floors of a building but also of social hierarchy. In contradiction to the motto, eleven copies of this luxury edition were not designated for sale, but rather an additional 110 copies that only featured paper labels. Art should be accessible to all like water and gas, but idea and reality diverge.[39]

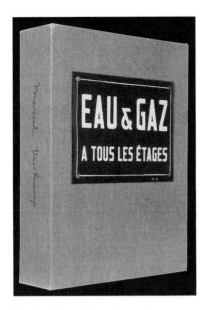

1.6. Duchamp, 'Eau & gaz à tous les étages', 1958; © 2006 Artists Rights Society (ARS), New York/ADAGP, Paris/Succession Marcel Duchamp.

The comparison between Beuys and Duchamp could include many more aspects,[40] but one must ask if Duchamp had not already anticipated the art of Fluxus, particularly in regard to steam- and gas-clouds. He established a correspondence between immaterial processes, which he continually presented to the viewer as an act of kindness.[41] It was Beuys, however, who wanted to bring such 'connections of energy' between nature and the immaterial into contact with social processes. This, he hoped, would help mankind to become free and creative. Beuys did not tire of elucidating these connections and of allowing the ideas of others to continue such a development. The silence of Duchamp should not only be broken; rather, his thread should be recovered and introduced into completely different areas of life. In contrast to Duchamp, Beuys insisted that he did not want his work to merely enter the museum: 'on the contrary – material for discussion should arise from it'.[42] A 'transformed' viewer would hopefully work towards social change.[43] Beuys therefore stood in the Romantic tradition of avant-garde artists who – especially in the Fluxus movement – felt obliged to carry out social duties. In response to the question of what a viewer of his work *Plight* might perceive (*Plight* was a room completely lined with thick rolls of felt, in the middle of which stood a grand piano), Beuys answered, 'He leaves as a changed being'.[44] Lynne Cooke discovered such positions in Marcel Duchamp's approach, since, as he explained to Dore Ashton, 'Artists are the only people in the world who have a chance to become citizens of the world, to make a good world to live in. They are disengaged and ready for freedom ... In a way the artist is no longer an artist. He is some sort of missionary ...

18 JOSEPH BEUYS: THE READER

Art is the only thing left for people who don't give science the last word. I didn't want to be called an artist, you know. I wanted to use my possibility to be an individual'.[45]

Beuys did not isolate himself as artist either. Thoroughly inclined towards anarchism, he imagined a social collective of all creative people. Duchamp gave Beuys the possibility to reflect on his own position. Beuys then responded to the demands of his own time in his 'anthropological art'.

NOTES

* In Rainer Jacobs, Marc Scheps and Frank Günter Zehnder (eds.), *In Medias Res. Festschrift zum siebzigsten Geburtstag von Peter Ludwig* (Cologne: DuMont, 1995), pp. 197–224, translated by Claudia Mesch.

1. Excerpts of the Cooper Union Dialogue, 7 January 1980, in 'Revolutions per Minute: The Art Record', produced by Jeff Gordon, New York, 1982. In the exhibition *Strategy: Get Arts* (Edinburgh, 1970), Beuys posted a list with numerous artists' names on the wall and asked, 'Where are the souls of van Gogh, Duchamp, Piero della Francesca, William Nicholson, Fra Angelico, etc.?' Richard Demarco recalls: 'It ended with Leonardo da Vinci.' See Uwe M. Schneede, *Joseph Beuys Die Aktionen* (Stuttgart: Hatje Cantz, 1994), p. 269. These named artists are not necessarily those who meant a great deal to Beuys' work.

2. Werner Spies has critically examined Beuys' relation to Duchamp. He claims that while Duchamp issued critical commentaries on the final stages of the avant-garde, one could only attribute a mere 'plagiarism' of folk-like superstition to Beuys. Werner Spies, 'Das Schweigen von Beuys. Anmerkungen anlässlich einer amerikanischen Wanderausstellung', *FAZ-Beiheft: Bilder und Zeiten* (18 September 1993), p. 2. Responses by Werner Hoffmann and Horst-Peter Zeinert in *FAZ*, 30 September 1993.

3. Joseph Beuys, *Eintritt ins Lebewesen* ('Honeypump at the Workplace'), 6 August 1977, *Documenta VI*, Kassel (Wangen: FIU-Verlag, 1991), audio recording.

4. Beuys was exaggerating; Duchamp later completed exhibitions, installations, works in series, graphics, posters, etc. He did not want to remain 'absolutely silent'; he responded when questioned – he simply wanted to quit. See also Pierre Cabanne, *Dialogues with Marcel Duchamp*, translated by Ron Padgett (New

York: Viking Press, 1971).

5. Joseph Beuys, Les Levine, Krzystof Wodiczko, Stephen Willats, William Furlong and Michael Archer (eds. and producers), *Audio Arts Magazine* vol. 8, no. 1 (London: 1986), audio recording (translated by the author).

6. In Bernard Lamarche-Vadel, *Joseph Beuys. Is It about a Bicycle?* (Paris/Verona: Marval, 1985), p. 125 (translated by the author).

7. *Partitur für Dieter Koepplin*, 1969, private collection, Munich. Illustrated in *Joseph Beuys. Natur Materie Form* (Düsseldorf: Kunstsammlung Nordrhein Westfalen, 1991/1992), p. 12.

8. See Mario Kramer, *Joseph Beuys Das Kapital Raum 1970–1977* (Heidelberg: Edition Staeck, 1991), p. 33.

9. Nr. 6, 80–2. Beuys also produced graphics in relation to this; see Jörg Schellmann (ed.), *Joseph Beuys Die Multiples* (Munich: Schirmer/Mosel Verlag; New York: Edition Schellmann, 1992), pp. 108 and 110, Nr. 74: *3–Ton-Edition*, 1973–1985. Two-sided silkscreen (Siebdruck) on PVC-foil, forty-four motifs altogether, mostly altered, 46 x 45.5 cm. On the Beuys-Duchamp relationship, see also Harald Szeemann, *Joseph Beuys* (Zürich: Kunsthaus Zürich, 1994), pp. 253–5.

10. German translation: Robert Lebel, *Marcel Duchamp* (New York: Grove Press, 1959). See Schneede, *Die Aktionen* (note 1), p. 81.

11. See Wilfried Dörstel, *Augenpunkt, Lichtquelle and Scheidewand. Die symbolische Form in Werk Marcel Duchamps. Unter besonderer Berücksichtigung der Witzzeichnungen von 1907 bis 1910 und der Radierung von 1967/68* (Cologne: W. Konig, 1989), pp. 11–28.

12. Thomas Zaunschirm with an introduction by Serge Stauffer, *Bereites Mädchen Readymade* (Klagenfurt: Ritter, 1983). See Duchamp himself, cited by Molly Nesbit in 'His Common Sense,' *Artforum* vol. 33, no. 2 (October 1994), p. 93.

13. Ecke Bonk, *Marcel Duchamp. The Box in a Valise de ou par Marcel Duchamp ou Rrose Sélavy*, translated by David Britt (New York: Rizzoli, 1989), p. 239. See also Jennifer Cooper-Gough and Jacques Caumont, 'Ephemerides on and about Marcel Duchamp and Rrose Sélavy 1887–1968,' in *Marcel Duchamp* (Venice: Palazzo Grassi, 1993), 15 January 1916 and 1 July 1966: 'The wheel serves no purpose, unless it's to rid myself of the conventional appearance of a work of art.'

14. He compared the 'warmth ferry' in this connection with the vision of the sun state of Campanella. See 'Joseph Beuys. Jeder Mensch ein Künstler. Auf dem Weg zur Freiheitsgestalt des sozialen Organismus. 23 March 1978' (Wangen: Internationales Kunstzentrum Achberg, 1991), audio recording.

15. A sheet of paper with the same inscription is in the van der Grinten Collection, Stiftung Schloß Moyland. Reproduced in Schneede, *Die Aktionen*, p. 81.

16. Lamarche-Vadel, *Is It about a Bicycle?* See also the conversation between Beuys and Achille Bonito Oliva (see note 6). Also see the exhibition catalogue *Quartetto, Joseph Beuys, Enzo Cucchi, Luciano Fabro, Bruce Nauman*, a cura di Achille Bonito Oliva, Alanna Heiss, Kaspar König (Milano: Coordinamente culturale A.B.Oliva, 1984). Beuys did not allow the work to be reproduced, only the title in special layout and various photographic portraits of himself, as well as various other works.

17. According to Johannes Stuttgen, Beuys formulated the title as follows: *is it about a bicycle? aus: VEHICLE ART.*

18. An edition by Klaus Staeck.

19. Flann O'Brien, *The Third Policeman* (London/Glasgow: 1989), p. 57.

20. O'Brien, p. 29.

21. In what follows, I make use, with gratitude, of statements by Johannes Stüttgen from a telephone conversation on 31 December 1994.

22. The FIU (Free International University) Kassel, under the direction of Rhea Thönges-Stringaris and the Friedrichshof, signed as organizers.

23. Schneede, *Die Aktionen*. For this reason, Schneede did not discuss this work as an 'action'.

24. Board I: Irrigation fields. This work was the final one to originate at the Düsseldorf Academy. Board II: 'In reality I am the Negro'. Africa seen from Europe. The Eurasian staff for the way from Europe to Africa. Board III: Cosmos and Damian. Cologne Cathedral. The transformation of forces: Capital, I like America, Where is Element 3? Board IV: Warmth time machine in the economy. The melting down of the crown into a hare in three stages. Board V: Hans in Glück. Board VI: Genesis of Beuys' works in two counter-rotating spirals. Board VII: *2 Wirtschaftswerte* (social values) according to Schmundt and according to Beuys: Results from the democratization of money. Board VIII: Two heads for the divided Germany. Perception as a bridge between humans. Board IX: The FIU as medicine. Freedom instead of free time/a cancerous growth. Board X: 'The intelligence of a blood sausage' according to a statement by Beuys in the Solomon R. Guggenheim Museum, New York, to Stüttgen in front of his vitrine *Samurai-Sword*: 'Intelligence that is needed to made a blood sausage world-famous...' With this drawing

Stüttgen illustrated the question 'Why is it that Beuys is famous even though no one knows his work?' Board XI: Capital- and money circulation expanded to the circulation of love. Board XII: The Circulation of the Apple as a rose plant. Board XIII: the Earth telephone between communicating heads. The addition 'Please leave behind!' concerns Stüttgen's experience as a night watchman in an asylum. The beds appeared to him like a forgotten earth 'telephone' while the patients communicate with each other somewhere else. Board XIV: Captain Future (a children's TV show). The community shovel as an inverted pyramid in contrast to the pyramid of the Ministry of Culture as a possible discussion topic for a school class and its teacher that considers 'Captain Future' a bad show. Board XV: *7,000 Oaks* action with an inscription by Beuys: container and the word *'Gefälle'* (descent).

25. Boards I, II, IV, VI, VII, X, XI,XIII, XIV, XV: Sarenco-Strazzer Collection, Verona; Boards V, VIII, X, XII: Galerie Beaubourg, Paris; Board III: Marianne and Pierre Nahon Collection, Paris.

26. Ecke Bonk, *Marcel Duchamp. Die grosse Schachtel*, translated by David Britt (New York: Rizzoli, 1989).

27. 'Oui, peut-être Marcel Duchamp s'est il intéressé au vehicle-art puisqu'il a conçu cet objet qui intègre une roue de bicyclette qui tourne sur elle-même'. Trans. Anna Arnar. Lamarche-Vadel, *Is It about a Bicycle?* (see note 6), pp. 134 ff.

28. Compare Schneede, *Die Aktionen*, p. 51.

29. Theodora Vischer, 'Joseph Beuys: 'Thermisch-plastisches Urmeter', a Late Work', in Volker Harlan et. al. (eds.), *Beuys-Tagung Basel 1.-4. Mai 1991* (Basel: 1991), pp. 214–19 and Theodora Vischer, *Joseph Beuys. Die Einheit des Werkes* (Cologne: W. Konig, 1991), pp. 197–9. Helmut Leppien, *Joseph Beuys in der Hamburger Kunsthalle*, with an epilogue by Uwe M. Schneede on Hamburg and Beuys (Hamburg: Hamburg Kunsthalle, 1991). Of course Leppien and Vischer understand 'entropy' as not only a physical phenomenon but also point to it as a continuous expansion of spirit.

30. Serge Stauffer (ed.), *Marcel Duchamp: Die Schriften* (Zurich: 1981). Szeemann, *Joseph Beuys* (see note 9), p. 254.

31. 'Ephemerides', 2 October 1958 (translation by the author).

32. 'Ephemerides', 15 January 1916 (translation by the author).

33. 'Duchamp additionally discovered in the core of the banquet an overcoming of an unreflected discourse on beauty. What remained stimulating was the identification of Eros with life, which Marcel Duchamp had claimed for himself (since

approximately 1920) and which became ever more important to him with his increasing age'. In Thomas Zaunschirm, with contributions by A. Feichtner, A.V. Garde et.al., *Marcel Duchamps unbekanntes Meisterwerk* (Klagenfurt: Ritter, 1986), p. 39.

34. The cover was intended for the book *New York Dada* by Duchamp and Man Ray. The little bottle came from the perfume Rigaut; see 'Ephemerides', 27 December 1919.

35. Schneede, *Die Aktionen*, 260. On the *Trans-Siberian Railway*: 'This work was planned in 1959 for a shed in which only a hole in the wall should allow a viewer to look in, was then partially realized in 1961 and completed in 1969, albeit without the originally planned viewing situation, which reminds one of Marcel Duchamp's late master work *Etant Donnés: 1. la chute d'eau 2. le gaz d'éclairage'.*

36. Bonk, *Box in a Valise*, p. 168.

37. 'Ephemerides', 11 May 1937.

38. The word 'gift' comes from Schneede, p. 80, in relation to the Aachen action on 20 June 1964. On the back cover of *VieW*, Duchamp had collaged the text in various fonts, like a secret message: 'When tobaco smoke smells also of the mouth that exhales it, the two odors are married by [the] ultra-thin' ('Quand la fumée de tabac sent aussi de la bouche qui l'exhale, les deux odeurs s'épousent par infra-mince'). His signature followed. In this conception, smoke and perfume clouds undergo a chemical union in the reader.

39. Bonk, p. 181.

40. In this way, the subject of androgyny could also be addressed, since Beuys also believed in his feminine component. In his action 'Hauptstrom' of 1967 in Darmstadt he appeared in triangular pants made of diaper fabric. (I thank Marion Hohlfeldt for this reference.) Further comparisons could be drawn between the use of the motif of the rose and the 'communal spade' in Beuys and the 'snow shovel' (*In Advance of a Broken Arm*), between affixed 'hair' (Duchamp) and fingernails (Beuys), between the strategic connection between technology, organs and landscape by both artists, the use of speech and music (also the inaudible), filters and dust or dirt, chocolate and sugar cubes in a cage or a carton (see Beuys' *Tantalus*, 1965).

41. Since he defined the viewer as a bachelor who, in his *Large Glass*, viewed the bride 'art' with an eye to love, a written work by Duchamp is significant in this regard. It is contained in the box of *La Mariée mise à nu par ses célibataires, même*: 'The Bride does not refuse this shipping by the bachelors, even accepts it

since she furnishes the love gasoline and goes so far as to help towards complete nudity by developing in a sparkling fashion her intense desire for orgasm'. Reprinted in Bonk, *Marcel Duchamp,* p. 91.

42. Lamarche-Vadel, *Is It about a Bicycle?,* p. 135.

43. John Tancock was the first to refer to this essential difference between Beuys' and Duchamp's activities in his essay 'The Influence of Marcel Duchamp', in Anne d'Harnoncourt and Kynaston McShine (eds.), *Marcel Duchamp* (New York: Museum of Modern Art/Philadelphia Museum of Art, 1973), p. 176. In contrast, Dieter Daniels hardly mentions Beuys in his book *Duchamp und die anderen. Der Modellfall einer künstlerischen Wirkungsgeschichte in der Moderne* (Cologne: Dumont, 1992), pp. 12, 251, 319.

44. *Parkett,* 7 (1986): 17.

45. Cited by Lynne Cooke, 'Reviewing Francis Picabia, Man Ray, Marcel Duchamp, Rrose Sélavy, Marchand Du Sel...', in René Block (ed.), *The Ready Made Boomerang. Certain Relations in the Art of the 20th Century, the 8th Biennale of Sydney* (Sydney: Art Gallery of New South Wales, 1990), p. 103 (see also footnote 32).

2. BEUYS, HAACKE, BROODTHAERS*

STEFAN GERMER

One fact is certain: commentaries on Art are the result of shifts in the economy. It seems doubtful that such commentaries can be described as political.

Marcel Broodthaers

WALTER BENJAMIN SUGGESTED THAT in order to establish the political tendency of a work of art one should establish its *position within* the relations of production rather than its *attitude toward* them. In this way, political commitment is linked to *artistic technique.* An engaged artist is expected to show more than mere partisanship: a reflection upon the conditions in which he produces must be made part of his artistic project.[1]

In an open letter of 3 October 1972, Marcel Broodthaers demanded that Joseph Beuys reflect on the conditions of his production. He reminded Beuys that artistic production is inseparable from its institutional framework, which – far from being something marginal – determines the work of art in its very structure.[2] Broodthaers wrote his letter on the occasion of an exhibition of works by artists from Amsterdam, Paris, and Düsseldorf held at the Guggenheim Museum that year, in which works by both Beuys and Broodthaers were featured.[3]

Broodthaers found participating in a Guggenheim exhibition problematic; in fact, he eventually withdrew his works, because the museum had cancelled Hans Haacke's first American museum show the year before.[4] In a by now notorious incident, the museum cancelled the show when Haacke refused to exclude

two documentations of Manhattan real-estate holdings and a poll of the museum's visitors. In a letter to the artist, Thomas Messer, the museum's director, justified the cancellation:

> We have held consistently that under our Charter we are pursuing esthetic and educational objectives that are self-sufficient and without ulterior motive. On those grounds the trustees have established policies that exclude the active engagement toward social and political ends. It is well understood, in this connection, that art may have social and political consequences, but these, we believe, are furthered by indirection and by the generalized, exemplary force that works of art may exert upon the environment, not as you propose, by using political means to achieve political ends, no matter how desirable these may appear to be in themselves. We maintain, in other words, that while art cannot be arbitrarily confined, our institutional role is limited. Consequently, we function within such limits, leaving to others that which we consider outside our professional competence.[5]

Even though Messer stated that he had no intention of restricting artistic practice, he formulated the conditions that a work of art had to fulfil in order to be acceptable within the museum space. Following the idealist concept of the autonomy of art, art is seen as distinct from the social, and the museum is defined as a neutral, non-social, apolitical institution.

The work of art is expected to confirm this fiction and thus to appear as the result of a process of production which, in its *artistic* character, differs from other forms of social production. Far better than any restriction of content, this institutional insistence on the specificity of artistic practice neutralizes all political implications of an artwork, since it forces the artist to depoliticize his work in his choice of means. Only in a generalized and unspecific way is 'outside reality' accepted into the museum space; the boundary between art and society is thus kept intact, while the social determination of the artwork remains unreflected and the political character of museum decisions unacknowledged.

Haacke's works did not follow these rules. Extending the project of Marcel Duchamp – who had demonstrated the degree to which the concept of the aesthetic autonomy was dependent upon the institutional mechanisms of exclusion – Haacke introduced systems into the museum space that challenged its alleged neutrality. These were systems that functioned in accordance with physical, biological, and social laws of change, growth, and exploitation. Haacke described the effect of this confrontation:

> If you work with real-time systems, well you probably go beyond Duchamp's position. Real-time systems are double agents. They might run under the heading 'art', but this culturalization does not prevent them from operating as normal.[6]

While Duchamp took the *separation* of cultural and social spheres as his point of departure, demonstrating that it was not the specific quality of an object but only the place and form of its presentation that decided its status, Haacke insisted on the *continuity* between both spheres, thereby unmasking the interests governing the seemingly neutral museum space, and thus making the political uses of culture apparent. While Duchamp *used* the concept of the autonomy of art, Haacke *attacked* it.

The cancellation of Haacke's exhibition made apparent the extent to which the museum expected its specific mechanisms of exclusion to be respected. This meant that an artist's political practice would have to take into account the institutional limitations of his role. Without consideration of the political character of the institutional framework within which a work of art is presented, the work is in danger of being neutralized, absorbed, and turned into an insignia of power. Broodthaers denied this very threat:

> Art is a prisoner of its phantasms and its function as magic; it hangs on our bourgeois walls as a sign of power, it flickers along the peripheries of our history like a shadow-play – but is it artistic?[7]

From this vantage point it would be foolhardy to rely on the 'magic of art' or to believe in its power. Whoever speaks of

the power of art deceives himself about the true character of political power and the actual function of art in society. Wishing to find aesthetic answers to political questions, he believes that, by inventing rather than analyzing social conditions, he could actually contribute to their change. Certainly the most important recent exponent of such a belief was Joseph Beuys.

When the show of the Düsseldorf artists opened at the Guggenheim, it became clear how quickly and easily Beuys' political messages could be absorbed by the institution. Beuys showed a primitive flag and a fur trunk, an ensemble he named *Gundfana of the West – Genghis Khan's Flag* and an object that detailed the social programme of his *Organization für direkte Demokratie durch Volksabstimmung* ('Organization for Direct Democracy through Referendum'). Both pieces, which the artist explicitly characterized as political, were shown in the very museum that had banned Haacke's work because of its political nature.

Sensitive to the political reasons for the museum's inclusion and exclusion of artists, Broodthaers decided to withdraw his works as an act of solidarity with Haacke.[8] Beuys, meanwhile, remained indifferent to the Guggenheim's act of censorship. Beuys' position led to the suspicion that there was in fact a *connection* between his definition of art and politics and his indifference to an actual political conflict; and therefore Broodthaers raised precisely this issue in his questioning of Beuys' equation of art and politics.

To Broodthaers, the situation had an exemplary character, and he therefore renounced the idea of a direct polemic against Beuys; instead he formulated his critique in the form of a historical fiction. In his open letter, Broodthaers reports that he has found, in a dilapidated Cologne slum tenement, a letter addressed to Richard Wagner from Jacques Offenbach; and he has decided to copy this letter and send it to Beuys in lieu of his own.[9] In the fragmentarily legible document, Offenbach comments on the difference between his and Wagner's conception of the relationship between art and politics and expresses his doubts regarding Wagner's receiving the patronage of King Ludwig II of Bavaria. In the historical fiction the allusion to recent New York events becomes clear:

> King Louis [Ludwig] II had Hans H. sent away [from]
> his castles. His Majesty prefers you to this specialist of
> compositions for the flute. I can understand – if it is a
> matter of artistic choice. But is not the enthusiasm that
> His Majesty displays for you motivated by a political
> choice as well? I hope this question disturbs you as
> much as it does me. What ends do you serve, Wagner?
> Why? How?[10]

Offenbach and Wagner are more than merely alter egos for
Broodthaers and Beuys respectively. They represent two
fundamentally different conceptions of the social role of the
artist. Broodthaers labels the identification of art and politics
Wagner, and has Offenbach say:

> Your essay 'Art and Revolution' ... discusses ... magic
> ... politics ... which you must be aware of. The politics
> of magic? of beauty or of ugliness? ... Messiah ...
> In this struggle against the degeneration of art the
> musical drama would thus be the only form capable
> of uniting all the arts. I can hardly go along with that
> contention of yours, and at any rate I wish to register
> my disagreement if you allow a definition of art to
> include one of politics ... and ... magic.[11]

Broodthaers refers here to events that immediately preceded
the New York exhibition. At Documenta V in Kassel (30 June–
8 October 1972) Beuys had set up an 'Information Office' to
propagate the ideas of his *Organization für direkte Demokratie
durch Volksabstimmung.* The programme of that organization
was characterized precisely by the confusion or conflation of
art and politics that Broodthaers criticizes in his open letter. At
Documenta, Beuys had stated:

> In the future all truly political intentions will have
> to be artistic ones. This means that they will have to
> stem from human creativity and individual liberty.
> This is why I concern myself mainly with the problem
> of schools, with pedagogy. But mine is a model of
> freedom that must be understood as revolutionary. It

is a model that issues from human thinking and the education of man in this sphere of freedom ... this cultural sector, of which the institutions, the means of information are part ... here would be a free press, free TV, and so on. They must be free from all state intervention. I am trying to develop a revolutionary model that formulates the basic democratic order in accordance with the people's wishes, because we want the rule of the people ... I want an area of freedom, which should be recognized as the area that breeds revolution, that changes the basic democratic order and then restructures the economic sector in a way that will serve the people's needs and not the needs of a minority that wants to make its profits. That is the connection, and this I define as Art.[12]

In this conception, the position of art is secure, and the role of the artist is unquestioned. By identifying political and artistic practice with one another, Beuys avoids the issue of the social relevance of his activity, since he borrows for it the aura of the political. The necessary precondition for this is the aestheticization of the political. Abstracting from actual conditions, Beuys in effect invents state and society, thus making both into artistic creations. In this aestheticization of politics Beuys follows Rudolf Steiner,[13] who, in his series of lectures entitled *Über die Bienen* ('On the Bees', 1923), had presented the organization of bee communities as a model for human society. Steiner defined this organization as the result of two *formative processes*: the 'crystalline-anorganic' construction of the honeycombs, and the 'organic-energetic' production of warmth within these combs. By analogy, Beuys could declare state and society (or, as he called them in a telling biologistic metaphor, the 'social organism') to be *works of sculpture*. In this fashion artistic practice was made the paradigm of all human activity, and creativity was presented as the means to shape and change society.

Consequently, Beuys defined the artist's task as one of making people aware of their creativity, as a demonstration of the possibility of change by employing creativity, and finally as the initiation of the necessary changes. The goal of this sculptural-political process was defined as a reorganization of society in a

fundamentally democratic fashion.[14] Beuys' political programme thus combined ideas as different as Steiner's definition of state and society, the concept of extended creativity put forward by the Fluxus movement, and the political demands formulated by the 1960s Ausserparlamentarische Opposition (APO, or Extra-Parliamentary Opposition). The intention of the Fluxus movement had been to free creativity from its confinement to the 'artistic field' by generating an awareness of creativity inherent in every activity, and was thus directed at the abolishment of the distinction between artistic and non-artistic practices. As Fluxus' principal organizer, George Maciunas, declared:

> The aims of Fluxus are social (not aesthetic) like the LEF Group – 1929 – in the Soviet Union – and are directed to: step by step elimination of the Fine Arts ... This motivates the desire to redirect the use of materials and human ability into socially constructive purposes ... So Fluxus is strictly against the artist with an income. At most it can have the pedagogic function of making clear how superfluous art is and how superfluous the object itself is ... Secondly, Fluxus is against art as a medium for the artist's ego ... and tends therefore towards the spirit of the collective, to anonymity and ANTI-INDIVIDUALISM ... the best Fluxus composition is one which is most strongly impersonal and readymade.[15]

Beuys shared the Fluxus movement's definition of extended creativity; his own practice, however, differed from the conception sketched by Maciunas to such an extent as to appear almost as its opposite. The difference was intentional: Beuys criticized Fluxus artists for what he considered an obsession with negating the traditional definition of art. Beuys insisted that instead of repeatedly demonstrating the futility of the separation between the artistic and social spheres, artists should apply their conception of extended creativity directly to society:

> They [the Fluxus artists] depended on a dramatic mise-en-scene of materials, without wanting to specify concepts. They were lacking a theory, an epistemological substructure, so to speak, with a clearly defined goal.

> They held a mirror up to the people without any effect
> and without any improvement of the situation.[16]

Beuys believed that Steiner's theories provided him with the 'epistemological substructure' he found lacking in Fluxus events, while the idea of 'direct democracy' was the 'clearly defined goal' that would permit him to go beyond Dada-like actions – to genuine political action.

The concept of direct democracy had initially been formulated by the extra-parliamentary opposition in the late 1960s. In those years West Germany's two major parties – Social Democrats and Christian Democrats – had formed the so-called Great Coalition, which encountered only weak opposition within parliament. This meant that any real reflection upon crucial political issues – the suspension of fundamental rights in a 'state of emergency', the monopolization of economic power in West Germany, the country's relationship with the USA during the Vietnam war, continuities between the Third Reich and the Federal Republic – was left to the student movement, which understood itself as part of a larger extra-parliamentary opposition.

Peter Brüchner and Johannes Agnoli analyzed the failure of the representative parliamentary system in their book *Die Transformation der Demokratie* ('The Transformation of Democracy'). The authors demonstrated how the parliament functioned as an agency for capitalist interests, excluded the majority of the people from political decisions, and was both unable and unwilling to control increasing monopolization in the economic sector. As a solution, the authors called for the formation of a *Fundamentalopposition*, which would organize itself in a system of councils that were to supplement and eventually to supplant the parliamentary system.[17]

Beuys borrowed the jargon but not the analysis of the extra-parliamentary opposition when he formulated his political programme. Thus his various organizational attempts – which ranged from the formation of the *Studentenpartei* (Students' Party, 1967) to the *Organization der Nichtwähler* (Organization of Non-Voters, 1970) to the *Organization für direkte Demokratie durch Volksabstimmung* (Organization for Direct Democracy through Referendum, 1971) appear more as a mimicry of politics than an actual attempt to politicize artistic practice. In no respect

do the programmes of Beuys' organizations correspond to political realities. Instead of following the extra-parliamentary opposition in its analysis of the economic structures of West German society, Beuys declared the 'abolishment of the two-party dictatorship' his main goal, and – adapting one of Steiner's ideas for current purposes – demanded the 'tri-partition of the social organism' in order to liberate individual creativity. Taken as a whole, the mixture of Steiner's ideas, the Fluxus concept of extended creativity, and the slogans of the extra-parliamentary opposition formed less a coherent political programme than a monumental apology for the artist. What had appeared as a radicalization of the Fluxus position was in fact a regression from it, since, for Beuys, *only the application, not the concept of art* seemed problematic. His enterprise is thus ultimately a conservative one, aiming only at restoring to the marginalized artist a central social role. This explains Beuys' insistence on the importance of *individual* creativity.

It was this concept that had most fascinated Beuys in Steiner's thought. Steiner declared creativity a transhistorical quality of man, which enabled him to shape the world according to his desires. For Beuys, as for Steiner, change is a question of subjective volition:

> If one is willing to enlarge art – the concept of art – to such an extent that it would also comprise the concept of science, and thus the whole of human creativity, then it follows that change to the conditions is a matter of human volition ... which means: if man realized the power of self-determination, then starting from it he will one day build democracy. He will abolish all nondemocratic institutions simply by practising self-determination.[18]

Belief in the power of creativity is both utopian and reactionary. *Utopian* because this concept gives back to the individual his labour power and thus opposes the division of labour characteristic of capitalist societies. *Reactionary* because it makes this reappropriation appear as an act of individual volition, independent of all social preconditions.

The historical context for Beuys' hypostasis of individual

creativity can be determined in a more specific fashion. Post-Second World War West German ideology has been characterized by dehistoricization and concentration on the labour power of the individual. In an attempt to repress the memory of fascism, all historical context was obscured and all energies were directed to *Wiederaufbau* ('reconstruction'), represented as the achievement of individuals. In this perspective, the economic restoration appeared as a *Wirtschaftswunder* ('economic miracle'), and the work of the individual assumed mythical status.

In true Herculean manner, Beuys denied his own biography as a sequence of 'works' and made all historical reality disappear behind a self-created myth of the artist-hero. This self-mythification begins with the crash of Luftwaffe pilot Beuys in the Crimea and his acceptance by a local group of Tartars, who shelter him with felt and fat.[19] The myth continues in the invention of state and society. In the end, Beuys' audience is presented with a system of interconnecting links and mutually supporting interpretations and definitions that no longer permit a consideration of anything outside the system. This system can only be understood through its own carefully constructed 'evidence'; it is especially in this respect that Beuys' procedure resembles that of Richard Wagner.

The composer had attempted to compensate for the social marginalization of the artist by extending the aesthetic realm to encompass the whole of society. In his exile in Zurich – following the failure of the Revolution of 1848–1849, in which Wagner had played an important part – he elaborated this concept in the essays 'Art and Revolution', 'The Artwork of the Future' and 'Opera and Drama'.[20]

Taking Greek tragedy as his model, Wagner envisioned the 'artwork of the future' as the centre of a cult in which the people as a whole would take part and which would fundamentally affect every individual. Originally, Wagner linked the creation of such a *Gesamtkunstwerk* to the overthrow of the capitalist system, and particularly to the abolishment of the division of labour. Once the preoccupation with everyday needs had ceased – Wagner wrote[21] – all activities of liberated mankind would assume artistic features; thus the whole society would become a work of art.

But while the *Gesamtkunstwerk* was in this manner first conceived

as the consequence of successful revolution, its meaning changed as Wagner's disappointment with the political situation grew. Eventually, Wagner envisioned the *Gesamtkunstwerk* as merely the *prophecy* of revolution and ultimately as its *substitute*. Even though none of its social preconditions were given, Wagner still insisted on realizing his *Gesamtkunstwerk*; he wanted to reconcile aesthetically what had remained irreconcilable in society. In order to do so he had to change both his own status and that of his work: while at first he wanted to express the dominant tendency of his epoch and thus conceived of his work as part of a universal social change, he now claimed this universality for his art. The precondition for this claim was dehistoricization, and thus Wagner's work finds its content in the prehistorical world of German myth.

Mythology permits the artist to style himself as a creator who is unbound by historical conditions and is able to shape the world according to his own desires. To be convincing, however, this fiction depends on the exclusion of every remnant of historical reality. In Wagner's work this operation took the form of an aesthetic substitution: in order to make the social totality disappear, the work itself had to assume a totalizing character. The artist thus forced music, poetry, and dance together, pretending that these media converged in the same project, while their amalgamation was in fact achieved only by his volition, not by any inner necessity. The combination of media is supposed to form a coherent work of art, which in its perfection and its over-determination of aesthetic means anxiously conceals the process of production behind the spectacular appearance of the product. Adorno defined Wagner's formal principle as precisely this attempt to conceal the conditions of production behind the appearance of the product, and continued in his description:

> This is the objective explanation for what is generally thought of in psychological terms as Wagner's mendacity. To make works of art into magical objects means that men worship their own labour because they are unable to recognize it as such. It is this that makes his works pure appearance – an absolutely immediate, as it were, spatial phenomenon.[22]

The 'magic of the artwork' resembles the phantasmagorical appeal of the fetish: instead of counterbalancing its attraction, the work of art mimics the commodity. Like the commodity, it is worshipped because the labour, the society, and the history that produced the work of art are concealed behind its spectacular effects. Wagner's aesthetic ideology kept him from realizing the congruence between his practice and the fetishization of commodities. Having stylized the aesthetic realm into a totality and thus remaining unable to determine his position in relation to the conditions of production, Wagner did not realize that, in concealing the social determination of his works, he followed that very determination.

Beuys was the victim of a similar illusion. Unlike Wagner, however, he could no longer maintain the credibility of his production by presenting the work of art as a self-contained, autonomous whole separate from society, since he worked in a period not only in which the commodity status of the art object had become apparent, but in which avant-garde practice constituted itself through a reflection upon that status. In this situation, Beuys renounced the fiction of the work of art as an autonomous whole and attempted to escape the social restrictions of artistic practice by regressing to a pre-societal state, archaically defining his work through the *presence* of the artist. This displacement proved to be a very efficient strategy for avoiding the question of the social relevance of artistic practice, because it allowed Beuys to acknowledge the particularity of his art objects while still claiming universality for his practice as a whole.

The fragmentary character of Beuys' objects is thus deceptive: although they mimic the allegorical form by inviting the beholders' participation, their understanding is always already pre-established within the totalizing system of meaning that Beuys supplied for them. It is within an interpretative discourse emanating from the artist himself that meaning is assigned to the individual works. The beholder's role is thereby restricted to ratifying a *Gesamtkunstwerk* whose logic of production eludes him, since it stems from the artist's volition. Beuys' concept thus required an interpretation that reduced critical commentary to a tautological repetition of his ideas, an interpretation thus incapable of assessing the artist's claims about the social and political implications of his work.

As in Wagner's case, the political is replaced by a totalizing aesthetic concept. But the emphasis with which Beuys' objects insist on *being something other than just art objects* betrays the act of repression necessary to maintain that fiction. Moreover, the more Beuys refused to acknowledge the social conditions of his practice, the more he fell prey to them. The concept of universal creativity prohibits the artist from recognizing the actual social function of artistic practice, since it blurs the boundaries between art and society, thus making it impossible to reflect on the institutional limitations of artistic production.

Broodthaers takes these institutional limitations as his starting point. By choosing Offenbach as his example, he indicates that artistic practice is less a mythical act of primal creation than the result of the necessities of the culture industry and the pressures of political censorship. The artist's political engagement cannot consist in expanding art into society, but only in reducing art's claims through the deconstruction of those mechanisms that establish and maintain 'the artistic' as different from other social practices. Instead of supplying the market with so-called 'political art', which would maintain the illusionary belief in the power of art, Broodthaers undermined this confidence in art through strategies of ironic affirmation.

Jacques Offenbach's work provided an example for such an intellectual subversion of the apparatus of production, which the composer neither owned nor controlled; thus it seemed to Broodthaers a suitable strategy for those forced to cater to the culture industry. Like Wagner, Offenbach operated in the reactionary period following the defeat of the 1848 revolution, but unlike Wagner, Offenbach could not take refuge to a mythical past, since his genre – the operetta – required cooperation with existing forces and conditions. Offenbach provided his audience with the entertainment it believed art to be; but he entertained his public with a parody of its own social mores and expectations. Offenbach's operettas could thus become a powerful instrument of oppositional critique. Siegfried Kracauer, who, during his exile from Nazi Germany, wrote a biography of the composer, was especially interested in this oppositional strategy:

> In a time characterized by the hardening of the bourgeoisie and the almost complete impotence of

the Left, Offenbach's operetta became the decisive medium of revolutionary protest. It provoked laughter that penetrated the prescribed silence and excited its audience to opposition while seeming only to entertain it.[23]

Broodthaers realized the usefulness of Offenbach's strategy of ironic affirmation in a situation in which a self-mystification such as that of Joseph Beuys tended to obscure the actual social position of the artist. Like Offenbach, Broodthaers undermined his audience's expectations of art by fulfilling them – a strategy already evident in his declaration that the desire to make money and invent 'something insincere' stood at the beginning of his artistic career.[24] Art is refused any quality that would separate it from the commodity, and thus the actual status of the arts in the era of universal commodification is defined:

> I doubt, in fact, that it is possible to give a serious definition of Art, unless we examine the question in terms of a constant, I mean the transformation of Art into merchandise. This process is accelerated nowadays to the point where artistic and commercial values have become superimposed. If we are concerned with the phenomenon of reification, then Art is a particular representation of the phenomenon – a form of tautology. We could then justify it as an affirmation of existing conditions, which would give it a suspect character.[25]

NOTES

* *October* no. 45 (Summer, 1988).

1. Walter Benjamin, 'The Author as Producer', in Brian Wallis (ed.), *Art After Modernism: Rethinking Representation* (New York: New Museum, 1984), pp. 297–309.

2. Marcel Broodthaers, 'Mon cher Beuys', Düsseldorf, 25 September 1972; published under the title 'Politik der Magie? Offener Brief von Broodthaers an Beuys', *Rheinische Post* (3 October 1972); reprinted in Broodthaers, *Magie. Art et Politique* (Paris: Multiplicata, 1973), pp. 8–12; and reproduced in Birgit Pelzer,

'Recourse to the Letter', *October* no. 42 (Fall 1987), pp. 174–6.

3. See *Amsterdam-Paris-Düsseldorf* (New York: Guggenheim Museum, 1972), nos. 108, 109 (Beuys) and nos. 110 and 111 (Broodthaers).

4. For the fullest account of this incident, see Rosalyn Deutsche, 'Property Values: Hans Haacke, Real Estate and the Museum', in Brian Wallis (ed.), *Hans Haacke: Unfinished Business* (New York: New Museum, 1986), pp. 20–37.

5. See Thomas M. Messer's letter to Hans Haacke of March 19, 1971, published in 'Gurgles at the Guggenheim', *Studio International*, vol. 181, no. 934 (June 1971), pp. 248–9.

6. Jeanne Siegel, 'Interview with Hans Haacke', *Arts Magazine* (May 1971), p. 21.

7. Broodthaers, 'To be bien pensant... or not to be. To be blind' (1975), translated by Paul Schmidt, *October*, no. 42 (Fall 1987), p. 35.

8. According to the Guggenheim Museum's wall-list, Broodthaers' works were still shown in New York but withdrawn from the subsequent presentations of the exhibition.

9. For Broodthaers' open letters, see Benjamin H.D. Buchloh, 'Open Letters, Industrial Poems', *October*, no. 42 (Fall 1987), pp. 67–100; and Birgit Pelzer, 'Recourse to the Letter', pp. 157–81.

10. Quoted after the reprinted letter in *October*, no. 42, pp. 175–6.

11. *October*, no. 42, p. 175.

12. Joseph Beuys, quoted in Götz Adriani, Winfried Konnertz, Karin Thomas, *Joseph Beuys* (Cologne: DuMont Verlag, 1973), pp. 163 ff. (author's translation).

13. For the impact of Steiner's ideas on Beuys, see Caroline Tisdall, *Joseph Beuys* (New York: Guggenheim Museum, 1979), in particular *SaFG-SaUG* (1953–1958) and *Honey Pump*. In connection with Beuys' political actions, see Ibid. p. 269.

14. Tisdall, *Joseph Beuys*, pp. 265 ff.

15. From a letter to Tomas Schmit of January 1964, quoted in Tisdall, *Joseph Beuys*, p. 84.

16. Beuys, in Adriani, Konnertz, Thomas, *Joseph Beuys*, p. 53 (author's translation).

17. Johannes Agnoli and Peter Brückner, *Die Transformation der Demokratie* (Frankfurt a.M.: Europäische Verlagsanstalt, 1968).

18. Beuys, in Adriani, Konnertz, Thomas, *Joseph Beuys*, p. 154 (author's translation).

19. For a demystification, see Buchloh, 'Beuys: The Twilight of the Idol', *Artforum* (June 1980), pp. 35 ff. (reprinted in this volume); and Buchloh, Rosalind Krauss and Annette Michelson, 'Joseph

Beuys at the Guggenheim', *October*, no. 12 (Spring 1980), pp. 3–21.

20. Richard Wagner, 'Kunst und Revolution', in Dieter Borchmeyer (ed.), *Dichtungen und Schriften* vol. III (Frankfurt a.M.: 1983), 273 ff. See also Rainer Franke, *Richard Wagners Züricher Kunstschriften* (Hamburg, 1983).

21. See Borchmeyer, p. 301.

22. Theodor W. Adorno, *In Search of Wagner*, translated by Rodney Livingstone (London: New Left Books, 1981), p. 83.

23. Siegfried Kracauer, *Jacques Offenbach und das Paris seiner Zeit* (Frankfurt a.M.: Suhrkamp, 1976), p. 280.

24. I am, of course, referring to the first exhibition at the Galerie Saint-Laurent in Brussels in 1964 and the statement published by the artist on that occasion. For a discussion of Broodthaers' statement see Buchloh, 'Open Letters', pp. 73 ff.

25. Broodthaers, 'Über die Kunst – im Sinne einer Antwort an Jürgen Harten', *Magazin Kunst*, vol. 15, no. 2 (1975), pp. 73–4.

3. BEUYS AND BROODTHAERS

Dialectics of Modernity between 'Analytic Geometry and the Belief in an Unbelieving God'*

DOROTHEA ZWIRNER

BEUYS AND BROODTHAERS BOTH occupy singular positions within late-twentieth-century modernism; it is no coincidence that they clashed. Despite their differences, both artists had several things in common: they shared collectors and patrons such as Johannes Cladders, Anny de Decker, Isi Fiszman, Reiner Speck, Harald Szeemann, Paul Wember and many more; both dealt with the oeuvre of Marcel Duchamp; they shared their critique of traditional institutions, the use of vitrines and of visual material interwoven with conceptually analytic material in the oeuvre, as well as the dissolution of a firmly defined art concept with a materially binding classification in moving towards a process-oriented work of art. This essay will discuss how similar approaches and means of expression in the oeuvres of these artists nonetheless point in different directions. First, the personal relationship between the two artists will be reconstructed using surviving data and facts in order to produce a concrete comparison of individual works that reveals structural similarities and differences. Structural points of comparison will be traced in their mutual address of language, politics and history, especially that of the Romantics. These topics can only be touched upon within the scope of this essay. This comparison of Beuys and Broodthaers seeks to determine the artistic location of each of the two artists more closely, from an historical perspective. [...]

In addition to Joseph Beuys, Marcel Broodthaers was one of the most important and prolific artists of the Wide White Space (WWS) Gallery in Antwerp, one of the leading European avant-garde galleries during its existence from 1966 until 1976.[1] Due to the mediation of Bernd Lohaus, art student at the Düsseldorf Academy and companion of the gallery owner Anny de Decker, a close contact was established between Antwerp and the Rhineland, especially with the Düsseldorf Art Academy and the Fluxus artists acquainted with Joseph Beuys. Beuys and Broodthaers probably met for the first time around 1966–67 through Isi Fiszman, the most important collector and supporter of the WWS Gallery. At the time Beuys had been a professor at the Düsseldorf Academy for five years, while Broodthaers had just begun his career as an artist in 1964.

Beyond their joint participation in various group exhibitions at the WWS Gallery, each of the artists became familiar with the other's work. Broodthaers suggested filming Beuys' performance *Eurasienstab* in February 1968.[2] Shortly before this performance, Broodthaers had completed the film *Le Corbeau et le Renard* for the experimental film festival at Knokke-Le-Zout, which was the starting point for the following exhibition at the WWS Gallery in March 1968. Thus Broodthaers was able to organize a professional cameraman for the Beuys performance. Several months later, Broodthaers addressed an open letter to Beuys which is less well known than his second one from 1972, but which already reveals a certain ambivalence on his part towards Beuys.[3] Nonetheless, the letter starts with a declaration of sympathy and friendship:

Brussels, 14 July 1968

My dear Beuys,

Oh God, born in another world it was so difficult to call a German a friend. You are my friend and Dutschke is my friend. Beautiful Germany is again reviving. [...] Oh Beuys, poet of the concentration camp, with your copper-plated tables, with your magic spark, your felt pieces full of graveyards, your beds encircled by pestilence; with your new friends, South Americans, Jews, Yankees... Are we standing on the threshold of a new slaughter?

I smell the distant decaying of flesh. Are we correctly informed? Here we do not know much about your art, no more than they do in France. Our journalists are strange. Here in Brussels they have announced the founding of a Museum of Modern Art. Nobody believes it. [...] Beuys, see you soon. Many people here cannot decide between analytic geometry and faith in an unbelieving god.

Marcel Broodthaers
M.B.

Like all open letters, it was sent out in small numbers to friends and acquaintances in the art scene.[4] The letter was triggered by a confrontation with the German past; after the euphoria of Germany's so-called 'economic miracle' and the typical mechanisms of the 1950s and 1960s of forgetting, the past was then claimed by a new generation – the '68 movement – represented here by Beuys and Rudi Dutschke.[5] The biography and work of Beuys is especially characterized by this problematic German manner of coping with the past, which made him *the* artist of post-war Germany for his scholars, while his critics saw echoes of Germanic *Völk*-ishness in his work.

The interwoven biographical and artistic aspects of Beuys' work are clearly documented by his air crash in the Crimea. The Crimea episode is so central to Beuys' biography that it is widely held to be a myth; without investigating the substance of the event, Caroline Tisdall places special emphasis on the relation between Beuys' work and the accident: 'It is certainly true that without this encounter with the Tartars, and with the ritualistic respect for the healing potential of materials, Beuys would never have turned to fat and felt as material for sculpture.'[6] While Tisdall accentuates the semantic dimension of the material and bases her assumptions more strongly on the artwork, Benjamin Buchloh's critique concentrates on Beuys' persona, his statements and his public self-representations.[7] According to Buchloh's analysis, the Beuys crash, followed by his several-day coma and rescue by the Tartars, is contradictory in itself and is stylized as an archaic myth. On the one hand it can be interpreted as paraphrasing the myth of (the) phoenix and on

the other as the wound of a stifled past, the loss of memory and history commonly suffered by the Nazi-regime war generation. Within his initial and sustained critique of Beuys, Buchloh still acknowledges: 'It is in making a theme out of a suppressed German past that Joseph Beuys' art developed strength, its very own specific nature and authenticity; here lies the credibility of his material and of his art's morphology.'[8]

It will remain unresolved as to what extent the reciprocal permeation of art and life is to be seen as an intuitive metaphor, as a programmatic method or as a strategic calculation. In Beuys' case, this permeation generated a mystical/mythical stylization of his persona and biography. The mere phenomena of self-stylization and of creating myths groups Beuys within the historical context of the 1950s, along with other post-war artists such as Yves Klein, Piero Manzoni, and later Andy Warhol and Marcel Broodthaers; they all made their personas into a subject of their work. As early as 1962, Piero Manzoni declared and certified Marcel Broodthaers as a work of living art. When one thinks of Broodthaers' various roles as museum director, actor in his own films, and commentator on his own work and that of other artists, these two fundamentally different behaviour patterns become apparent, and can be distinguished from one another through degrees of consciousness of disclosure. While in the case of Beuys artistic and biographical aspects in their reciprocal permeation are inextricably linked, Broodthaers never leaves any doubt in the mind of the viewer about the fictional character of his role play, which he demonstrates with certificates, letters, props and costumes.

At times, Beuys' self-styling seems to be on a strategic and tactical level, while at other points it seems to take place on a semi-conscious or subconscious level that appears to result from direct access to the subconscious mind, serving a creative process of change and healing. Broodthaers uses his playful and ironic character to attempt to take on the Cartesian position outside of himself that is customarily known as self-reflection. This does not mean that Beuys lacks any form of self-reflection. On the contrary, in his self-characterization as a shaman, Beuys seemed to want to overcome and heal that specific state of the split self that signifies the intellectual. The mystical figure of the shaman can be compared to the tragic figure of the self-

reflecting Narcissus, with whom Broodthaers compares the artist.[9] A shaman initiation occurs by simulating death, thereby making today's death character surmountable in the future; [10] on the other hand the tragic fate of Narcissus admonishes us to endure the vivid tension of the split self in the present.

In considering these differing concepts of self-image in the role of the artist it becomes clear as to why Beuys' past in the war – however marginal his role may have been – and its mythical stylization were reasons for suspicion on the part of Broodthaers.[11] After all, Broodthaers had, as a young man, joined the Resistance against Nazi Germany, probably in an equally marginal role. One should not forget that a strong dislike of Germans lingered at the time in Belgium, as in all of Germany's neighbouring countries. [...] Nonetheless, it is said that there was a hearty joviality between the two and Broodthaers acknowledged Beuys' creative talent.[12]

In his description of Beuys' oeuvre, Broodthaers places great emphasis on suggestive allusions to the Second World War. What Broodthaers doubtlessly had in mind was Beuys' sculpture, previously exhibited at *Documenta 4* in Kassel; two years later, it had already become part of the Ströher Collection at the Darmstadt Landesmuseum.[13] In comparison to the neighbouring installation *Roxy's* by Edward Kienholz, the copper tables, bed constructions and technical supplies from the physical sciences had an enormous suggestive impact, and made Beuys the first and only German artist to be presented in an international context.[14] In addressing Beuys as 'Poète concentrationnaire' (poet of the concentration camp), the associations with Auschwitz seemed problematic to Broodthaers, in accordance with Adorno's dictum that after Auschwitz no more poetry could ever be written. [...]

Finally, the open letter ends with a remark on the two kinds of people who are torn between 'analytic geometry and the belief in an unbelieving god', which clearly demonstrates Broodthaers' antagonistic attitude towards Beuys. However, rationality and belief or Enlightenment and mythology are dialectical contradictions, which, as in all contradictions, are simultaneously dependent on each other while remaining exclusive of each other. In his polarization Broodthaers opens a space for nuance when he formulates 'analytic geometry' as the progression of 'synthetic geometry' or uses 'faith in an

unbelieving god' to accentuate the rational doubt implied by faith. This use of contradictory poles will prove a good criterion for the comparison of the works of both artists.

Written in the year of the student revolts in 1968, Broodthaers would react to the critique of institutions by founding his own museum in his flat in the Rue de la Pépinière on 26 September, which he had already casually announced in the letter he wrote to Beuys in June 1968. In May, Broodthaers participated in the occupation of the Palais des Beaux-Arts in Brussels, but some days later he had already distanced himself from the other activists. Broodthaers used a strategy of 'semblant' (appearance) when instituting his own museum.[15] The strategy revealed itself to be just that. In contrast, Beuys strove for a true reconciliation between art and life on the level of the extended concept of art in founding the 'Deutsche Studentenpartei' (German Student Party) in 1967 and successive organizations such as the 'Organization für direkte Demokratie' (Organization for Direct Democracy) in 1971 and the 'Freie Internationale Universität' (Free International University) in 1973. It is true that Broodthaers loved to diffuse the difference between appearance and reality, play and honesty, but only as a means to sharpen the boundaries between art and life. His museum was constructed as a place to experience the process of symbolization. Fiction provides us with a stronger awareness of reality: 'Fiction allows us to grasp reality while still grasping what fiction conceals.'[16] In this respect, Broodthaers differs from Beuys in that he never dealt with the social, institutional and economic conditions of art on a primarily political level but rather on a fictional and poetic one, which the second open letter to Beuys of 1972 substantiates. [...]

This latent tension culminated when Beuys appeared at Broodthaers' 'Eagle Exhibition' at the Kunsthalle in Düsseldorf with a television crew in order to give an interview without the artist's permission; this entailed using the setting of Broodthaers' exhibition to present himself. [...] Broodthaers had collected 266 eagle objects from various museums and other sources for the exhibition 'The Eagle from the Oligocene to the Present' for his *Section des Figures,* which had received recognition in the art scene. All objects were captioned in three languages: 'This is not a work of art.' With the evident paradox between the description, the exhibited object and its museological context,

Marcel Broodthaers reversed the right of the artist – introduced by Duchamp and further developed by Manzoni – to declare anything a work of art by using a variant of Magritte's '*Ceci n'est pas une pipe*.'[17] Broodthaers' epistemological interest combined Magritte's visually immanent questions with the contextual discourse of Duchamp. While Broodthaers declared his explicit support for Duchamp by referring to the urinal in the accompanying catalogue, Beuys criticized Duchamp's concept of non-art in his performance *Das Schweigen von Marcel Duchamp wird überbewertet* ('The Silence of Marcel Duchamp Is Overrated') of 1964. [...]

It was not until the end of the year that Broodthaers found the appropriate means to react to Beuys' violation of his artistic integrity. He used the fiction of a recovered letter from Jacques Offenbach addressed to Richard Wagner as a masquerade to express his differences with Beuys in a rather elegant manner. He writes in his second open letter to Beuys:

> I can hardly go along with that contention of yours, and at any rate I wish to register my disagreement if you allow a definition of art to include one of politics ... and ... magic ... My dear Wagner, our relations have become strained. I dare say this will be the last message I am sending you.[18]

The model of identification is clear. 'Broodthaers – Flemish but proficient in French thinking – lets Jacques Offenbach, the Cologne-born composer with lucid French *esprit*, write to Wagner, the Germanic magician of the *Gesamtkunstwerk* ('synthesis of the arts') – or even to Beuys, the magician of art-is-life-is-politics-romanticism.' This was the explanation provided in the introduction to the open letter published in the *Rheinische Post* of 3 October 1972.[19] The following passage supplies the background to the open letter:

> King Ludwig II. had Hans H. sent away from his castles. His Majesty prefers you to this specialist of compositions for the flute. I can understand – if it is a matter of artistic choice. But is not the enthusiasm that His Majesty displays for you motivated by a political choice as well?

I hope this question disturbs you as much as it does me. What ends do you serve, Wagner? Why? How? Miserable artists that we are.

Vive la Musique!

Jacques Offenbach

This farewell letter to Beuys was motivated not only by Broodthaers' move to London, but also by the rejection of a Hans Haacke exhibition at the Guggenheim Museum in New York in 1971, for apparently political reasons.[20] Beuys and Broodthaers were invited to the exhibition 'Paris-Düsseldorf-Amsterdam' at the Guggenheim Museum in the following year; their participation would evidently have been regarded as supportive of the museum's policy of censorship that had caused such a stir within the art scene. Beuys tried to react to this precarious situation by exhibiting only his programme for the *Organization for Direct Democracy by Referendum*. Broodthaers instead withdrew from New York his contribution *Ma collection* of 1971.[21] [...]

Although Broodthaers was temporarily a member of the Communist Party, he was never a political artist in a strict sense. Broodthaers' position can best be described in terms of Walter Benjamin, who suggested gauging the political intention of an oeuvre by its position within the relations of production and not by the oeuvre's stance towards them. Not any old partisanship, but rather the reflection of the conditions of producing art must be the object of the artist's project.[22] Yet Benjamin Buchloh goes too far in his critique of Beuys when, with reference to Walter Benjamin, he positions the 'aestheticism of politics' by Beuys against the 'politicization of art' by Broodthaers.[23] To begin with, this polarization is bound by the historical antagonism between fascism and communism and is not easily applied elsewhere. Most of all, however, Buchloh underestimates the sculptural quality of Beuys' oeuvre, which he does not distinguish from his theoretical work; conversely, Buchloh overestimates the political dimension of Broodthaers, who was not producing a politicization but rather a form of poeticized art. [...]

In looking at and coming to terms with Germany's past

and its culture, the different historical starting points of the two artists becomes apparent, and both have to be taken into account. While for Beuys his own experience of the war, against the background of the reports on Auschwitz, led to a personal crisis, for Broodthaers it was possible to continue the tradition of the avant-garde without rupture. In regard to the self-stylizing of the artists, Beuys makes use of the role of the shaman who tries to reconcile the ruptures in our culture and society with psychic powers. Broodthaers, on the other hand, makes use of the role of Narcissus to renew the suicidal dangers of such dreams of unification. Broodthaers critiqued traditional institutions in founding his fictitious museum, while Beuys sought a concrete change to society through his diverse organizations, and especially in his function as a teacher and, later, as a member of the Green Party.

It is necessary to separate Beuys' discursive activity in the form of speeches, podium discussions, organizations and interviews from his sculptural activity, as Theodora Vischer has pointed out.[24] This essay does not seek to analyze in detail the function of the discursive activity of both artists; however, their differing rhetorical styles do point in a certain direction. In her comparison of Beuys and Broodthaers, Maria Kreutzer analyzes their relationship to language and applies the semantic dimension of the Greek term 'word' as *mythos* and *logos* to both artists.[25] While the sharp, subtle, refined and cultivated language of Broodthaers in its varying literary forms continuously reveals the poet, Beuys' harsh, vivid and reduced language follows the principle of simplification and communication.[26] As such, the discursive activity of Beuys is grouped into the sphere of reality, while the diverse literary forms in Broodthaers' oeuvre – especially his open letters, of which we have seen two examples here – form an integral part of his 'Gesamtkunstwerk' and whose artificial and fictitious character placed them in the sphere of art.

In what follows, I will discuss the extent to which the oeuvres of Beuys and Broodthaers differ on an artistic and visual level. In dealing with Duchamp, Beuys criticizes the 'hermetic, private enclosure of Duchamp's system, something I have described as a sphere of silence rather than one of communication...'[27] In the multiple *Das Schweigen* ('The Silence') of 1973 (Fig. 3.1), Beuys galvanized five rolls of Ingmar Bergman's film with the same

title. In comparable fashion, Broodthaers covered the remaining editions of his own poem booklet in plaster in his programmatic sculpture *Pense-Bête* of 1964 (Fig. 3.2), in order to manifest his transition from poet to artist. The fact that this book was made impossible to read – accompanied with the silence of the poet – became the precondition for a new form of communication on a visual level.

3.1. Joseph Beuys, *Das Schweigen* ('The Silence'), 1973; © 2006 Artists Rights Society (ARS), New York/VG Bild-Kunst, Bonn.

In a similar manner, Beuys allows his multiple to 'silence the silence' of Duchamp in order to open the door to a new form of communication by means of titling the individual film spools.[28] While Broodthaers uses the negation affirmatively, Beuys' negation of a negation automatically sets an affirmation. Thus a

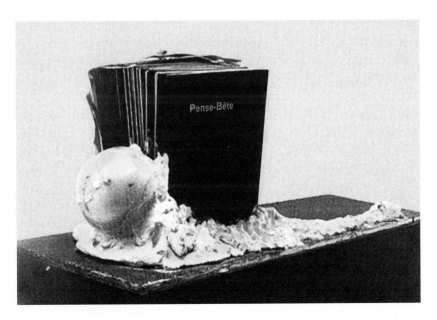

3.2. Marcel Broodthaers, *Pense-Bête*, 1964; © 2006 Artists Rights Society (ARS), New York/SABAM, Brussels.

visual comparison of these two similarly structured artworks reveals a symptomatic difference between these poles. Where Broodthaers tried to render productive the dialectical tension between opposing poles, Beuys tried to overcome contradiction in order to achieve a higher synthesis. In order to apply this to the relationship between art and life it may be said that Beuys rejected an insistence on separate and autonomous spheres and instead strove for their reconciliation on the level of his *'erweiterter Kunstbegriff'* (expanded concept of art), which he viewed as a consequence and continuation of the path Duchamp had pursued. While Beuys included his choice of artistic elements in order to express his shift towards reality, the invention of the readymade emphasized the shifting of the boundary as a universal strategy that could form the basis of all innovative gesticulations.[29] [...]

The variety of media and techniques used is significant for the oeuvres of both artists. Not only their nationalities but also their original professions as sculptor and as poet remain characteristic for their entire work. Against this background, it once again becomes evident that the level of discursive activity used by each artist in relation to visual art occupies a different status and belongs to a different domain. A similar development can be charted in the work of both artists: the first tentative steps made during the early 1950s in what were still rather intimate mediums of drawing and poetry; relatively late, that is in the 1960s, these developed into independent work that made both artists visible to a wider audience in their first respective museum exhibitions in 1967 – Broodthaers in the Palais des Beaux-Arts in Brussels, and Beuys in the Municipal Museum of Mönchengladbach. In the 1970s they both developed grand overarching scenarios, increasingly oriented toward installation. Both artists demonstrate the dissolution of a traditional concept of art into a fluid art process, which makes it very difficult to deal with their work today. [...]

The Artists' Roles in Performance and Film

The different costumes Broodthaers and Beuys invented correspond to the different roles in which the artists functioned as actors within their respective performances[30] or films.[31] [...] With his traditional style of clothing, Broodthaers connects

more to the figure of the dandy, while Beuys appears as a nomad armed for survival. [...]

While Broodthaers' performances indicate a classical understanding of roles, Beuys' interest was not in the role itself but in the visualizing of an image: the image of the messiah, the shepherd, the traveller, nomad or shaman that in the end collapsed into the image of the artist. Broodthaers may not have used professional actors for his films (this was never possible for financial reasons), but Beuys' performances were always inseparably connected to the artist's persona, to his charisma and his physical presence.[32] Broodthaers as an actor appears to stand outside himself, while Beuys melts completely into his role, becomes mediator, messiah and agitator.

The Artist as Collector or Curator: Art in Vitrines

The single most striking similarity between both artists was in their use of vitrines as a form of presenting art, which has continued in numerous variations to this day. Vitrines appear in the work of Beuys in his exhibition at the Municipal Museum in Mönchengladbach in 1967, where he found cabinets viewable from all sides; these were an appropriate form of presentation for his range of objects – many of them small and fragile.[33] [...] The frontal orientation of the vitrine, resting on a high iron frame, was developed in 1971 and offers the possibility of presenting works from different periods and of bringing together a variety of objects, relics, textiles, remnants and other substances into a new unity. However, his vitrines are often seen as storage places for relics from performances, which have connotations of mustiness and of reliquary cults. The intentional connection with the history of art cabinets and *Wunderkammern* (cabinet of curiosities) is made especially vivid in the Darmstadt Landesmuseum's natural history sections. While Beuys intended to combine science and art with this form of presentation, Broodthaers used this very museum-like form of presentation to lay more emphasis on the process of 'musealization'. Vitrines appear in the oeuvre of Broodthaers in connection with his museum concept and especially in his big retrospectives of the final two years, 1974–76. This 'vitrinization' combined a didactic and ironic aspect that demonstrated the process promoted by the museum in forming myths and metasymbols.[34] [...]

The Message of the Artist: Art on Blackboards

The blackboards in Beuys' oeuvre take on a position between a didactic instrument and an independent work of art.[35] Beuys used blackboards from his first Fluxus concert in the early 1960s. The blackboard began to play a major part in his oeuvre with the performance *Celtic (Kinloch Rannoch) schottische Symphonie* of 1970. As tools and relics of performances or speeches they belonged to the domain of conceptual discourse. At times they form new works and even determine the structure of installations, such as *Richtkräfte* ('Directional Forces') of 1974–1977. Beyond their formal analogy to Rudolf Steiner's boards, both have to do with a didacticism that is aimed at achieving a powerful effect. The frequently poor state of the blackboards and their more unprompted rather than organized inscriptions serve as a guarantee for the spontaneity and genuineness of the effect intended; the deliberate absence of 'aesthetic packaging' enhances the immediate power of the message. The thesis of Beuys' intended unity and wholeness can be confirmed by the first version of the blackboard *Freie demokratischer Sozialismus* ('Free Democratic Socialism', Fig. 3.3) shown at Documenta 5 in

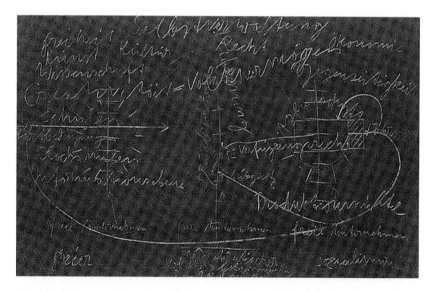

3.3. Joseph Beuys, *Freier demokratischer Sozialismus* ('Free Democratic Socialism'), 1972; © 2006 Artists Rights Society (ARS), New York/VG Bild-Kunst, Bonn.

1972 in Kassel; the second version was exhibited one year later in the exhibition *Kunst im politischen Kampf* ('Art in the Political Struggle') at the Kunstverein Hannover. As Helmut Leppien described them: 'The triad of signs and concepts referred clearly to Rudolf Steiner, whose image was integrated by Beuys into his own space, whilst retaining its style of speaking: the titular state form of "free democratic socialism" divides into the three areas of freedom, civil rights and economy. Beuys demonstrated his vision of an inseparable unity of artistic work and political activism in unifying the image of the three overlapping spheres with an enlarged numeral three.'[36]

In contrast to the large number of blackboards in the oeuvre of Beuys, there are only two blackboards with the title and inscription *Les Aigles* from 1970 in the work of Broodthaers. [...] More interesting in this context is one of his few oil-on-canvas paintings *Il n'y a pas des structures primaires* of 1968 (Fig. 3.4); the white lettering upon a black background is reminiscent of a blackboard. By consciously imitating the character of a blackboard with handwritten and crossed out letters, he also accentuates the eminent artistic character of the work, even adding a swab of red paint. In the centre the title 'Il n'y a pas des

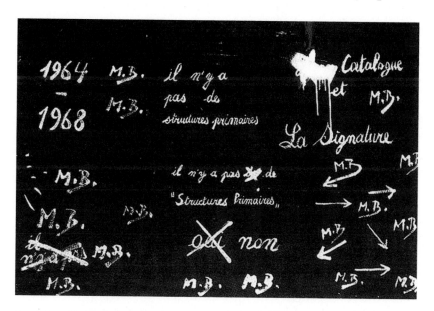

3.4. Marcel Broodthaers, *Il n'y a pas des structures primaires*, 1968; © 2006 Artists Rights Society (ARS), New York/SABAM, Brussels.

structures primaries' appears twice; in its negation it refers to the exhibition *Primary Structures* of 1966,[37] and generally sums up the artist's first working period between 1964 and 1968. Broodthaers expresses his rejection of any kind of claim to absoluteness, be it in the field of ideology, science or art. Broodthaers confronts the idealism of immediacy, authenticity and unity with his brand of relativism, in which the sign, the object or that which generally exists, is shown as being of a historic or mediated nature.

Beuys uses the blackboards to support his messages, which gain a verified and authentic value because extinction and over-inscription is always immediately and spontaneously possible. For Broodthaers any intention appears dominated by concrete power structures; any message is determined by its linguistic and visual form.[38]

The visual comparison of works by Beuys and Broodthaers reveals that both work repeatedly with contradictions: Beuys seeks to illustrate the ephemerality and the common bond of 'polarized states' by emphasizing physical substance, whereas Broodthaers does the reverse in articulating the situation of a dualistic fragmentation as *conditio humana* and as a scope for his artistic development.

Both artists refer to the nineteenth century and to Romanticism in particular as an historical context for their concepts.[39] While artistic self-assertions cannot be examined more closely here, the position of Werner Hofmann should be mentioned. In his various analyses of this period he pointed to the 'ruptures and anticipations', 'the dissonances and contradictions', in short to 'polyfocality' as the crucial characteristic of the 'divided century' which he allows to terminate, dialectically, between reconciliation and confrontation.[40] The art-historical reappraisal of this period evokes a fundamental re-evaluation of the Romantic period as the real origin of modernity, which was split from the start by a conflict between the poetic on the one hand and philosophical/scientific modernity on the other.[41] The central figures of Romantic consciousness, the reflexivity of the artwork and the fantastic, are first rediscovered by Walter Benjamin and the French Surrealists as central *leitmotifs* of modernity. Broodthaers is rooted in Belgian Surrealism; consequently he is already situated in this tradition of linking the theoretical domain of critique, irony and reflection with one of an imaginative-

fantastic nature. One might point to Magritte's play with the reflexivity of the artwork that no longer creates the illusion of a consistent relation between reproduction and reality, but manages a reciprocal reflection on both contrasting poles.

In comparison, 'the entire oeuvre of Beuys is based on the concept of polarities which lead to a synthesis. With the model of sculptural theory, a concept of unifying poles has found its systematization and universalization.'[42] Theodora Vischer finds that such thinking is based on the harmony of poles conceptualized in the relation of science and art within Romanticism. The parallels between Beuys and the early German Romantic period are particularly convincing, and can be proven, for example, in Novalis' dictum, 'Every human being should be an artist. Everything can become fine arts,'[43] or in his concept of polarity: 'Polarity is an imperfection – originally there should be no polarity.'[44]

Beginning in the early Romantic period, the path towards modernity evidently reveals a pattern of rationalism and re-mythification.[45] Following this path from its common historical source, two different lines of development become apparent, which I want to describe using the notion of the Romantic discovery of the subject as an individual, since the artistic self-concept is an especially significant aspect in the comparison between Beuys and Broodthaers.[46] This turning towards the self that begins with Descartes is affected by ambivalence between an increasing demand for freedom on the one hand and the ensuing loss of existential certainty on the other. This tension between a gain in selfhood and a loss of world provokes two different lines of development, which in turn accentuate the aspect of gaining freedom or that of a break in the bond with the world.

The first of the two paths is consistent with the Romantic notion of self-development and self-realization, i.e. the expressive and creative side of the subject. This notion is found in Novalis' remark 'everyone should be an artist,' in the most extreme form of heightened individualism in the genius cult of Richard Wagner, in Rudolf Steiner's anthroposophy, and can also be tracked in Beuys' dictum 'everyone is an artist.'

The other path that can be traced is a dismantling of the absolute subject which results from the experience of temporality,

plurality and relativity of the human subject. This can be traced in Kant's critique of the power of judgement [*Urteilskraft*], in the surrealist discovery of the subconscious and also in Broodthaers' ambivalent *Eloge du Sujet*.[47] I refer here to the title of a work and an exhibition by Broodthaers of 1975, in which he operates with a double meaning of *Sujet* (subject and theme/object). The clear precedent once again is Magritte, and Broodthaers further develops his script-images into a three-dimensional work by giving diverse objects contradictory inscriptions. When, for example, a bowler hat is inscribed with 'Sujet', there is no doubt as to which subject Broodthaers praises. However, at the same time it is Cartesian 'praise' for a self-conscious subject that can fashion the activity of recognition into the object of epistemology, albeit at the cost of one's own identity.

Beuys tried to compensate for personal crisis and the resulting lack of existential security with a programmatic reconciliation between art and life. Important indicators of this attitude have been identified by Cornelia Klinger as 'characteristic elements of the Romantic complex which result from an examination of historical Romanticism as well as the renaissance of the Romantic syndrome in later constellations':[48]

- the turn towards aesthetics, as is advanced in the idea of the *Gesamtkunstwerk* and continued in Beuys' expanded concept of art;

- the turn towards the community, as found in early life-reform movements and in the wide circle of students and disciples around Beuys;

- the turn towards nature, as developed in the Romantic philosophy of nature and carried out in Beuys' ecological engagement, such as in his project *7,000 Oaks*;

- the turn towards mythology and to the subject, best described in Harald Szeemann's paradoxical notion of 'individual mythology'.

In contrast, 'with Baudelaire we see … the failure of the utopia of reconciliation with the critical reflection of a social world that

could not be made to look better. A relation of opposites had come into being; art had become a critical mirror, showing the irreconcilable nature of the aesthetic and the social worlds.'[49] In this uninterrupted tradition Broodthaers followed an avant-garde conception of art that does not try to compensate for the change in its concept of reality and of the subject; instead it represents and reflects. Important origins for this attitude are:

- the historical and cultural roots of the subject, as it is elaborated from historicism to Broodthaers' consciousness of tradition;

- the determing element of language for the subject, from the language theories of Wittgenstein to the French Structuralists to the poeticization of art extended by Broodthaers to all areas of life;

- the decay of the subject through the discovery of the unconscious, as it is articulated in Lacan's combination of psychological and linguistic method and as a symbolic strategy of appearance in the work of Broodthaers.

Despite the reduction and schematizing that is characteristic of a comparison between Beuys and Broodthaers, the two paths of development outlined here suggest two general positions of modernity. The contrasting nature of these two positions makes them simultaneously dependent on and mutually exclusive of each other. The relation of these two lines of development is a coherent pattern of reaction which oscillates between 'conciliation and confrontation,' synthetic and analytic thought, between the claim for the absolute and the concept of contingency.

NOTES

* In Christian Posthofen Köln (ed.), *Essays on the Oeuvre of Films by Marcel Broodthaers* (National Galerie Berlin, Verlag Walther König, 2001), pp. 93–127, translated by Viola Michely and Kayvan Rouhani.

1. *Wide White Space. Hinter dem Museum 1966–1976* (Düsseldorf: Richter Verlag, 1995).

2. Anny de Decker (ed.), *Joseph Beuys, Eurasienstab* (Antwerp, 1987), p. 5.

3. Marcel Broodthaers, 'Mon cher Beuys', Brussels, 14 July 1968, facsimile in Marcel Broodthaers (Paris: Galerie national du Jeu de Paumes, 1991), p. 22.

4. Birgit Pelzer, 'Recourse to the Letter', in *October* 42 (1987), pp. 157–81, and, Benjamin H. D. Buchloh, *Broodthaers. Writings, Interviews, Photographs* (Cambridge: MIT Press, 1988), pp. 67–100. See also Dorothea Zwirner, 'Marcel Broodthaers – Je manifest manifestement', in *Manifeste: Intentionalität. Avant Garde Critical Studies 11* (1998), pp. 141–60, especially p. 150.

5. It is interesting that Broodthaers mentions Beuys and Dutschke in the same sentence. Their first encounter did not take place until the 'working place' of the FIU near the *Honey Pump* in Kassel at Documenta 6 in August 1977; see Johannes Stüttgen in his article on Rudi Dutschke in the 'Beuysnobiskum' in *Joseph Beuys* (Zurich: Kunsthaus Zürich, 1993), pp. 255f. A poem by Heinrich Böll also refers to the affinity between Beuys and Dutschke, although presented with a critical undertone; see 'Für Beuys zum 60. – In memoriam Rudi Dutschke' in *Die Zeit*, 8 June 1981, p. 38.

6. Caroline Tisdall, *Joseph Beuys* (New York: The Solomon R. Guggenheim Museum, 1979), p. 17.

7. Benjamin H. D. Buchloh, 'The Twilight of the Idol', *Artforum* (January 1980), pp. 35–40; reprinted in this volume.

8. Buchloh, 'The Twilight of the Idol', p. 66.

9. The role of the artist and his possibilities of self-reflection become obvious in Broodthaers, *Magie. Art et Politique*, Paris 1973, here under the title *Être Artiste – Être Narzisse*. See also Rainer Borgmeister, 'La Signature, L'Artiste', in *Marcel Broodthaers, L'Oeuvre graphique – Essais* (Geneva: Centre Genevois de Gravure Contemporaine, Geneva, 1991), pp. 43–52; Dorothea Zwirner, 'Spieglein, Spieglein an der Wand ...' ('Mirror, mirror on the wall...'), in Wilfried Dickhoff (ed.), *Marcel Broodthaers* (Cologne: 1994), pp. 230–47.

10. Joseph Beuys, quoted from 'Wenn sich keiner meldet, zeichne ich nicht' (a conversation between Joseph Beuys, Heiner Bastian, Jeannot Simmen, Düsseldorf, 8 August 1979) in *Joseph Beuys – Zeichnungen, Tekeningen, Drawings* (Munich: Prestel-Verlag, 1979), p. 32.

11. Anny de Decker, 'Bericht über die Beziehung zwischen der Wide White Space Gallery in Antwerpen und der Akademie von Düsseldorf in dem Zeitraum 1965–1970' ('Report on the

Relations between the Wide White Space Gallery in Antwerpen and the Düsseldorf Academy'), in *Brennpunkt Düsseldorf* (Düsseldorf: Kunstmuseum Düsseldorf, 1987), p. 116.

12. de Decker, p. 116.

13. The elements Broodthaers describes have most to do with the work *Fond II*; see Theodora Vischer, *Beuys und die Romantik* (Cologne: Walther König, 1983), p. 14, excerpts in this volume.

14. Broodthaers was not chosen to participate in Documenta in 1968, but was represented by the Wide White Space Gallery in the rooms of a hotel in Kassel, where films by Broodthaers and Beuys were shown; see the interview by Anny de Decker and Bern Lohaus in *Wide White Space,* pp. 45ff.

15. See Birgit Pelzer, 'Die symbolischen Strategien des "semblant"', in *Essays on the oeuvre of films by Marcel Broodthaers* (Cologne: Walther König and the National Galerie Berlin, 2001), pp. 45–74.

16. Marcel Broodthaers, 'Museum für Moderne Kunst – Werbeabteilung', in *Heute Kunst* 1 (April 1973), pp. 20–23.

17. Michael Compton, 'Marcel Broodthaers', in *Marcel Broodthaers* (Cologne: Museum Ludwig, 1980), p. 19.

18. Broodthaers, 'Mon cher Beuys', Düsseldorf, 25 September 1972, reprinted in German, English and French in *Magie. Art et Politique* (Paris: Multiplicata, 1973), p. 14.

19. Introduction to Broodthaers' text 'Politik der Magie', in *Rheinische Post*, Düsseldorf, 3 October 1972.

20. Two of Hans Haacke's works that were planned for this exhibition were to disclose the conditions of land ownership in Manhattan using photographs of building façades in Manhattan in conjunction with explanatory texts; this was to form part of his work on social systems. The museum director explained this rejection, pointing to an exhibition policy which excluded active engagement in social and political questions. See *Hans Haacke, Unfinished Business* (New York: MIT Press and The New Museum of Contemporary Art, 1986), pp. 96ff.

21. Stefan Germer, 'Haacke, Broodthaers, Beuys', *October* 45 (1988); reprinted in this volume.

22. Walter Benjamin, 'The Author as Producer', in Brian Wallis (ed.), *Art after Modernism: Rethinking Representation* (New York: New Museum of Contemporary Art New York, 1984), pp. 297–309.

23. Buchloh, 'The Twilight of the Idol', pp. 75–77.

24. Theodora Vischer, *Joseph Beuys. Die Einheit des Werkes* (Cologne: Walther König, 1991).

25. Maria Kreutzer, '"Plastische Kraft" und "Raum der Schrift", Überlegungen zu den Kunstauffassungen von Beuys und Broodthaers', in *Brennpunkt Düsseldorf*, pp. 19–24.

26. Vischer, *Joseph Beuys. Die Einheit des Werkes*, p. 87; Walter Grasskamp writes about Beuys' profiteering with terminology in *Der lange Marsch durch die Illusionen* (Munich: C.H. Beck, 1995), pp. 64–78; Max Reithmann identifies the pre-linguistic/imaginary as a condition for Beuys' own speech; see his 'Sprache Bild und Gegenwärtigkeit bei Beuys', in *Brennpunkt Düsseldorf*, p. 46.

27. *Joseph Beuys* (Luzern: Kunstmuseum Luzern, 1979), n.p.

28. See Harald Szeemann's description of 'Das Schweigen' as well as his Duchamp article in 'Beuysnobiscum', both in *Joseph Beuys* (Zurich: Kunsthaus Zürich, 1993), pp. 90f. and pp. 253–255.

29. Boris Groys, *Über das Neue* (Munich/Vienna, 1992), pp. 73ff; for a comparison between Beuys and Duchamp see also Vischer, *Joseph Beuys. Die Einheit des Werkes*, p. 249, and Grasskamp, 'Soziale Plastik – Schwierigkeiten mit Beuys', in *Der lange Marsch durch die Illusionen*, p. 75.

30. Uwe M. Schneede, *Joseph Beuys – Die Aktionen* (Ostfildern-Ruit: Hatje Cantz, 1994).

31. *Marcel Broodthaers. Cinéma* (Düsseldorf: Kunsthalle Düsseldorf, 1997).

32. In this respect, Beuys' performances differed from the anonymity of the Fluxus event, sometimes executed by artists but not necessarily by the authors/composers. For Beuys' rapprochement towards and distancing from Fluxus see Schneede, *Joseph Beuys Die Aktionen*, pp. 9–12.

33. Gerhard Theewen, *Joseph Beuys – Die Vitrinen* (Cologne: Walther König, 1993); and together with Harald Szeemann in exhibition catalogue *Joseph Beuys* (Zürich: Kunsthalle Zürich, 1993), pp. 113–137.

34. Isabelle Graw, 'Glasstürze. Kunst in der Vitrine', *Artis*, 42 (March 1990), p. 53.

35. Caroline Tisdall, *Joseph Beuys* (New York: Guggenheim Museum, 1979), pp. 204–206.

36. Helmut R. Leppien, *Joseph Beuys in der Hamburger Kunsthalle* (Hamburg: Hamburger Kunsthalle, 1991), p. 36.

37. *Primary Structures* (New York: Jewish Museum, 1968); the title of this exhibition curated by Kynaton McShine became synonymous with 'Minimal Art.'

38. Concerning his vacuum-formed plastic plaques, Marcel Broodthaers speaks of a complete rejection of a clear message:

'Do not limit the message to either image or text. This means refusing the relief provided by a clear message. [...] For me, there can be no direct relation between art and message and even less so if this message is political; otherwise one can get burnt by the artefact', in the interview with Irmeline Lebeer, 'Dix mille francs de récompense', in *Catalogue/Catalogus* (Brussels: Palais des Beaux-Arts, 1974), p. 64.

39. Vischer, *Beuys und die Romantik*; see also her essay in this volume.

40. Werner Hofmann, *Das entzweite Jahrhundert. Kunst zwischen 1750 und 1830* (Munich: C.H. Beck, 1995), p. 676.

41. Karl Heinz Bohrer, *Die Kritik der Moderne* (Frankfurt a. Main: Suhrkamp, 1989) undertakes an historically oriented analysis and offers insights stretching from early Romantic criticism of Heine and Hegel, the modern renaissance of Romanticism by Walter Benjamin and the French surrealists, and the aesthetic turn-around in the criticism of Wilhelm Dilthey, Ricarda Huch and Carl Schmitt.

42. Vischer, *Beuys und die Romantik*, p. 67.

43. Vischer, *Beuys und die Romantik*, p. 60.

44. Vischer, *Beuys und die Romantik*, p. 69.

45. Cornelia Klinger, *Flucht Trost Revolte – Die Moderne und ihre ästhetischen Gegenwelten* (Munich: C. Hanser, 1995), p. 7.

46. Klinger, Chapter 3: 'Die Wendung zum Subjekt als Individuum', pp. 105ff.

47. Peter Bürger, *Das Verschwinden des Subjekts. Eine Geschichte der Subjektivität von Montaigne bis Barthes* (Frankfurt a. Main: Suhrkamp, 1998).

48. Klinger, *Flucht Trost Revolte*.

49. Jürgen Habermas, 'The unfinished project of Modernity', in Hal Foster (ed.), *The Anti-Aesthetic: Essays on Post-Modern Culture* (Seattle: Bay Press, 1983), p. 10; see also Klinger's model of correlation, *Flucht Trost Revolte*, p. 33.

4. LETTERS AS WORKS OF ART
Beuys and James Lee Byars*
VIOLA MICHELY

JAMES LEE BYARS WROTE to Joseph Beuys from the early 1970s onwards. In all, 151 letters and envelopes from the American artist entered the van der Grinten collection at Museum Schloss Moyland. Most of the letters can be dated to the period 1977–1982. They reflect upon artistic creativity and the attempt to avoid its opponent, namely depression that leads to death (of art?). As the correspondence continued, its content increasingly focused on the confrontation with death. James Lee Byars sent an equal number or more letters to others, male and female alike: curators, gallery owners, collectors and friends. Restlessly present at every major art event, he met with an entire series of artists. But Joseph Beuys is the only artist, the only colleague, to whom he wrote continuously. This is significant, since Byars did not lack contact with fellow artists.[1]

James Lee Byars' letters are effusive, exuberant, and works of art. Their extreme fragility, as well as their unusual wealth of materials, forms and inventiveness, are spellbinding. Byars wrote on any material he could think of – from precious Japanese or Chinese paper, colourful silk papers, glossy and gold papers, papyrus and leaves, to whatever was at hand, airline or hotel notepaper, even kitchen tissue or toilet paper. Glued together in long strips, the papers usually produce a special shape: a snake, a heart, a human figure or putto, a tower, a torpedo, a flag, or an airplane. Often consisting of a whole stack of cut paper upon which a single sentence, word or single letter has been written, the letters can be reassembled over and over again. Sometimes

the meter-long letters contain a single word or exclamation that comes into view only after a long, patient process of unfolding. The inside of the letters often harbour surprises in the form of scattered pigments, seeds or gold dust. Larger than life, they captivate beholders and immerse them in golden, pink, yellow, red, white or black visual sensations. One must carefully unfold in order to reach the text, which usually is without periods or commas and has the same tone as the paper, often shimmering with gold through the stars on all of the corners and edges of the letters. The cryptic language, abbreviations, formulas and allusions allow for various plays on meaning. Beuys' interpretation of these letters has not been conveyed to us, since no letters from Beuys to Byars exist. While Beuys never wrote back, this did not deter Byars from continuing his stream of letters.

There is something hermetic about setting up genealogies. Nevertheless, artists and art critics necessarily refer to current discourse. Female artists and art critics also need to refer to their predecessors if they wish to advance culture. Whether they refer to their female predecessors, thus establishing a female genealogy, or whether they refer to a more traditional canon of (male) predecessors, they automatically place themselves in opposition to predominant assumptions. Statements and assumptions must be examined, and the question regarding the nature of the modern must be redefined. In this sense, art history should not be content to point to genealogies, but in a precise manner examine the relationships between artists, as well as elements outside any genealogy, either for or against modernity. One hundred years later, Baudelaire's words strike at the core of James Lee Byars' art with astonishing precision.[2] From the early 1970s onward, James Lee Byars never failed to attend major art events, be it the Documenta in Kassel, the Biennale in Venice, or other major exhibitions that attempted to seismographically record contemporary trends. He would appear cloaked in velvet and silk or glittery material, wholly immersed in red, pink, white, black or gold. He was invariably seen on a high perch, tiny and alone on top of the skyscrapers in the big cities. From his vantage point, the tiny figures in a concrete desert were those he attempted to enchant with miniscule scraps of abbreviated words, scraps of poetry, sighs on paper, a golden megaphone held to his lips.

As he wandered through cities, he had to keep moving since he was without a permanent address, studio, community, or base. His flighty, vagabond-like behaviour increasingly served a single goal: the search for suitable material for his staged productions. His settings consisted of shining white marble or gilt steel. Byars directed light and space around the objects in a way that made their materiality appear to dissolve. He occasionally set the stage for a moment of extreme brevity – a gesture, a smile, a kiss. He allowed no materialized form to transport the ideas created in his performances.

In public and private, the artist's garments generally revealed his desire to avoid the appearance of an individual persona. Byars sought to cast off the physical limits of his body through the brevity of his presence and style of dress. This desire drove him deeper into art. He staged his own death, and even looked for a suitable tombstone. He imagined himself at rest within the stone. He descended into the sphere of death in order to re-emerge as the manifestation of the future on earth, as the inscription on one envelope reveals: 'I am from the future.' James Lee Byars' modernism lies in his discovery of his own inconspicuous and revolutionary category, in which he could work. Letter-writing, day in, day out, is the actual artistic legacy of James Lee Byars. No other artist attributed such a lofty and radical status to the letter. The letter as the organ of communication in the artist's hand served the Fluxus and Mail Art movements of the late 1960s and 1970s, during the revolt against the autonomous work of art, remote from life and embodied by the museum institution. But James Lee Byars wrote personal letters with a paradoxical character inherent to this form of writing. The letter possesses an objective existence that is unable to guarantee any secrecy.[3] And yet by invoking the secrecy of correspondence with each letter, the artist bound his friend to the common cause of art: living in the contact that it conveyed, and living in the future as well. What was the future (of art) that Byars sought to seal in these letters to Beuys?

Letters and diaries are always a good source for satisfying hunger for biographical details. The letters of James Lee Byars, however, offer few such details. Sometimes one seems to learn more about Beuys' habits than those of the letter writer. Is it possible that Byars chose Beuys as an alter ego? Beuys, like

Byars, was often in the public eye, albeit in a very different way. The contact between the two was not purely private, but it was conducted between one public person and another. It would be inadequate and unsatisfying to view the letters from an exclusively biographical standpoint. Throughout the letters, the desire to establish contact with an audience and its attendant problems are obvious. How can the public be reached? What audience is sought, and where? Is the audience loved? Should it be challenged? And how can this connection with the audience be maintained?

Since I am using the letters as point of departure, it is initially possible to clearly answer these questions, but only as far as Byars is concerned. For this reason, I will now focus on two photographs of the addressee and the writer for their informational value regarding each artist's understanding of self and the audience (Figs. 4.1 and 4.2).[4] Both taken in 1972, the life-sized portrait-photographs were displayed for the duration of the Documenta 5 exhibition in an underpass of a Kassel train station, together with photographs of other artists who participated in the exhibition *Individual Mythologies* in the Museum Fridericianum.[5]

4.1. James Lee Byars, Documenta Archiv, Kassel; Photo: Heyne, Neusüss, Pfaffe.

James Lee Byars is completely enveloped in a white suit. He is wearing a white hat with a wide brim and a dark band that outwardly marks a division between his hair and unseen face because the artist has turned his back on the viewer. His long, dark brown hair blends into the dark background, and his hands remain shadowed. He does not reveal a single inch of skin. The viewer must return to the clothing, the white colour of the suit and the stark relief of the hat against the dark background. It is a soft, flowing, smooth material – probably silk. The hat, too, has a soft contour and a round form that

apparently funnels downwards. The material seems to be equally delicate, soft and elegant, and it is probably fine wool rather than common felt. The hat spontaneously conjures mental images of the last century, the arrival of stagecoach passengers with scant luggage and an air of elegance in a desolate region – perhaps the Wild West with dusty streets and log-cabin saloons. What is this stranger doing here? Is this the latest fashion in a distant metropolis? Or has he come from another time? With a stance that is straight as an arrow (one might also say stock-straight), heels together and immobile, Byars simply stands there and apparently wants nothing from his audience. But it is not only the clothing that betrays a secret elegance and curious discretion; a slight upward turn in the positions of his head is perceptible, and tenses his backbone. Does this peculiar pose result from the black blindfold invariably worn by the artist? Does he have to raise his head like a cheating Pin-the-Tail-on-the-Donkey player? The body recedes; it is passive and inactive; the posture becomes the focus. It bespeaks a tense and even excited state, prepared for astonishment and accompanied by joyous calls. What is he looking at? Can the public hope for a secret revelation, which he blindly allows to be suspected?

Beuys faces the viewer head-on. He has a balking, almost unwilling air. The pose is tense. He is unable to find a certain lasting pose. His right arm hangs down awkwardly and the left hand seeks protection in the pocket of his pants. Every facet of this portrayal communicates that Beuys is an activist who has been summoned here in order to represent and remind others of the common cause. He stands motionless, but a fighting spirit is palpable. His eyes are piercing and his gaze incites, as if to say,

4.2. Joseph Beuys, Documenta Archiv, Kassel; Photo: Heyne, Neusüss, Pfaffe; © 2006 Artists Rights Society (ARS), New York/ VG Bild-Kunst, Bonn.

'This concerns you!' Accordingly, his torso is bent slightly and menacingly forward; Beuys obstinately blocks the path of the passer-by. The situation becomes uncomfortable, they are roused to prepare for immediate action to do what is necessary, be it a counter-gesture or to go along with him. The watch signals that there is a date to be kept to take action, and thus there is a consideration of time. The clothing is part of the worker's persona. These are work clothes, which are rugged, without any special colour or decoration and made of natural materials. The jeans are practical and contemporary, and they do not hinder his stride. Sturdy shoes serve his long march; the short jacket has space to stow away a few utensils. Everything seems to be subject to the potential threat of combative movement. But how does the hat fit into this picture of militant pragmatism? From the major revolts against the monarchies in Europe onward (since the early beginnings of the modern period, according to Baudelaire), the felt hat, also called the *Demokratenhut* ('Democrat's hat'), has been symbolic. Somewhat later, in 1907, the reformers cried, 'Off with their hats.'[6] But Beuys has donned the hat again, tenaciously wearing the trademark of the modern revolutionary. It is the cry of a citizen who makes use of democracy and wants to use it and seize it with the audience.

Byars and Beuys not only take different, even opposing, attitudes towards the public, but their clothing also contributes to a specific impression of their personalities.[7] Both artists use the material of their clothing to serve their purpose. It is calculated to achieve an effect, and subjected to the desire to achieve this. The material character of their clothing is also reflected in their works. With Byars, these noble materials are created in a manner that they conceal references to the working process and corporeality. They leave a sustained colour-induced impression of atmospheric concentration and of heightened attention directed towards the heavens. If one thinks of James Lee Byars' appearances in his gold lamé suits, he seems to outshine his own corporeality, thus sublimating it.

With Beuys, it is the material of felt and a certain down-to-earth, worker-like common sense that contributes to the tone of his persona, and sometimes resonantes with equipment such as the pump in *Honigpumpe am Arbeitsplatz* ('Honey Pump at the Workplace') made for Documenta, or the implements of a

sculptor's workshop in *Hirschdenkmaler + Wurst-Lehm Werkstatt* ('Deer Monuments and Sausage-Clay Workshop') shown at the Berlin exhibition *Zeitgeist* ('Spirit of the Times'). Thus, not only the works of each artist can be cited here but also their clothing and the attitudes they take in public. They represent two extreme positions of contemporary art and two differing types of artist: celestial interpreter and worker. Astonishingly, they came from similar environments and, in the final analysis, were motivated by the same goal of social change. The presentation *Individuelle Mythologien* ('Individual Mythologies') at Documenta 5 attests to this question of the role of art in society. It was resplendently printed on a banner on the tympanum of the Museum Fridericianum: '*Kunst ist überflüssig*' ('art is superfluous'). And Byars appeared here, sheathed in red tulle and elevated into the realm of the muses that stood behind him, *Calling German Names* to his audience below.[8]

Meanwhile Beuys spent one hundred days in his *Bureau for Direct Democracy* and gave an account of what it all meant. What Byars and Beuys called into question was the role of the artist, so exposed and separated from society and yet so demonstratively present, if only for the sake of others.[9] The different ways they presented themselves and their relationships to the public are striking. It is precisely this difference that makes it plausible to hypothesize that Byars chose Beuys as his alter ego. Beuys' talent for public speaking and for establishing direct contact with people was deeply admired by Byars,[10] as is evidenced in a letter: 'Teach me how you get such good publicity and I get none [sic].'

Finally, Joseph Beuys embodied a prototype of the teacher, the academic, the social reformer.[11] Roundtable discussions were part of his artistic concept. The blackboards that were inscribed with the results of these discussions and the discussion protocols became works of art; the discussion itself became an art form of self-portrayal. Teaching at the academy and direct communication with students were important components of his artistic practice. Byars, in contrast, only held one public lecture.[12] He did not seek direct contact and open discourse. Instead, he looked for indirect contact, so his public speaking appearances were conducted from a considerable distance, through a golden megaphone, or in a whisper.[13]

A celestial bird of gigantic proportions in the form of a dive-bomber (Stuka), made of black silk paper with gold, has survived from the early days of this epistolary contact. The shape of Byars' letter is a reference to Beuys' airplane crash during World War II. Byars noted, 'don't get scared, you don't have to fly it.' The remark might also be an ironic jab at Beuys' willingness to divulge biographical details, which was something Byars always refused in interviews. But the letter also reflects Byars as an individual who is determined to conquer and who matches Beuys' ardor in a mutual campaign for art for a new society but who fights with wholly different means. For the 1974 exhibition *Art into Society/Society into Art* at the Institute of Contemporary Arts in London, Beuys discussed, developed and documented on blackboards. Byars sent a silk paper measuring 354 x 554 cm which had been written upon, folded, wrinkled and wadded into an envelope measuring 30 x 40 cm.

Byars first arrived in Europe in 1969, with several pink silk outfits in his suitcase. His interactive actions had attracted attention in New York.[14] They were the beginning of his pilgrimage with a pink airplane – a gigantic reproduction of an airplane as a silk dress for one hundred people, who each took their 'seat' by sticking their head through one of a hundred holes. The artist's directions stipulated that they should all inhale simultaneously and imagine that they were taking off.[15] He visited Beuys and performed *The Pink Silk Airplane for 100 People* outside of the Düsseldorf Academy, where Beuys and his students were barred at the time (Fig. 4.3). The pink airplane unfurled its wings, ready for a transfer to a Byarsian utopia. The passengers were invited to 'board' and set off on a journey from which they would return changed. As tokens of this transformation, each passenger received a cut out section of the silk airplane.[16] This was the first of many meetings between Byars and Beuys. In London, Beuys formulated *Richtkräfte* ('Directional Forces') on blackboards. On one board, Beuys noted, 'and tomorrow I'll do it with my friend James Lee Byars.'

With the foundation of the *Organization for Direct Democracy by Referendum* ('Free People's Initiative') in 1971 and of the society for the promotion of the *Free International University for Creativity and Interdisciplinary Research* two years later, Beuys presented his ideas for teaching and cultivating artistic and

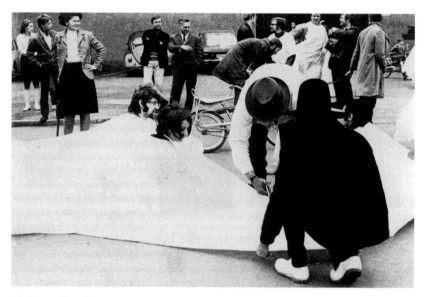

4.3. James Lee Byars and Joseph Beuys with *The Pink Silk Airplane*, Düsseldorf 1969; Photo: Katharina Sieverding.

political responsibility in society to a broad public. He called into question the limiting narrowness of academia and formal art education and, as an artist, he discussed political questions outside the realm of the academy and museum. At Documenta 5 in 1972, Beuys set up the *Office for Direct Democracy* in the Museum Fridericianum. He made himself available for discussion with Documenta visitors for the duration of the 100-day exhibition. Likewise, Byars was present for the same duration. He called out to his audience from the roof of the Museum Fridericianum, a monument to Friedrich II, to the square outside the museum, or to an elm tree in the Auepark. He dispatched telegrams to all heads of state and urged them to perceive art as a socio-political power and participate in it.[17]

Documenta became a symbol of the utopian potential of art, which could be effective in societal change and in many other fields. For one hundred days, according to a notion expressed in Byars' letters to Beuys, all powers and energies would culminate there and combine internationally to form a great force. Particularly with the next Documenta in mind, Byars sought to win Beuys over to his views and to encourage him to also use Documenta as a place for art with the potential of

exercising socio-political power. Byars took an active interest in the appointment of the various Documenta directors and their policies for art selection. He repeatedly criticized the staunch Euro-American perspective and the limitations it imposed on artists from elsewhere in the world. Though his involvement at Documenta 5 included spectacular appearances rather than works, Byars showed restraint at Documenta 6 and took part, tellingly, only by letter. Prior to Documenta 7, he was plagued with worry that it could turn into a typical commercial exhibition. With his performance entitled *The 5 Continent Documenta 7*, Byars pleaded for a global, revolutionary art event. He sent a large number of black silk papers in the form of the digit '7' to Beuys in various sizes, with and without text.[18] Beuys was to hang the small, blank 7s everywhere in Düsseldorf as a work in the spirit of Documenta with the following instruction: 'Put these little 7s up all over Düsseldorf at night with just a touch of spit or a very wet kiss.' Byars had carried out the action *The 5 Continent Documenta 7* in several different cities in 1979 in a similar manner. In a ritualistic ceremony, a wet sponge was used to temporarily attach a large black silk-paper '7' to a wall printed with the title of the action. Byars also campaigned in Venice for a Documenta 7 that would be open to the world. As late as 1985, Byars continued to promote Beuys as candidate for the directorship of Documenta 8: 'I've asked the Lord mayor of Kassel to change the rules again and make you even from bed D8s chief do D8 [sic].'

The Venice Biennale was the other international art venue where Byars and Beuys met regularly. Here, too, Byars' art was more often represented with ephemeral works than monumental installations, actions and performances. In 1975, he opened the Biennale with a performance entitled *The Holy Ghost on Piazza di San Marco*. Assisted by passers-by, a large piece of white silk in the form of a giant human figure was spread out and held up. The letters reveal that Byars felt attracted to Beuys' more ephemeral but no less effective works, those which were not work-like in nature. In a commentary on a work entitled *Tramstop* that Beuys had carried out for the German Pavilion one year after *The Holy Ghost*, which had necessitated, among other things, drilling down to the ground water, Byars wrote, 'Lov'd your Venice hole!' Byars valued Beuys' work for its social-reform potential, and he

was accordingly enthused by the works that moved beyond the temples of art, such as Beuys' contribution to Documenta, *7,000 Oaks*. He tried to talk Beuys into bringing them to New York: '1. I sit in N.Y.C. in a very huge sweat. 2. I await yr. extra trees.' At the beginning of their epistolary contact, Byars gave Beuys contact addresses for the further building of the FIU in Santa Barbara. In return, Beuys was to help him found the Museum of the Perfects in Germany in a few years, as stated in another letter.

A collaborative work was produced in 1980: a graphics portfolio entitled *Framenti Veneziani* for which each artist contributed five sheets. Byars and Beuys refer to each other ironically in their drawings; the sequence has the appearance of a personal correspondence. In the middle of one graphic by Joseph Beuys, the names 'BeuYs' and 'BYars' appear against a black background, wherein the 'Y' common to both names is the main compositional element.[19]

Byars begins his graphics series with the words 'Joseph Beuys teaches James Lee Byars english [sic] in Venice.'[20] This strange twisting of the facts also occurs in a letter to Beuys: 'How's your 'TH' coming.' There appears to be an ironic undertone, an ambivalence, to all of his proclamations of admiration, which further indicates Byars' understanding of Beuys as an alter-ego. Another letter reveals: 'you should hire me as your American guide … as your consciousness ornament.' In several letters, Byars describes himself as Beuys' ghost. These are the nuanced expressions of an artist who, no more convinced than his addressee, wants to show Beuys another path; he therefore appeals to his conscience, guides him as a shadow and ornament, and accompanies him with criticism and praise. Byars' relationship to Beuys is complex. He loves him because they share the same goals, but has no intention of following the same path. He admires the fact that Beuys lives out the aspects of Byars' self that he loathes and suppresses. In his experience of Beuys as an alter ego with its own positive and negative aspects, the inspiration Byars receives from Beuys is positive but at the same time encourages him to do exactly the opposite.

The same contrast can be seen in the works, whose disparate character becomes clear, particularly in their respective contributions to the Venice Biennale in 1980. For the special retrospective exhibition *L'arte degli anni 70*, Byars conceived a

several-meter-long flag made of pink silk, a material he had used frequently in the first half of the 1970s. The work, entitled *The New National Flag for Italy (The Social Flag)*, was to be displayed in a glass cabinet. The artist's directions for the installation contained a supplementary instruction: 'Imitate it.'[21] Originality was to be avoided, and the audience was called upon to tailor a flag following Byars' description. Since the flag Byars devised considerably exceeded the size of a normal glass cabinet, the artist decided to present it on the Piazza di San Marco. There, he paraded it aloft on a pole, and the continuously changing path of his march resulted from his blindfolded eyes. Byars' contribution proposed a new heraldic emblem for Italy, the exhibition's host country, which possessed a spark of poetry and a slightly more silky sheen. It was also an ironic allusion to the nation-oriented structure of the Biennale.

Beuys showed his installation *The Capital Space 1970–77*, featuring thirty objects and fifty blackboards from his previous works.[22] The objects – equipment, tools and instruments of audiovisual media – point to his performances on the one hand and to his self-perception as a sculptor on the other. The blackboards date back to discussions connected with Documenta exhibitions of 1972 and 1977. All of the objects lie desolately within the space, waiting to be used and carried forward. Accordingly, Beuys called it a monument to work on the future. Neither artist presented finished works of art in a traditional sense. But in a gesture of ironic potential, Byars suggested that an atmosphere of a rosy, if ephemeral, utopia would be possible. On the other hand, Beuys created a workroom with a self-pronounced imperative. Notwithstanding the level of sensitivity the work displays in staging objects as transitory and usable, the monumental and a memorial-like aspect of the work predominates in a way that was possibly misunderstood as a self-staging. Byars, in contrast, stood motionless in front of an old lectern in the room that also accommodated Beuys' installation.[23] Wearing pink silk from head to toe, he distributed small slips of pink paper with the command: 'Be Quiet.' Byars sent this command to Beuys glued to a life-sized pink piece of paper. Byars followed up on this silent but eloquent gesture in a letter which unequivocally called upon Beuys to be silent. It was his first major criticism of his alter ego. For Byars, the close

observation of Beuys was a way of maintaining a critical view of his own actions in art. Each letter was also a reminder to Beuys that an alternative to Beuys' chosen method of speech existed in the path of being quiet, of silence, of not speaking, of the unspeakable in art.

The artists' contact was, however, not confined to public meetings at colloquia, exhibitions and major art events. In addition to the collaboratively issued graphics portfolio, the artists carried out two performances together. In a seemingly spontaneous performance during the opening of the 1983 exhibition *To the happy few: the Reiner Speck Collection* at the Haus Lange in Krefeld, Byars and Beuys each reclined on a slab of black marble that Byars had placed there as part of the exhibition (Fig. 4.4). They enacted a moment of coming closer to each other in this act of lying down. Taken by surprise, Beuys seemed somewhat overwhelmed by the situation. He laughed, talked and sought to establish contact with Byars, a task which was by no means easy since Byars was dressed completely in black and had masked his entire face in black silk, effectively covering his eyes, mouth and ears. He looked as though he was disappearing

4.4. James Lee Byars and Joseph Beuys at the opening of the Speck collection, Haus Lange, Krefeld 1983; Photo: Benjamin Katz; © 2006 Artists Rights Society (ARS), New York/VG Bild-Kunst, Bonn.

into the black of his own art. The marble slab was first used by Byars in the Kunsthalle Bern in 1978, where it rested upon a white silk pillow and leaned against the wall, as if waiting to find the right location. The golden inscription 'Both', which was obscured by the bodies of the artists, originally referred to the artist and his audience, but in Krefeld it became a concrete reference to Byars and Beuys. Was Byars trying to draw Beuys into the atmosphere of disappearance? This absence, the loss of proximity or unity, is the source of Byars' letter-writing and of the ever-pressing urgency to mingle his works with those of Beuys: 'I'm traveling with "The Planet Sign" Let's show it in your Grand Studio. ... I urge Imitate it [sic].' Furthermore, Byars gave his own performances to Beuys as gifts. They were equally gifts and works for an exhibition, and he urged Beuys to carry them out: 'meanwhile here's The Perfect Love Letter my gift exhib. to you ... write it to the people [sic],' and in another letter: 'Will you be my The Soliloquist on Perfect?' Beuys was expected to assume Byars' role. Given the fact that artists customarily carefully distance themselves from others and pass their work on to posterity as a personal (spiritual) creation, Byars' letters reveal an unusual relationship to his own persona and creations. Is it possible that he was formulating a different ideal for art, one in which both the spiritual and the material flowed freely from one artist to another?

Unlike traditional works of fine art and literature, the letter presupposes a direct addressee and at the same time his or her absence. In 1985, one year before Beuys died, the theme of death entered many letters: 'Don't / I heal you / die / up [sic],' rearranged without the Byarsian jumping of lines, this reads as follows: 'Don't die I heal you up.' Did Byars suspect that Beuys' death was imminent, or does this have to do with his own increasing confrontation with death? Byars spent that summer in Sicily in search of a suitable stone for his tomb. The stone needed to be round and large enough to hold his reposing body.[24] In the quarry at Agrigent he found a sandstone sphere. Unfortunately, it was only slightly larger than one meter in size. In *The Tomb of James Lee Byars* the artist did not create a monumental grave. Its roundness eludes a fixed location. One year before, the artist had staged his own death outside the Philadelphia Art Museum. Dressed entirely in gold, he walked

in a circle, then briefly laid down upon a golden surface, against which he was rendered invisible and therefore became one with the surface. He titled this performance *The Perfect Death of James Lee Byars*. Byars' confrontation with death, closely related to the possibility/impossibility of the creation of art, and to the notion of the life/dissolution of a substantial artwork, culminates in the letters to Beuys with provocative remarks like, 'send me... a Death Telegram [sic],' and 'yr. Last word or Action please [sic]?' Byars also sent a postcard of Pirandello's tomb to Beuys, asking him what he thought of it; he wrote several letters on condolence paper, which he seemed to prefer for conveying birthday greetings.

There are multifaceted reflections on death in the work and life of Beuys – from his life-threatening creative crisis of the 1950s; works such as *Zeige deine Wunde* ('Show your Wound') of 1974–1975; to the *Schmerzraum* ('Pain Room') of 1983 and the installation *Plight* of 1985. A parallel shift from staged performances to installations, monumental in their colour and material totalities, may be witnessed in both artists' work. Yet Byars' continued themes of loss and Beuys' use of themes of pain may be traced throughout phases of their work and in varying forms of their art. The tendency to immerse in the totality of the material as Byars did with his tomb and his perfect performances also took hold of Beuys, as expressed conceptually in his felt suit pieces. In his 1974 performance *I like America and America likes me* in New York, Beuys was completely covered in felt; in *Plight* the entire room was clad in rolls of felt, creating the ambivalent impression of safe warmth on the one hand and the ominous swallowing-up of all human sounds on the other. The ongoing confrontation with death also reveals itself in Beuys' trans-formation of Christian motifs such as the cross, as well as in his tendency to transport substances from their material form into immaterial energy, such as in *Thermisch-plastisches Urmeter*.[25]

Aware that the inevitability of death threatened to destroy Beuys' creative powers, Byars challenged him, constantly placing his finger in the wound and questioning what would ultimately remain. He suggested that Beuys allow him to perform his death or prepare his tomb, or that Beuys do this himself: 'Great Genius Joseph I am sorry you are sick. How sick? Little then be well. Death then let me do your Death. or yr. Tomb or yr. Epitaph? or

are you doing your own? Great Joseph I hope you live forever Love J.L.B. [sic].' To reckon with, perform and sell one's own death or the death of another means to envision it as a work of art; this idea is indicated by Byars in his suggestion in another letter: 'Everyo. likes even better than you buying your Death fro. me that you buy it fro. yrself and give me [sic].' But to whom does death belong? Like the notion of the letter as a work of art, the idea of death as a work of art is contrary to all the customary structures of ownership.

At the opening of the exhibition *Beuys zu Ehren* ('In Honor of Beuys') at the Munich Lenbachhaus in 1986, Byars performed *The Perfect Death in Honor of Joseph Beuys* along the lines of his own death-performance. He appeared on the balcony wearing a golden suit, black top hat and blindfold, lay down on the floor for a short time, got up and departed.[26] The announcement for the performance depicts Byars, once again wearing a golden suit, lying in the quarry in Agrigent. Byars made several attempts to sell this performance as a work and sent out obituaries proclaiming, 'Buy the Perfect Death for Joseph Beuys.' The moment of realizing his stagings – which Byars calls 'a sort of recognition' – is only a fleeting moment of contact between the audience and what is being presented.[27] It is a foreboding moment that is recorded as an ideal in letter form. The letters attest to a loss of unity and to the hope that it may be restored 'as yr Ghost' 'as a Golden Footnote' and as quoted in another letter, 'Let me sell you your Ghost' or 'Now you have 2 hearts.' These letters are to be read, unfolded, smoothened, and deciphered. The wrinkled and porous material they are written on has the tone of vulnerable skin, the dynamic border between one person and another. In James Lee Byars' letters to Joseph Beuys a new kind of art is brought to completion: one that combines one artist's Socratic gift of questioning with the other's Socratic gift of speech.

NOTES

* Excerpt from *James Lee Byars: Letters to Joseph Beuys* (Ostfildern: Stiftung Museum Schloss Moyland, 2000), pp. 10–68.

1. Donald Kuspit, *The Cult of the Avant-Garde Artist* (Cambridge: Cambridge University Press, 1993). Entry into the field of art

sociology does not necessitate a market-oriented interpretation of these artists' self-portrayal in the manner of Donald Kuspit.

2. Charles Baudelaire, 'Der Maler des modernen Lebens' (1863), in H. Schuhmann (ed.) *Charles Baudelaire. Der Künstler und das moderne Leben. Essays, 'Salons,' intime Tagebücher* (Leipzig: 1990), p. 300 (trans. L. Volk): 'So he goes, walks and searches. What is he looking for? Most certainly: this man, such as I have portrayed him, this hermit, so gifted with an active imagination, who always travels through the great *human desert*, pursues a higher goal than pure leisure, a different, more comprehensive goal than the fleeting pleasure of the moment. He is in search of that certain something, which I allow myself to refer to as modernity; ... He is intent on releasing from fashion whatever is poetic from what is historical, and eternal from what is ephemeral.'

3. Georg Simmel, *Soziologie. Untersuchungen über die Formen der Vergesellschaftung* (Frankfurt/Main, 1999), pp. 429–33.

4. These photographs were taken in a project by Neusüss, Heyne, Pfaffe.

5. Documenta V, *Individuelle Mythologien I + II* (Kassel: Documenta GmbH, 1972), section 16, pp. 1–220; on Beuys pp. 91–6; on Byars p. 97.

6. O. Timidior, *Der Hut und seine Geschichte* (Leipzig, 1914), pp. 81 and 93; and Franz-Joachim Verspohl, 'Joseph Beuys – Das ist erst einmal dieser Hut', *Kritische Berichte* 14, no. 4 (1986), p. 77–87.

7. Simmel, pp. 415, 420.

8. This is the title of an action that James Lee Byars carried out from several locations, in which he used a megaphone to call out German names.

9. Simmel, p. 421.

10. This is according to the artist in a conversation with the author in Santa Fe on 10 February 1995.

11. Barbara Lange, *Joseph Beuys – Richtkräfte einer neuen Gesellschaft. Der Mythos vom Künstlers als Gesellschaftsreformer* (Berlin: Reimer, 1999). See Lange's essay in this volume.

12. On 21 April 1970, Byars spoke to students at the Nova Scotia College of Art and Design in Halifax. He did not speak about his own artistic education, nor did he otherwise reveal any biographical details.

13. For example, during the performance *Calling German Names* at Documenta 5 in 1972 or during the performance *Hear the First Totally Interrogative Philosophy around this chair and it knocks you out*, Marian Goodman Gallery, New York, 1977.

14. Viola Michely, 'Stoffliche Entwürfe eines anderen Miteinanders', in *Glück in der Kunst? Das Werk von James Lee Byars* ('Luck in Art? The oeuvre of James Lee Byars') (Berlin: 1999), pp. 142–51. In October 1968, Byars conducted several such interactive performances with silk clothing in the Architectural League in New York. In a newspaper article about Byars' performance week, one visitor commented, 'He looked like a pink pilgrim' *P/A News Report* (November 1968), p. 52.

15. A film by Jef Cornelis gives information about Byars and documents the actions carried out in the Wide White Space Gallery in Antwerp in 1969.

16. This is documented by a series of 51 photographs by Katharina Sieverding. See the exhibition catalogue *James Lee Byars – Letters to Joseph Beuys*, pp. 46–7.

17. His telegram to the German chancellor, sent shortly before Documenta closed on 26 September 1972, ran as follows: 'Great Brandt, it is perfect and logical that a great head of state would visit the world's greatest art show and give great comment? May I invite you to Documenta 5 in Kassel Germany on October 7th or 8th. Sincerely JLB p.s. or your representative or by phone? Byars.' The text to the other heads of state is identical. Archives of the Michael Werner Gallery, Cologne.

18. According to one letter, Byars lobbied the German postal authorities to issue a black stamp for Documenta.

19. Jörg Schellmann, *Joseph Beuys. Die Multiples. Werkverzeichnis der Auflagenobjekte und Druckgraphik 1956–1986* (Munich: Schirmer/Mosel Verlag, 1992), p. 472; pp. 274–5; illus. 339–43. The work is listed in this volume. Only the works of Beuys are reproduced here. For Byars, see Deecke, Thomas and Schraenen, *Guy James Lee Byars, Bücher Editionen Ephemera* (Bremen: 1995), cat. no. 22, no illustrations.

20. This is the first sheet and an alteration of pages by Byars and Beuys follows.

21. La Biennale di Venezia, *Ambiente, partecipazione, struttre culturali* (1980), p. 39; illus. 27.

22. Mario Kramer, *Joseph Beuys. Das Kapital Raum 1970–1977* (Heidelberg: Edition Staeck, 1991).

23. *Bolaffi Arte*, II (1980), p. 100; illus. 16. See also the article in *Süddeutsche Zeitung*, 14/15 (June 1980).

24. Joachim Sartorius, *James Lee Byars, Kunst heute 16* (1996), p. 35. This information was supplied by Byars during the interview.

25. Antje Oltmann, *Joseph Beuys für und wider die Moderne* (Ostfildern: Tertium, 1994), p. 163. This is made clear by Antje Oltmann

who uses the holes which frequently appear in the drawings of Beuys as an example. On this subject see also Antje von Graevenitz's essay in this volume.

26. Armin Zweite, *Beuys zu Ehren* (Munich: Städtische Galerie im Lenbachhaus, 1986), pp. 558–60.

27. Sartorius, p. 30. Byars explained his intentions concerning the posthumous performance of *The Perfect Death in Honor of Joseph Beuys* as follows: 'First, what I did in Munich, calling it the Perfect Death, is an exaggeration and an ideal. Because, of course, I do not know what the perfect death might be. Second: using symbols, I wanted to show that it is possible for a person to die and achieve a sort of recognition again, if he really wants it badly enough. The symbolism of lying down and rising up again shows this. I will leave it up to others to interpret it. I also believe that I wanted to show how much Beuys was surprised by his own death.'

Section II
CRITICS' PERSPECTIVES

5. BEUYS: THE TWILIGHT OF THE IDOL*

Benjamin Buchloh

> The fact that people in Germany deceive themselves concerning Wagner does not surprise me. The reverse would surprise me. The Germans have modeled a Wagner for themselves, whom they can honor: never yet have they been psychologists; they are thankful that they misunderstand. But that people should also deceive themselves concerning Wagner in Paris? Where people are scarcely anything else than psychologists ... How intimately related must Wagner be to the entire decadence of Europe for her not to have felt that he was a decadent. He belongs to it: he is its protagonist, its greatest name ... All that the world needs most today, is combined in the most seductive manner in his art – the three great stimulants of exhuasted people: brutality, artificiality and innocence (idiocy) ... *Wagner est une névrose.*
>
> *Friedrich Nietzsche,* The Case of Wagner[1]

DURING THESE DAYS OF the Guggenheim Museum's Beuys exhibition, one wonders why that most beautiful building, normally beaming with clarity, warmth and light, is dimly lit in a grey and moody twilight. Is this a theatrical trick, to create a setting of 'Northern Romantic' light, meant to obscure? What mental semi-trance are we supposed to enter before we are allowed to embark on wandering down the spiral of *24 Stations* (whose martyrium, whose mysterium)? Perhaps we are prevented from seeing belated automatist drawings on the walls,

pompously framed in chthonic iron, and weathered, withering relics and vestiges of past activities, which might be 'souvenirs of a life of spectacle, poor dead things. Bereft of the confectioner, the life of his art has vanished.'[2]

The presentation of the souvenirs, however, is most elaborate. Enshrined in specifically designed glass and wood cases that look like a cross between vitrines in Victorian museums of ethnography and display cases in turn-of-the-century boarding schools, the objects, or rather their containers, signal to the viewer you are entering interior spaces, the realm of archetypal memories, an historic communion. Ahistoricity, that unconscious or deliberate obliviousness toward the specific conditions that determine the reality of an individual's being and work in historical time, is the functional basis on which public and private mythologies can be erected, presuming that a public exists that craves myths in proportion to its lack of comprehension of historic actuality. The ahistoric mythology of fascism, to give an example from *political* history, could only develop and gain credibility as a response to the chiliastic and debauched hopes of the starving and uneducated masses of the German Weimar Republic and postmonarchic Italy. Veneration for leaders grows out of the experiences of severe deficiency.

The private and public mythology of Joseph Beuys, to give an example from art history, could only be developed and maintained on the ahistoricity of aesthetic production and consumption in post-war Europe. The substantially retarded comprehension of European Dada and Russian Constructivism, and their political as well as their epistemological implications, determined both European and American art up until the late 1950s and served for both producers and recipients as a basis for mythifying subsequent aesthetic work. Once put into their proper historic context, these works would lose their mystery and seemingly metaphysical origin and could be judged more appropriately for their actual formal and material, that is, historical, achievements within the situation and the specific point of development of the discourse into which they insert themselves.

The public myth of Beuys' life and work, by now having achieved proportions that make any attempt to question it or to put it into historic perspective an almost impossible critical task, is a result of these conditions, just as it tries to perpetuate

them by obscuring historical fact. This very attitude, however, of making the artist a cult figure, historicizes Beuys and aligns him with representatives of his own generation in Europe during the 1950s who were equally grand masters of the public spectacle: figures like Yves Klein and Georges Mathieu. No other artist (with the possible exception of Andy Warhol, who certainly generated a totally different kind of myth) managed – and probably never intended – to puzzle and scandalize his primarily bourgeois audience to the extent that he would become a figure of worship. No other artist also tried and succeeded so systematically in aligning himself at a given time with aesthetic and political currents, absorbing them into his myth and work and thereby neutralizing and aestheticizing them. Everybody who was seriously involved in radical student politics during the 1960s in Germany, for example, and who worked on the development of a new and adequate political theory and practice, laughed at or derided Beuys' public-relations move to found the Grand Student Party, which was supposed to return an air of radicality to the master who was coming of aesthetic age. Nobody who understands any contemporary science, politics or aesthetics, for that matter, could want to see in Beuys' proposal for an integration of art, science and politics – as his programme for the Free International University demands – anything more than simple-minded Utopian drivel lacking elementary political and educational practicality.

Beuys' existential and ideological followers and admirers, as opposed to his bourgeois collectors and speculators, are blindfolded like cultists by their leader's charisma. As usual with charisma, this seems to be nothing but a psychic interaction between hyperactive unconscious processes at the edge of sanity and the zombie-like existence of supposed normality in which individuation has been totally extinguished, so it seems perfectly necessary to become a 'follower' of whomever seems to be alive. Ernst Bloch, the German philosopher, when talking about Beuys' philosophical master Rudolf Steiner, gives an exact description of those processes that constitute the mythical figure and the cult, and this portrayal seems to describe Beuys word-for-word:

> It is not surprising to meet peculiar dreamers. They are sufficiently disrupted to be open [to] unconditioned

experiences. [The dreamer] tends to remove frontiers of everyday life so that it can cover the unusual with the ordinary, and vice versa. The divided self accumulates a feeling of sin whose power seems almost forgotten and unfathomable. The internalized super-ego, the pride and certainty of mimic messiah that those characters develop, would never be attained by any normal being, even in states of highest mental exaltation. No false Demetrius would maintain himself for long, but a false Jesus among madmen will do well … The occult journalist Rudolf Steiner established himself at the top of the 'Cognition of Higher Worlds,' a particularly odd case. A mediocre, but unsupportable oddity, yet efficient … as though some rotten druids were chatting on newsprint-paper.[3]

As for Beuys, the cult and the myth seem to have become inseparable from the work, and as his confusion of art and life is a deliberate programmatic position, an 'integration' to be achieved by everybody, it seems appropriate to take a critical look at some aspects of Beuys' private 'myth of origin' before looking at the actual work.

Beuys' most spectacular biographic fable convenue, the plane crash in the Crimea, which supposedly brought him into contact with Tartars, has never been questioned, even though it seems as contrived as it is dramatic. The photographic evidence, produced by Beuys, to give credibility to his 'myth of origin,' turns against itself: in Adriani's Beuys monograph (until the Guggenheim catalogue the most comprehensive documentation of Beuys' life and work, and published in cooperation with the artist),[4] we see Beuys standing beside a JU 87 that is in fairly good shape and flat on the ground. The caption reads: 'Joseph Beuys after a forced landing in the Crimea in 1943'.[5] The accompanying text reads:

During the capture of the plane over an enemy anti-aircraft site, Beuys was hit by Russian gunfire. He succeeded in bringing his plane behind German lines, only to have the altimeter fail during a sudden snowstorm, consequently the plane could no longer function properly. Tartars discovered Beuys in total

wilderness in the bottleneck area of the Crimea, in the wreckage of the JU 87, and they cared for Beuys, who was unconscious, most of the time, for about eight days, until a German search commando effected his transport to a military hospital.[6]

In Caroline Tisdall's Guggenheim catalogue[7] we are presented with three totally different photographs showing a severely damaged and tipped-over plane that under no circumstances can be identical to the one given in Adriani's book. Beuys' own recollection (or updated version of the fable convenue in Tisdall's book) reads as follows:

> Had it not been for the Tartars I would not be alive today ... Yet it was they who discovered me in the snow after the crash, when the German search parties had given up. I was still unconscious then and only came round completely after twelve days or so, and by then I was back in a German field hospital ... The last thing I remember was that it was too late to jump, too late for the parachute to open. That must have been a couple of seconds before hitting the ground ... My friend was strapped in and he was atomized by the impact – there was almost nothing to be found of him afterwards. But I must have shot through the windscreen as it flew back at the same speed as the plane hit the ground and that saved me, although I had bad skull and jaw injuries. Then the tail flipped over and I was completely buried in the snow. That's how the Tartars found me days later. I remember voices saying *voda* (water), then the felt of their tents and the dense pungent smell of cheese, fat and milk. They covered my body in fat to help it regenerate warmth, and wrapped it in felt as an insulator to keep the warmth in.[8]

Who would, or could, pose for photographs after the plane crash, when severely injured? And who took the photographs? The Tartars with their fat-and-felt camera?

Beuys' 'myth of origin', like every other individual or collective myth, is an intricate mixture of facts and memory

material rearranged according to the dynamics of the neurotic lie: that myth-creating impulse that cannot accept, for various reasons, the facticity of the individual's autobiographic history as such (a typical example would be the fantasy, more common in the beginning of this century, that a person believes he is the illegitimate child of an alien nobleman, not the simple progeny of a factory worker). As in every retro-projective fantasy, such a narcissistic and slightly pathetic distortion (either dramatization or ennobling) of the factually normal conditions (made either more traumatic or more heroic) of the individual's coming into the world, the story told by the myth's author reveals truths, but they are different from what their author would want them to be. Beuys' story of the messianic bomber pilot, turned plastic artist, rising out of the ashes and shambles of his plane crashed in Siberia, reborn, nurtured and healed by the Tartars with fat and felt, does not necessarily tell us and convince us about the transcendental impact of his artistic work (which is the manifest intention of the fable). What the myth does tell us, however, is how an artist, whose work developed in the middle and late 1950s, and whose intellectual and aesthetic formation must have occurred somehow in the proceeding decade, tries to come to terms with the period of history marked by German fascism and the war resulting from it, destroying and annihilating cultural memory and continuity for almost two decades and causing a rupture in history that left mental blocks and blanks and severe psychic scars on everybody living in this period and the generations following it. Beuys' individual myth is an attempt to come to terms with those blocks and scars. When he quotes the Tartars as saying 'Du nix njemcky [you are not German], they would say, "du Tartar" and try to persuade me to join their clan ...'[9] it is fairly evident that the myth is trying to deny his participation in the German war and his citizenship. But of course, the repressed returns with ever-increasing strength, and the very negation of Beuys' origin in a historic period of German fascism affirms every aspect of his work as being totally dependent on, and deriving from, that period. Here lies, one has also to admit, certainly one of the strongest features of the work, its historic authenticity (formally, materially, morphologically). Hardly ever have the characteristic and peculiar traits of the anal-retentive character, which forms the characterological basis of

authoritarian fascism (inasmuch as these features once specific to the German petit bourgeois have by now become dangerously universal), been more acutely and accurately concretized and incorporated into an act of the post-war period.

In the work and public myth of Beuys, the new German spirit of the post-war period finds its new identity by pardoning and reconciling itself prematurely with its own reminiscences of a responsibility for one of the most cruel and devastating forms of collective political madness that history has known. As much as Richard Wagner's work anticipated and celebrated these collective regressions into Germanic mythology and Teutonic stupor in the realm of music, before they became the actual reality and the nightmare that set out to destroy Europe (what Karl Kraus had anticipated more accurately as the *Last Days of Mankind*), it would be possible to see in Beuys' work the absurd aftermath of that nightmare, a grotesque coda acted out by a perfidious trickster. Speculators in Beuys' work did well: he was bound to become a national hero of the first order, having reinstalled and restored that sense – however deranged – of a national self and historic identity.

Beuys' obsession with fat, wax, felt and a particularly obvious kind of brown paint that at times covers objects totally and at others is used as a liquid for painting and drawing on paper and other materials, and his compulsive interest in accumulating and combining quantities of rejected dusty old objects of the kind that one finds in rural cellars and stables, are imbued with metaphysical meaning by the artist, and his eager exegetes: they could just as easily be read in psychoanalytic terms, and perhaps more convincingly so (which, again, would by no means disqualify the work). Obviously Beuys himself consciously implements materials and forms that have a strong suggestive and associative quality of anality as a particular aspect of the infantile stages of instinct development: 'I placed it [the fat] on a chair to emphasize this, since here the chair represents a kind of human anatomy, the area of digestive and excretive warmth processes, sexual organs and interesting chemical change, relating psychologically to will power. In German, the joke compounded as a pun since "Stuhl" (chair) is also the polite way of saying "shit" (stool), and that too is a used and mineralized material with chaotic character, reflected in the cross section of fat.'[10]

But an outspoken affirmation of one's compulsive inclinations does not necessarily transform or dissolve them, either in one's behavior or in work and object production. Let us quote from a popularized comprehensive study of psychoanalytic theory, published in 1945, when Beuys, aged twenty-four, could easily have started to familiarize himself with recent psychological theories:

> If an adult person still has sexual excitability connected with the execretory functions (either with those of his object or autoerotically with his own) he clearly shows that his sexuality is on an infantile level. But in these uses too, the regression serves as a defense against genital wishes, not only in a general way as in any compulsion neurotic but also in a more specific way, the coprophilic fantasies regularly representing attempts to deny the danger of castration … The stressed anality expresses the wish to have sexual pleasure without being reminded of the difference of the sexes, which would mobilize castration fear.[11]

But Beuys, in his general contempt for the specific knowledge of contemporary sciences and in his ridiculous presumptuousness about the idea of a universal synthesis of sciences and art, as late as 1966 phrased his disdain for psychoanalysis in a polemic against the German psychoanalyst Alexander Mitscherlich by calling the discipline 'bad shit' ('schlechter Mist').[12] Apparently he follows the archaic and infantile principle that as long as you do not acknowledge the existence of things in reality that seem to threaten your ideas, they will not concern or affect you.

Functional structures of meaning in art, as in other sign systems, are intricately bound into their historical context. Only inasmuch as they are dynamic and permanently changing their field and form of meaning do they remain functional, initiating cognitive processes. Otherwise they simply become conventions of meaning or clichés. As such, they do, of course, follow different purposes, becoming the object of historically and socially latent interests contradictory to the author's original aims when trying to develop a meaningful sign. Obviously it is possible to ignore or reject the basic scientific steps that

have been taken in twentieth-century science, such as Freudian psychoanalysis or de Saussure's linguistic and semiotic concepts (to give only the two most prominent examples that Beuys rejects). Obviously it is also possible to ignore or reject the crucial epistemological changes that have occurred in one's own field of discourse, for example the consequences of Duchamp's work for art in the second half of the twentieth century. But again, such infantile behavior, hiding one's eyes and ignoring and negating phenomena that seems to threaten one's existence in order to make them disappear, is of very limited success; it successfully limits the comprehension of an adult person. By simply making a hypothetical (and obscure) statement like 'The silence of Marcel Duchamp is overrated' (1964),[13] the theoretical position of Duchamp and the lasting impact of his work are simply not even understood and, therefore, are not at all rebutted. This misconception and ignorance is evident in Beuys' own comment on the statement:

> This statement on Duchamp is highly ambivalent. It contains a criticism of Duchamp's Anti-art concept and equally of the cult of his later behaviour ... Apart from that Duchamp had expressed a very negative opinion of the Fluxus artists claiming that they had no new ideas since he had anticipated it all ... Most prominent, though, is the disapproval of Duchamp's Anti-art concept.[14]

Just as structures of meaning are permanently altered, so also the forms, objects and materials of meaning change within that dynamic process. The designation of a given, industrially produced, readymade object and its introduction and integration into artistic context were viable and relevant primarily as epistemological reflections and decisions within the formal discourse of post-Cubist painting and sculpture. Within this context the 'meaning' of these objects is established, and here they fulfill their 'function': they change the state of a formal language according to given historical conditions. Only later, when the original steps become conventionalized, imitated, interpreted, received, misunderstood – as in most Surrealist and Neo-Dada object art, do they enter that field of projective crisscrosses of

individual meaning. Only then do they acquire psychological, emotional, metaphysical meaning, and finally they are imbued with myth and magic. Unlike his European peers from the late 1950s – Piero Manzoni, Arman or even Yves Klein – Beuys does not change the state of the object within the discourse itself. Quite to the contrary, he dilutes and dissolves the conceptual precision of Duchamp's readymade by reintegrating the object into the most traditional and naive context of representation of meaning, the idealist metaphor: this object stands for that idea, and that idea is represented in this object. Beuys has often affirmed this himself, obviously intrigued by Duchamp but not understanding him, and therefore, not coming to historical terms with him either; as, for example, when talking about his *Bathtub*, 1960: 'But it would be wrong to interpret the *Bathtub* as a kind of self-reflection. Nor does it have anything to do with the concept of the readymade: quite the opposite, *since here the stress is on the meaning of the object* [my italics]. It relates to the reality of being born in such an area and in such circumstances'; [15] or, when talking about his *Fat Chair*, 1964: 'The presence of the chair has nothing to do with Duchamp's Readymades, or his combination of a stool with a bicycle wheel, although they share the same initial impact as humorous objects.'[16]

The more an aesthetic decision, a formal or material procedure, is removed from its functional historical context – which, in the system of art is first of all the aesthetic discourse itself – the more the work will be in demand for meaning; it will depend on its generation of projective meaning and will be susceptible to it. The very suggestiveness, the highly associative potential and quasi magic attraction that Beuys' work seems to exert on many followers and his public, paradoxically enough, results precisely from that state of obsolescence that his works maintain within the discourse of art itself. It seems that the more removed the aesthetic discourse is from the cognitive process, the more the necessity and claim for 'meaning' develop. Visual ideology (commercial movies and television, advertising and product propaganda) immerses its viewers in 'meaning' as much as the discourses of religion and neurosis do: to the extent that literally everything within these belief systems is 'meaningful,' reaffirming the individual's ties to such systems, the actual capacities of individual development are repressed. Beuys keeps

insisting on the fact that his art-object and dramatic performance activities have 'metaphysical' meaning, transcending their actual visual concretion and material appearance within their proper discourse. He quite outspokenly refers to the anti-historic, religious experience as a major source and focus for his art production: 'This is the concept of art that carries within itself the revolutionizing not only of the historic bourgeois concept of knowledge (materialism, positivism) but also of religious activity.' Notably, he does not even attempt to qualify his understanding of 'religious activity' in historical terms, which would seem obvious, since Feuerbach, Marx and Freud have differentiated it in a fairly relevant manner that hardly allows for a simplistic concept of 'religious activity.' Again it seems inevitable to quote from Nietzsche's poignant analysis of Wagner's aesthetic position, discovering an amazing congruence with that of Beuys:

> As a matter of fact, his whole life long he [Wagner] did nothing but repeat one proposition: that his music did not mean music alone. But something more! Something immeasurably more! ... Music can never be anything else than a 'means': this was his theory; but above all it was the only practice that lay open to him. No musician however thinks in this way. Wagner was in need of literature, in order to persuade the whole world to take his music seriously, profoundly, because it meant an infinity of things.[17]

Precisely because of Beuys' attitudes toward the functions and constructions of meaning in linguistic and visual signs, and his seemingly radical ahistoricity (which is a maneuver to disguise his eclecticism), his work is different from that of some of his European colleagues as well as his American contemporaries. This becomes particularly evident in a comparison of works that seem to be connected by striking morphological similarities: Beuys' *Fat Corner*, 1960–1963(?) and *Felt Corner*, 1963–1964(?), with Robert Morris's *Corner Piece*, 1964, and Richard Serra's *Lead Antimony*, 1969; Beuys' *Fat up to this Level*, 1971, with Bruce Nauman's *Concrete Tape Recorder*, 1968, and Beuys' *Iron Chest*, 1968; Beuys' *Site*, 1967, with Carl Andre's *12 Pieces of Steel*

(exhibited in Düsseldorf in 1967).[18] In many instances it seems adequate to speculate about priorities of formal 'invention' in these works that seem structurally comparable, as Beuys certainly commands an amazing integration and absorption of principles of formal organization that have been developed in a totally different context, changing them with his private meaning system so that, in fact, they no longer seem comparable in any way. In other cases, such as Beuys' *Rubberized Box*, 1957, and *Fat Chair*, 1964, there simply can be no doubt about Beuys' original vision in introducing into a sculptural discourse issues that became crucial years later in Minimal and post-Minimal art. If we compare Beuys' *Fat Corner*, 1960(?), with Richard Serra's *Splash Piece*, 1968, we discover a comparable concern for the dissolution of a traditional object/construct-oriented conception of sculpture in favor of a more process-bound and architectural understanding of sculptural production and perception. On the other hand, one tends to overestimate Beuys' originality and inventiveness if one forgets about his eclectic selection of historic information and influences absorbed from Futurism, Russian Constructivism, Dada and Surrealism, as well as their American and European successors in Happening and Fluxus activities, plus the Nouveaux Réalistes.

The very beginning of modernist sculpture is marked by a mixture of heterogeneous materials within the sculptural unit: Degas's *Little Dancer of Fourteen*, 1876, assembles wax, cloth and wood. And Medardo Rosso's wax-over-plaster sculptures, which were supposed to 'blend with the unity of the world that surrounded them,'[19] should be remembered when Beuys talks about the universally process-oriented nature of sculpture. Rosso's use of beeswax as a sculptural material that can maintain two aggregate states, liquid and solid, has a particularly strong process quality, thanks also to the precision with which it records modelling processes. Further, Beuys' sense for the specific nature of sculptural materials and the wide variety of materials that can be introduced into sculpture, was most obviously informed by the Italian Futurists, who did acknowledge Rosso as one of their precursors. We should recall Boccioni's 'Manifesto of Futurist Sculpture' (1912): 'We claim that even twenty different materials can be used in a single work to achieve sculptural emotion. Let us mention only a few: glass, wood, cardboard, horsehair, leather,

cloth, mirrors, electric light, etc., etc.'[20] Moreover, the sculptural discovery of that crucial point in space, where two planes meet at an angle of ninety degrees, thus constituting a most elementary evidence of spatial volume and, one could argue, a point of transition between sculptural space and architectural space, finds its first clear demarcation in twentieth-century art in Tatlin's *Cubo-Futurist Corner Counter-Reliefs*, 1915, and the explicit use of an inserted triangle shape in Tatlin's and Yakulov's decoration of the Café Pittoresque in Moscow in 1917. Beuys, whenever he might have placed his first triangle into a corner – whether fat or felt – has to be seen as much in that perspective as with respect to Morris's *Corner Piece* and Serra's *Splash Piece*.

That other great German artist who was an eclectic of the first order, and equally knew how to conceal and to transform his sources to the point of almost total unrecognizability, Kurt Schwitters – and who is certainly, within German art history of the twentieth century, the focal point of Beuys' references[21] – was equally aware of Italian Futurist notions in sculpture, as well as Russian Cubo-Futurist works. By joining the innovative sense of sculptural materiality of the former with the idea of sculptural expansion into architectural dimensions of the latter, and by merging them with his peculiar brand of German Dadaism, he conceived the Merzbau environment. This *Gesamtkunstwerk*, which included live guinea pigs as well as collected bottles of urine by his friends, was obviously a structure that attempted to define sculpture as an all-encompassing activity, including even everyday life in the aesthetic creation. Beuys' definition of 'sculpture as an evolutionary process, everyone as an artist,'[22] has its visual/plastic roots here as much as it paraphrases Lautréamont's proto-surrealist dictum 'Poetry must be made by all.'

Beuys' problematic attempt to revitalize Dada and Surrealist positions becomes apparent within the concrete materiality and the formal organization of the sculptural work itself. Precisely because of its claims for universal solutions and global validity, the work does not achieve the acuity and impact of some of the seemingly comparable sculptures mentioned above. The historic precision and function within (as it seems) the limits of a formalist tradition and of work growing out of it, such as Serra's, Nauman's or Andre's, is lacking in Beuys' works altogether.

Their opulent nebulousness of meaning and their adherence to a conventional understanding of meaning, makes the visual experience of Beuys' work profoundly dissatisfying. His work does not initiate cognitive changes, but reaffirms a conservative position of literary belief systems. The same would become evident in a comparison of Beuys' work with sculptural works done in the late 1950s and early 1960s in Europe. Arman's *Le Plein*, 1960, which filled a gallery space with two truckloads of garbage (expanding Arman's sculptural procedure of 'poubelles' – garbage accumulations), still strikes us today as a vital and consequential work (and more complex in its ramifications) exactly because of its self-imposed restriction to function within the discourse of art, first of all. The same is true of Stanley Brouwn's proposal to declare all shoe shops of Amsterdam as his exhibition (in 1960), or for every single work of Piero Manzoni's since 1958. Too bad for Beuys, but it seems that after all Gustave Flaubert was correct when predicting: 'The more that art develops, the more scientific it must be, just as science will become aesthetic.'

Aesthetic as well as political truths are concrete phenomena. They manifest themselves in specific reflections and acts, hardly in grandiose gesticulations and global speculations. Beuys' supposedly radical position, as in so many aspects of his activities, is primarily marked by his compulsive self-exposure as the messianic artist (think, for example, of his preposterous offer at a women's liberation gathering in New York: 'What can I do for You?'). When called upon in particular commitments within the art world, which is, after all, the prime and final sphere of his operations, he shows an astonishing reluctance to commit himself to anything that might harm his good standing with the existing power structure of cultural institutions.

When, for instance, in 1971, the Guggenheim Museum censored and closed down the show of Hans Haacke, firing its curator Edward Fry, an impressive list of signatures by artists and critics was circulated afterward to support Haacke, a proof of international solidarity and a public condemnation of the oppressive politics of the Guggenheim's director, Thomas Messer. Beuys never signed. Shortly afterward, an international group show, *Amsterdam-Paris-Düsseldorf*, was installed at the Guggenheim. A Belgian artist, the late Marcel Broodthaers, then living and working in Düsseldorf, withdrew his contribution

from the show (his work had been originally dedicated to Daniel Buren, whose work had been equally censored at the Guggenheim's international exhibition in the preceding year) to protest the treatment of Haacke's and Fry's work, and published an open letter to Joseph Beuys in a Düsseldorf newspaper. The letter, disguised as a found letter by the German-French composer Jacques Offenbach addressing Richard Wagner, reads as follows:

> Your essay 'Art and Revolution' discusses magic ... politics ... the politics of magic? Of beauty or of ugliness? ... Messiah ... I can hardly go along with that contention of yours, and at my rate I wish to register my disagreement if you allow a definition of art to include one of politics ... and magic ... But is not the enthusiasm that His Majesty displays for you motivated by a political choice as well? What ends do you serve, Wagner? Why? How? Miserable artists that we are.[23]

The aesthetic conservatism of Beuys is logically complemented by his politically retrograde, not to say reactionary, attitudes. Both are inscribed into a seemingly progressive and radical humanitarian programme of aesthetic and social evolution. The abstract universality of Beuys' vision has its equivalent in the privatistic and deeply subjectivist nature of his actual work. Any attempt on his side to join the two aspects results in curious sectarianism. The roots of Beuys' dilemma lie in the misconception that politics could become a matter of aesthetics, as he repeats frequently: 'real future political intentions must be artistic'; or, more outrageously:

> How I actually bring it as theory to the totalized concept of art, which means everything. The totalized concept of art, that is the principle that I wanted to express with this material, which in the end refers to everything, to all forms in the world. And not only to artistic forms, but also to social forms or legal forms or economic forms ... All questions of man can be only a question of form, and that is the totalized concept of art.

– or, finally, in explicit terms of crypto-fascist Futurism:

I would say that the concept of politics must be eliminated as quickly as possible and must be replaced by the capability of form of human art. *I do not want to carry art into politics, but make politics into art.*[24]

The Futurist heritage has not only shaped Beuys' sculptural thoughts, but even more so, it seems, his political ideas fulfill the criteria of the totalitarian in art just as they were propounded by Italian Futurism on the eve of European Fascism. It seems that Walter Benjamin's most over-quoted essay has still not been understood by all. It ends as follows:

Fiat ars-pereat mundus, says Fascism, and, as Marinetti admits, expects war to supply the artistic gratification of a sense perception that has been changed by technology … Mankind has reached such a degree of self-alienation that it can experience its own destruction as an aesthetic pleasure of the first order. This is the situation of politics which fascism is rendering aesthetic. Communism responds by politicizing art.

NOTES

* *Artforum* (January 1980): pp. 35–40.

1. Friedrich Nietzsche, *The Case of Wagner*, in Oscar Levy (ed.), *The Complete Works of Friedrich Nietzsche* (New York: 1909), pp. 12–14. The idea of seeing Joseph Beuys in the tradition of Richard Wagner was proposed by the late Marcel Broodthaers in his public letter to Joseph Beuys, Düsseldorf, October 3, 1972. Published in book form later as *Magie – Art et Politique* by Marcel Broodthaers (Paris, 1973).

2. This is the way Dore Ashton described her impressions of Yves Klein's work on the occasion of his first retrospective show in New York, 1967, in 'Art as Spectacle', *Arts Magazine* (March 1967), p. 44.

3. Ernst Bloch, 'Das Prinzip Hoffnung', in his *Collected Work* (Frankfurt: 1959), Chapter 53, pp. 1393 ff. (author's translation).

4. Adriani Goetz, et al., *Joseph Beuys: Life and Works* (New York: Barron's, 1979).

5. Goetz, p. 15.

6. Goetz, p. 16.

7. Caroline Tisdall, *Joseph Beuys* (New York: Guggenheim Museum, 1979), p. 17.

8. Tisdall, p. 16.

9. Tisdall, p. 16.

10. Tisdall, p. 72.

11. Otto Fenichel, *The Psychoanalytic Theory of Neurosis* (New York, 1945), p. 349.

12. Joseph Beuys, *Catalogue Sigmar Polke* (Berlin, 1966), p. 2.

13. Tisdall, p. 92.

14. Tisdall, p. 92.

15. Tisdall, p. 10.

16. Tisdall, p. 72.

17. Nietzsche, *The Case of Wagner*, p. 30.

18. As in the fable convenue, the dates of Beuys' crucial works at times seem a little dubious and again the information given by Beuys himself is contradictory. In Adriani's book, Beuys is quoted as follows: 'The titles are not original; many of them were given later, because exhibitors and buyers felt the need to name these works.' On the evening at the Zwirner Gallery (on the occasion of a lecture by Allan Kaprow, Cologne, 1963) fat actually made its first appearance in the form of a carton of lard (see Adriani, p. 96). Caroline Tisdall mentions in regard to *Fat Chair*, 1964: '*Fat Chair* appeared at the same time as the first *Fat Corners*.' On the following pages of the same catalogue, however, these works, *Fat Chair* and *Filter Fat Corner* are dated 1960 and 1962 (see Tisdall, pp. 72–5). The very same *Filter Fat Corner* is dated 1963 in Adriani's monograph (see p. 102). The *Felt Corner* is dated 1953 on p. 75 of the Guggenheim catalogue and dated 1964 on p. 125 of the same catalogue, in a slightly different photograph of the same installation. Caroline Tisdall's information on Beuys' work seems unreliable in other regards as well. On p. 271, for example, we are made to believe that Beuys swept up Karl Marx Platz in East Berlin, May Day, 1972. Obviously it would be quite spectacular and courageous to perform such an activity under the conditions of the rigid police control of the regime in East Berlin, particularly during the official May Day celebrations of the Communist Party. Unfortunately (or fortunately), however, Beuys did perform his little act in West Berlin, where nobody cares about harmless artistic jokes and where you can express 'solidarity with the revolutionary principles through the bright red broom...' (Tisdall, p. 271) at any given time.

19. Margaret Scolari-Barr, *Mendardo Rosso* (New York, 1966), p. 21.

20. Umberto Boccioni, 'Manifesto of Futurist Sculpture' (1912), in Umbro Appollonio (ed.), *Futuristische Manifeste* (Cologne, 1965), p. 72.

21. Again in Germany the drawings of Kurt Schwitters would be the key reference for Beuys' drawings. In the drawings around 1919, Schwitters combined the expressionistic drawing with the mechanomorphic 'drawing' elements: his rubber stamp impressions that enter abruptly into the seemingly lyrical lines of the drawings. The rubber stamp image as a counterbalance to the scriptural expressionist line figures frequently and prominently in Beuys' drawings.

22. Tisdall, p. 7.

23. Marcel Broodthaers, p. 11ff.

24. Adriani, pp. 227 and 238.

6. DISCONTINUOUS NOTES ON AND AFTER A MEETING OF CRITICS, BY ONE OF THE ARTISTS PRESENT*

Vera Frenkel

Part VI: The Question of Charisma 1: Hoax
A digression to the plane crash? I love the plane crash.[1]

TO UNDERSTAND WHAT THE Postmodernism conference means, we have to pay attention to a notable silence. There was no serious reference in the Montreal discussions to the work of Joseph Beuys. A clue to this silence is available in an article by Benjamin Buchloh called, 'Beuys: The Twilight of the Idol', which appeared in *Artforum* in January 1980.

In a serious effort to demystify Beuys' life and work Buchloh rightly addressed the issue of charisma. Beuys' relation with his public is, as is usual with charisma, he says, 'nothing but a psychic interaction between hyperactive unconscious processes at the edge of sanity and the zombie-like existence of supposed normality in which individuation has been totally extinguished, so it seems perfectly necessary to become a "follower" of whomever seems to be alive.' There is a note of contempt here for people lost in a charismatic collusion: they are 'zombie-like', their individuation extinguished, their 'supposed normality' fitting them to be only blind followers.

Toronto analyst Irvine Schiffer discusses the charismatic relation as a phenomenon founded on projection: 'the psychic process whereby the individual perceives his own psychological machinations as originating from outside himself.'[2] Projection is the mechanism by which we attribute to an Other, especially a leader, entertainer, or artist, the secret urges within ourselves which we deny.

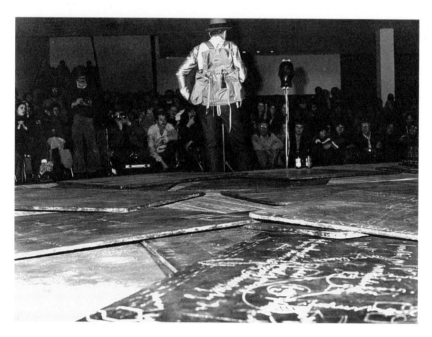

6.1. Joseph Beuys (c.1981), Photograph by Wolfgang Isle; © 2006 Artists Rights Society (ARS), New York/VG Bild-Kunst, Bonn. Photograph courtesy of Vera Frenkel.

Although not stated explicitly at the conference or in Buchloh's critique of Beuys, the issue of mutual projection, or, more accurately, the wish to escape it, is central to understanding what Postmodernism represents. In the case of Beuys and his 'followers' no one has escaped anything. Beuys is effective in his fiction of the self which Buchloh finds so annoying (the airplane crash, the rescue by Tartars, the not really being German, etc.) and in his emblem of the self (vest, shirt, hat). It remains to be seen, however, whether this invention of Beuys by Beuys which is now being used against him hasn't been useful for its demonstration of the techniques of myth-making.

Buchloh's contribution to clarifying these mechanisms is valuable. My one objection is that this important analysis is presented by him as if he has been personally misled, even betrayed, by Beuys' efforts, and is somehow implicated by the impact on others of what may indeed be a grand hoax.

We know how annoying it is to watch complicated collusions, any of the helpless alliances in which people persist in being duped; love affairs, election strategies, art and audience relations.

But we also know that one of the key components of charismatic power is precisely the hoax factor. 'Hoax is one of the least understood elements in human behavior, but it has a place in the fabric of charisma. It would seem to follow that we who demand such acting, such theatricals, such elements of hoax from our political leaders must be equally endowed with at least a sprinkling of hoax.'[3] Buchloh, in his polarizing discussion of Beuys and his work, has reaffirmed one of its chief powers, the charisma of hoax.

Another commentary on Beuys which has served the purpose of raising questions is in the form of a series of performances by Clive Robertson. In the one I saw in 1978, *Explaining Pictures to Dead Air*, Robertson enacting the persona and aspects of the work of Beuys alerted viewers to processes of media co-option, of Beuys, of them, by Beuys. The work was a fine instance of performance as critique, raising questions about the motives of all concerned; Robertson, the media, Beuys and us. It is a succinct method of appraisal.

Part VII: The Question of Charisma 2: Undoing the Mechanism

Hitlers are bred by slaves.[4]

Benjamin Buchloh discusses Beuys and his fans as the relation of a disrupted personality and a public whose hopes are debauched, 'a public ... which craves myths in proportion to its lack of comprehension of historic actuality.' Underlying this statement is a confidence that an awareness of 'historicity' and 'facticity' will itself protect us from malign charismatic collusions. His article is itself an effort at providing such protection; stating facts, pointing out contradictions, revising contexts.

That Beuys uses the same mechanisms as his supposed enemies, and that he has invented a myth of himself akin to other saviour myths (resembling, interestingly, Jerzy Grotowski's[5] account of his own beginnings, a story which includes also a rebirth), is worth pointing out. But the clever, self-mythified Beuys draws a following of those who already have the tendency to project their needs into and empower an exemplary Other. It is a grave optimism which holds out the hope that this particular public can part with the powerful charisma of hoax by which it feels expressed, and become constructively committed to important social change.

Believers in the rescue fantasy are candidates for demagoguery of any kind. They need their miracle maker, their talking puppet. Evidence of this need outrages and frightens all of us (even those among us who want to be the puppets in charge; being more afraid than others of being controlled). Beuys is not to be seen as a complete cynic, however. His admirers are not utterly passive victims of his coprophilic charms. Theirs is a working relation and the key to it is denial; of troubling aspects of the world, the body, the self. Certainly a denial of the Germanness which permitted the Holocaust, denying which guarantees remaining in thrall to its habits of mind and body. Yet, however gruesome this is, one cannot see it clearly if one is busy looking for culprits.

It is just possible that Beuys' work represents the need to find another way. With the help of the 'ahistoricity' to which Buchloh objects, Beuys allows others to project on him the attributes of benign leader, a sort of counter-Führer who makes the shit visible as opposed to endorsing the pathological cleanliness of the Nazi torture and murder machine; a kind of promise of redemption through transgression of the diaper. The use of people's need of others as containers for the impulses of the forbidden self is not Beuys' method alone, and it's certainly not peculiar to multidisciplinary performance work; on the contrary. Nor is it a problem to be solved by information on the one hand, or outraged denunciation on the other, though both may be useful, but by looking clearly at and living with the terror of what it has been possible for humans to do.

'It is nauseating and unbearable to recall what was done and spoken, but one must. In the Gestapo cellars, stenographers took down carefully the noises of fear and agony wrenched, burned or beaten out of the human voice,' wrote George Steiner in a controversial article about post-war Germany, drawing to our attention how language itself, the vehicle of our humanness, can be undone when facts are denied.[6] 'Everything forgets', he wrote, 'but not a language. When it has been injected with falsehood, only the most drastic truth can clean it. Instead, the post-war history of the German language has been one of dissimulation and deliberate forgetting.'[7]

The error in Beuys' work, and that which differentiates it from the climate of work which is being called Postmodernist, is that it purports to represent a version of escape for us from a generic

Germanness (called by Virginia Woolf in 1940 'subconscious Hitlerism'[8] and by Hans-Jürgen Syberberg 'the Hitler-in-us' in his 1979 film, *Our Hitler*) which we share. Beuys and his fans suffer from the same charismatic longing (with Beuys as thing, emblem, puppet and master) that brought about the mass trauma that corrodes us.

The silence about Beuys at the Montreal conference struck me, however, as a fashionable silence. Beuys is out, it seems, his 1980 show and catalogue the crowning part of a hagiographical enterprise which he has initiated and grooms with skill. I think there's far too much holier-than-thou-ness about the current reappraisal, which actually prevents us from seeing what's going on with some detachment. The story of the 'rescued' reborn un-German, the embodiment of exile in his own land, as an invention of perhaps the best-known performance artist in the West is not irrelevant to the subject we met to discuss.

What this has to do with Postmodernism in art is this: while the roots of modern mass trauma are in Germany, its branches reach everywhere. The field of work called Postmodernist, its themes, emblems, props, strategies and purposes is, in its peculiar mix of rage, humour, confusion and staged distances from the culture which is its passionately chosen subject, working to absorb and express some of the shock. Postmodernism subverts the charismatic relation, and works towards a non-charismatic understanding which permits us not to believe so readily in the Other as the keeper of our treasures or our disease. A core mechanism is being undone, its most important feature the refusal to deny. Bruce Barber came close to this point in his statement at the conference, 'The "post" of Postmodernism is the "post" of denial ... "post" denotes the past; a cleansing or denial, but "post" to what?' We don't know, he shrugged.

Denial, mystification, silence are techniques for maintaining a person (or a culture) in a double-bind. Immediate pain is masked only to guarantee a greater one. Denial, mystification, silence are part of the recipe for inducing schizophrenia through certain manipulations of language and gesture.[9] The pain which is denied infiltrates everything. Steiner again: 'Languages have great reserves of life. They can absorb masses of hysteria, illiteracy, cheapness ... but there comes a breaking point – something of the lies and sadism will settle in the marrow of the language.'

This is part of our inheritance. What happened in Nazi Germany actually happened. Nazi Germany is also a metaphor for mass hysteria and totalitarianism carried to their dreadful end point. With its language so split from sense by Nazi uses, Germany couldn't cope, couldn't manage to grieve, did a big cover-up, so we're stuck with the job. Beuys gets credit for doing his best, or that best of which charisma is capable. But it's not surprising that in our music, dance, narrative, in our multidisciplinarity, in fact, some form of 'de-occidentalization', a move away from depending on charisma, is at work. What else, after all, is this work with animal sound and movement on the one hand (Meredith Monk, Joan La Barbera, Robert Wilson's work with deaf and autistic children, Simone Forti, Alvin Lucier), and with mechanisms of projection on the other (Elizabeth Chitty, Laurie Anderson, Tom Sherman, Tom Graff), within an art community of consciously invented selves, but an effort to exorcise a collective Hitlerism and our terror of it, and to start, somehow, again.

NOTES

* Excerpts from a ten-part response to 'Multidisciplinary Aspects of Performance: Postmodernism', the conference organized at the University of Québec, Montréal, 9–11 October 1980, by Chantal Pontbriand, editor of *Parachute*, philosopher Jean Papineau and curator Bruce Ferguson, in *artscanada* 240–241 (March–April 1981), 28–41.

1. Rosalind Krauss, 'Joseph Beuys at the Guggenheim', *October* 12 (Spring 1980), 8.

2. Irvine Schiffer, *Charisma: A Psychoanalytical Look at Mass Society* (Toronto: University of Toronto Press, 1973), p. xvi.

3. Schiffer, p. 49.

4. Virginia Woolf, 'Thoughts on Peace in an Air Raid' (1940), in *The Death of the Moth and Other Essays* (New York: Penguin Books, 1969).

5. Co-founder with Ludwig Flaszen of the Polish Lab Theater.

6. George Steiner, 'The Hollow Miracle' (1959), in *Language and Silence. Essays on Language, Literature and the Inhuman* (New York: Atheneum, 1977), p. 99.

7. Steiner, p. 108.

8. 'We must help the young Englishmen to root out from themselves the love of medals and decorations. We must create

more honourable activities for those who try to conquer in themselves their fighting instinct, their subconscious Hitlerism.' Virginia Woolf, 'Thoughts on Peace in an Air Raid'.

9. Gregory Bateson, 'Towards a Theory of Schizophrenia', in *Steps to an Ecology of Mind* (Chicago: University of Chicago Press, 2000), pp. 201–27; originally published by Chandler Pub. Co., San Francisco, 1972).

7. JOSEPH BEUYS, OR THE LAST OF THE PROLETARIANS*

Thierry de Duve

> Milton produced *Paradise Lost* for the same reason a silkworm produces silk. It was an activity of his nature.
>
> *Karl Marx,* Capital, *Book IV*

> If the silkworm were to spin in order to provide for its existence as a caterpillar, it would be a perfect wage-worker.
>
> *Karl Marx,* Wage-Labour and Capital

OVERCOME BY AN ILLNESS that took hold of him – like a statue – by the feet, Joseph Beuys died on 21 January 1986, having installed in the Capodimonte Museum in Naples what should be seen as more than just his last exhibition; it was his testament. On the walls were seven gold-leafed monochromes, measuring the height of a man and asymmetrically arranged: four on the right-hand wall, one on the far wall, two on the wall at the left. Within the room stood two cases or, rather, glass caskets – one displaced to a position near the left-hand wall, the other right in the middle. The first contained the pathetic implements of a transient or bum, these arranged in a vaguely anthropomorphic manner: a backpack serving as 'head'; two bronze canes, one rolled in felt, doubling as 'arms'; two rolls of fat and a roll of copper bound with twine standing for 'chest'; and a slab of lard for 'legs'. Alongside this dismembered body ran a bronze crutch to which were attached two large electrical clamps. There lay the artist as vagabond, encumbered with his meagre supplies and limping down the road to exile. Oedipus at Colonnus.

In the central casket the portrait was more composed, tragic, majestic. Oedipus Rex. A cast head (the same that topped the *Strassenbahnhaltestelle* at the 1982 Venice Biennale), its mouth agape as for a last death-cry, protruded from a great coat made of hare skin and lined in blue silk, at the feet of which was set the conch shell of a hoped-for rebirth. Two cymbals (used in the performance *Titus/Iphigenia)* stood in at the place where, in the other coffin, the electric clamps with their supporting crutch were located. There lay the artist as tragic monarch, clad in the regalia of his office. The installation was, moreover, titled *Palazzo Regale.*[1]

It is as vain to try to choose between the two images of himself the artist wished to bequeath us as it would be mistaken to think that they map a trajectory from the marginality of Beuys' beginnings to the triumph of his end, as if retracing his career. Like the faces of Janus, the two *gisants* are inseparable. And they are mutually indispensible for understanding what Beuys, throughout his life as an artist, wished to incarnate. The ruler and the tramp, the king and his fool, form but one of the bicephalic avatars of the artist. There are many others of them that also show, on the one hand, his indefatigable evangelism, his political combativeness, his pedagogical joy, his revolutionary or evolutionary optimism, his propensity to take the role of leader; and, on the other hand, his mystical archaism, his high sense of the pathetic in constant oscillation between farce and tragedy, his tendency to play the victim, his empathy for all the anomic and sacrificial figures of humanity. That of Christ – victim and redeemer – is at the crossing of a double series of identifications: chief and child, priest and scapegoat, shepherd and coyote, stag and hare, composer and thalidomide baby, social reformer and rebel, legislator and outlaw, statesman and prisoner, mediator and recluse, orator and deaf-mute, prophet and buffoon, professor and student, shaman and sham, utopianist of the future and embalmer of the past.[2]

The ritual, obsessional, and quasi-exhaustive character of this list of the roles he either assumed or impersonated (lacking – and this is significant – only those of factory worker and prostitute) sets up echoes between Beuys' work and an already extensive litany of similar identifications, all of them allegorical, of the condition of the artist within modernity, and all of them leading

directly – more than a century distant – to a mythical country peopled with all the romantic incarnations of the excluded as bearers of social truth. The name of this country – where strollers and dandies cross paths with peddlers and ragpickers; where art students and medical students thumb their noses at philistines; where the sins of the streetwalker are redeemed by the love of a young poet; where humanity is more humane in the brothel than in the church or palace; where the underworld is the true aristocracy, tuberculosis the pardon for syphilis, and talent the only riches – the name of this country that rings with all the cries of injustice and where the only one radically denied a visa is the bourgeois, the name of this country is of course bohemia. It is a literary and imaginary country where, in a deformed image at once tragic and ideal, there was dreamed a humanity to replace the real humankind that peopled the Europe of the nineteenth century, and that industrial capitalism had pitilessly set against itself by dividing it into two new antagonistic classes, the bourgeoisie and the proletariat. Doubtlessly, the real name of bohemia or at least, the name of its correlate within the actual world, is the lumpen proletariat: a no man's land into which there fell a certain number of people incapable of finding a place within the new social divisions – expropriated farmers, out-of-work craftsmen, penniless aristocrats, country girls forced into prostitution. Dickens and Zola have described this dark fringe of industrialization, these shady interstices of urbanization. Like Baudelaire, Hugo and many other novelists who hardly professed naturalism, they also poured their inspiration into it, and contributed to the fabrication of the image of this marginal lumpen proletariat society transposed into bohemia. Bohemia functions all the more as the figure of a humanity of replacement in that it is a suffering humanity, such that nothing but true human values – liberty, justice, compassion – can survive there, and such that it contains the seeds of a promise of reconciliation. To the denizens of bohemia, to Daumier, Degas, Toulouse-Lautrec, to the Picasso of the Rose and Blue Periods, to Rouault and many others, there were presented the faces of Don Quixote and Scapin, of laundresses and opera dancers, of dwarfs and nightclub singers, of saltimbanques and harlequins, the face of Mary Magdalene and that of Christ. It is to this gallery of portraits that Beuys adds his own, it is this gallery that he

recapitulates and brings full circle, and which he reconnects – perhaps unwittingly – to its conditions of emergence. All these portraits show the artist as bohemian, the incarnation of suffering humanity and of the just man of the future. All are portraits of the artist as a proletarian.

The proletarian – a term that transcodes *the bohemian* as a social type that excludes *the bourgeois* but includes all the rest of humanity suffering from industrial capitalism – is not (or not necessarily) a member of the proletariat, that is, the working class. Of this latter, the myth of bohemia offers a displaced and transposed image; it creates of a transnational reality an imaginary land, a quasi-nation, without real territorial frontiers, peopled with nomads and gypsies, unreal, like Jarry's Poland. The worker himself is rarely an inhabitant. The image of bohemia, one could say, is ideological to the extent that it occults the reality that it is precisely charged with transposing: the massive proletarianization of all the men and women who did not belong to the bourgeoisie. But *the proletarian* is a construction no less ideological – or mythical – of the same personage or social type that *the bohemian* expresses in the discourse of art and of literature. Simply, it expresses it in the discourse of political economy, that of Marx, and even more specifically, of the young Marx.

What, then, is a proletarian for Marx? He is someone – no matter who – who finds himself to have everything to lose from the capitalist regime and everything to gain from its overthrow. Everything to lose – which is to say, his very humanity – and everything to gain – this same humanity. The proletarian is, then, from the outset of industrial capitalism, a figure torn from the future horizon of his own disappearance. He is literally the prototype of the universal man of the future, the anticipated type of the free and autonomous man, of the emancipated man, of the man who will have fully realized his human essence. According to Marx, two things define man ontologically: he is a productive and a social being. He is also a historical being. But as historical changes are only conceivable against the ground of an invariant substrate, the history of men can be nothing but the growth of productive forces and the progress of the relations of production. For Marx only conceives of man as *homo faber*: labour – the faculty of producing – is what makes him man, and the consciousness he

has of it is the import of his humanity. It transforms the simple biological belonging to the human species into consciousness of participating in humankind, and thus makes of all products of labour the privileged place of collective living. This is why the social relation is the essence of the individual as *Gattungswesen* (species-being), and why, in turn, all social relations are, in the last instance, reduced to relations of production. These latter will only be free and autonomous with the advent of the classless and stateless society, the communist society of which the proletariat is the avant-garde. In the meantime, the class struggle will be the order, since the proletariat is exploited and alienated by the capitalist regime to which it is subjected, or, to put it another way, since *the proletarian,* dispossessed of his human essence by social relations of production which admit of nothing but the regime of private property, still needs to reappropriate it through struggle.

Even while already being, in anticipation, the type or prototype of man-in-general, the proletarian suffers under the yoke of capitalism from being exploited and alienated. Exploitation, which consists in the fact that surplus value is extracted from the unpaid labour time that the worker is constrained to offer to the owner of the means of production who employs him, is a damage he sustains, a damage which a regrouping of the working forces – as in unionization – could make amends for or lessen, to a certain degree. But alienation is not a damage that can be made up for; it is a wrong that must be righted.[3] It derives from the nature of the transaction between wageworker and employer meeting on the capitalist labour market, as if each were in possession of a ware in which the other is interested, in order to proceed to their exchange. The capitalist offers a salary and the worker his labour power. Now labour power – *Arbeitskraft* or *Arbeitsvermögen* – is, par excellence, that which defines or will define man as productive and social being, universal man in his essence. To have to sell his *being* as if it were a property one *has* is precisely what alienates *homo faber* and makes the worker into a *proletarian.* All languages distinguish the auxiliary verbs *to be* and *to have;* these are verbs that do not translate one into the other. But this is what the regime of private property pretends to do where it treats labour power as a commodity, 'neither more nor less than sugar', Marx says. Therein rests the irreparable wrong

that Marx calls alienation and that only the abolition of private ownership of the means of production could right.

To say that the proletarian suffers from a confusion between two auxiliary verbs might seem rather light in view of what the working class has had to endure. Marx is much more concrete: it's his life that the worker alienates in selling his labour power to the capitalist; it's his muscular and cerebral force that he cedes to him; his blood that he spills for him; his skin that he wears out; his flesh that he exhausts. But this loss follows from exploitation; it does not involve a change of essence. After all, the salary that his boss pays him allows the worker to reconstitute his lost energies; it is even exactly calculated for a reproduction of his labour power to make up for the expenditure. It is true that the worker wears himself out, but, like everyone else, he is subjected to the irreversible march of time. It is also true that he gives away more time – labour time, that is, sole measure of the value of the commodities he produces – than he receives back in the form of wages, but this is precisely because he is exploited. There is no case for calling that alienation.

In fact, the Hegelian concept of alienation disappears from the writings of Marx after the manuscripts of 1844. As for that of labour power, it does not appear before 1865, in *Wages, Prices, and Profit*. In the first edition of *Wage-Labour and Capital*, which dates from 1849, it is not his labour power that the wageworker sells to the capitalist, but his labour itself. It is only in the posthumous edition of 1891, amended by Engels (who accounts for it in the preface) to take account of the theoretical advances of *Capital*, that labour power takes the place of labour. This replacement is hard to support as such without the concept of alienation. It seems that Marx has rehabilitated if not the concept itself at least the ontological and dialectical sense that it carries and which remains from start to end fundamental to Marxist thought. Without 'alienation', the proletarian as essential protagonist of the class struggle would vanish like a ghost. The 1849 conception was, moreover, more logical and more exact: the measure of exchange value being labour, and the measure of labour being time, it is obviously time that the capitalist treats as commodity and 'measures with the clock, as he measures sugar with a scale'. But once the concept of alienation is abandoned, whether it be his labour or his labour time that the wageworker sells, no wrong

is done him. He suffers the injury that is exploitation, but that is reparable. A better distributive justice could render exploitation tolerable, as has effectively occurred in the western democracies. To justify the revolution and to write the abolition of capitalism onto the political agenda, it is necessary that the wageworker suffer a wrong that affects him in his human essence. If it is his labour power that he sells rather than simply his labour time, then he is forced to part with the very thing that constitutes his humanity. He is alienated in his nature as *homo faber* and suffers a wrong that goes beyond all reparable injuries and damages. Then he is a proletarian and not simply a salaried worker, and the wrong he suffers must be righted for him to reappropriate his essence, his labour power. (The word 'appropriation' betrays the embarrassment of a Marx caught in the trap of his own thought and forced to treat the essence of *homo faber* in theory in the same manner as the capitalist treats it in practice.)[4]

Whether the messianic import was religious, political, or cultural in colouration, an enormous part of modern art and all its utopias have demanded that the wrong done to the proletariat be righted. In thus insisting that the labour power of man-in-general (the individual as *Gattungswesen*) be liberated and 'dis-alienated', the modern utopias postulated that all humans have this power, yet remain dispossessed to the extent, precisely, that they can merely have it, whereas it constitutes them, or will constitute them, in their very being, in their belonging, at once unique and universal, to humankind. It is to the demand that this wrong be righted that modern or avant-garde artists (those at least who fully claimed those titles) have testified, by incarnating *the proletarian*. Obviously what is at stake here has nothing to do with certain ideological alignments by artists with proletarian positions – there are cases, but they remain the exception – and is not in contradiction with the objective economic situation of artists, which is more akin to that of a small entrepreneur than to that of a wageworker. But subjectively speaking the modern artist is the proletarian par excellence, because the regime of private property forces him to place on the art market things which will be treated as commodities, but which, in order to have aesthetic value, must be productions and concretions of the artist's labour power and, if possible, of nothing else. The bourgeois conception of art 'reifies' the work (via the market) on

the one hand and, on the other, judges it (via the aesthetic) for the way that it manifests this faculty of *producing value*, which, in order to be authentic, must be unique to the artist and be valid for all, and thus must have its seat in the very nature of the artist as individual human-in-general.

Marx calls this universal faculty of producing value *labour power*; Beuys calls it *creativity*. Beuys is certainly not the first to give it this name, far from it. He is more like the last to be able to do it with conviction. Beuys' art, his discourse, his attitude, and above all the two faces presented by his persona – the suffering face and the utopian face – constitute the swan song of creativity, the most powerful of the modern myths. Perched on a threshold that he called 'the end of modernity', he was in effect its doorman, but the postmodernity onto which he hoped to open the door was as black as his own death. For this tragic and optimistic Janus is above all pathetic; both his faces are turned backward, towards the modernity that he brings to a close. It could not be otherwise, since that which Beuys promised by creativity is what all of artistic modernity never ceased to promise, to hope for, to invoke as the emancipatory horizon of its achievement. 'Everyone is an artist.' Novalis already said it, long ago. The students of 1968 – in Paris, in California, and gathered around Beuys in Düsseldorf – proclaimed it once again and wrote it on the walls. It had always meant, since the German romantics, 'power to the imagination'. It has never become a reality, at least not in that sense. But all that the nineteenth and twentieth centuries have implied for the will to emancipation and the desire for dis-alienation has always meant: everyone is an artist, but the masses don't have the power to actualize this potential because they are oppressed, alienated, and exploited; only those few, whom we stupidly call professional artists, know that in reality their vocation is to incarnate this unactualized potential. Hence the two faces of modernity, of which it is Beuys' pathetic grandeur to have worn both: the public, revolutionary, and pedagogical face, the one that is convinced that an adequate teaching will liberate creativity; and the secret, insane, and rebellious face, the one that claims that creativity is already of this world precisely there where it lies fallow and in waiting, crude and savage: in the art of madmen, children, and primitives. If he had lived in the Germany of Weimar, Beuys could have been at one and the

same time Gropius and Beckmann, or perhaps a Klee amended by his teacher Lehmbruck.

Clearly, Marx does not slip out of the mythic fabric of modernity; he is even one of the most formidable of its craftsmen. Creativity is to the cultural field what labour power is to the field of political economy. The two fields imbricate throughout the course of modernity, and in all possible manners. With Beuys (this is why the translation attempted here is so easy), the two fields precisely overlap – and this is what signals to us that their dialectic is over. For, during the last decade of his life and work, Beuys constructed an actual political economy on which he hoped to found his theory of *social sculpture*. Its anchor point was creativity, which is *the* universal faculty of man, the one that makes him human. 'Der Mensch ist das kreative Wesen,' Beuys said, as if echoing Marx. Like labour power, but unlike talent – the notion on which classical aesthetics is based – creativity is the potential of each and every one, and, being the capacity to produce, in general, it precedes all division of labour. From this it follows that everyone is an artist and that art is not a profession. All productive activity, whether of goods or of services, can be called art; creativity is the true capital, and the exchange of goods is to the flow of creativity within the social body what the circulatory system is to the flow of vital forces in the individual body. (This is what the *Honigpumpe* from the 1977 Documenta symbolized.)[5] In order that this utopia become reality and that creativity be 'dis-alienated', goods, money included, must not be commodities. Money, called 'production capital', will thus be created from scratch by a central bank (it embodies neither time nor labour power) and distributed democratically. Once placed in the hands of social agents, it would become 'consumption capital', a kind of paper money with no value but that of representing a certain purchasing power, a value that it will lose in the course of the transaction before returning to the central bank and being reinjected into the economic circuit. Beuys intended in this way to neutralize the private ownership of the means of production.[6] This utopia is seducing, naive and hardly original. It has Fourierist and Proudhonnist overtones, and Marx had already denounced something similar proposed by John Gray. It is difficult to see more in it than an involuntary caricature of numerous broken promises of modernity, a slightly

grotesque farce with nothing but a retrospective meaning. The last of the proletarians has tried to right the wrong of his condition, which is that of artists and of everyman, by mapping the hopes and prophecies of the modern cultural field onto the field of political economy, in order to revive them. But he has not seen that if they in fact find a part of their historical truth there, it is in the past tense, in terms of the translations made possible by this mapping, and not in the future tense, in terms of the emancipation it was *the proletarian's* vocation to promise.

There remains the suffering of the proletarian and the pathetic irony that means that if the promise of emancipation should be abandoned, the character of the proletarian would vanish. Beuys, the sculptor, knew how, with pain and humour alike, to work out the contradictions that Beuys, the charlatan economist, pretended with utter seriousness to dissolve. The talented artist didn't do the same thing as the prophet of creativity. When it is convincing, his work avows, it promises nothing. Until the new order arrives, money is capital, not creativity. Everyone has not become an artist, and the art market continues to treat as commodities the productions exuded by the 'creativity' of those it recognizes as professional artists. At this level, Beuys was coddled: alienated, perhaps, but not exploited. *Raum 90.000 DM*, which is the title of an environment produced in 1981, states its own price.[7] Strewn over the room, five old, rusted drums, which had once contained various industrial chemical products, warn of the ecological damages and wrongs wrought by industry (one of them had contained fluorocarbon, the pollutant responsible for destroying the ozone layer), and testify to the consumption of use value. Useless and used up, the drums will be treated nonetheless as precious objects by the commercial gallery that shows them, wholly aware of their exchange value. But by arranging them as unaesthetically as possible (they don't even make an interesting formal configuration), Beuys succeeds in making their presence incongruous and frustrating. They are different sizes and filled to different levels with scraps of aluminum slag that have been fused together. One of them overflows, and a ladle is attached to the mound of debris. The staging is allegorical, and the allegory is pessimistic: under the conditions of industrial capitalism (the containers), artists' creativity (the content) can only congeal into commodities and become alienated in their exchange value. The

artist is supposed to draw from the well of his labour power, but the alchemy that turns it into gold for the dealer leaves him nothing but slag ('coagulated labour-time', Marx would say).

In a corner of the room, facing this arrangement, is crammed a large copper bathtub filled to the brim with a solution of sulfuric acid. This is another allegory of the artist, and this time the well is alive. Under the conditions of a renewal (the container: the theme of the bathtub has autobiographical resonances of baptism and rebirth within Beuys' work), artists' creativity (the content: as corrosive as the original content of the drums was polluting) preserves its subversive potential. But the container is itself contained: the bathtub is not bare but enveloped by a thick layer of terracotta that seems to protect it and to hide in the depths of its material some strange pouches that the sculptor has modelled as if they were the pockets of a beggar's wallet, or of the artist's famous vest. The dialectic of contained containers (of conditioning conditions) does not stop there, and, even overflowing with corrosive labour power, the bathtub does not escape exchange value. Getting the jump on the dealer, Beuys gouged the price of the work into the still-damp clay: 90.000 DM. Illusion has no foothold. Time gets the last word. Beuys, who understood materials like no one else, knew that, in drying, the clay would contract and would end by cracking. Whether by chance or by design, it happened that one of the fissures has neatly sliced through the price and separated the nine from the zeros, symbolically canceling the monetary value of the work. The bathtub of creativity breaks out of its sheath of reification and the artist strips off his old man's cloak, ready to bear the novices of a Beuysian utopia to the baptismal font. The ensemble is more ridiculous than sublime and, formally, only semiconvincing. To the left of the bathtub, negligently pinned to the wall, a collage of notes and sketches mounted between two sheets of glass pretends to explain the work and, of course, explains nothing.

Time always has the last word, in effect, and time cracks the statues and corrodes utopia more surely than sulphuric acid. Creativity has nothing subversive left; that myth is dated. *Raum 90.000 DM* subscribes to it, but also exposes its extreme vulnerability, testifying to the hope of *the proletarian* but attesting as well the comic aspect of this character. With Beuys gone, and

the concretions of his talent (and not of his creativity) more than ever fetishized by a necrophilic art market, time will decide if his sculpture should survive the ruin of *social sculpture,* this modern *Kunstwollen* that he ignited one last time.

In counterpoint to Joseph Beuys, one is tempted to place Andy Warhol, to oppose the vitalism and populism of the former, the *morbidezza* and worldliness of the latter. In the art of the past twenty years, only Warhol equals Beuys in legend-value – that is, media-value – and the shadow of both of them hovers equally over the art of the younger generation. But Beuys is a hero and Warhol is a star. Beuys had to immolate himself on a stage dating from the *Comédie humaine*, and his aesthetic is theatrical, confusing art and life in the same authenticity. He lived and died, a perfectly cast character of bohemia. Warhol died as though by mistake, after having survived, as though by necessity, an assassination attempt, made useless by the fact that all the front pages were already taken up, on that day, by the real assassination of Robert Kennedy. His life and his art were projections of the same lifestyle, and his aesthetic is that of the simulacrum. Beuys' art demands a myth of origin and a historical *telos*, that of Warhol the fiction of the eternal return and the steady state of post-history. For one, capitalism remained the cultural horizon to leave behind; for the other, it was simply nature. Beuys, like Marx a bourgeois German, wanted to incarnate the proletarian; Warhol, an American immigrant of working-class origins, wanted to be a machine. At the centre of all these oppositions is the fact that Beuys based art on will and thus on a principle of production, and Warhol on desire and thus on a principle of consumption; that Beuys believed in creativity and Warhol did not; and that for Beuys art was labour while for Warhol it was commerce. Nevertheless, labour and commerce have this in common: the domain of these notions is that of political economy. Indeed political economy is divided up by these concepts that, beyond this field, also divide up the anthropological one: either labour or exchange is primary and defines the social essence of man. Either history or structure. The opposition not only opposes Marxist to liberal economics; it traverses all the human sciences and colours them with economism. That art is available to be decoded by means of political economy does not mean that it is absorbed into it.

That, with Beuys and Warhol, art is decoded so obviously by political economy would mean instead that the time has come to decode the code rather than to decode messages by means of it. Perhaps economic values – and the very notion of value – are nothing but a dated translation, neither the most natural nor the most fruitful, of what we must continue to call, lacking a better term, aesthetic appreciation.

NOTES

* *October* 55 (Summer, 1988), 47–62.

1. For a similar description, though with more hagiographic overtones, see Thomas McEvilley, 'hic Jacet Beuys', *Artforum* 24:9 (May 1986), 130–1.

2. Whereas Beuys claimed a forward-looking, emancipatory *theory of social sculpture,* he often gave his work an archaic, purportedly timeless *look.* In fact both the theory and the look are dated. Annette Michelson noted that Beuys' fascination with electrical energy refers to both theories of electricity and formal aspects of electrical contraptions that leave *off* around 1830, 'just after Faraday'. This precise date is a symptom indeed. See 'Joseph Beuys at the Guggenheim', a conversation between Benjamin H. D. Buchloh, Rosalind Krauss and Annette Michelson, *October,* no. 12 (Spring 1980).

3. For the difference between a damage and a wrong, see Jean-François Lyotard, *Le Différend* (Paris: Editions de Minuit, 1983), 18 ff.; in English translation by Georges Van Den Abbeele, *The Differend: Phrases in Dispute* (Minneapolis: University of Minnesota Press, 1988).

4. The interpretation I have offered of *alienation* thus conflates two separate moments of Marx's thought in a way that suggests that it is essential for the 'romantic' Marx to survive in between the lines of the later, 'scientific' Marx, in order to uphold the emancipatory horizon of Marxism. Only if the concept of *labour power* (i.e. the ability to deliver work at large, what Marx calls 'simple, homogeneous, general, and abstract labour') is given the same ontological meaning – defining man in his essence as a *species-being* – as, in the manuscripts of 1844, the concepts *of life-activity, productive life,* i.e. *species-life,* can it be said that: 'From the relation of alienated labour to private property it also follows that the emancipation of society from private property, from servitude, takes the political form of the emancipation of the workers, not in the sense that only the latter's emancipation

is involved, but because this emancipation includes the emancipation of humanity as a whole.' Karl Marx, *Early Writings*, trans. and ed. T. B. Bottomore (New York: McGraw Hill, 1964), 132.

5. Which suggests that, if Beuys' 'electricity theory' refers back to Faraday, his 'physiology' refers back to Harvey (as does his 'medicine' to Paracelsus). But to translate the economic flow of merchandise into the image of the blood circulation is, again, very much a nineteenth-century idea.

6. See Caroline Tisdall, *Joseph Beuys* (New York: The Solomon R. Guggenheim Museum, 1979), 264. From Tisdall's account, it is not, however, absolutely clear to what extent Beuys is indebted for his political economy to his former student and secretary, Johannes Stüttgen. His own account is best expressed in the 'Munich discourse'; 'CAPITAL is not money (means of production); CAPITAL is ability and the product of ability. Here there appear further proofs of the idea that "Everyone is an Artist", proofs of the fact that ability really is a lever. Money is not an economic value! ... That approach will logically develop the social totality, taking as its starting point the creative human being as the creator of the world, and proceeding from freedom by way of law to new economic laws and a credit system for the public good.' Joseph Beuys, 'Talking about One's Own Country: Germany', in *In Memoriam Joseph Beuys: Obituaries, Essays, Speeches* (Bonn: Inter Nationes, 1986), 50–1.

7. First shown at the Galerie Jöllenbeck in Cologne. A photo album was subsequently produced, with a short presentation text by Sarenco. Joseph Beuys, *Raum 90.000 DM* (Milan: Factotummulthipla, 1982).

Section III

BEUYS AND THE LIMITS

OF ICONOGRAPHY

8.1. C.D. Friedrich, *Verschneite Hütte*, 1827, Alte Nationalgalerie, Berlin.

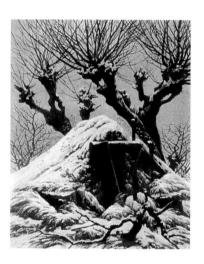

8.2. Joseph Beuys, *Schneefall*, 1965 (view, Guggenheim, New York); © 2006 Artists Rights Society (ARS), New York/VG Bild-Kunst, Bonn.

8. BEUYS AND ROMANTICISM*

THEODORA VISCHER

UNSPECTACULARLY, CASPAR DAVID FRIEDRICH chose as the main motif for his small painting a close view onto an earthen mound identifiable as a snow-covered hut, through the rotted wooden door (Fig. 8.1). A scorched branch, dying winter grass and dried flowers pierce the gloomy but rather strange blanket of snow. The impenetrable darkness in the interior of the hut obstructs one's view, as does the grey, depthless sky. Gnarled willows frame the still-life-like ensemble and grant it an impression of death, despair and finality. The tips of the young bushes evidence new life; a certainty, guaranteed by nature, must follow the represented state of desolation.

In *Snowfall* (1965), one of the most beautiful and powerful sculptures by Joseph Beuys, three branchless pine trunks lie on the ground, gathered together and covered by a dense pile of square felt mats (Fig. 8.2). Thin and hard, lost, also injured and helpless, the trunks rest softly among themselves, the felt shrouds and protects. The fundamental opposites of the withering away and the bestowing of life are mutually appropriate in an easily read image. The title delivers an additional image to our imagination that can enrich and support the sensual associations released by the work. The juxtaposition of these two works by Friedrich and Beuys seems correct. Differences between them can be located in the forms and means that Beuys chooses and which render his work less 'site specific'. It thereby achieves a more open-ended and intense potency.[1]

If this comparison seems enlightening, it doesn't address the appropriateness of comparing Beuys to Romanticism. It is an almost automatic and human reaction to place artworks that escape known experience (due to their strange appearance) by comparing them with more familiar examples. Often, however, the confidence and understanding won in this process denies firm insight into the new work, which can only come into focus by insistently dealing with that element which seems strange. For this reason the comparison attempted here between Beuys and Romanticism should be preceded by some further considerations.

Romanticism is contemporary. The Hamburg Kunsthalle began its exhibition calendar in 1974 with *Art around 1800*, a prelude to the cultural reappraisal of an epoch of European history thus pushed into consciousness as part of our own, a past that still reaches into the present. [...] A discovery of the Romantic in contemporary art, which intends to understand an initiating segment of 'modern art' as a coherent line of development to the present day, is concomitant with this true 'discovery' of Romanticism as a spiritually related epoch. One can cite Robert Rosenblum's exploration, *Modern Painting and the Northern Romantic Tradition: Friedrich to Rothko*, as exemplary of this tendency, which also parallels the self-understanding of many artists. Rosenblum formulates his fundamental problem around a comparison between the *Monk by the Sea* by Friedrich and a characteristic painting by Mark Rothko, replete with dematerialized and luminous colour:

> If these paintings look alike in their renunciation of almost everything but a sombre, luminous void, is this merely an example of ... the accidental appearance at different moments in the history of art works whose close formal analogies falsify the fact that their meaning is totally different? Or does this imply that there may be a true connection between Friedrich and Rothko, that the similarity of their formal structure is the result of a similarity of feeling and intention and that, indeed, there may even be a tradition in modern painting that could bridge the century and a half that separates them?

Rosenblum answers this question rhetorically on the last page of his book:

> ... could it not be said that the work of Rothko and its fulfilment in the Houston Chapel are only the most recent responses to the dilemma faced by Friedrich and the Northern Romantics almost two centuries ago? Like the troubled and troubling works of artists we have traced through the nineteenth and twentieth centuries, Rothko's paintings seek the sacred in the modern world of the secular.[2]

Rosenblum's main argument proves a continuity between 1800 and the present based on the claim that the loss of religion and an associated decline in values filled artists with the need to find old religion again or to seek an ersatz religion in its widest sense. This diagnosis is surely not wrong. It fits Rosenblum's evidence, but it is one-sided. It limits art's capabilities to mere passive reaction and banishes art to the reality-distanced realm of sensory perception. Rosenblum's judgement thereby approaches an old cliché about Romanticism that is only to some extent differentiated in the 'new discovery' of the epoch. In this regard, Tina Grütter notes that the 'assessment of German romantic painting ... is today still primarily achieved by means of the cliché of atmosphere, and an emphasis on emotionalism and the mythic-religious' – one should add the passive and the unspecific – and is tainted by it.[3] Even if Rosenblum had not focused exclusively on painting, there would have been no place in his conception for an artist like Beuys.

In certain respects, Harald Szeemann's 1983 exhibition *The connection to the total work of art* is comparable to Rosenblum. The point of departure here is also Europe around 1800, thus the 'point in time of release of the artist to his freedom'.[4] While Rosenblum paints a picture of the artist who merely suffers from this freedom, Szeemann foregrounds the other side of the picture. Szeemann's proof of continuity since 1800 has to do with reacting individuals who creatively circumvent this situation in the form of utopias with a claim to totality. For these individuals, the concept of the total work of art is no longer restricted to the realm of visual art. It is logical and revealing that Beuys figures centrally here.

m-p

Wherever connections to an earlier epoch are weighed in connection with Beuys – either consciously or unconsciously, voiced critically or polemically – German Romanticism in its broadest sense is found to be most appropriate to the comparison. Corresponding to the interest which drives the comparison, the indecisiveness outlined above is mirrored in assessments of the Romantic movement. Polemical arguments mainly agree that late Romanticism – particularly Wagner and Nietzsche, figures that are loaded with negative associations in connection with German history – should be cited. Thus American and German reviewers title their reviews of the 1979 Beuys exhibition at the Guggenheim Museum '*Götterdämmerung* at the Guggenheim', 'Arm in Arm mit Parzifal zum Gral', 'The Wagnerian Chorus of Joseph Beuys at the Guggenheim'. Benjamin Buchloh begins his text for *Artforum* [in this volume] with a quotation from Nietzsche's pamphlet 'The Case of Wagner'; and Marcel Broodthaers addresses an open letter to Beuys in 1972, in which he adapts a fictional letter from Jacques Offenbach to Richard Wagner and thus suggests the identification of both addressees.[5] In other, similar comments, Romanticism seems reduced to platitudes such as subjectivity, mystification, heated emotionalism, and distance from reality.

If, however, the comparison has to do with references to Romanticism that are not guided by preconceived definitions but rather are preceded by an argument concerning the work of Beuys, these references focus primarily on early Romanticism. They thereby find themselves in agreement with Beuys, who repeatedly mentioned this feeling of affinity: 'I can only follow when, as much as possible, one radically returns. The other good point of departure would be the age of German idealism in which my conception first emerged. One finds it in the Romantics, in Novalis; one finds it in Carl Gustav Carus, in Caspar David Friedrich, one finds it in Schelling, in Hegel, etc.'[6] […]

One reaches the limitations of this kind of comparison in such incompatible differences in judgement that are obviously based in common thought or philosophy. On the one hand, the characterized connections rarely go beyond sketchy slogans and, as a result, Romanticism becomes a collecting bin for all possible inconsistencies. More fundamental however is the danger inherent in such comparisons. In the long run, the

interest is not in Beuys' works and their effect but rather in the conditions of the possibility of their emergence. For even when I know that Beuys' work evidences connections to Romantic thought, this doesn't reveal anything about how Beuys treats Romantic thought or how these connections take effect in his creative work. As long as this latter aspect remains unclarified, it is up to one's discretion to present Beuys as a mystical Romantic, as Wagnerian, or as a contemporary artist who consciously deals with his own tradition. The comparison only succeeds when it acknowledges the artistic deployment of precise aspects of Romantic thought. Only then – in insisting on the strange element that opposes the familiar – does one recognize Beuys' specific achievement and particular statement.

The following remarks are therefore presented in two sections, the first of which concerns thought common to Beuys and Romanticism, while the second deals with its visual implementation by the Romantic artists and by Beuys.

II

In association with Romanticism, Beuys repeatedly stresses the names of Lorenz Oken, Carl Gustav Carus and Novalis, as well as Caspar David Friedrich and Philipp Otto Runge. His 'feelings of affinity' are therefore not primarily with visual artists but with naturalists, medical doctors and philosophers of nature. In our search for common aspects of thought we will allow ourselves to be guided by this reference to the Romantics' natural-history research, with the presupposition that natural-history research or the natural sciences are also themes in Beuys' work.

IIa

If one researches the chronological and motif/thematic systemization of Beuys' drawings since 1947, it can be determined that the landscape motif or an excerpt from nature plays a consistent role from the start. Until 1950, nature appears in a geological or botanic/morphological perspective, or, there are landscapes in which an invisible, supernatural occurrence is represented.[7] In 1951 an additional interpretation of nature appears in Beuys' drawings. In the landscape space elements surface – sounding balloons, coils, lamps, filters, magnetic flows – which do not come from the natural realm yet appear to be

integrated with it.[8] Soon these elements become so pronounced that the landscape dissolves into them or the elements become independent as their own motif, particularly after 1957–1958.[9] Circulations of energy, magnetic fields, batteries, and storage cells refer to the realm of physics; a transformation of elements simultaneously takes place in these drawings, a spiritual instrumentalization, as it were. These drawings are not to be comprehended analytically. Almost in the realm of objectivity, these allusions present associations in Beuys' drawings which are, strangely, like personal seismographs.

Beuys further developed and concretized this apparently vague and evocative quality of the drawings (exhausting its genre-specific characteristics) in the medium of sculpture and performance (the term 'action' is used from the 1960s). In sculpture this process allows itself to be demonstrated in an almost exemplary fashion in the *Fond*-works.

Fond I (1957), a conservation jar filled with pears by Beuys' mother, is an image of the process of preservation. *Doppelfond* (Fig. 8.3, 1954) consists of and also presents the principle of a lightning conductor in exemplary fashion: a freed electrical charge in the heavens is directly caught, channelled and guided into the earth by the conductor. *Fond II* of 1968 (Fig. 8.4, centre) conveys a brief historical overview of the development of charge-sources, and simultaneously demonstrates the possibility of greatly intensifying voltage by means of a series-connection. In *Fond III* of the same year Beuys builds a monumental battery from his own materials: the storage of energy is presented in the stacking of felt sheets (Fig. 8.4, right). These 'storage batteries'

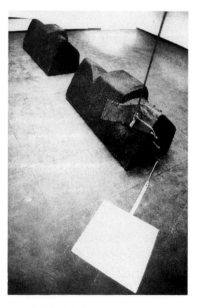

8.3. Joseph Beuys, *Doppelfond*, 1954/1974 (Staatisches Museum Mönchengladbach; Photo U. Klophaus); © 2006 Artists Rights Society (ARS), New York/VG Bild-Kunst, Bonn.

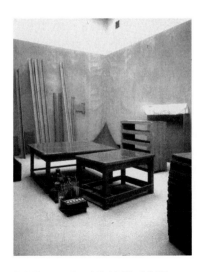

8.4. Beuys, *Fond II*, 1961–1967 (centre), and *Fond III*, 1969 (right; Beuys Block, Hessisches Landesmuseum, Darmstadt); © 2006 Artists Rights Society (ARS), New York/VG Bild-Kunst, Bonn.

are each covered with a copper plate so that a concentrated accumulation of energy can strike a highly conductive material. In various forms all the *Fond*-works are constructed according to instruments of physics or from elements alluding to the properties of physics that are constructed into object-complexes. One notes the insistence on formulations (usually) foreign to art.

It is known that, because of his multiple talents, Beuys gained experience in both the natural sciences and in art in his career. He was dissatisfied with the extreme specialization of fields that once belonged together. Leonardo, a visual artist and technical researcher in the natural sciences, and Galileo became for Beuys key historical figures for this situation: 'Leonardo was already oriented in two directions ... on the one hand, he looks at the unity within the spiritual and with a spiritual concept of nature; on the other hand, he is already analytic, that is, he became a scientist.'[10] Galileo no longer made use of the scientism, with its synthesizing ability, established by Leonardo. He rather initiated the development toward the analytic method which came to displace the concept of the spiritual within the system of science. This displacement reached a high point in materialism. 'Through research and analysis I came to the understanding that the two concepts of art and science are diametrically opposed in the development of western thought and that by reason of this fact a dissolution of this polarity must be found and expanded notions must be cultivated.'[11] The polarity of art and science – or of spirit and matter – must be abolished if both disciplines are to find their integration into an expanded notion of art. Beuys could later say, 'Actually, in my activity, art as I practise it means the natural sciences as I wanted to practise it.'[12]

With this background, we see the *Fond*-works in a new light. In all four works, energy sources and power fields are positioned, uncovered, and are thereby made potentially available. The creation of energy means the production of warmth, a central notion in Beuys: 'The warmth concept extends much further – not even physical warmth is meant ... I actually meant a completely different warmth, namely, spiritual or evolutionary warmth or an initiation of evolution.'[13] The use of materials such as felt and fat are meaningful in connection with this. If one can thereby conclude that the *Fond*-works hardly deal with real energy, their common title opens to a further dimension of meaning. 'Fond' – foundation or fundament – is the base where one stands and from which one should act. Material that is available for action can be understood in Beuys' sense as spiritual energy, as evolutionary warmth. The *Fonds* thereby establish the relation of material to spirit on a new foundation and at the same time make available an open situation leading to action. Mankind is addressed in this situation with a central and responsibility-laden function. That is, mankind is to make sensible use of the opportunity, to mediate between matter and spirit, for example, and to liberate the restricted materialist notion of science. To correspond to its importance, Beuys placed great emphasis on the development of an adequate conception of mankind.[14] In their significance as foundations the *Fond*-works connect directly to matter. Their constant freeing of energy potential indicates the possibility of overcoming the tie to the base and leads to a reconciliation. In this situation, as Franz Joseph van der Grinten put it, mankind then finds itself 'involved in a field of tension between radiation and electrical energy.' [...]

The question of whether nature or natural sciences research are in any way themes in Beuys' work, in accordance with his interest in the Romantics' research in the natural sciences, was the point of departure for these considerations. The example of the *Fond*-works showed that the notion of an organic totality is evoked in presenting the processes of physics. A review of the drawings has hinted that the confrontation with nature entered Beuys' pictorial work through allusions to the realm of the natural sciences. However nature – and here the varied interpretations of nature the drawings allude to are telling – is much more than landscape for Beuys. Nature is part of what

is understood as an evolutionary-organic totality, consisting of all visible and invisible phenomena and made tangible in presenting the relation of forces and flows of energy. It is therefore consistent that formulations of objects beyond the realms of physics or the natural sciences are to be found in Beuys' work in all mediums. A decisive characteristic is the particular emphasis on modern natural sciences.[15] On the one hand, it is significant that Beuys places emphasis on the realm where specialization and instrumentalization have had the most devastating and immediate consequences. In this way he manifests his demand for an active reference to the contemporary situation. On the other hand, his particular emphasis on the warmth concept is revealing. It is oriented toward an expanded way of thinking, in the open-endedness of its possibilities of meaning. By definition it also contains the characteristics of movement and of dynamics. In works having to do with notions of reincarnation or that play out in the realm of plant morphology and geology, Beuys emphasizes a demonstrative notion of totality. However, in the concept of warmth and energy the demonstrative is transformed into a request. Potentially active creativity replaces passive insight.

IIb

Carus and Oken, both of whom Beuys read, are offshoots of a movement which formed itself around 1800 against the backdrop of Napoleonic activities, with its first centre in Jena. Philosophers, naturalists, and artists formed the core of this group – the Schlegel brothers and their wives Karoline and Dorothea, Schelling, Novalis, Tieck, Steffens and Ritter. Runge, who was close friends with Novalis and Friedrich Schlegel, or Friedrich, who knew Runge, or Carus and Oken, for example, are also to be indirectly included within this group. The tight-knit membership of natural-history researchers in a group of this kind – foreign to us today – sheds light upon how the natural sciences were conceived at the time. Romantic research into natural history 'is a result of the modern development of nature … it is an attempt to connect the natural sciences and philosophy immanently with each other.'[16] In contrast to the primacy of mechanical laws following Newton, immaterial forces were the primary conditions whereby the philosophers of

nature categorized electricity, magnetism, light and warmth, for example. They forwarded a genetic-dynamic concept of nature instead of an atomized, static-analytic one. This was part of an overall notion of the inner coherence of nature and its connection to the sphere of the intellect. The great organism was an answer to mechanical unity. Romantic natural-history research lasted only a few years and only in Germany, and even there its effectiveness was debated. However, its historical significance as a reaction to the positivistic development of the natural sciences reaches far beyond these years. Traces are occasionally to be found in concepts of twentieth-century science. Such traces are also to be understood as a diagnosis of alienation and isolation, which Beuys recognized as characteristic of the polarizing of art and science, intellect and material.

The measures whereby individuals in the circle of the early Romantics worked to remedy this 'polarized' situation are also comparable to Beuys. In the sphere of the natural sciences, the physicist Johann Wilhelm Ritter can be cited as an exemplary instance. He strove to integrate scientific research by uniting empirical method and hypothesis. Although he gained the respect of specialists through important discoveries, he did not achieve this unification, since he interpreted his discoveries through Galvanism or through the early study of electrical phenomena in a particular manner. He understood the cohesion of nature as a living process in a constant polarizing state, against which a standardizing of the whole then reacted. To Ritter this seemed to demonstrate the conclusion that 'the infinite expanse of electricity sources are situated as nothing more than revealed sources of being.'[17] Here again we find the Beuysian recognition that electricity, warmth and energy are basic forces that run through human existence. The striving of these forces toward unity is therefore a foundation that guarantees meaning for that existence.

Beuys' interest in Romantic naturalist-researchers then finds its first resonance in this characterization of Romantic natural-history research and in Ritter. A concept of nature determined by organism-based thinking, and a subsequent drive towards standardization in polarized fields or areas, is then proven to be decisive. One can further deduce – as was the case earlier in this essay in relation to Beuys – that the model of the organism is not

only to be found in the concept of nature but by definition it must form an entire worldview. In this way the extended interest of the Jena circle in research in the natural sciences of their time can be understood as a consequence of their drive towards a totalizing experience of the world.

For this reason, Romantic visions of unity which are not developed in the realm of the natural sciences but which could include them are interesting for us. When Novalis creates a programme for the poeticizing of the sciences as a counter-movement to the positivistic sciences, for him it is about attaining, through the method of combinatorial and involution analysis, a point of view that includes all the sciences and tends toward a totalizing science. The combined individual sciences result in the notation of a 'spiritual physics', of a 'philosophical physics' or a 'poetic psychology' which is elevated as a higher realm, the highest of which is poetry. Involution, an active and dynamic process and a method toward the synthesis of the individual sciences, reminds one of Beuys' conception of energy and warmth as well as the above-mentioned function, and further suggests integrated phenomena. If the creative authority of poetry and the poet who brings it forth stand for reconciliation in Novalis, so Beuys addresses the creative-active human in general.

Novalis evidences the fact that Romantic visions of unification were developed outside the realm of the natural sciences. Philippe Otto Runge represents a further variation. He foregrounds the idea that the unity of the universe finally lies in God or in a higher power, and that polarities are only to be overcome through a belief in God or in a higher power, a notion which is either unspoken or is determining in conjunction with other aspects in all of these conceptions. Like Beuys, Ritter and Novalis, Runge understands that all existence is constituted and penetrated by forces. However, he cannot imagine it in an unmediated way in the realms of the physical or of science, but rather as grounded directly in God (in Runge's dependence on nature-mysticism of Bohemian origin). In the sense that art has the task to connect 'words, tones or pictures … with our premonition of God, and the certainty of our own eternity through the sensation of the coherence of the whole', it almost becomes religion. The coherence should become representable in that the artist strings

together 'these sensations of the most meaningful beings around us' and in that he presents the 'characteristic, that is: holds fast those features of these beings which coincide with sensations' – 'symbols of our thoughts regarding great forces of the world'.[18] In his unfinished 'Zeiten', Runge attempted to represent 'his view of the coherence of the cosmos with all phenomena in living and in inanimate nature ... whose boundaries collapse into God.'[19] [...]

IIIa

Opinion and thought are also closely positioned in the work of Runge, a visual artist of Romanticism; we will now focus on him. In the course of his artistic beginnings, and conclusively after his disastrous participation in an 1801 Weimar prize competition for the representation of Achilles battling the river gods, Runge became painfully aware that classicism could no longer be the most contemporary form of art. 'How could we think that we could again attain old art? The Greeks brought the beauty of forms and figures to the highest levels during the time when their gods hit bottom; the new Romans brought historical representation the furthest as the Catholic religion hit bottom; with us something is hitting bottom again, we stand at the brink of all religions which sprang from Catholicism ... they reach incorrectly again for history and confuse themselves.'[20] Thus Runge wrote to his brother Daniel, and later: 'I see the connection which the old art had with the old world, and I know with certainty that a new art must now emerge.'[21] In the detachment from the void resulting from that which was overcome, the contact with the Jena circle held a decisive meaning. Seen historically as an artist facing a suddenly no-longer-surmountable task – the creation of an adequate form of representation through 'new art' – Runge landed in a situation of constant self-clarification and self-justification, just as his contemporaries did. This self-clarification responded to the fundamental criticism of a public that measured art against tradition. This situation was new in 1800 and it continues to the present day.

Juxtaposing Runge's visual values as an artist of early Romanticism to those of Beuys is not a matter of carrying out stylistic or formal comparisons. In terms of innovations in content, particular characteristics of Romantic thought, and of

artists disputing representation, separate them from the artists who preceded them. They also render the earlier art comparable to the art of the twentieth century and to Beuys.

If, for Runge, the 'sensation of the coherence (culminating in God) of the entire universe with us' becomes an object of representation, he establishes the creating power of the artistic subject and its related objects as predetermined content. If it is the task of 'the engendering power of sensation' to erect an image in the form of a correspondence between 'innermost sensation with the most exterior form,' this task approaches a radical relativizing of the meaning of the object. Old content is not simply replaced by the new in that for Runge, for example, the sensed 'coherence of the entire universe' in the face of a landscape attempts not to capture it in its rendering, but rather in symbols of 'our thoughts about the great forces of the world'.[22] As these symbols approach the 'almighty power', Runge seeks 'to concentrate everything simultaneously and in this way create an image of the infinite'.[23] This dynamic world of the imagination is tied to process-oriented thought and its limiting of all representation to a condition that is defined only inasmuch as it finds fulfilment in association with all existence. It demands too much of every traditional means of picturing. The classical concept of the symbol, which suggests a concrete content, must then be replaced by a representational form that is not tied to specific matter but that is rather characterized exclusively by a function that presents the process-oriented, dynamic development of a final unity. This demand would first be achieved in the absolute painting of Kandinsky. Runge met it with pictorial measures that lagged far behind his theoretical considerations, which are only outlined here.

Appropriate to the task of art to present 'the sensation of the coherence of the entire universe with us', a theme of the new art for Runge becomes the registering of laws governing life, being based in sensation and not in scientific study. In many silhouettes and more so in geometric-based representations of flowers, Runge attempts to trace images of nature back to their growth structures, to reduce them to their basic forces. Among Beuys' earliest works are plant and leaf studies that can certainly be understood to correspond to Runge's efforts.

'It is not enough ... that we penetrate appearance and can

explain it within nature; it is equally necessary that we penetrate
… the nature of our materials, and that we understand the
commonalities of our materials with those through which the
actions of nature were brought about.'[24] This excerpt from the
introduction to Runge's colour theory should communicate not
only the themes of his art but also the method of the forces of
the universe. The theory of methods that Runge invents should
also be a theory of the forces of nature that are at work within
it. In this identification of method with its content Runge
anticipates a principle of abstract art. Just as the notions of the
early Romantics generally present an interplay between material
and spiritual, scientific and metaphysical considerations, so also
Runge's scientific research on colour has a religious/mystical
foundation where the medieval metaphysics of light plays a
constitutive role, insofar as colour was understood as a medium
for the revelation of light.[25]

This is more difficult to maintain from today's vantage point in
relation to the formal/objective form of Runge's representations.
Runge constantly expresses his concept of symbol, where an inner
sensation stands in agreement with an exterior form. As we've
seen, however, a precondition for an adequate representation
of his theory would be an avoidance of objectivity – or also, as
Runge formulated it, an expansion into the medium of music.[26]
To then remain in the realm of figurative, traditional art betrays
a historical sense of being tied down, but also reveals the rift
that underlies the thought and activity of the early Romantics
in its entirety and which forms their epoch. It is the rift between
the audacity of a dynamic world of imagination which finds
itself in permanent process and in the perceived need to hold
fast to an opposite, fixed, eternal power: 'In this procedure we
require something fixed, otherwise we would run aground or we
must begin to lie … this fixed support is, however, the Christian
religion.'[27] Finally it is not the conventions of the figurative but
the fear of loneliness in the world that leads to the rift.

We have examined Runge as representative of early
Romanticism, with an emphasis on the imagistic realization of
Romantic thought in his art. In its essential features, his thought
evidences similarities with that of Beuys. We have seen that the
new world of the imagination led away from established realms
of the objective and toward a process-oriented image world,

which Runge attempted to express through various pictorial means. The rift that resulted from these new demands proved to be existential and irreconcilable.

IIIb

[…] The differences that emerge in an examination of pictorial elements in Runge and in Beuys lie not only in the varied conditions of aesthetic discourse around 1800 and 1960. More important is the polarity between a dynamic world of the imagination and a commitment to apparently incompatible final truths that form the early Romantic era. Beuys distances himself on exactly this point:

> I think I belong to this cultural movement … but the action that I have chosen does not allow itself to be completely identified with that of Novalis (or of Runge) because they instead understood the relation between man and transcendental powers as those between man and matter. In Romanticism therefore a method of analysis exists that is more geared to the observation of the supernatural than of matter.[28]

We have seen that Beuys takes as his starting point the experience of polarity between matter and spirit and that he attempts, with particular means in his works, to render energy, movement and exchange understandable as active potentials for mediation.

Beuys constructs neither a day-after-tomorrow nor a day-before-yesterday ideal. He attempts to connect to present reality directly and utilize existing possibilities. He does not want his activity to appear contemplative since only active behaviour appears to be meaningful. This is all contained under the notion of a new concept of art, or the theory of sculpture, whose main quality can be characterized as an all-encompassing claim for the validity of all aspects of life: politics, economy, and culture. How Beuys came to develop his theory of sculpture can be seen for example in his basic preoccupation with the natural sciences and art. As a consequence of this preoccupation a model-like picture presented itself to him for this problem: if the ossified condition of matter (here also the specialized sciences) is taken as a given, so the necessity arises to create an antithesis that

is positioned to melt this hardening. This hardened condition relates, in the examples discussed, to the physical apparatuses of the specialized natural sciences. Energy and warmth sources mark the antitheses in these apparatuses. While the poles are dependent on and condition each other, they stand opposed, as a duality. Beuys therefore illuminates connections and is only then fully aware. He thereby makes connections to an open situation that can be worked. This is the situation in which every person is urged to use their creativity, where each person can become an artist or sculptor. Humans are then a dynamic element that mediates between the poles. Beuys introduces formulas for sculptural processes developed on the example of real experience and thereby obtains the components: chaos for undifferentiated, arbitrary energy; movement for the mediating, dynamic element; and form for hardened material. Reduced to a model, Beuys works through it on various pictorial and conceptual levels:

> I have never rejected movement, rather I have always attempted to investigate the sculptural principle that is revealed when one takes this element from a sculptural principle, particularly when one builds it into a notion of sculpture. It would then be an essential component of the sculptural theory that I have developed, it takes on various elements, namely, of polar forces and of the mediating element, and they become the concept of sculpture.[29]

Like energy and movement as interpretive leitmotifs, an understanding of material per se and also of selected materials consequently proves itself as a pictorial relation. With certain materials Beuys could find experimentally the forces that travelled through all things and that he had objectively imagined in his drawings. In this consciousness of forces in neutral, non-representational material, phenomena are rendered representable that would otherwise remain incomprehensible and could only be intimated. Oppositions such as warmth/cold, expansion/contraction, body/soul, activity/passivity can be made understandable as a particular expression of a totality. These oppositions are not presented as given dualities but as a

polarity that repeatedly suggests, in a relation of dialogue, the condition of suspension.

Beuys was not a theorist, and he did not want to ground a new philosophy. Connections to his thought can be found in early Romanticism, just as they can be found in Rudolf Steiner. Beuys was a pragmatist and an artist. Most crucial is the pictorial quality of his thought, which obtains its form and working power from the artistic or creative realm.

In this way, Beuys is able to dissolve the Romantic polarity; he no longer understands mankind as related exclusively to the spiritual and to the afterworld, but also related to matter, time, and reality. Thus his conviction about mankind's capacity for action, which he expressed superbly in his art.

IV

Beuys: a Romantic? Artists such as Wassily Kandinsky and Mark Rothko followed the path blazed by the early Romantics: in realizing non-objectivity, they created an adequate form of representation drawn from attending to the characteristic, understood as both interior and also as part of a universal totality. They therefore remain caught in the Romantic conflict and can with some validity be called Romantics.[30]

They thereby ignored an intended dimension of Romantic works that is given a central meaning in Beuys' work. As we have seen, in Runge's world of the imagination there is a tendency toward relativizing an object's meaning and with it a fixed content, or, a background of wisdom of insight. Then something beyond a step into non-objectivity is to be expected. Far more drastic is the procedural thinking that contains within it a shift from the production of the work to the intended effect on the viewer. Beuys followed this path. The quality of solicitation, which we can cite in regard to the *Fond*-works, the manner of deployment of forms and materials, the central significance of the creative being in the sculptural theory – this all points to the intent underlying the entire structure of Beuys' creative work: the appeal to each human's individual responsibility to think and to act. Beuys connects with the era around 1800 but he is no longer a Romantic.

NOTES

* First published in *7 Vortrage zu Joseph Beuys* (Museumsverein Mönchengladbach, 1986). Translated by Claudia Mesch.

1. This comparison was also undertaken by Werner Jehle, 'Joseph Beuys' *Schneefall* – Poesie der Materialien', in *Werk, Bauen + Wohnen*, Nr. 1/2, 1981, 6 ff.

2. Robert Rosenblum, *Modern Painting and the Northern Romantic Tradition: Friedrich to Rothko* (New York: Harper and Row, 1975), pp. 10–11; 218.

3. *Zeichnungen der Romantik aus der Nationalgalerie Oslo* (Zurich: Kunsthaus Zurich, Graphisches Kabinett, 1985), p. 12.

4. *Der Hang zum Gesamtkunstwerk. Europäische Utopien seit 1800* (Zurich/Düsseldorf/Vienna: Sauerländer, 1983), p. 16.

5. See press clippings to the exhibition 'Joseph Beuys' at the Solomon R. Guggenheim Museum, New York, 1979/80. Buchloh, 'Beuys: The Twilight of the Idol. Preliminary Notes for Critique', *Artforum* XVIII: 5 (Jan. 1980), pp. 35–43; Laszlo Gloser, *Westkunst. Zur zeitgenössische Kunst seit 1939* (Cologne, 1981), p. 325.

6. *Joseph Beuys Zeichnungen* (Rotterdam/Berlin/Bielefeld/Bonn: Nationalgalerie Berlin, Staatliche Museen Preussischer Kulturbesitz, 1979/80), pp. 36 ff.

7. Compare, for example, *Glacier* (1950) and *Lady's Cloak* (1948) in the exhibition catalogue *Joseph Beuys. The Secret Block for a Secret Person in Ireland* (Oxford: Museum of Modern Art, 1974), Numbers 2 and 3.

8. Compare for example an untitled drawing of 1951 and *Sunpower work* (1954) in *The Secret Block*, Numbers 42 and 110.

9. Compare for example *Landscape with filter sculptures* (1953) in the exhibition catalogue *Joseph Beuys. Arbeiten aus Münchener Sammlungen* (Munich, 1981), Cat. 43; and *Nornenbild* (1959) in the exhibition catalogue *Räume heutiger Zeichnung. Werke aus dem Basler Kupferstichkabinett* (Baden-Baden: Staatliche Kunsthalle, 1985), Cat. 58.

10. *Joseph Beuys. The Secret Block for a Secret Person in Ireland* (Oxford: Museum of Modern Art, 1974), pp. 23 ff.

11. Götz Adriani, Winfried Konnertz and Karin Thomas, *Joseph Beuys Leben und Werk* (Cologne: Dumont, 1981), p. 74.

12. Helmut Rywelski, 'Einzelheiten. Interview mit Joseph Beuys: Heute ist jeder Mensch Sonnenkönig', *art intermedia* Buch 3 (Cologne, 1970), n.p.

13. *Joseph Beuys. Multiplizierte Kunst.* Jörg Schellmann and Bernd

Klüser, Eds. (Munich: Edition J. Schellmann, 1977) Fourth edition, n.p.

14. See T. Vischer, *Beuys und die Romantik* (Cologne: W. König, 1983), pp. 82–90.

15. See also Axel Hinrich Murken, *Joseph Beuys und die Medizin* (Münster: Coppenrath, 1979).

16. Dietrich von Engelhardt, *Historisches Bewusstsein in der Naturwissenschaft von der Aufklärung bis zum Positivismus* (Freiburg/Munich: 1979), pp. 106 ff.

17. Johann Wilhelm Ritter, *Fragmente aus dem Nachlass eines jungen Physikers. Ein Taschenbuch für Freunde der Natur*, Facsimile printed after the 1810 edition (Heidelberg: L. Schneider, 1969), Nr. 309.

18. Philippe Otto Runge, *Hinterlassene Schriften*, Ed. by his oldest brother (Hamburg: F. Perthes, 1840–41), two volumes; vol. I, 11.

19. Jens Christian Jensen, *Philippe Otto Runge. Leben und Werk* (Cologne: DuMont, 1977), p. 130.

20. Runge, *Hinterlassene Schriften* I, p. 7.

21. *Hinterlassene Schriften* II, p. 179.

22. *Hinterlassene Schriften* I, p. 11.

23. *Hinterlassene Schriften* I, p. 12.

24. *Hinterlassene Schriften* I, p. 84 ff.

25. Jörg Traeger's investigation of the use of colour in Runge's paintings *Morning* and *Rest on the Flight to Egypt* reveals that Runge's use of colour consistently presents a historically contextualized correspondence to theory. Jörg Traeger, *Philipp Otto Runge und sein Werk* (Munich: Prestel, 1985), pp. 62 and 164–7.

26. 'We express these thoughts in words, tones or images, and thereby arouse the identical sensation in the breast of the man next to us.' *Hinterlassene Schriften* I, p. 11.

27. *Hinterlassene Schriften* I, p. 35.

28. Italian-language citation in Germano Celant, *Beuys. Tracce in Italia* (Naples: Amelio, 1978), p. 10.

29. *Joseph Beuys. Spuren in Italien* (Lucerne: Kunstmuseum Lucerne, 1979), n.p.

30. Robert Rosenblum's assessment of the Romantic can also be understood in this sense.

9. NO TO... JOSEPH BEUYS*

ROSALIND KRAUSS

LAUGHING ABOUT THE PUN it incarnated, since the German for chair ('Stuhl') is also the polite term for shit (stool), Beuys was happy to give an excremental spin to his celebrated sculpture *Fat Chair* (1964):

> I placed [the fat] on a chair to emphasize this, since here the chair represents a kind of human anatomy, the area of digestive and excretive warmth processes, sexual organs and interesting chemical change, relating psychologically to willpower ... '[S]hit' ..., too, is a used and mineralized material with chaotic character, reflected in the cross-section of fat.[1]

He was also eager to place his preferred materials – wax, felt, fat, a thick brown paint with which he coated many of his assemblages, musty old objects he gathered together as so much detritus – at the service of a set of performance rituals, so that they would function as the remains of so many acts of communion, the relics of so many elaborated rites. Carrying his felt-wrapped walking stick or his shapeless knapsack, or huddled beneath a felt blanket next to a pacing coyote, he thus took on a succession of roles: of shaman, of wandering Jew, of scapegoat, of martyr.

All of this – the scatological nature of the materials, the insistence on the sacred – might strike one as textbook Bataille, especially since Beuys' various allegories of the sacred tended

to join high and low to articulate the sacrificial figure as an exemplary being catapulted from his position as sovereign into an identification with the lowest of his social subjects.[2] Beuys himself projected this dual identity in one of his last works, *Palazzo Regale* (1985), a funerary monument organized as an allegorized double self-portrait in which the paraphernalia of the tramp or beggar are laid out in one glass-walled sarcophagus and the regalia of the king or emperor in the other.

In the course of analyzing *Palazzo Regale,* Thierry de Duve speaks of Beuys as reflecting, in all their variety, the denizens of that fabled land from which the personality of the romantic artist was thought to have sprung, the land in which the outcast rises above the heads of the philistines, where love redeems the lost and dying, and where the only true nobility is that of talent, the land that came to be called 'la boheme'.[3] Because the modernist artist was thought of as emerging from this country, as the harbinger of a form of life not territorialized by the social divisions created by industrialization, and thus as the incarnation of the almost unthinkable condition of non-alienated labour, the early modern avant-garde had projected utopian visions from this very place of marginalization. And Beuys, eager to promote his own aestheticized version of a post-capitalist Utopia – what he called a 'social sculpture' – worked specifically to transcode the character of the bohemian into that of the proletarian, the figure whom Marx had cast as both the subject and object of history, who would rise from the ashes of capitalism as the controller of his own labour power, producing his own being as value. Collapsing these two figures – bohemian and proletarian – together, Beuys came up with the redemptive phrase, 'Each man is an artist,' thus recasting each specific act of labour – the nurse at her station, the digger in the ditch – as creative and thus an act of sculpting, just as he proclaimed every spoken word an element in the same great collective work.

If, however, Marx was repelled by Bohemia – not the mythical one of Murger, but the real one of the lumpen proletariat – it was because these motley figures, gathering in the interstices of the great social divide between the bourgeoisie and the proletariat, had dropped out of the system of representation on which both class identification and class struggle depended. Representing nothing, they were thus a scandal for the logic of history.

Yet, it was for this very same reason – that they had been able to void the economy of *representation* – that the lumpen proletariat fascinated Bataille. For the *informe* is of course grounded on the wreckage of representation, of assimilating everything to form. In the articles he wrote after 1934 for *La Critique sociale*, Bataille explored the subversive work – the transgression from below, the (in *his* terms) scatology – of the lumpen, seeing it as something that could not be assimilated within rule-regulated, representative society, the society of the 'homogeneous.' On the contrary, what interested Bataille was the fact that homogeneous society, anxious to submit everything to the laws of efficiency and thus to recycle all its products, nonetheless produces waste that it cannot assimilate – excremental waste that builds up as a heterogeneous threat.

It is Beuys' drive toward a totalized system in which everything is recuperated by the 'social sculpture' that we see the fault lines opening up between his idea of the excremental or the heterogeneous and that of Bataille's. Added to Beuys' belief in total assimilation ('Every man is an artist'; every speech act is a sculpture) there is his interpretation of the shamanistic figure as the one who reveals the form always already locked within the chaos of matter, who therefore informs matter. Speaking of his use of fat as dramatizing this work of form giving, of *Gestaltung,* Beuys said, 'In this way I could transform the character of this fat from a chaotic and unsettled state to a very solid condition of form … [with] a geometrical context as its end.'[4] And, indeed, Beuys' allegorical use of substances, and his constant insinuation of his own body into a network of myth, was devoted to this idea of breathing *logos* into his materials, so that by assuming form they would also be resurrected as meaning.

Beuys' notion of total recuperation connected to a system from which nothing escapes being impressed into the service of meaning is thus involved in an idea of the sacred that is as far away as possible from that of Bataille's. Beuys' expressionism, his mythico-religious drive, found echoes in many other practices in post-war Europe, most prominently those of Hermann Nitsch, who dominated the Vienna *Aktionismus* group with his own performances of a redemptive version of sacrificial self-mutilation. As should be more than clear by now, the *formless* is inimical to this drive toward the transcendental, which always

tries to recuperate the excremental, or the sacrificial fall, by remaking it as *theme*.

NOTES

* In Yves Alain Bois and Rosalind Krauss, *Formless: A User's Guide* (Cambridge, MA: Zone Books/MIT Press, 1997), pp. 143–6.

1. Götz Adriani, et. al., *Joseph Beuys: Life and Works* (Woodbury, N.Y.: Barron's, 1979), p. 72, as cited by Benjamin Buchloh in 'Beuys: The Twilight of the Idol', *Artforum*, no. 18 (January 1980), p. 39 (reprinted in this volume).

2. See Georges Bataille, 'La Structure psychologique du fascisme' ('The Psychological Structure of Fascism'), *La Critique sociale*, no. 10 (Nov. 1933), pp. 159–65 and no. 11 (March 1934), pp. 205–11; Bataille, *Oeuvres complètes*, vol. I (Paris: Gallimard, 1970–), pp. 339–71; Bataille, *Visions of Excess: Selected Writings, 1927–1939*, ed. and trans. Allan Stoekl (Minneapolis: University of Minnesota Press, 1985), pp. 137–60.

3. Thierry de Duve, 'Joseph Beuys, or The Last of the Proletarians', *October* no. 45 (summer 1988).

4. Bernard Lamarche-Vadel, *Joseph Beuys, Is It about a Bicycle?* (Paris: Verona, 1985), pp. 91–93, as cited in Eric Michaud, 'The Ends of Art according to Beuys', *October*, no. 45 (summer 1988), p. 39.

Section IV

BEUYS, ART AND POLITICS

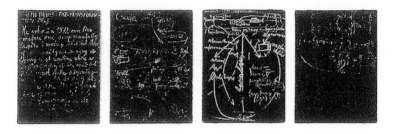

10.1. Joseph Beuys, *Four Blackboards*, 1972, Tate Gallery, London; © 2006 Artists Rights Society (ARS), New York/VG Bild-Kunst, Bonn.

10. 'QUESTIONS? YOU HAVE QUESTIONS?'
Joseph Beuys' Artistic Self-Presentation in *Fat Transformation Piece/Four Blackboards* (1972)*

BARBARA LANGE

A WORK BY JOSEPH Beuys with the lapidary title *Four Blackboards* entered the Tate Gallery in London in 1983 (Fig. 10.1).[1] Before this date it had been preserved behind a cabinet in the museum's archives as a relic of the performance *Fat Transformation Piece*, staged by the artist at the Tate in February of 1972. According to Beuys, the transfer of these objects – formerly valued as purely documentary – constituted a decisive step and altered the institution of the museum towards one of permanent conference, a site of relevant social reform. In a conversation with Horst Kurnitzky and Jeannot Simmen, Beuys stated that for him the presentation of the blackboards in the museum's galleries continued the discussion that his performances had initiated concerning social reform, achieved by using the creative potential of human beings. As a scenario of creativity within the museum, *Four Blackboards* should then function, by means of its inherent communicative structure, as a permanent system of inspiration.[2]

I want to follow the artist's demands by examining the work *Fat Transfomation Piece/Four Blackboards*, which has not yet been considered in art historical writing and which, in its clear contextual relations, offers an exemplary test case.[3] I will point out that these blackboards were not at all intended as an impulse for creative self-determination. In contrast to the artist's stated intention, they more likely functioned as an attempt at self-

assertion, that is, they had to do with Beuys' manifestation of the role of the (male) artist as genius, in the face of an increasing loss of this social position.

I

Fat Transformation Piece was performed by the artist at the Tate Gallery in London on 26 February 1972. Within the development of the artist's oeuvre, the performance profiled the role of the artist as a social reformer. Beuys had previously summed up this programme in the catchy poster *La revoluzione siamo noi*, printed on the occasion of the exhibition *Ciclo sull'opera di Joseph Beuys 1946–1971* at Lucio Amelio's Modern Art Agency gallery in Naples.[4] With this photograph, Beuys implied that he could initiate the necessary dynamics of social reform himself. The image expresses this visually by depicting Beuys alone, marching at a brisk pace towards the viewer.[5] In the first half of the 1970s, discussions, events and speeches with a duration of several hours, a whole month, or 100 days – such as *Fat Transformation Piece* – took on a key role in demonstrating the endurance of the artist as well as his artistic energy.[6] Here the artist wanted to give a necessary impulse for the public to take part in the evolutionary renewal of society on the basis of creativity. This role as initiator of a social reform movement is constructed by means of a process of interactions which Beuys knew to manipulate, and by the descriptive practice of art history and art criticism, which took on the conditions of its interpretation in creating and reaffirming the culturally established presumption of the autonomous artist.

II

Fat Transformation Piece was Beuys' main contribution to *Seven Exhibitions*, a milestone in the history of the Tate Gallery; staged between 24 February and 23 March 1972, it was the first conceptual art exhibition to take place at this renowned institution. With this exhibition, an art movement that took a critical attitude towards the usual forms of art, their presentation and reception, was considered *within* an established British art institution.[7] As an open forum in search of a new notion of art, this exhibition articulated demands which are programmatically revealed in the event's title: at a loss for a common norm for art,

the group exhibition could only be realized in presenting seven separate and parallel exhibitions.

Seven artists were invited by the Tate Gallery to contribute a work in their chosen medium within a span of four weeks.[8] The selection of participants was determined by discussions in the British art scene at that time. Six of the artists, Keith Arnatt, Michael Craig-Martin, Hamish Fulton, Bob Law, Bruce McLean and David Tremlett, had attracted attention in London through gallery exhibitions and performances that questioned conventional practices of representation in art. In *Seven Exhibitions*, Keith Arnatt demonstrated how meaningless and opaque descriptions of art can be in his use of the technique of photomontage; Michael Craig-Martin installed a hall of mirrors, in which he revealed the dynamics of reception; Hamish Fulton presented a slide show; Bob Law wanted to transform every visitor into an artist by means of a huge paper roll where every exhibition visitor could enter him or herself onto an expanding column of numbers (representing counted artists); Bruce McLean criticized art commerce with a one-day retrospective of his work.[9]

Joseph Beuys, who was invited through the negotiation of the Edinburgh gallerist Richard Demarco, played the role of the outsider and not only because of his older age; Beuys was the only artist less anchored in the British art scene and more established in the art scene of the continent. He had participated in the widely recognized exhibition *When Attitudes Become Form* (1969), curated by Harald Szeemann. This exhibition established a context and discussion of a new understanding of art.[10] Beuys' invitation to *Seven Exhibitions* was mainly the result of the attention that his performance *Celtic (Kinloch Rannoch) Schottische Symphonie* (26–30 August 1970, Edinburgh, Edinburgh College of Art, together with Henning Christiansen) had garnered amongst the British art public. The hope was that Beuys would make a similar contribution to *Seven Exhibitions*.[11] Beuys in fact presented himself as a performance artist: for the first two weeks, documentary films and videos of earlier performances were screened, and on 26 February he appeared in person for the first time.[12] His title *Fat Transformation Piece* referred directly to his contribution to *When Attitudes Become Form*, at the Institute of Contemporary Arts (ICA) in the autumn of 1969, where he

was represented with a *Fat Piece*.[13] During his subsequent visit – his first public appearance in England – he presented a quasi-continuation to the London public, the transformation of the material fat corner into social action.

Beuys had prepared the public for *Fat Transformation Piece*. Like his colleagues, he used the exhibition catalogue to disseminate information. It consisted of a (European) DIN A4-sized brown envelope in which the artists included posters and invitation cards to announce their events. While the other artists kept to themes immanent to the commerce of art – Craig-Martin documented the dates of his education and exhibition history, Law gave insight into the mechanism of his number-roll – Beuys, in contrast, underscored the general social relevance of his engagement: the recto side of his poster reproduced photographs of the Berlin performance *Eurasia* (31 October 1966, Berlin, Galerie René Block) and *Ich versuche dich freizulassen (machen)* ('I try to set (make) you free') (27 February 1969, Berlin, Akademie der Künste; Fig. 10.2); the verso featured the English translation of the informational flyers of the *Office for Direct Democracy by Referendum* (Fig. 10.3). For those who already knew about Beuys' performances, the poster revealed a classical, three-step exposition of meaning. Beuys determined the formal design of *Fat Transformation Piece* as a discussion-event due to the necessity of having to convince, through debate, with a combination of: 1) a photograph of a performance which dealt with the balance of opposing forces;[14] 2) a photograph of a failed performance, which intended to deal with freeing spiritual energies but was interrupted and vandalized

10.2. Joseph Beuys, *Ich versuche dich freizulassen (machen)* ('I try to set (make) you free') (27 February 1969, Berlin, Akademie der Künste), poster for the exhibition *Seven Exhibitions*, 1972, Tate Gallery, London; © 2006 Artists Rights Society (ARS), New York/VG Bild-Kunst, Bonn.

10.3. Verso of Fig. 10.2, features the English translation of informational flyers from the Office for Direct Democracy by Referendum; © 2006 Artists Rights Society (ARS), New York/ VG Bild-Kunst, Bonn.

by the public and was not realized as originally planned;[15] and 3) texts with the political programme for eliminating the causes of vandalism. While his colleagues based their self-representations on evidence and objectivity – usually in regard to their artistic curriculum vitae or the function of the art object – Beuys articulated, through the customary technique of argument, a demand logically grounded in personal experience. This demand formed the basis for the construction of a genuine relation between the artist's persona and a given social reality.

III

Fat Transformation Piece took place in the highly frequented rotunda of the Tate Gallery. Each visitor had to pass through this space while choosing a route through the museum's galleries. In the course of the six-hour performance (which is documented in a tape recording),[16] the room was constantly filled with people.[17] Many came to see the internationally renowned artist, but those who more or less accidentally visited the Tate on this Saturday afternoon came across the discussant guest from Germany as well. Beuys was prepared for this mixed and changing audience. A podium was constructed in front of a wall onto which four blackboards were attached;[18] one was inscribed with the moral and appellative text (Fig. 10.1, left board):

JOSEPH BEUYS: FAT TRANSFORMATION PIECE. He who in 1972 can live carefree and sleep peacefully despite knowing that two thirds of humanity are hungry or dying of starvation while a large proportion

of well-fed third must take slimming cures in order to
stay alive should ask himself what kind of man he is,
whether [sic] moreover he is a man at all.[19]

From the podium, a microphone transmitted his voice to
nearby rooms. Flyers from the *Office for Direct Democracy by
Referendum* were distributed to visitors. Thus Beuys conceptually
demonstrated the roles of sender and receiver. Despite his
insufficient knowledge of the language, he wanted to hold the
discussion in English without the help of a translator. He was
interested in direct and immediate transmission. The enquiry he
repeated – 'Questions? You have questions?' – reveals that Beuys
did not aspire to change roles, where he then would have had to
give up his position of transmission, or his role as a teacher.

As the tape recording reveals, two major themes can be
discerned in the discussion, and which indicate the divergent
interests of the artist on one hand and the public on the other:
Beuys defined the majority of the six-hour performance, which
is documented in the *Four Blackboards*. Here the artist spread out
his political programme in a pontificating style. He criticized
global politicians, propagated the establishment of a people's
referendum, and demanded free schools.[20] To clarify his ideas he
drew white, red, yellow and blue charcoal sketches and diagrams
on the second blackboard from the left side (as they are installed
today); he used similar signs in other contexts to exemplify his
ideas.[21]

Due to an increasing disturbance among the audience, the
dialogue between the artist and the public was shortened.[22] One
part of the audience pointed to the intention of *Seven Exhibitions*
to open debate on new forms and concepts of art within the
frame of the exhibition. The artist-colleague Richard Hamilton,
who was present during the entire course of the performance,
attempted to characterize the structure of *Fat Transformation
Piece* as being in a constant fluctuation of tension, controversy
and relaxation.[23] Beuys showed little interest in this analysis.
He made it clear that, for him, the formal aspects of his work
were of less importance than the democratic ideas it propagated,
ideas which he could best disseminate in these kinds of public
discussions. When the criticism was voiced that only Beuys had
a microphone and therefore he only was audible for the entire

audience while other voices drowned in the murmur of the crowd, Beuys responded that he was following his duty as an artist in society to inform.[24] He ignored the main thrust of the criticism: that he assumed the dominant role throughout the discussion. His concentration on his own central role as stimulus for social reform conformed to his self-image: he articulated his demand for *Fat Transformation Piece* in the following manner: 'I hope I am developing a bit of you.'[25] Consequently, on the third blackboard from left (as they are installed today) he summarized his ideas only and not the statements of all participants in the discussion as a record of the performance (Fig. 10.4).[26] Here Beuys once more underscored the necessity of his own physical presence:

Creativity is the development of thinking ideas, and I

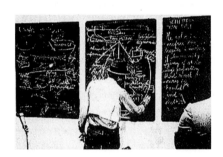

found out that the ideas [sic] process begins on a (border)[27] between reality who [sic] lies directly between the reality of material or physical, physical reality and another reality ..., where we are able to transform the [sic] ideas thought in one type environment, in the spiritual environment, when we use material like matrix or matrix like material. Simple to say [sic] we need to express our messages to other people beneath the material, at first as the human corpse by self [sic].[28]

10.4. Joseph Beuys, *Fat Transformation Piece*, 1972, Tate Gallery, London; © 2006 Artists Rights Society (ARS), New York/VG Bild-Kunst, Bonn.

IV

In the *Four Blackboards* which emerged from the performance of *Fat Transformation Piece*, Joseph Beuys based his self-portrayal on a traditional understanding of the unique role of the artist. This role was also manifested in post-war Germany through the confrontation with the experiences of National Socialism. While in the late 1940s and 1950s the unique role of the artist was

stabilized and grounded within the debate on modernism, by the mid 1960s the question of its legitimation was raised anew in the face of the development of new modes of thought in society.[29] In this discourse, Beuys sought a more concrete integration of the artist: the integration of his persona into a changing society. For this reason, he used the newly established scope of the 'public artist'. This meant that the artist was relevant, self-explaining and self-justifying based on the demands of society, in the manner that Donald Judd or Robert Smithson had exemplified in the international art scene during the 1960s.[30]

Unlike Craig-Martin and Law, and in contradiction to the intentions of conceptual art, Beuys retained the mystified position of the modern artist.[31] Since the early 1970s (as in *Fat Transformation Piece*), Beuys made use of the formal aspect of his physical presence in his exhibitions, where the image of an all-embracing, goal-oriented personality could be concretely demonstrated by endurance and patience. Furthermore, in *Seven Exhibitions* he used the free catalogue design space that the Tate Gallery offered to present this constructed identity in an image depicted on a poster. A dismissal of Beuys' dominating behaviour and pontificating style in the discussion as pure egocentrism and as an inscription of patriarchical hierachies would neglect the aspect of reassurance that is achieved by the presence of the audience and the public stage. The performance of the discussion functioned as a means of self-assurance in respect to Beuys' own position, which should have worked against the marginalizing of the artist in a technocratic society and the disillusioning end to the unique aspect of the artist's position. Here Beuys' self-presentation remained tied to the role of the (male) modern artist and continued the story of the heroic artist-persona, in opposition to an endangering loss of the value of that persona.

In fact, the main theme of Beuys' theory of social sculpture was not the importance of the artist in society, but instead the desire to integrate the artist with a social task in society, a desire motivated in many respects by the Christian tradition. With his repeated, almost formulaic question in *Fat Transformation Piece*, 'Questions? You have questions?' he attempted to create this connection between the artist and the audience, a position which Beuys manifested in material form through the *Four Blackboards*.

NOTES

* First published in Inge Lorenz (ed.), *Joseph Beuys Symposium Kranenburg 1995* (Basel: Wiese Verlag, 1996), pp. 164–71. Translated by Viola Michely. See also Barbara Lange, 'Joseph Beuys: Der Mythos vom Künstler als Gesellschaftsreformer' ('Joseph Beuys: Myth of the Artist as Social Reformer') in *Joseph Beuys: Directional Forces of a New Society. Myth of the Artist as Social Reformer* (Berlin: Reimer Verlag, 1999). This essay is based on one chapter of my habilitation from the Department of Philosophy at University of Kiel. I thank the employees of the Tate Library London for their help in reconstructing the performance *Fat Transformation Piece,* as well as the German Research Society (DFG), which supported me with a grant for the necessary research travel to London.

1. Each blackboard has the dimensions 121.6 x 91.4 x 1.8 cm, Inventory Number: T 03594.

2. Joseph Beuys, Horst Kurnitzky and Jeannot Simmen, 'Das Museum – ein Ort der permanenten Konferenz' ('The Museum: A place of permanent conference'), in *Notizbuch 3. Kunst Gesellschaft, Museum,* ed. Horst Kurnitzky (Berlin: 1980), 47–74. In this conversation between Beuys, Kurnitzky, and Simmen, Beuys gives his definitions of 'permanent conference' and 'permanent inspiration system' (64). Beuys explicitly refers to the installation *Directional Forces,* which consists of 100 blackboards (1974–1977, Berlin, Staatliche Museen zu Berlin Preussischer Kulturbesitz, Nationalgalerie). As I point out in detail in my habilitation, 'Joseph Beuys: Myth of an Artist as Social Reformer', *Fat Transformation Piece/Four Blackboards* is a direct precursor to the work *Directional Forces.* The artist's remarks on *Directional Forces* also refer to the other four blackboards.

3. 'Beuys was here,' *Frankfurter Allgemeine Zeitung,* 29 November 1972. The performance *Fat Transformation Piece* is noted in the anonymous published report. The performance is also noted in the eye-witness report of Penelope Marcus, a research assistant at the Tate Gallery. Penelope Marcus, 'Entretien avec Joseph Beuys,' *arTitudes,* March 1972. Both sources only partially describe the performance and neither includes a wider context. The blackboards which I only briefly describe here were first published in *The Tate Gallery Illustrated Catalogue of Acquisitions 1982–84* (London: 1986), 100.

4. Achille Bonito Oliva and Filiberto Menna, text in *La rivoluzione siamo noi – partitura di Joseph Beuys* (Naples: Modern Art Agency,

1971). The text by Achille Bonito Oliva is published in an English translation in *Umbrella* 1, no. 3 (1973), as well as in a small catalogue of the Dayton Gallery, Minnesota, 1974. Parts of the discussion Beuys held at the opening of the exhibition are documented in the video tape *Lucio Amelio, Vent'anni con Beuys* (Berlin: Staatliche Museen zu Berlin Preussischer Kulturbesitz, Nationalgalerie Archiv Beuys Audio-visuell, 18 October 1991), video recording.

5. The poster with the photograph by Giancarlo Pancaldi refers to the painting by Guiseppe Pelizza da Volpedo, *Il quarto stato* (Milano: Galleria d'Arte Moderna, 1901). This painting became a political icon for awakening social movements in Europe during the late 1960s and early 1970s. In the exhibition poster, the advancing group in Pelizza da Volpedo's painting is reduced to the single figure of Beuys.

6. Uwe M. Schneede, *Joseph Beuys. Die Aktionen. Kommentiertes Werkverzeichnis und fotographische Dokumentationen* (Ostfildern-Ruit/Stuttgart: Verlag Gerd Hatje, 1994), pp. 6–7. Although Schneede remarks in his catalogue raisonné of the artist's performances that Beuys' widely understood term 'Aktion' included 'lectures and demonstrations, speeches, activities of the political party and discussions or ritualized installation of art,' Schneede excludes them from his publication without notation or explanation. It remains for art history to specifically document Beuys' performance art of the late 1960s and early 1970s and to analyze how art form and daily experience are interwoven by the artist in discussions and lectures.

7. *The Tate Gallery 1972–1974. Biennial Report and Illustrated Catalogue of Acquisitions* (London: Tate Gallery London, 1975), 29. For the questionable term conceptual art, see Benjamin Buchloh, 'Conceptual Art 1962–1969: From Aesthetic of Administration to the Critique of Institutions,' *October* 55 (Winter 1990), pp. 105–143; 107–108. This essay was first published in the exhibition catalogue *L'Art conceptuel: une perspective* (Paris: Musée d'art moderne de la ville de Paris, 1989). See also, in conjunction with Arte Povera, Thomas Dreher, *Konzeptuelle Kunst in Amerika und England zwischen 1963 und 1976* (Frankfurt/Main, 1992), pp. 39–45.

8. 'Seven Exhibitions: Introductory Note', in *Seven Exhibitions* (London: Tate Gallery, 1972).

9. See Guy Brett, 'Live action pieces at the Tate', *The Times*, 29 February 1972.

10. Harald Szeemann, Foreword, *Live in Your Head. When Attitudes*

Become Form. Works - Concept - Processes - Situations - Information (Bern: Kunsthalle Bern, 1969). In addition to the foreword, Szeemann's own historicization of the exhibition is included: 'When Attitudes Become Form, Bern, 1969,' in *Die Kunst der Ausstellung. Eine Dokumentation dreissig esemplarischer Kunstausstellungen dieses Jahrhunderts*, Bernd Klüser and Katharina Hegewish (eds.)(Frankfurt/Main: Insel Verlag, 1991), pp. 212–19.

11. 'Fat Transformation Piece' in Tate Archive, London, TAV 616A Tape 2; Transcription, 18, tape recording transcription.

12. Caroline Tisdall, 'Joseph Beuys,' *The Guardian*, 28 February 1972 (also published in the Manchester edition of *The Guardian*, 29 February 1972). In addition to the already cited critiques of this performance (see Note 4), it was also discussed by Guy Brett (see Note 10) and here, by Caroline Tisdall.

13. Shunk-Kender, portrait of Joseph Beuys, *Avalanche* 1 (1970): 28–33. See the portrait of Joseph Beuys during the installation of his work for *When Attitudes Become Form* at the Kunsthalle Bern.

14. Schneede, *Joseph Beuys: Die Aktionen*, pp. 127–132; for photographs that document the performance, pp. 138–145.

15. Schneede, *Joseph Beuys: Die Aktionen*, pp. 224–227; for photographs that document the performance, pp. 228–231.

16. Tate Archive, London, TAV 616A Tape 1 and 2; transcriptions. These tapes in the Tate Archives were for the most part transcribed in the 1970s. Due to the poor condition of the tapes, my reconstruction of the perfomance is mainly based on the transcripts. In the photographic documentation which illustrates the article by Guy Brett (see Note 10), a person with a film or video camera is included in the background. This supports Brett's statement that the performance was documented on video. Nevertheless, this video documentation has not been found.

17. TAV 616A Tape 2; Transcript, pp. 20–2. In the discussion regarding the use of the microphone on the afternoon of this day, 80 people were counted in attendance. Throughout this discussion it is obvious that an equal number of people were present for the entire duration of the performance.

18. Photographic documentation shows only three blackboards. The blackboard which is currently installed on the right and whose white charcoal diagram of the social triad is turned 90 degrees probably belongs to another context.

19. During the performance, this blackboard was placed on the

right while it is currently installed on the left as a starting point and introduction, according to the Latin reading system.

20. TAV 616A, Tape 1; transcript, pp. 1–14. Beuys brought these topics into the discussion from the start.

21. Franz-Joachim Verspohl, *Zeichnen ist eigentlich … nichts anderes als eine Planung (to draw is actually nothing else but to plan). Joseph Beuys bei der Tafelarbeit (Joseph Beuys at work with blackboards)* (Mönchengladbach: Galerie Löhrl Mönchengladbach, 1988). This essay includes an example of two blackboards he completed while teaching as a guest professor at the art academy (Hochschule der bildenden Künste) in Hamburg during the winter of 1974–1975). Later, Beuys stopped using colored charcoal.

22. TAV 616A, Tape 2; Transcript, p. 12. This phase of the discussion begins here.

23. TAV 616A, Tape 2; Transcript, pp. 23–9. See this exchange and the dialogue when Hamilton also questioned Beuys' artistic theory.

24. TAV 616A, Tape 2; Transcript, pp. 13–14.

25. TAV 616A, Tape 2; Transcript, p. 7.

26. TAV 616A, Tape 2; Transcript, pp. 30–2. In this summary, Beuys again explains in great detail the meaning of each sign on the blackboard.

27. TAV 616A, Tape 2; Transcript, p. 32. Here the transcript suggests the senseless term 'bauble' or 'bubble'.

28. TAV 616A, Tape 2; Transcript, p. 32.

29. Lange, *Joseph Beuys: Der Mythos vom Künstler*, Part I, Ch. 1 and 4.

30. Charles Harrison and Paul Wood, 'Modernity and Modernism Reconsidered,' in *Modernism in Dispute: Art Since the Forties*, Paul Wood (ed.)(New Haven and London: Yale University Press and the Open University, 1993), pp. 170–260. For changes in art production and reception see *Six Years: The Dematerialization of the Art Object from 1966 to 1972*, ed. Lucy Lippard (London and New York: Praeger, 1973).

31. *Tate Gallery. An Illustrated Companion* (London 1990), 266; also Mel Ramsden and Michael Baldwin, 'Art & Language on Beuys,' *The Independent* 30 January 1990. After Simon Wilson introduced Joseph Beuys, along with these blackboards, as one of the most charismatic figures of the conceptual art scene, Mel Ramsden and Michael Baldwin articulated their harsh critique of *Four Blackboards*: 'a massive success in self-mythologizing, literal falsehood and gullibility.'

11. EVERY MAN AN ARTIST

Talks at Documenta V

by Joseph Beuys*

Clara Bodenmann-Ritter

Joseph Beuys' contribution to the *Documenta 5* exhibition is the *Office for Direct Democracy*. Beuys is present in Kassel for one hundred days. He discusses different subjects with visitors and speaks from morning until evening. Beuys explains, 'Explanation is also an art form.' What does Beuys have in mind with his demand for 'more creativity for every person'?

Many visitors who come once return. They feel that Beuys addresses their natural desire to develop themselves. Some simply feel encouraged, which is the first stimulus towards the development of a free personality. Beuys states, 'One must make it palatable to people that it is interesting to totally abandon oneself with all of the mistakes that one has. I just want to encourage people not to wait for an ideal state of awareness. They must begin with the current means and with their mistakes.' Beuys' encouragement incites action and many are compelled to do something. Working groups are forming in Germany and abroad.

The conversations reproduced here were recorded over the course of one weekend in Beuys' 'Office' by Clara Bodenmann-Ritter. They correspond to the course of these discussions with unchanged dictation; they give a picture of the course of two days in this office. In a few places in the manuscript, Joseph Beuys later completed or clarified certain aspects of these conversations.

[...] B: Yes. Now we are at the starting point again. Now we are at our real issue: that we understand ourselves first as sites

of education, for information for democracy, for a three-part structure, and so on.

That would be a kind of circulation then?

B: We have to ensure that it is structured organically so that it functions like a person functions internally, like the organs function ... First, in the examination of the matter. Secondly, in that one develops a concept of ... a social order that has never existed before. That simply means: to realize freedom, democracy, and socialism – free democratic socialism. And for this one needs the model of the three-part structure, decartelization on a large scale, so that the domain of culture, all that which makes

11.1. Photograph, Beuys in *Documenta Office for Direct Democracy*, Kassel, 1972; © 2006 Artists Rights Society (ARS), New York/VG Bild-Kunst, Bonn.

up intellectual life, is administered on its own, that the basic structure of law is chosen by the people in terms of its basic principles and that likewise, economic life becomes autonomous but must hold itself to the people's democratic constitution.

... Our plan is to gradually get laws into the constitution accordingly ... in order to be there at the end of the century, we have to work on the issue now ... In the meantime, there are many people who understand this. There are already a large number of people who have insight into this issue and want to handle it accordingly. So one must strengthen these minorities.

But through what type of mechanism?

B: Through bargaining. Through thinking and bargaining. There is no other possibility ... Here [at *Documenta*] we introduce the model of an information-site. We are interested in developing as many information-sites as possible in the near future as educational sites for democracy, for freedom, democracy and

socialism. That is our task. We can only solve this as well as possible, reveal with it or produce something out of it that can function as a model, that is, something that other people will also do. For example, when we leave Kassel, a working group or maybe two working groups will work on things here in Kassel. We want to cause a snowball effect. We want to build a network throughout Europe that will work on these things, right? I can only say: of course we can only do it as well as possible.

When you try then, inside of this snowball[ing] system, to present alternative models of schools, subculture or whatever you want to call it...

B: No. We don't want subculture. I didn't say that ... this is not to deny the fact that some very good elements are working in subculture. We don't just want subculture, we want real culture.

It is classified as a subculture.

B: Because it is understood as anti-social.

... So the people that work in your sense don't acknowledge the difference between subculture and culture any more?

B: I don't acknowledge it anyway. We only acknowledge it under certain circumstances.

You must realize, however, Mr Beuys, that there is an enormous mechanism behind this. That is when you have your school, someone may enter it but he is still not free of the compulsory education that is forced on him by the state. That means that he is not allowed to go to Beuys, but must attend a state school instead. He cannot get around this.

B: But why...

No, he cannot go to you...

B: Sure.

Are you building an elementary school that...

B: That is exactly my idea. I want to found a free school for creativity and interdisciplinary research in Düsseldorf. I hope that I will succeed. Everyone can come to me. This school has

a legal status. The basic law offers enough possibilities to found free schools and private schools according to a new model, for example.

But for how many?
 B: Yes, of course. That can naturally be a starting point again. It can also just set an example that awakens interest so that the people say yes, this works better, so we want it that way.

And the constitution allows for this possibility?
 B: Sure.

I would argue against that.
 B: ... First a school is there to develop ability, that is, consciousness. And when the school develops consciousness, then the children will recognize what a future social structure should look like; that means, that one can learn a social feeling or a social sense or knowledge in a free school like this.

Only there, of course. But in our regular schools one is not allowed this, that is clear.
 B: Wait a minute!

What does it mean, 'one is not allowed'? One can do so much, that is here or there in the context of the diagram that is being presented here without being immediately reprimanded.
 B: Yes. Most don't try it, though. Most just talk.

But it is not desired.
 B: But you don't have to do that which is desired; instead do that which is the result of your own thinking.

Thinking must first be prompted, though.
 B: Thinking must be prompted in everyone.

But it isn't.
 B: You say it isn't. But I have been troubling myself with this issue for years.
You want to create a school where that (independent thought) can be done. Where the teachers...

B: There are also other schools where it can be done. You have to be careful about these overall judgements. Enough intent exists among people who think in this direction. So one must organize these people. They must, shall we say, operate a network and must increasingly teach the majority the direction in which one must think.

The work of Sisyphus!
B: Not Sisyphus. It is a difficult job but one that pays off. And is interesting precisely because it is difficult.

But first there must be a start to it.
B: One beginning is already available, though.

Naturally this is a beginning. I also find it an important one. I just doubt that the established power…
B: But your doubt is not useful. Let's determine that your doubt is not useful to you. If you recognized something good, that is, when you have an idea of where one must go, doubt is of no use, in that one despairs over the difficulty. One says, the power is so vast, the counter-power is so vast…

We misunderstood each other here. I am missing the way, that is, with me…
B: You are perfectly entitled to that. But you can't do that in your head for all eternity, instead, if possible, attempt to practise as a model. One gains a lot more experience this way than when one just broods over these things.

… And these doubts, understood in terms of what you just said, would then be a constant doubt, while doubt can also be interpreted differently.
B: I don't doubt at all, no.

But this is also a form of resignation.
B: Me? No, excuse me. When I criticize it is something positive. Wait a minute. What criticism?

I criticize this alternative model, the way you are thinking of it…
B: You still know it … First, you are criticizing something that

you have not yet fully understood. Now first read through this in detail. If you find mistakes, you are invited to tell me about these mistakes. You want to criticize something generally that you have not yet examined sufficiently.

My criticism is clearly without an exact knowledge, but it is a positive criticism, not destructive.
 B: Yes, yes.

It is only criticism in that with this snowball effect – now a question that will not be answered by this issue – it is a question that one can possibly solve through consensus – such a snowball effect takes an enormous amount of time and its effectiveness is enormously meagre.
Yes, when you doubt it from the beginning.
But I am not doubting.
 B: No...

I'm not... I also want to have this alternative model, I also want to carry out a type of sensible socialism somewhere. But I am not of the opinion that one can accomplish this by a snowball-like production.
 B: Yes, well then tell me how one could accomplish this.

Well, so easily... would say, to slip into the existing places slowly and then there...
 B: Yes, that is what we are doing.

No, I believe that would be the bigger multiplier.
 B: What do you mean by that?

The children that would then possibly come to this school are those whose parents can make it possible, or whose parents already have this awareness. Because the typical parent would not send their children to a school like this. You must agree.
 B: But why? They are already torn about this. In principle, I am already practising a free school at a state school. That means, I am not concerning myself with the department of culture.

I know that. But is that sensible, is that correct? Let's say the people that come to you are those whose parents could facilitate it...

B: Whatever! But I have a bunch of working-class children who don't have anything. So I will go in with a grant as long as there is nothing better.

But working-class children can also have an awareness, a good awareness.
B: Right.

But it's about awakening this awareness in people that don't have it.
B: Where can one awaken awareness? ... School is universal. That means, on the street – when you talk about these things with people at the grocer's, the school is at the grocer's at that moment. That means that the educational process not only takes place in schools, but begins when people talk to people about these things.

For that reason I am also of the opinion that I would be the bigger multiplier if I were a teacher. I'm not. If it were the case that I was a teacher in middle school or high school or somewhere I would certainly have a bigger percentage of ... students lacking awareness than you have at your school, where there is interest in the same things.
B: What you say is right – when you say you would have to be the multiplier. I can't accomplish this multiplication alone. So you have to act. Everyone must. Everyone!

I just want to encourage everyone to take this into their own hands, the educational process. Everyone that already can or who could at the moment – we don't need a brilliant talent somewhere. Precisely the ability that one has at the moment must be put to work.

I'm just wondering: How efficiently can I even address all of these problems? Not by, like you said, creeping slowly into institutions through which one would then have a greater influence, but instead to begin working on it at that moment, in which one has recognized that something like this is right, regardless if you are standing at the lathe or...
B: What is your profession anyway? This possibility is probably an absolute given in your job.

Editor (laughing); this is great, though: it's also the job for this.

Isn't it clear that it's easier to disassemble an existing process that appears to us to be negative than to establish a counter-power? If I, for example, or people in my profession, wanted to make a 'counter-cultural' newspaper it would be a tremendous expenditure… Wouldn't it be more sensible to enter the Springer publishing concern?

B: That would be an example of a task for you. Go to the Springer firm and try to change the Springer newspaper.

I wouldn't be able to.

B: I go to the typical state school and try to infiltrate it. Yes! But I'm not giving up, I'm also not sacrificing doing something on the outside. One can do something in the institutions in trying to infiltrate them and outside one can do something to set a model in place … That is my opinion. One must work with diverse methods anyway. One must always carry on with what is possible.

We also have groups in Southern Germany that are working on the same things, but with different methods. I can't really judge from here what is possible in [the state of] Schleswig-Holstein at the moment. They have to determine that through their own initiative because they know the social situation: what problem is the most important, what has priority? Which method is suitable, either to infiltrate, or to set up a model [outside the institution], or, what doesn't work?

Is there, shall we say, an idea that's moving away from the parliamentary system – where to? To the council system?

B: To democracy. Yes we call it a council system or an active-trustee administration.

Okay, so a council system.

B: Yes, right. But a true one, without a central government.

Without a central government? And who controls cross-regional necessities?

B: The trustees. The councils – those that develop only according to a construction from the bottom up, not a government from the top down. Strangely, many say the council model is good but they don't quite want to get rid of the government format, for example. But we want to get rid of the from-the-top-down

form of government and only want a government built from the bottom up. Then one can organically reach centralized organizations that don't function centrally.

Decentralization, right?
B: I don't want to say that because we need centralized task functions. Decentralization wouldn't mean any- and everything to me. In this case what does the central self-governing organ look like?

... But government from the top down is still present visually. Even with the council system there is a leader somewhere.
B: A representative. For example, a first chairman. But the government no longer functions from the top down, that is, parties can no longer make laws without majority opinion however they please, without asking the majority, as it is possible now, as it is possible in Soviet Russia. Rather the people must be asked about decisions here that deal with the constitution, for example. And the other legal decisions lie with the self-governing committees, such as business policies, school policies, etc.

Yes, I find that sensible. It is clear; it assumes that everyone is political.
B: Yes. No area of life will be free from this concept in the future. That means that people will recognize the social organism, and they must think within this context. They must not only think about schools but also about the legal system and economic structures. They must always think through the entire social organism. [...]

NOTE

* Excerpt from *Every Man an Artist: Talks at Documenta V by Joseph Beuys* ('Jeder Mensch ein Kunstler: Gesprache an der Documenta V'), ed. Clara Bodenmann-Ritter (Frankfurt: Ullstein, 1972; 6th edition, 1997), pp. 5–20.

12. INSTITUTIONALIZING SOCIAL SCULPTURE

Beuys' *Office for Direct Democracy through Referendum* Installation (1972)*

CLAUDIA MESCH

Our suggestion: Equal rights for men and women! 20 years of party politics have not managed to realize this basic right: the recognition of domestic work as labor (career); to legally place this career on an equal level with others and to legitimate it through salary. Homemakers salaries! Women and men! If you would like to support our work toward the citizens' demand to secure a true equal rights for women, then please sign this list. True freedom for women.[1]

Blackboard, Office for Direct Democracy, Kassel, 1972

BEGINNING IN THE LATE 1960s, Beuys conducted his artistic work along two paths, or as he called it, as a 'parallel process'.[2] Beuys produced sculptures, objects, multiples, installations and action-performances on the one hand, and, on the other, he established a number of counter-institutional frameworks for what he termed 'permanent conference', or, for the public debate and discussion of a multitude of social and political issues. By means of these institutions and their wide-ranging discussions, Beuys would realize his theoretical system of social sculpture and the 'expanded notion of art'. In the 1970s, Beuys would render his theory, which posited the existence of radical individual freedom or agency in the contemporary world, into the practice

of intersubjective communication within the sphere of art. Beuys believed that deep social and political reform could be realized beyond the cultural sphere in this art. Initially Beuys established these institutions as political parties, the first of which, the 'German Students' Party', he helped found in Düsseldorf in 1967. Later Beuys reconfigured this party into the 'Organization for Direct Democracy', an activist organization that advocated the people's referendum as the key mechanism which would redemocratize society.[3]

Beuys' preoccupation with institutional systems after 1972 marks the secularizing shift in his production toward conceptual art practice. While Beuys is often not included in the recent histories of this artistic direction, this essay will focus on Beuys' institutionally centred conceptual project, the *Büro der Organization für direkte Demokratie durch Volksabstimmung* ('Organizational Office for Direct Democracy through People's Referendum', hereafter 'ODD') at Documenta in 1972, and outline how Beuys' institutionally focused works of the early 1970s problematized developments in art that have come to be described as 'conceptual' in nature.[4] Through the discussions of the ODD Beuys critiqued the celebrations of positivism, or the traditions of Enlightenment thought, which formed the basis of the most empirically driven practices of conceptual art by Joseph Kosuth, the British Art and Language group, and Hans Haacke. Beuys grounded his counter-institutions in the 'intuitive' theoretical system of 'social sculpture'. As Beuys implemented it, the exchange of individual opinions within an open public dialogue and debate comprised social sculpture; a functioning and unmediated public sphere therefore became the realization of social sculpture. Beuys advocated the 'grassroots' process of *Volksabstimmung* or people's referendum as a way to inject true public debate into the political process. Free public discussion and the political implementation of its conclusions formed the basis of the ODD in West Germany and in several other countries. As is the case with most conceptual artwork, these Beuys works generally depart with the production of the material object; however, Beuys continued to emphasize the importance of form and material within his work.

I take the term 'public sphere' from Jürgen Habermas' historical delineation of the phenomenon in *The Structural Transformation*

of the Public Sphere, published in German in 1962. Habermas traced the development and decay of an intermediate sphere of activity in modern society formed by the bourgeois class, which he defines as the bourgeois public sphere, realized between the public realm controlled by the state and the private realm. Habermas connects changes within culture in modern (western) society to political and economic conditions in the eighteenth and early nineteenth centuries. Peter Hohendahl notes that Habermas' conception of the public sphere functions both as an historical construct, i.e. 'the classical public sphere' and its demise, and as a normative one, as a set of conditions which are still desirable although they have collapsed 'irretrievably' with the passing of history.[5] As an ideal the classical bourgeois public sphere consisted of individuals who critiqued – and may have chosen to reject – the regulations of the state through 'critical-rational public debate', an intellectual activity that also had to do with issues raised within cultural production. The public sphere became established as 'a forum in which the private people, come together to form a public, readied themselves to compel public authority to legitimate itself before public opinion'.[6] Of course, property, class and gender relations determined those individuals who could access and contribute to this forum, and who could become the subjects of this public sphere.

As new media forms blossomed, intellectuals in the 1960s concerned themselves with the issue of communication within mass media society. Marshall McLuhan celebrated mass culture society and idealized the utopian possibilities inherent to the budding technology of television.[7] McLuhan's optimism found its counterpart in American Pop Art's visual affirmation of consumer icons, as it was developed in American painting in the early to mid 1960s by Warhol, Lichtenstein, Rosenquist and Wesselman. Much intellectual analysis of these years focused not on the lack of rational discourse in late capitalist mass culture society as Habermas did but generated models which posited the increasing impossibility of communication, the element most necessary to any functioning discourse. This pessimistic view of communication in mass media society had generally been argued by Horkheimer and Adorno in the *Dialectic of Enlightenment*. Their view of a totally administered culture claimed that communication existed only in one direction, from

state and corporate interests down to the private individual. Guy Debord and Hans Magnus Enzensberger continued this view of total administration which culminated in Jean Baudrillard's 'simulationist' model of communication and of experience itself.[8] Michel Foucault's model of the panopticon, and Louis Althussar's notion of the ISA or 'institutional state apparatus', presented other totalizing philosophical scenarios of complete state control through surveillance, and further posited the effective end of intersubjective communication within late capitalist society.[9]

Peter Bürger noted that Habermas viewed the strict separation of the activities of the spheres of science, ethics and art as part of the historical evolution of modernity; therefore he could only view the mantra of Fluxus and Allan Kaprow in the 1960s about the conjoining of art and life as a wishful but impossible step back to pre-modern conditions before these spheres had been differentiated.[10] Beuys' counter-institutional forums for rational discourse could also accommodate epistemologies alternative to the rationalizing and modernizing agendas of the Enlightenment. Beuys mounted a complex attempt to implement theory into practice and to realize the 'life into art/art into life' motto first enunciated by Robert Rauschenberg. Beuys introduced the ODD into established state institutions: first, at the art academy in Düsseldorf, and then into the institution of the art museum, most successfully in his Documenta installations of 1972, 1977, and 1982. Beuys institutionalized a public sphere within the museum, thereby reforming the museum into a site for broad public rational discourse on matters of social and political change. Beuys designated these institutions and the debates they engendered as manifestations of individual creativity and as public realizations of social sculpture. In equating the communicating individual as a producer of art, Beuys insisted on the rational possibilities of intersubjective communication initiated in art as a point of connection between autonomous and critical individuals.

The successes of the political programmes proposed by the ODD – particularly as they were integrated for a short time into the 'alternative grassroots' political party, die Grünen – was evidence that Beuys' realization of individual agency (within a public sphere) extended beyond the sphere of art. To do

so, Beuys also followed alternative models of society which envisioned a broad range of creative activity as art and rejected the strict positivistic separation of social spheres that Habermas describes. In the ODD, Beuys debated the viability of alternative conceptions, or counter-Enlightenment epistemologies, offered by Friedrich Schiller (in his notion of 'aesthetic education') and, in the twentieth century, by Rudolf Steiner.[11] In the late 1960s, Herbert Marcuse most powerfully theorized the possibility, even the necessity, of profound social and political change originating in and finally collapsing the sphere of art, although he (unlike Beuys!) quickly retreated from this position.[12]

Beuys' route toward an engaged conceptual art was attacked vociferously from the start, by the mass media who branded him a 'charlatan', and, on a more eloquent level, by other artists, most famously Marcel Broodthaers. It is of interest to note that Broodthaers' lyrical attack on Beuys is itself an act of remembrance and repetition, since his criticism of Beuys recapitulated Stephan Mallarmé's attack on Richard Wagner, first published in 1885.[13] The Broodthaers/Beuys debate concerning the possibilities of engaged art has cast a long shadow in US art history, and merits a study of its own. I will not trace its development here, but I will note that the performative aspect of Beuys' conceptual project of public *communication*, of the confrontation of ideas that approaches an ideal and unmediated public sphere, was a strategy antithetical to Broodthaers' sensibility and to his theory of language.

From Düsseldorf Activism to Institutional Critique

When Harald Szeemann invited Beuys to participate at Documenta 5 as part of the exhibition *Individual Mythologies*, Beuys transferred the contents of the Düsseldorf ODD informational office to the site of the exhibition. He and Karl Fastabend manned the office there each day for the three months of the exhibition and engaged visitors in social, political, and philosophical debate.[14] Beuys similarly transplanted the ODD office for the exhibition *Kunst im Politischen Kampf* (Kunstverein Hannover, 1973). Beuys used blackboards to punctuate discussion, first in the exhibition *La Rivoluzione* in Naples in 1971, and for the later exhibitions *Kunst/Mensch* at the Museum Folkswang in Essen, the Tate Gallery and the Whitechapel Art Gallery in London; the *Art into Society*

exhibition in London in 1974; and for a lecture-discussion staged at the Studenski Centro in Belgrade, Yugoslavia, of that same year.[15] Beuys travelled widely across Europe and the USA for the first time in 1974. Beuys' streamlined presentation of lecture-discussions related to the logistics of travel; a discussion with blackboards acquired at the site of discussion was economically more feasible than the continued transfer and reconstruction of the ODD information office.

Both the ODD and Beuys' ODD-related installations of the 1970s grew out of a number of activist organizations that Beuys and students had organized at the Düsseldorf Art Academy beginning in the 1960s. Arguably, these organizations reacted to the strained circumstances and mounting censorship of Beuys' work within the academy, in that they established forums for discussion outside its auspices. In March of 1970, Beuys and two students, Jonas Hafner and Johannes Stüttgen, founded the oppositional citizen's group and information office, 'Organization der Nichtwähler für freie Volksabsstimmung (die direkte Demokratie)' (Organization for Non-Voters for a Free Referendum, or Direct Democracy). Its founding agenda called for a voting boycott of the upcoming elections but it advocated other points of resistance against established party politics.[16] Two publications from the Non-Voters organization, one entitled 'The era of political parties is over' and the other 'Boycott against Party Voting', both cite the *Grundgesetz*[17] and citizen's rights around two connecting issues: the *Grundgesetz* Article 20/2 (reading: *alle Staatsgewalt geht vom Volke aus* – 'all state power comes from the people'), and the absolute right of citizens to 'free uncensored information'. The former was to be realized through *Volksabstimmung* or popular referendum, the political mechanism whereby Beuys sought over the next decade to realize Rudolf Steiner's social organism in 'democracy in matters of the state' as the most direct manner in which to re-establish true democracy or 'direct democracy', from the grassroots.

The Non-Voters urged referenda on the following topics: the *Grundrechte*, education, armament, the 'dissolution of the bureaucracy', the equality of women, the 'depoisoning' of the earth, water and the air, and the 'freeing of the mass media from the power structure'.[18] Flyers gave the address of an information

office in Düsseldorf as well as Beuys' address at the academy. This organization hoped to draw upon those individuals within society who had, as a form of rejection, withdrawn from the political process entirely (*Nichtwähler*), much like the activist student movement but not limited to the university system or the academy. The Organization of Non-Voters hoped to replace a party-system vote with one that proposed alternative programmes and policies, and to transform citizens in all levels of society into activists in granting them a voice within public debate.

With the influx of co-workers drawn from other levels of society such as the activist Karl Fastabend, the office and the organization located at Andreasstrasse 25 was renamed the 'Organization für direkte Demokratie durch Volksabstimmung (freie VolksReferendum e.V.)' (Organization for Direct Democracy through People's Referendum) in July of 1971. In a reversal of its original boycott strategy, the ODD organization registered itself in the state of North Rhine-Westphalia as an official not-for-profit organization, a 'free people's referendum', so that it could participate in the electoral process. The ODD published a *Satzung* (charter) programme in August 1971. The charter demanded implementation of *Volksabstimmung* as a legal alternative to the current party system, based on broad discussion of 'independent and uncensored information'.[19] In order to work through such information, the ODD proposed discussion and research on topics of concern such as direct democracy, the three-part model of society (Steiner), the press, radio and television, the protection of the environment, conscientious objectors to military duty, health issues, and on culture (art and science), to be organized in the form of *Arbeitskreisen*, or working committees.[20] Beuys had posters placed in the windows of the office on the Andreasstrasse which invited passers-by to pick up brochures and other information on ODD issues or on membership. The space was also to be used for group discussion.[21] Informational blackboards that schematically outlined concepts such as *Volksabstimmung* and *Dreigliederung* were placed on display; it is unclear as to who in addition to Beuys may have worked on the boards within discussion.[22]

Beuys' installation of the ODD at the Documenta in 1972 is his first and perhaps most successful restructuring of the

museum institution [see Fig. 11.1]. Beuys continually referred to this installation as an information and educational centre and 'model of freedom' throughout numerous discussions held in the galleries of the Fridericianum in Kassel.[23] He transferred the bureaucratic office space of the Andreasstrasse office in Düsseldorf, including desks, cabinets, boxes, blackboards and wall panels, into one room on the ground floor of the museum. Beuys positioned a blue neon sign against one of the walls that read, in his handwriting, 'Organization for Direct Democracy through People's Referendum'. Another permanent fixture of the office, an often-replaced single red rose in a graduated chemistry beaker, the 'Rose for direct democracy', was placed on the desk of the office each day during the exhibition. Beuys produced two multiples in conjuction with this object: *ohne die Rose tun wir's nicht* ('We won't do it without the rose', Fig. 12.1, 1972), a photograph of Beuys in conversation with a Documenta visitor, and the *Rose für direkte Demokratie* ('Rose for direct democracy', 1973), a series of chemistry beakers signed with this phrase (Fig. 12.2). Beuys was surely familiar with the rose as both a symbol of

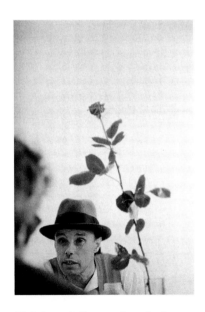

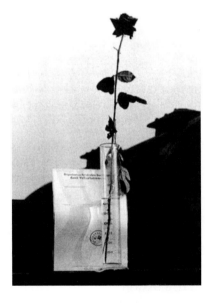

12.1. Joseph Beuys, *ohne die Rose tun wir's nicht* (1972), multiple; © 2006 Artists Rights Society (ARS), New York/VG Bild-Kunst, Bonn.

12.2. Joseph Beuys, *Rose für direkte Demokratie* (1973), multiple; © 2006 Artists Rights Society (ARS), New York/VG Bild-Kunst, Bonn.

romantic love and of international socialism. He spoke of the significance of this flower as 'a very simple, clear example and picture of this evolutionary process to a revolutionary goal'.[24] While the plant grows, the flowerbud transforms from green leaves into red petals, an organic and natural process which visualizes (and renders olfactory) the natural evolution or transformation of the individual toward revolutionary change. Beuys acted upon the suggestion that he place the rose into a graduated cylinder, a tool of empirical investigation. Like Beuys' emphasis on 'intuition' as a valuable aspect of human thought marginalized and belittled by empiricism, the rose, in Beuys' often-repeated phrase, points to the human emotion of love as a necessary means toward thought and creativity: *Ohne die Rose tun wir's nicht, da können wir gar nicht mehr denken* ('we can't do it without the rose, then we can't think anymore').[25] Human compassion must also remain an element of rational thought in order for creative change to be implemented. The multiple critiques the strident faith in positivism which marked much conceptually focused art exhibited at Documenta in 1972; the *Rose* also connects with Arte Povera's critical approach toward the industrial materials of minimalism in its use of organic matter as a multiple.

The ODD staff at Documenta in 1972 covered another wall of the office with photos and reproductions of portraits of immediately recognizable women such as Paula Modersohn-Becker and Käthe Kollwitz, with a wall label reading *Frauen* (women). This display was a response to Gerhard Richter's phallocentric Venice Biennale installation, *Forty-eight Portraits*, which had been exhibited to represent West Germany earlier that same year. Pamphlets and other information were available for visitors. Beuys and Fastabend, the ODD volunteer from Düsseldorf, were also present in the office for the 100 days of the exhibition between the hours of 9 and 5. A record of the number of visitors on a single day lists 811 total visitors, of which 35 asked questions or engaged Beuys and/or Fastabend in discussion.[26]

Visitors to the ODD installation/office could purchase a plastic carrying bag illustrated on both sides. Beuys had previously used this multiple within two actions, the *Strassenaktion* ('Street action') in the Hohestrasse in Cologne in 1971, where they

were given to passers-by. Beuys had also integrated the bag into another multiple named after the ODD ecological protest action in the Düsseldorf Grafenberger forest that year, *So kann die Parteidiktatur überwunden werden* ('This is how the dictatorship of (political) parties can be overcome', Fig. 12.3). This 1971 Grafenberger Wald multiple consisted of the plastic bag and a large square of cut felt.

12.3. Joseph Beuys, *So kann die Parteidiktatur überwunden werden* ('This is how the dictatorship of (political) parties can be overcome'), multiple, 1971; © 2006 Artists Rights Society (ARS), New York/VG Bild-Kunst, Bonn.

In *So kann die Parteidiktatur*, Beuys unified his earlier use of artistic materials with the ideological agenda and the ecological activism of the ODD. The material of felt is central to many of Beuys' most important works of the 1960s as an insulating material, a material for warmth and heat which can retain the thermodynamic manifestation of energy. In juxtaposing a Steinerian diagram with the material of felt in the *So kann* multiple, Beuys loads an identifiable artistic material with a specific political content, that is, a protest against the destruction of a natural forest. The material of felt is also aligned with a political alternative in that it is connected to a longer-standing tradition of struggle for the realization of alternative social models. In earlier works such as the performance *MANRESA* of 1966, Beuys had manipulated felt in conjunction with the sign of the cross as a symbol of warmth, which also signalled the potential for human spiritual transformation as exemplified in theological conversion. For the first time in his work, Beuys coded felt as a container for the energy of a specific political action in

the *So kann* multiple. Felt then points to the possible translation of energy into the psychic and physical movement required for future political struggle. Beuys thereby adds an activist content to his earlier felt pieces and another valence of meaning for his work in this multiple. In distributing a part of this multiple in the ODD installation to visitors at Documenta in 1972, Beuys reasserts this activist content as part of the installation and again mobilizes the multiple as a vehicle for communication.

Discussion as Object/Critique

The topics of discussion at the ODD office during the three months at Documenta are far-ranging: educational reform, Christianity, state capital and the Eastern Bloc, atomic energy, race relations, women's rights, the problem of money, and, as I mentioned earlier, the issue of terrorism or violent resistance against the state, particularly around the state prosecution of the Baader-Meinhof Group. These issues had been points of contention between Beuys and visitors to the ODD office.

Beuys' discussion with an angered and vocal member of the DKP (German Communist Party) who visited the ODD office at Documenta is a sampling of one of the discussions that constitutes this artwork in Kassel. The visitor accused Beuys of being absorbed by the current art system. Beuys responded that the ODD office was to be seen as his implementation into praxis of his *Kunstbegriff* or concept of art, which thereby made use of the current system or institution of art in order to shift it in another direction.[27] Beuys also elaborated various ways in which new ideas leading toward social and political change might be deployed by people in all walks of life. In another conversation with an editor and speaking specifically about his own position within the Düsseldorf Academy, Beuys outlined opportunities this person might seize to awaken public consciousness towards social activism:

> I go to a typical state school and attempt to infiltrate it ... one can do something in the institutions in that one attempts to infiltrate them, and can do something on the level of a model outside of them ... methodologically one has to work in very flexible ways. One always has to seize upon that which is possible at the time.[28]

However, these routes of 'infiltration' into institutions, or of 'doing something outside' of them, are not anarchistic end goals but part of what Beuys called the 'educational process'. This process has nothing to do with an authoritarian teacher-pupil relationship, but with the awakening of consciousness which begins 'not only in schools, but also in grocery stores ... as soon as people talk to one another about these things' (i.e. individual creativity to be used for the good of the social organism). This awakening could also take place within the museum institution and within the experience of art, perhaps made possible for visitors to the ODD office in the Fridericianum in Kassel.

Beuys constructed several works that incited debate surrounding the West German state's handling of the police search for the Baader-Meinhof group, or recapitulated debate on the subject afterwards, much like the blackboards themselves. The assemblage *Dürer, ich führe persönlich Baader und Meinhof durch die Documenta V* (Fig. 12.4)

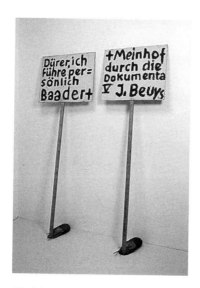

12.4. Joseph Beuys, *Dürer, ich führe persönlich Baader und Meinhof durch die Documenta V* ('Dürer, I personally conduct Baader-Meinhof through Documenta V'), Museum Ludwig, Cologne) 1972; © 2006 Artists Rights Society (ARS), New York/ VG Bild-Kunst, Bonn.

is also comprised of relics from a performance staged by the Hamburg artist Thomas Peiter at the Office for Direct Democracy, in which Peiter appeared as the figure 'Dürer'. In an office discussion, Beuys is said to have stated that if he could acquaint the terrorists or the radical opponents of the status quo with the forms of non-violent resistance of the ODD and of social sculpture, they would then be 'resocialized'.[29] Emblazoned with a quote from Beuys regarding the state-wide hunt for RAF terrorists from this explosive public discussion at the ODD, Peiter carried protest boards as he and Beuys walked through the Fridericianum. Peiter conceived of his signs as a criticism of Beuys' public claim;

his walk through the exhibition space carrying this quote from Beuys and accompanied by Beuys finally seemed to perform this claim rather than to attack it. Beuys exhibited Peiter's signs afterwards to which he added felt slippers that were stuffed with margarine and rose-stems of the 'roses for direct democracy' gathered at the ODD Documenta office. The assemblage refers to public debate on the issue of terrorism as a form of violent opposition to the German state, and to the realm of art as an alternative sphere of activity for non-violent opposition and revolutionary resistance. *Dürer* also makes reference to Peiter's critique of Beuys, and to his walk through the galleries with these signs.

Pointing to Beuys' 1972 multiple *Lo Rivoluzione siamo Noi*, it has been argued that Beuys pictured his revolution only around himself and utilized his own image to construct a 'cult of the artist'.[30] However, the large public discussions Beuys held as part of the exhibition of the same name in Naples in 1971, and the work *Dürer, ich führe persönlich ...* would indicate otherwise. In *Dürer* the image of revolution within art grows from public debate and it does not carry the features of Joseph Beuys. This tension in Beuys' work, so beautifully illuminated in Broodthaer's critique, is often difficult to reconcile as a 'parallel process'. I hope to point to the other, rarely discussed, side of this dialectic: to Beuys' formation of a counter-institution around his theoretical system and the resulting transformation of these art institutions into sites of 'permanent conference', which possibly are Beuys' most powerful artworks.[31] Yet for all the revolutionary potential of art which is pointed to in this work, and also to viewpoints which opposed Beuys' own on the issue, *Dürer* also appears to point to the limited revolutionary potential of art: as the piece is installed, the fat-filled slippers stride directly into the wall.[32]

Beuys' incorporation of group discussions into performance and exhibition parallels other developments in conceptual art of the late 1960s. Ian Wilson staged discussions as part of his study of 'oral communication' beginning with his *18. Paris IV.70* exhibition in Paris. In distinction to the specific political and philosophical focus of Beuys' discussions, Wilson appears to have been more interested in a self-reflexive examination of discussion for its own sake, its function as 'idea and activity', of intersubjective communication. As Wilson said, 'Though the

carriers are physical, their thought-object is not and therefore becomes an easily transported experience'.[33]

For Beuys, discussion is less the study of 'an example of the object of my thought or the object that I am trying to communicate to you', as Wilson phrased it, but instead manipulates language as a creative and individual contribution to discussion which can benefit the greater social whole. Unlike Wilson, Beuys integrated the multiple and the blackboard as carriers of information within a discussion and as a means of documenting the flow of discussion. The fact that these objects were ultimately absorbed and traded by the art market does not lessen their importance as evidence of the flow, exchange, and energy potential of ideas; Beuys insisted that the objects remain intact as vehicles, 'even if the merchant who sells it is dishonest'.[34]

Social sculpture as counter-institution

In his essay 'I am Seeking Field Character' of 1974, Beuys foregrounds creativity as the central concept of 'social sculpture' which had been the basis of many discussions in the ODD office. Beuys clearly had the concept of social sculpture in mind during the Documenta exhibition, as the following exchanges at the office would indicate:

> Q.: Is what you're doing now a directly political action?
>
> B.: No. For me it's an artistic action. Because this notion of art is formulated such that self-determination, which democracy of course demands, must now be seen as a possibility ... More and more we proceed from the assumption of self-determination, from human freedom as a creative, that is, also an artistic point of departure. So it is a cultural question in the first place.[35]
>
> [...] Q.: You see the path of art as the best possibility of reaching these goals [toward individual freedom]?
>
> B.: Yes because all human knowledge comes from art. Every capacity comes from the artistic capacity of man, which means, to be active, creatively.[36]

In such exchanges, Beuys forwarded the (cultural) notion

of social sculpture and the idea of individual creativity as a totalizing practice of art, undertaken by all democratic citizens in a non-party state democracy, as central to it. This development in Beuys' thought, and his consequent revision of Steiner's social model, marked a shift in the agenda of the ODD as it had been formulated in 1971. After the Documenta installation of 1972 Beuys began to conceptualize the ODD organization as an *aesthetic* model. Beuys would remark several years later:

> When we founded the ODD, there was a great interest present in democracy ... the concept of democracy is the stem of the entire organic structure. But to the right and left it has its branches, buds and leaves, that is, the problem of freedom and the problem of socialism, specifically the problem of culture and the problem of economic events. That must be joined to the notion of democracy ... only democratic work remains in this office which can not lead to anything ... nevertheless the organization has achieved very difficult tasks, for example, the free university ... but it is, however, still based in a too one-sided way on the notion of democracy.[37]

The first DSP documents of 1967 presented the role of culture and art within an oppositional politics. It is perhaps the case that Beuys realized the limitations of an organization with no clearly articulated political goals (with the exception of its lobbying effort for the process of referendum). Beuys would seek a solution to these organizational limits within the ODD through another organization, the FIU or the Free International University, which he began to discuss publicly at Documenta in 1972.

Beuys' conceptual art practice challenges the view that conceptual art from its beginnings was motivated by an endgame aesthetics of loss that did not share the radical 'utopianism of avant-garde movements' or the goals of social and political transformation.[38] Notably, a number of conceptually based feminist artists, Mary Kelly and Margaret Harrison, Shelley Sacks, Rosemary Troeckel, Katherina Sieverding, and Ulrike Rosenbach, were either students of or worked directly with Beuys within the

FIU, an institution which he co-founded with the West German novelist Heinrich Böll in 1974. The FIU became a network of artistic and activist workshops conducted and coordinated in Germany, Ireland, England, Wales, Yugoslavia, Italy, and South Africa. It is surely not coincidental that many conceptual feminist artists of the late 1970s and 1980s germinated in the ground of the FIU. Beuys' institutionally centred conceptual project served as a point of departure for these engaged conceptual artists.

NOTES

* First published in Claudia Mesch, *Problems of Remembrance in Postwar German Performance Art* (Ann Arbor, Michigan: UMI, 1997), pp. 250–88.

1. 'Postulat auf Wandtafeln im Büro Beuys, Documenta 1972' (postulate on boards of ODD office at Documenta 1972), reprinted in Clara Bodenmann-Ritter (ed.), *Jeder Mensch ein Künstler. Gespräche auf der Documenta 5/1972* (Frankfurt a.M.: Ullstein, 1975), p. 30.

2. The title of Beuys' first major solo exhibition in 1967, *Parallelprozess 1* (Städtisches Museum Mönchengladbach).

3. I will only note briefly that there is an enormous difference, in terms of historical and national context and otherwise, between Beuys' optimistic pursuit of the voter's referendum in West Germany during the 1970s and the recent manipulations of the ballot initiative in the USA, specifically, in the state of California in 2003. There a ballot initiative was successfully used to remove an elected governor from office. In the wake of this recent development, one questions the relation of the California ballot initiative, and even the referendum process itself, to the democratic process in the USA.

4. Antje Oltmann places Beuys within the history of conceptual art. Antje Oltmann, 'Voraussetzungen für Beuys erweiterten Kunstbegriff', in *'Der weltstoff letztendlich ist ... neu zu bilden'. Joseph Beuys für und wider die Moderne* (Ostfildern: edition tertium, 1994), pp. 15 ff. For the first time in English-language assessments of concept art, Lucy Lippard in her *Six Years: The Dematerialization of the Object of Art* (1973) a purposefully 'chaotic' timeline which charts the course of an art Lippard understood as dealing with 'dematerialization', included several Beuys performances of the 1960s (*Eurasia* of 1966 is most closely chronicled) but does not mention Beuys' institutional activities

beginning in 1967. Lippard recognizes Beuys' significance in this regard in her essay 'Escape Attempts' of 1995. In a discussion that focuses broadly on concept art in the 1960s, ' … work in which the idea is paramount and the material form is secondary, lightweight, ephemeral, cheap, unpretentious and/or "dematerialized"', Lippard speaks of Beuys' work as contradicting the concern of most conceptual art with language as medium and not as a means of communication. Lippard maintains that 'it was usually the form rather than the content of Conceptual art that carried a political message' and she implies engaged conceptual art moved beyond this concern. Her essay offers a revisionist notion of conceptual art that is open to both directions in taking note that its oppositional quality can be found not only in its radical form but also in its activist content, as was the case in Beuys' work. In Ann Goldstein and Anne Rorimer (eds.), *Reconsidering the Object of Art 1965–1975* (Los Angeles: Museum of Contemporary Art and MIT Press, 1995).

5. Peter Uwe Hohendahl, 'Critical Theory, Public Sphere and Culture. Jürgen Habermas and his Critics', *New German Critique* 16 (Winter 1979), p. 92.

6. Jürgen Habermas, 'On the Genesis of the Bourgeois Public Sphere', *The Structural Transformation of the Public Sphere* (Cambridge, MA: MIT Press, 1989), pp. 25–9.

7. McLuhan's reading of media technology of the 1960s is presented in his books *The Gutenberg Galaxy: The Making of Typographic Man* (Toronto: University of Toronto Press, 1962); *Understanding Media: The Extensions of Man* (New York: Signet, 1964); and *The Medium Is the Message* (New York: Random House, 1967).

8. The primary texts are Debord's *La société du spectacle* (1967); Hans Magnus Enzensberger, *The Consciousness Industry: On Literature, Politics and the Media* (New York: Seabury Press, 1974); and Jean Baudrillard, *Simulations* (New York: Semiotext(e), 1983).

9. Michel Foucault, *Discipline and Punish: The Birth of the Prison* (New York: Pantheon, 1977); Louis Althussar, 'Ideology and Ideological State Apparatuses', in *Lenin and Philosophy* (New York: Monthly Review Press, 1971), pp. 127–88.

10. Peter Bürger, 'Im Schatten von Joseph Beuys', *Kunstforum* 90 (1987): pp. 70–79, translated and reprinted in this volume.

11. The connection with Schiller has been detailed by C.L. Coetzee in 'Liberty, art and fraternity: Joseph Beuys and the symphonic education of post-war Europe', *S.-Afr. Tydskr. Kult.-Kunsgesk. (S.*

Africa) 3.4 (1989), pp. 350–361.

12. Herbert Marcuse, *An Essay on Liberation* (Boston: Beacon Press, 1969). The book was published in German in the same year.

13. Stephan Mallarmé, 'Richard Wagner. Rêverie d'un Poëte Français', *La Revue Wagnerienne* VII (8 August 1885), pp. 195–200, republished in the *Oeuvres Completes* (Paris: Gallimard, 1945), pp. 543–6. I thank Anna Arnar for this reference. For further commentaries on the Beuys/Broodthaers divide, see the Germer and Zwirner essays in this volume, and also: Maria Kreutzer, 'Plastic Force and the Sphere of Writing. Considerations on the Interpretation of Art by Joseph Beuys and Marcel Broodthaers', in *Punt de confluència. Joseph Beuys 1962–1987* (Barcelona: Fundació Caixa de Pensions, 1988), 169 ff (first published in German in 1987); Antje von Graevenitz, 'Erlösungskunst oder Befreiungspolitik. Wagner und Beuys', in Gabriele Förg (ed.), *Unsere Wagner: Joseph Beuys, Heiner Müller, Karlheinz Stockhausen, Hans-Jürgen Syberberg* (Frankfurt: Fischer Verlag, 1984), 11–49.

14. Many of these public discussions are collected in the volume by Clara Bodenmann-Ritter; and in Dirk Schwarze, 'Protokoll eines Tages im Büro ODD durch Volksabstimmung', *Hessische Allgemeine* (26 July 1972), reprinted in Veit Loers and Pia Witzmann (eds.), *Joseph Beuys die Documenta Arbeit* (Kassel: Museum Fridericianum und Edition Cantz, 1993), pp. 86–7, describes a single-day of visitor interactions with Beuys, and was originally published in a local Kassel newspaper.

15. Photographs of the discussions Beuys held in the galleries of the exhibition at the ICA are published in *Joseph Beuys Richtkräfte* (Berlin: Nationalgalerie Berlin, 1977), pp. 18–54.

16. The Organization for Non-Voters continued the agenda of the DSP, the German Students Party. Discussions regarding political reform had reportedly taken shape in Beuys' classes already in 1965, but were first publicly formulated in 1967. Stüttgen, a Beuys student and collaborator, established the so-called Deutsche Studenten Partei in a protocol dated June 22, 1967. The accounts published in student newspapers connect the DSP to Fluxus, in noting that the political discussions which ultimately gave rise to the DSP were part of the 'Fluxus movement, a seven-member brain trust which was unanimous about certain founding ideas, and which used the Berlin events in order to continue these themes'. 'Fluxus in der Politik', *folia: Blätter aus dem Studentenwohnheim I am Klausenphad Heidelberg* (Heidelberg) 15 (1967), p. 1, reprints an original

article from *Pro-These 67. Unabhängige Studentenzeitung an der Universität Düsseldorf* (Düsseldorf), Nr. 1 (1967), p. 9. This article is probably by Johannes Stüttgen. The protocol is reprinted in *Interfunktionen* 3 (1969), p. 125. While the 'brain trust' is unnamed, photographs of Beuys' academy rooms during this period feature Stüttgen, Henning Christiansen and Bazon Brock with Beuys, who probably comprised it; see also Thomas Kellein, *Fluxus* (Basel: Kunstmuseum Basel, 1994), 249.

17. The Grundgesetz is the basic law of the Federal Republic of Germany.

18. Non-Voters document, 'Parteien-Wahlverweigerung', reprinted in *Beuys Documenta Arbeit*, p. 136.

19. *ODD durch Volksabstimmung Satzung und politisches Programm*, p. 5.

20. 'Beitrittserklärung, Organization für direkte Demokratie durch Volksabstimmung', reprinted in Christos M. Joachimides and Helmut R. Leppien (eds.), *Kunst im politischen Kampf. Aufförderung, Anspruch, Wirklichkeit* (Hannover: Kunstverein Hannover, 1973), pp. 46–8.

21. Volker Harlan, Rainer Rappmann, Peter Schata (eds.), *Soziale Plastik. Materialen zu Joseph Beuys* (Achenberg: Achenberger Verlag, 1984), p. 33.

22. The board from the ODD office is in the Adolf-Luther Foundation in Krefeld. It is reproduced in *Joseph Beuys Documenta Arbeit*, p. 33, and in Adriani, p. 268.

23. *Beuys Documenta Arbeit*, 83, and Jeder Mensch, pp. 13–25 ff.

24. Adriani, quoted in *Documenta Arbeit*, p. 113.

25. A phrase repeated in a number of multiples, such as *ohne die Rose tun wir's nicht.* Schellmann no. 61.

26. Schwarze, reprinted in *Documenta Arbeit*, p. 87.

27. Schwarze, *Documenta Arbeit*, pp. 86–7.

28. Jeder Mensch, 19; see the excerpt reprinted in this volume.

29. *Documenta Arbeit*, p. 114.

30. On this view, see Pamela Kort, 'Joseph Beuys' Arena: the Way In', in Lynne Cooke and Karen Kelly (eds.), *Joseph Beuys Arena: Where Would I Have Got If I Had Been Intelligent!* (New York: Dia Center for the Arts), pp. 27–8; see also Barbara Lange's essay in this volume.

31. On this point see Joseph Beuys and Frans Haks, *Das Museum* (Wangen: FIU Verlag, 1993).

32. In addition to the Dürer piece, Beuys included critiques and protests of his work within an artwork in at least one other instance. The piece *Hearth I*, acquired by the Kunstmuseum

Basel, prompted citizens' protests over the price of the artwork. Beuys responded to the public debate about his piece in incorporating the public critique into it, as *Hearth II* (1978). On the story of *Hearth I*, see Jürg Federspiel, 'Joseph Beuys oder der Weg zu Sich', *Tages Anzeiger Magazin* Nr. 4 (Basel, February 28, 1970), pp. 19 ff.

33. Wilson in conversation with Ursula Meyer in Meyer, *Conceptual Art* (New York: Dutton Books, 1972), 220–1; see also Anne Rorimer, 'Ian Wilson', in *Reconsidering the Object of Art*, p. 226.

34. 'A score by Joseph Beuys: We are the Revolution', interview with Achille Bonito Oliva, in *La rivoluzione siamo noi* (Naples: Modern Art Agency, 1971), n.p.

35. *Jeder Mensch*, pp. 51–2.

36. *Jeder Mensch*, p. 68.

37. Beuys (1975), quoted in Harlan/Schata, p. 35.

38. This view is offered by Benjamin Buchloh, 'Conceptual Art 1962–1969: From the Aesthetic of Administration to the Critique of Institutions', *October* 55 (Winter 1990), pp. 140–41. Buchloh's delimitation of the politics of conceptual art has also been questioned by Helen Molesworth in her essay on feminist conceptual artists Mierle Laderman Ukeles and Mary Kelly, 'Cleaning Up in the 1970s: The Work of Judy Chicago, Mary Kelly and Mierle Laderman Ukeles', in Jon Bird and Michael Newman (eds.), *Rewriting Conceptual Art* (London: Reaktion Books, 1999), pp. 107–22.

13. *ÜBERBLICK* SERIES ON THE PARLIAMENTARY ELECTION*

THIS TWO-PART ROUNDTABLE discussion delivered a post-mortem on Beuys' failed attempt to secure a nomination as a Green Party candidate for the state of North Rhine/Westphalia in 1983. Bernd Bruns and Otto Schily were instead chosen as Green Party candidates. Part I of the discussion features two Düsseldorf journalists, Klaus Hang and Hubert Winkels, Beuys, his student Johannes Stüttgen, and several Green Party members including Rainer Bartel and the successful candidate, Bruns. The roundtable documents the new boundary Beuys established for engaged art. A brief chronology of Beuys' entry and expulsion from party politics, also included in the original article, precedes the discussion.

PART I: BEUYS ON THE GREENS

The Bundestag Elections in the State of Nordrhein/
Westphalen, West Germany, 1983

Continuing work on the new concept of politics

22 June 1967 – Founding of the 'German Student Party as Metaparty' in Düsseldorf. Joseph Beuys founds this party as a reaction to the assassination of Benno Ohnesorg on 2 June in Berlin, in order to obtain information, to compel an explanation, and to more effectively express political ideas concretely.

1 June 1971 – Founding of the 'Organization for Direct Democracy through National Referendum' in Düsseldorf. The organization deals with the development of a socio-political

concept on the principles of the ideas of Rudolf Steiner. The bureau of information in the old town becomes a centre of discussion, in which all kinds of people discuss the abolition of the party state with Beuys.

1974 – Joseph Beuys and Heinrich Böll found the 'Free International University' in Düsseldorf. The FIU represents itself as a research institute for creativity and interdisciplinary studies. The results of the FIU create several stimuli for the founding of the Greens. The FIU counts as one of the founding organizations of the Greens.

1976 – Beuys runs for the Bundestag as a candidate of the AUD (Action group of independent Germans). Beuys sees the election race as a continuation of his pedagogical occupation with different devices. The AUD is also one of the founding organizations of the Greens.

June 1979 – Beuys runs as a candidate of the Greens in the Europa-election. The Europa-election surprisingly gives the Greens, who at this time still did not have the status of a recognized party, more than three per cent of the votes. This success is the impetus of activities toward founding a nationwide Green Party.

November 1979 to January 1980 – Beuys is a participant in the founding meetings of the Greens on the local, state, and nationwide level.

September 1980 – Beuys runs as a candidate in Düsseldorf for the Greens in the Bundestag election.

Rainer Bartel: The provisional title of this article might be 'People's Party without Beuys?'

Joseph Beuys: What is that supposed to mean? That it's better to leave me out or that I am being pulled into this people's party? I don't quite follow.

Klaus Hang: The Green Party [has] tried to wear the mantle of a people's party … In other words [they now] move away from a [kind of] exotic party to one led instead by a strong clique in which figures like Joseph Beuys no longer have a place.

JB: Yes, now I understand. That's how it happened here. But then the concept of 'people's party' takes on the character of established parties. One wants to compare oneself with them, with the expectation that through this comparison one could win

support. But the voters, who want something totally different, something new, an organization with human foundations, are not taken into consideration. I hold this estimation of voter potential to be psychologically false.

KH: Many have hoped that a counterweight will be established against the botching of political goals, lobby interests etc. – viz. the Flick scandal[1] – through the Green Party. It would be a slap in the face for them not to send someone like Joseph Beuys to the Bundestag and to say instead, nah, we want to adapt nicely to the usual norms.

JB: Yes, yes.

KH: Although I first believed they wanted to set an example in Düsseldorf that as a 'Green' one must participate in every meeting, all the same if one is Beuys or simply a child.

JB: To that I can prove, though, that I have done party work that was much more intense. When I was called all over, to all possible kinds of functions whether in Hessen or somewhere else, I could not be here [Düsseldorf] at the same time.

RB: Isn't it true that the Düsseldorf Greens supported you in all of these things?

[…] *JB:* They treated me in the way that Franz Josef Strauss[2] speaks of contemporary art; Strauss speaks of 'after-culture' and 'cultural degeneration'.

RB: Bernd Bruns has complained, for example, that it is tremendously difficult to represent your ideas in everyday political life.

JB: OK, it's not terrible if he does not understand these things. But he must tell himself, nevertheless, that the Greens began with the requirement of variety … Many voted for the Greens because they know the entire continuity, from the 'Organization for Direct Democracy', the AUD (Action group of independent Germans), to the FIU (Free International University), etc. It was an organic development that has now been interrupted. This is simply a psychological misjudgement in front of the voters. If Willy Brandt[3] can now say that the Greens have no face in the NRW, then it might have been better if they had taken me in.

RB: I have the impression that nationwide many who have joined in the last years only know everything from hearsay and have swept it from the table without examining it for themselves. If one would do a survey at the regional representative conference

and ask 'What does the term "Organization for Direct Democracy" or FIU mean to you?' Seventy to eighty per cent would maybe say, I've heard of it, but I don't know exactly what it is.

JB: One can't say much more than there are people who did not follow the entire development, who at the moment are determining this pragmatic or reformist trend that foregrounds old political thought. I don't even use this concept, but instead the idea of creation that holds the rearrangement of society as most necessary, and begins with human creativity as the only path to changing society.

KH: This path duplicates itself. Where, though, are the differences between the political ideals? I am thinking of the money concept that plays a big role in your conversation with Bruno Kreisky.[4] That is something where one is very sceptical of the foundation.

JB: But this new money concept[5] is extremely important, because we have a finance system that cannot fund human work. To the question of unemployment: the methods that the Bundeswirtschaft-AG [FRG Federal Ministry of Economic Affairs] proposes supports this system that only negotiates work over profit. So, what we need is a new rotation of money that finances work and not profit. If we had this new finance system we would not arrive, first of all, at the question of how to fight unemployment, at the shortening of working hours. Then we would realize that there are not even enough people to heal the damages that have already occurred in the worst way. And it is absurd, when in a situation in which for every dead pine tree three deciduous trees have to be planted in order for the forest not to die, someone asks the dumb question: 'Who should pay for this?' We have a solution for this question, though, and verifiably the single potential one to manage unemployment and the quality of ecological products. [...]

KH: The accusation [by the Green Party], nevertheless, is not so much that you criticize an abnormal programme, but instead one says, he has this new concept of money and is going to the media and is possibly contradicting our entire programme. We must see to it that we reconcile the image that Beuys produces through his media power with those people who don't understand this. The question is, whether you [Beuys] will even let yourself be tied into such egalitarianism.

JB: But with this you prove that the fundamental idea behind this egalitarianism is still wrong. We must acknowledge that the entire association has its damages in other places: at the tip, in all structures of this society, but also at its foundation … We can't forget the fact that they said, we don't really exactly understand this, but we realize that there is an element there we shouldn't lose sight of. I had thought there was a feeling for the kind of elbowroom … I expected that and not the opposite, blank scorn and getting laughed at when one explains one's intentions. In any case, my standpoint is very clear and many people have caught on. I am a complete opponent of the SPD; I see something against the development of productive forces in people in all SPD activities. […] So we arrive at the point: why should I get out now?

RB: Who says that you should get out?

JB: No, but it played itself out like that, that I should have as small a platform as possible for my point of view. And that I should remain a member as much as possible, no one has anything against that.

RB: Surely, while the Düsseldorf Greens are not free of reservations about your ideas, up until now they were always united with you.

JB: I have just seen a lobby that worked against me even in Düsseldorf. I know which people were parties to it, I don't make any accusations against them, they have to answer to that themselves.

RB: Yes, I also know them…

Hubert Winkels: So this doesn't have any further consequences at the moment?

JB: No, only in the sense that, like I said, if you don't want my ideas in the Bundestag, then I also don't want to be the one out in the street getting the chestnuts out of the fire for you. This simply has to be the lesson.

RB: An accusation surfaces: did Beuys and the FIU fail the Greens from a pedagogical standpoint in the last two or so years?

JB: A pedagogical element though is also in the proceedings that contributed to the founding of this party. I played a certain role in the history of this party, and for those who don't realize or suspect this it [my teachings] is surely inaccessible in terms of

any kind of academic point of view. If, in the short time between the communication of concepts to the end goal of complete understanding has not yet been reached, then this is due to the lack of time and also to my exertion – I was always being pulled away for different functions, and at party conventions there simply was not enough room to explain my viewpoints. To this belongs, first of all, the principle that with the old politics nothing is achieved, and every attempt to conform (to mainstream party politics) is an absolutely false psychological assessment. The approach in principle of human capability in work is the only approach ... so that the single possibility for the rearrangement of society is the starting point of creativity with art.

RB: Is that not the process that we all, coming out of our occupation as artists to the Greens, are again branching from?

JB: Not only artists. I relate this to everyone; agreement or disagreement is determined by the criteria of 'interesting' or 'boring'. And if the Greens become boring they will get no more voters. One gets them through something fascinating. The boring things are delivered by the SPD; the SPD is the better bore ... I can only wish the Greens all the best!

RB: You'll vote for the Greens this time, too?

JB: Yes. I'll see if the question of some sort of mission arises from the Greens that I can realize with them. That is unclear at the moment. Therefore it is of a certain necessity for me to pull back a bit until the election. And after the election we'll see if there is still a need for my point of view, for my method, for my 'theatre'...

HW: Could you even imagine that if success comes in the election, one would come back to the 'singer' Beuys, in the sense of the phrase, 'democracy must be sung!'

JB: The term 'theatre' must not be misunderstood. I mean theatre in the sense that something exciting is happening in the Bundestag again, not that the Greens let themselves be killed as the minority in that they divide themselves into working circles and committees.

RB: But wouldn't a success on the two questions on which the tolerance debate centres, namely the prevention of rearmament/ remilitarization and the termination of atomic energy plants, actually legitimize all of the idiosyncratic things that we are

experiencing at present?

JB: Yes, if it would be possible along the way, I would see this as truly positive. But I don't believe that this can be reached without (a change to) overarching standards. With small goals nothing can be reached.

PART II: THE GREENS ON BEUYS

The Bundestag Elections in NRW, 1983

The participants of this second part of the 1983 roundtable discussion include two Düsseldorf journalists and four NRW Green Party members who share their differing views on the role Beuys-the-candidate played in keeping the new party truly 'alternative' to established parties and political interests, and assess what it may have lost in ending a connection with him.

Conversation Participants

Klaus Hang, Hubert Winkels (*Überblick* reporters), Rainer Bartel, Bernd Bruns, Ingrid Landau, Wolfgang Pohl (Green Party members).

Klaus Hang: We have all had our experiences with the established parties and their authoritarian structures. What are the Greens doing to prevent such hierarchies from asserting themselves? … You've resisted hierarchy through principles of rotation, mandate imperatives, etc. What else do you propose in order to prevent the Greens from developing into a microcosm of classes with differing influences?

Bruns: That is naturally a danger; I see that, too. We have to admit very self-critically that even within the Greens certain structures are developing. But that is inherent in the structure of a party. I am a simple labourer. But it's like that with the Greens: when someone has a better education and therefore can better translate his ideas into rhetoric, he has better chances to get to the top.

Hang: Are there examples?

Bruns: … Naturally the prospect of getting into the Bundestag and into choice [political] positions motivates people. And I observe, with great concern, the treatment that a man like Joseph Beuys received at the state delegate conference and that I

do not like – by this I mean the fact that he was not voted onto the state ballot. I am not a fan of Joseph Beuys, but this method of dealing with the minority worries me [...]

Hang: The question still is: Why not Joseph Beuys, who as a shimmering personality, at least represents a part of Düsseldorf?

Ingrid Landau: The fact that Otto Schily[6] is running here [as the Green Party delegate from Düsseldorf] is to the credit of the very few. The organization did not consent to it. It was more like, we'll ask him and then, well, he was already here, and he was up for election, and got more votes. That was certainly not a coincidence. I find this very typical of Düsseldorf. [...]

Winkels: One cannot subsume two extremely opposite personalities like Schily and Beuys under the term 'prominent figure'. On the one hand we have the versatile speaker, with an extensive understanding of politicians, and on the other hand – at least in the eyes of the public – we have the crazy nut. But it is precisely the latter who has always represented an important part of the Greens, the fact that business competence is not always the only important thing, but rather the person's colourfulness. In addition Beuys is a legitimate international emblem of the combination of art and politics, of a piece of practical utopia here and now that I believe the Greens will survive historically. How one can allow such an important person to fall through the cracks personally angers me more than a little, it is almost incomprehensible and makes the entire party suspect to me. To see the revolutionary beginnings that I had always desired in politics go over the edge – and I don't care if it is embodied in a person – is a painful process of the stripping away of the pubescent energy that the Greens had until now and will no longer have in the future.

Ingrid Landauer: I also see this as very painful, but the organization does not consist only of me and those who think like me. I believe Joseph Beuys is in part also at fault, because it is a fact that for two and a half years he did not concern himself with the organization in Düsseldorf or in NRW. He and his supporters actually did nothing to make him more understandable to us. I noticed that what is available in terms of literature – for example from the FIU [Free International University] – is not provided to our organization. They apparently think that one must go to them if one wants to know something.

Winkels: One cannot expect a career politician's management of resources from Beuys. The question is if someone like Beuys, who is not necessarily firmly attached to the organization but instead personifies one himself through his permanent political work, should be granted the status of an exception. One asks oneself, if one does not understand this as power and therefore can vote for him.

Rainer Bartel: The problem is simple: Beuys wanted to run for the Düsseldorf Greens, in other words, he wanted us to support his ideas in the election. But we can't do that, because we don't know his ideas. In the last two and a half years we have only learned of his insights through press, radio, and television.

Winkels: But one knows Beuys!

Bartel: That's exactly it. Beuys has become a trademark, but the contents that he represents are no longer familiar to us. In the past years he has functioned less like a politician and more like a label.

Hang: But a unique personality also has its unique media, through which it expresses itself. Beuys also demands that one argue with him publicly and not over coffee, because he has developed and chosen a specific form of expression that has a publicity noticed by the general and international public. As a potential Green voter I just find it terrible that one now becomes agitated on the basis of frustration and says, so, now we are letting him have it and are not electing him. [...]

Winkels: Bernd, you said before, that you also don't like Beuys that much.

Bruns: I find the person Joseph Beuys very fascinating. But I want to make the overall problem clear in terms of my day-to-day political experience. I deal with very different people on a daily basis when I talk to customers as an electrician and then – understandably – when I talk to them about the Greens, in order to demonstrate to them a Green party member that they can 'touch'. There I largely find agreement on many points. But it always comes to the point where the conversation turns to the 'fat artist' Beuys. I cannot represent Joseph Beuys the artist. With all due respect I have no relation to his method of forming something on the wall with margarine. In this respect I probably have a different concept of art.

I can understand why many of those who have never

encountered the type of art that Joseph Beuys practises see it as insanity. I know what the Green main points are: NATO-double resolution, environmental protection, etc., but I have to pass on the fat art. The following happens: the 'crazy' artist Beuys is identified with the 'crazy' politician Beuys. I can't get past this bias.

For the past one and a half years I have been working as a 'water boy' for the Greens, to the disappointment of my family I am there practically every evening. I have not once seen Joseph Beuys at the local organization. I just don't have the time with my involvement with labour circles and initiatives to concern myself with Joseph Beuys and his unique outlook. I would expect that if he wants to win over the people of the local organization to share his special vision of things he would also explain it to them.

And still the local organization supported him. We delegated him to different state and national conferences. He didn't even show up in Wattenscheid [October 1982] and in Hagen, where the discussion of the Green economic programme caused a stir, we expected that Joseph would contribute to this debate. And Joseph did not say a word in front of the assembly. Instead he delivered statements for Hagen television. Something like this naturally leads to annoyance within the party.

Winkels: ... couldn't one have reached the conclusion that through Beuys' nomination for the Bundestag election he does 'concrete' political work?

Bruns: I can only say that I feel empowered by communicating completely radical things to the 'people.' It is however revolutionary to say that this economics system must be abolished.

Landau: But it is also of concern what comes after that. And there Joseph Beuys has articulated completely realistic ideas.

Bruns: I am one of those who are saddened that Joseph Beuys was pushed out in this manner. To the second proposition, Hubert: I think the idea is good, but I have a few qualms. I think – and this is again a result of my experience with 'simple people' – that the situation is much too serious to organize happenings in the Bundestag, as Joseph Beuys suggested.

Winkels: ... I recently followed a discussion of the election on television where the ex-general Bastian participated for the

Greens, and I only noticed that there was a Green Party member sitting in the round by reason of the pin on his suit. There was absolutely no difference between Bastian's appearance and that of the CSU-nobility.

Landau: I find that unfortunate, too, although I don't see that Joseph Beuys, in respect to his lifestyle, is particularly alternative. At the party conferences I always see him drinking cola and eating sausages. I don't find that extremely alternative. That is naturally a different quality of being different.

Hang: Which voices outsmarted Beuys in establishing the state list [of Green Party candidates]?

Bruns: Several local organizations had equipped their delegates with an imperative mandate that stated, they were allowed to vote anything, but not for Joseph. In contrast the Düsseldorf organization put out an imperative mandate to hoist Joseph Beuys onto one of the front spots on the state list. It [Beuys' removal from the list] was not a result of this.

NOTES

* From *Überblick* (Düsseldorf), Jg. 7 Nr. 3 (1983), p. 14 ff.
1. By 1984, the year after this roundtable was held, Rainer Barzel, a former CDU (Christian Democratic Union) party chairman who was elected president of the Bundestag in 1983, would be revealed to have been on the payroll for the Flick Corporation, an international conglomerate.
2. Franz Josef Strauss, a conservative involved with the Bavarian Christian Social Union and the CDU, was elected premier of the state of Bavaria in 1978, a position he occupied until his death in 1988. He unsuccessfully ran for the West German chancellorship in 1980. He served as Minister of Defence in 1956 and Finance Minster from 1966 to 1969. His term as defence minister came to an abrupt end when Adenauer was forced to remove him from his cabinet in the wake of Strauss' involvement in the 1962 Spiegel affair, when the offices of this publication, critical of CDU policies, was raided and many in its staff arrested. As Beuys points out here, Strauss's aesthetic tastes were also very conservative.
3. Willy Brandt, member of the Social Democratic Party (SPD), served in the Bundestag from 1949 to 1957 and was mayor of West Berlin from 1957 to 1966. He was elected chancellor in 1969 and served in that office until 1974.

4. Bruno Kreisky, a social democrat (SPÖ), was chancellor of Austria from 1970 to 1983. He met with Beuys in the late 1970s.

5. Beuys had come in contact with the work of Wilhelm Schmundt and Ernst Löbl sometime in 1973, when he began attending lectures at the Internationalen Kulturzentrum Achberg (International Cultural Centre, Achberg) in Achenberg, Germany, particularly the section 'Aktion Dritter Weg' (Third Path Action), which held an independent annual congress. After 1977, Beuys increasingly came to use his own public image as a vehicle of dissemination for agendas (such as those of Rudolf Steiner, Wilhelm Schmundt, and the deep ecology of the newly formed Green Party and Greenpeace) alternative to extant social systems and institutions. Beuys recognized the significance of Wilhelm Schmundt's economic models, which were discussed at the Internationalen Kulturzentrum Achberg congresses he attended. Schmundt attempted to synthesize 'base'-centred socio-economic Marxism with Steiner's totalizing organic social models. Schmundt's rethinking of certain Steinerian ideas therefore paralleled some of Beuys' ideas but focused on the development of economic models in drawing distinctions between capital and money, and in proposing an alternative system of money circulation. The *Honigpumpe am Arbeitsplatz* (Honeypump at the Workplace, 1977) project at *Documenta* reveals Beuys' familiarity with Schmundt's thought and his increasing attention to questions of economics, to 'economic values' (*Wirtschaftswerte*) and their connection to creativity and social sculpture. Beuys introduces Schmundt's model of the circulation of money within society, as opposed to the accumulation model of capital, in his writing on the *Honeypump* project and particularly on the role of the FIU workshops in it. After the *Honeypump* project Beuys continued to investigate Schmundt's circulatory model in a number of works, most specifically in his installation *Wirtschaftswerte* of 1980, and the series of multiples and objects he began to produce in conjunction with this installation in 1977. On the *Honeypump* project see Veit Loers and Pia Witzmann (eds.), *Joseph Beuys Documenta Arbeit* (Kassel: Museum Fridericianum und Edition Cantz, 1993), pp. 145–220.

6. Otto Schily was by the 1970s a prominent lawyer in West Germany who had close ties with key figures in the West German student movement and had represented suspected RAF member Horst Mahler and Baader/Meinhof member Gudrun Ensslin. Schily joined the Green Party in 1980. With

the election of Gerhard Schröder as chancellor in 1998 and as part of the 'red/green coalition', Schily was appointed director of the Ministry of the Interior.

Section V
BEUYS AND POSTMODERNISM

14. PERFORMANCE: JOSEPH BEUYS*

GREGORY ULMER

LACAN PROVIDED AN EXAMPLE of how to lecture in a way adaptable
to applied grammatology. What we need now is an example of
how to perform in a grammatological classroom in a way that
fulfils the possibilities outlined in Derrida's notion of the Mime,
including the use of mnemonics and models. Examples of
what an applied grammatology might be like – of a picto-ideo-
phonographic Writing put to work in the service of pedagogy –
are already available in the intermedia practices of certain avant-
garde artists. Contemporary movements such as conceptual art,
performance art, and video art may be considered from our
perspective as laboratories for a new pedagogy, since in these and
other movements research and experiment have replaced form
as the guiding force. 'Now, as art becomes less art,' Allan Kaprow
maintains, 'it takes on philosophy's early role as critique of life.'[1]
In short, there is a general shift under way, equally affecting the
arts and the sciences, in which the old classifications organizing
the intellectual map into disciplines, media, genres, and modes
no longer correspond to the terrain. The organizing principle of
the current situation is the collapse of the distinction (opposition
or hierarchy) between critical-theoretical reflection and creative
practice. Derrida's promotion of a fusion between philosophy
and literature is just one symptom of this hybridization. One
lesson of these circumstances, which have increased the normal
disparity in the schools between invention and pedagogy, is that
models for reform are as likely (perhaps more likely) to be found
outside as inside our own discipline.

It is not possible in the space of one book, of course, to survey all the pedagogical materials and procedures available in the intermedia arts. Rather, I shall focus on one example of an artist-pedagogue – Joseph Beuys – to examine in detail one version of Writing beyond the book. My point in discussing Beuys in the context of grammatology is not to suggest that he represents a norm for a new pedagogy but that, in his very extremity, he demonstrates more clearly than anyone else the full implications and possibilities of Writing. Working in the spirit of Foucault's observation – that in our era the interrogation of limits has replaced the search for totality[2] – I find in Beuys someone who is as extreme, as singular, as exemplary in the field of performance art as Derrida is in philosophy. Together they form a paradigm that may serve as a point of departure for a new pedagogy. [...]

My interest in Beuys, similar to my interest in Lacan, concerns not his ideology or themes so much as his strategies of presentation, his Writing, his Style as itself an idea. There is no concern for 'influence' in either direction in my discussion. Derrida did visit the Guggenheim exhibition, choosing to *ascend* the museum's famous spiralling ramps. After climbing from station to station (as the display sectors were called), Derrida remarked to his son Jean that the exhibit experience replicated nicely the 'Stations of the Cross'.[3] In any case, placing Beuys' work in the context of grammatology has the virtue of addressing at least one of the problems associated with the reception of his work, which is that commentators thus far have tended to confine themselves to descriptions of his work, venturing by way of explanation little more than paraphrases of Beuys' own statements. But, as Lothar Romain and Rolf Wedewer stress in calling for analyses that bring to bear other categories and contexts, Beuys' interviews and lectures do not constitute interpretations but exist at the same level as, even as part of (verbal extensions of), the art.[4] Not that this chapter is an interpretation, either, since I am interested in borrowing some of Beuys' procedures exactly as he explains them (I want to learn from him, not account for him). The fact that Beuys' Actions lend themselves so readily to grammatological terms – indicating the convergence at a theoretical level of two radically different idioms – I take as evidence supporting the feasibility and fruitfulness of a 'general writing'.

My argument will be guided by the principle of the postcard – I have found in Beuys' works more postcards (he does in fact use the post card as a medium) for Derrida's texts, providing the verso for the texts' recto, similar to Derrida's own discovery with respect to Adami's drawings or Titus-Carmel's *Tlingit Coffin*. My approach to Beuys, then, will be in terms of Derrida's principles, performing the transition from a theoretical to an applied grammatology. [...]

Grammatology

[...] I would like now to examine more systematically the grammatological character of the Actions – [...] I will take as my point of departure one Action – *How to explain pictures to a dead hare* – which is often designated as typifying Beuys' work. I will first describe the work, including Beuys' statements about it, and then discuss it as a version of grammatology.

In the performance, on 26 November 1965 – Beuys' first exhibition in the art world context, Tisdall notes – 'Beuys spent three hours explaining his art to a dead hare. The gallery was closed to the public, and the performance (though recorded on television) was visible only from the doorway and the street window.'[5] 'Beuys, whose head was covered with honey and gold leaf, held a dead hare in his arms and carried it, walking through the exhibition and talking to it, from picture to picture, letting it touch the pictures with its paw. After the tour was finished he sat down on a chair and began to thoroughly explain the pictures to the hare "because I do not like to explain them to people".'[6]

'In putting honey on my head I am clearly doing something that has to do with thinking. Human ability is not to produce honey, but to think, to produce ideas. In this way the deathlike character of thinking becomes lifelike again. For honey is undoubtedly a living substance. Human thinking can be lively too. But it can also be intellectualized to a deadly degree, and remain dead, and express its deadliness in, say, the political or pedagogic fields. Gold and honey indicate a transformation of the head, and therefore, naturally and logically, the brain and our understanding of thought, consciousness and all the other levels necessary to explain pictures to a hare: the warm stool insulated with felt, the "radio" made of bone and electrical components under the stool and the iron sole with the magnet.

I had to walk on this sole when I carried the hare round from picture to picture, so along with a strange limp came the clank of iron on the hard stone floor.'[7]

The honey on the head is another manifestation of the idea of thinking as a sculptural activity. The process of bees making honey (honey in the geometric beehive) is a version of the same principle demonstrated in *Fat Corner*.[8] Not only the honey on the head but the hare itself is a model of thinking: 'The hare has a direct relation to birth ... For me the hare is a symbol of incarnation. The hare does in reality what man can only do mentally: he digs himself in, he digs a construction. He incarnates himself in the earth and that itself is important.'[9] The hare burrowing into the earth is an image of thinking – of man embodying his ideas in forms. The Action as a whole is especially useful in our pedagogical context because, as Beuys explains, it deals with 'the difficulty of explaining things',

> particularly where art and creative work are concerned, or anything that involves a certain mystery or questioning. The idea of explaining to an animal conveys a sense of the secrecy of the world and of existence that appeals to the imagination ... The problem lies in the word 'understanding' and its many levels which cannot be restricted to rational analysis. Imagination, inspiration, intuition and longing all lead people to sense that these other levels also play a part in understanding. This must be the root of reactions to this action, and is why my technique has been to try to seek out the energy points in the human power field, rather than demanding specific knowledge or reactions on the part of the public. I try to bring to light the complexity of creative areas.[10]

Beuys' own accounts of his intentions do in fact articulate the programme desired for applied grammatology. My purpose, then, is to show that one reason why Beuys' practice is so relevant to this programme is that the specific elements of grammatology as Derrida defines them are also available in Beuys' work, although Beuys himself never makes them explicit. There is no need, in other words, to impose the categories of grammatology on

Beuys but only to call attention to the manner in which Beuys employs them.

My procedure here will be to treat Beuys' objects or 'ciphers' the same way Derrida treats vocabulary, that is, in terms of the entire semantic field or symbolic topos that is evoked. The hare, for example, as Romain and Wedewer remind us, means many different things in various world mythologies and legends besides 'incarnation' or 'birth', any of which may be brought into play in the reception effect when this animal is used in an Action.[11] The hare is perhaps Beuys' chief totem animal, employed in a variety of ways, including its literal presence, as in *How to explain pictures to a dead hare*, or *Siberian Symphony* (which included a dead hare hanging on a blackboard), *The Chief* (with two dead hares, one at either end of a large roll of felt in which Beuys was wrapped), *Eurasia* (in which Beuys manoeuvred along a line a dead hare with its legs and ears extended by long, thin, black wooden sticks), and so forth; the hare is also included as an image sculpted in chocolate, gelatine, and other materials, or as a toy; it may be evoked as an image in titles, such as *Hare's grave* (actually a 'genre' of works – boxes or reliquaries of detritus).

Of the several meanings of the hare available in mythology, the most significant one in our context, the one that reveals the convergence in grammatology of Derrida and Beuys, *is the hare as an embodiment of Thoth, the god of Writing:* 'The divine hare was closely connected with the Egyptian god Thoth, the Greek god Hermes, and the Roman Mercury, all of whom were supposed to have similarly invented writing.'[12]

It is of no less interest, perhaps, considering Derrida's concern with the function of the copula 'to be' and its confusion with the ontological 'being' (in 'The Supplement of Copula', or 'Ousia and Gramme', for example), that the hare was in ancient Egypt the hieroglyph for the auxiliary verb 'to be'. The scholars noted, of course, that the hare was used to represent the copula verb for phonetic reasons – the hare hieroglyph was used whenever the phonetic value 'un' was needed, with 'to be' being the only word in which this sound occurred alone. Since we are now taking up the *Moira*, or destiny, of this term in the context of Derrida's homophonic and macaronic methods, I might add that Derrida's deconstruction of the problem of the 'first' (origins) or the *'one'* – *Un* in French – may be transducted into Beuys'

manipulation of the hare, whose name as a deity is *Un*.[13] The legendary fertility of the rabbit also motivates the hieroglyph, as shown by research into the symbolic connection of the hare to the copula, which demonstrated that the hare sign signified 'leaping' and 'rising' and hence, according to the argument, 'being'. The Greek word for 'I leap', moreover, means also 'emit semen' and hence 'beget'.[14] Derrida, of course, does not take such etymologies at face value, but he does play with them in order to generate texts.[15]

The hare as Thoth indicates that the special importance of Beuys for applied grammatology is not only that his Actions demonstrate a picto-ideo-phonographic Writing but that they teach the theory of grammatology in a dramatic form ('theorter' or philosophical theatre). More than just a translation of the theory of writing into a performance mode, the Actions show a way to work with the question of Writing non-conceptually (non-theoretically), in a 'creative' rather than in an 'analytic' mode. From this perspective, agreeing with Beuys' denial that his use of animals is 'atavistic', we can see that his principal animal imagery connotes the metaphorics of *inventio*. His performances, following the score of *Fat Corner* (itself an embodiment of the principle of creativity), are a manner of *doing* what he is saying – they literalize and enact the philosophemes of 'invention' used in the rhetorical tradition (he generates 'original' works of art by performing the rhetorical description of creativity, in works whose lesson is meant to be 'everyone an artist').

The structuring principle of Beuys' Actions (the metaphors of *inventio*) relates to the chapter on Mnemonics, in that Beuys' imagery resonates with the images used in Medieval and Renaissance commonplace books to describe the operations of 'invention'. As the Book achieved dominance in education, replacing the oral tradition, the location of hypomnemics shifted from the mind (memory) to the pages of commonplace books, those encyclopaedic compendia, organized by topic, collecting and classifying a great range of materials from every imaginable source and subject area (including, of course, the 'flowers of rhetoric' – the jewels, stars, or ornaments constituting the best of 'everything' that had been spoken or written). As Lechner explains, the commonplace books 'were often called the artificial memory. The desire for possessing a kind of universal knowledge

led to the distrust of the 'natural' memory and the supplying of an auxiliary one.'[16]

Derrida's interest in hypomnemics can be seen to include this rhetorical phase in the history of knowledge (leading up to Hegel's 'Absolute Knowledge'), as discussed in terms of the 'scene of teaching' in which, in grammatology, 'nothing takes place but the place itself' (understood now as the topics or places of invention). The crucial point of Lechner's study of the commonplaces for my purpose is her account of the metaphors traditionally employed to describe the use of the commonplace book as artificial memory (for the generation of a composition), that is, the metaphorics of the invention process, involving the gathering together of the material to be used in a presentation. Invention in the commonplace tradition was associated with movement about a field, locating ideas stored in 'seats'. Two metaphors were used pedagogically to teach this process (and were repeatedly alluded to wherever the tradition was influential): 'The two images which recur most frequently in the rhetorical works for describing the invention and storing of material are the bee gathering nectar and the hunter pursuing game. Both images relate to wild life in nature, which suggests some kind of "searching for" or hunt, and to human life, which implies industry of some sort. Here "invention" is seen as a search which somehow "covers ground".'[17]

It is no accident, considering Beuys as an applied grammatologist, that the two most predominant, consistent images in his Actions involve some aspect of bees making honey and the hunting of the hare (the example Lechner cites does, in fact, refer to the hare: 'Those that bee good hare-finders will soone finde the hare by her fourme, for when thei see the ground beaten flatte around about, and faire to the sighte: thei have a nar-rowe gesse by al liklihode that the hare was there a litle before'[18] – the example serving to show the 'relation between the mark or "identity" of the locality and the game sought in the place'). Similarly, Seneca's image of the bee, Lechner says, was echoed by many Renaissance rhetoricians: 'We should follow, men say, the example of the bees, who flit about and cull the flowers that are suitable for producing honey, and then arrange and assort in their cells all that they have brought in.'[19]

In this context we are reminded that Derrida's entire discussion

of the flowers of rhetoric in the Genet (*genet*) column of *Glas,* including his exposition of creating by means of dissemination (dehiscence), is a rhetoric of invention. One of Lechner's examples, taken from *Novum Organum* to show Bacon's application of the *inventio* metaphor, is especially relevant to Derrida (and Beuys): 'Those who have handled science have been either men of experiment or men of dogmas. The men of experiment are like the ant; they only collect and use: the reasoners resemble spiders that make cobwebs out of their own substance. But the bee takes a middle course; it gathers its materials from the flowers of the garden and of the field, but transforms and digests it by a power of its own.'[20]

Derrida, similarly, discussing the inside-outside problem in 'Outwork', uses the spider metaphor, evoking specifically the one described in the *Songs of Maldoror:* '"Every night, at the hour when sleep has reached its highest degree of intensity, an old spider of the large species slowly protrudes its head from a hole in the ground at one of the intersections of the angles of the room"'[21] – the spider *is* the corner (rationality and form in Beuys). Derrida elaborates: 'A spider emerging "from the depths of its nest," a headstrong dot that transcribes no dictated exclamation but rather intransitively performs its own writing.' Lautréamont's textuality as spider is beneficial transitionally in its break with the dogmas of naive realism. But Hegel's equally intransitive textuality reveals the negative limitations of this model, with the description of his method (in speculation 'the conception of the concept is an autoinsemination') calling to mind the spider invoked a few pages earlier, spinning its web out of itself: 'It [philosophy] must therefore produce, out of its own inferiority, both its object and its method.'[22] That Derrida is concerned with the problematic defined in Bacon's metaphor may be inferred from the etymological associations he provides for 'hymen'. Within the various *hymenologies,* or treatises on membranes, one finds all three of Bacon's *inventio* models – *hymenoptera* include winged insects, ants as well as bees and wasps; *huphos* includes spider webs, and so forth.[23] Where Derrida's sympathies lie, however, must be surmised by the process of elimination.

From his earliest drawings and sculptures, such as *Queen Bee* (1947 – but there are many works with this title), through *How to explain pictures to a dead hare,* to *Honey Pump* (the huge pump,

made with ships' engines to circulate two tons of honey, which accompanied the information room at *Documenta 6)*, Beuys has drawn upon the bee and its activities as one of his central images:

> The heat organism of the bee colony is without a doubt the essential element of connection between the wax and fat and the bees. What had interested me about bees, or rather about their life systems, is the total heat organization of such an organism and the sculpturally finished forms within this organization. On one hand bees have this element of heat, which is a very strong fluid element, and on the other hand they produce crystalline sculptures; they make regular geometric forms. Here we already find something of sculptural theory, as we do in the corners of fat.[24]

His explicit interest extends to the symbolic significance of bees and honey, beyond his own theory of creativity: 'This warmth character is to be found in honey, in wax, and even in the pollen and nectar gathered from plants. In mythology honey was regarded as a spiritual substance, and bees were godly. The bee cult is basically a Venus cult.'[25]

The point, however, is that, whatever Beuys says about his frequent use of the bee or hare images, they may also be understood as references to the rhetorical theories of creativity and composition. Thus, his Actions fulfil the grammatological goal of a *Writing which does what it says,* showing how the root metaphors or philosophemes of western thought might be interrogated and deconstructed at the applied level.

A further insight into Beuys' principal images of creative thought (keeping in mind that the beehive filled with honey is a version of fat in the corner) is made available in Derrida's notion of the signature (the contamination between life and art, the motivated relationship between the proper name and the work). The name 'Beuys' ('speculation – on "Beuys"'), that is, *signs* the metaphorics of *inventio* mounted in the Actions (both the hunting of the hare and the bee in its hive). Although antonomasia in Beuys' case only produces a near rhyme, the relevant term does designate the elements *of inventio*, revealing

that Beuys' Actions are an enactment of his name. There are in fact two feminine nouns involved – homonyms (so that Beuys' signature itself includes Derrida's homophonic principle) – with the root being *Beut* (*die Beute*). One is a hunting term, meaning 'quarry' or 'game', illustrated by the phrase 'the hunter pursues his quarry' or 'to return with a good bag'. The other *Beut* means 'a wooden beehive', with the verb *beuten* meaning 'to stock a hive with wild bees'. In short, hunting (the hare, or the stag – another one of Beuys' totems) and bees, as terms and images, line up at three levels – in the *Beut* homonyms; in the *inventio* metaphors of the hypomnemic commonplace books; and as the organizing images in many of Beuys' Actions. The *Beut* is also in 'Beuys'. *Beute* is to 'Beuys' what *genet* is to Genet, *die Kante* to Kant, or *éponge* to Ponge – all are rebus signatures.

To appreciate the destiny of this signature effect, it is important to note that the *t* of *Beut is* present in the signature, in that Beuys sometimes signs his name with the tail of the *u* extended (to look like an upside-down *h* – the *h* being the letter signifying *Mensch* or *Human* in the formulas presented in the Action *24 hours ... and in us ... under us ... landunder*), the tail of the *u* not only extended but crossed, thus adding a buried *t* to his name (recalling the transduction techniques of writing-drawing Derrida recommended in his discussion of Adami).

The cross, which appears in a variety of forms in his work, is itself one of Beuys' trademarks (he uses it in his rubber signature stamp 'Fluxus Zone West'), suggesting an important convergence of his programme with Derrida's use of the chiasmus (which Derrida himself associated with the red cross mark in Adami). Beuys' cross is meant to suggest many other crosses, the history of this sign in religion and politics, art and science (related as much to Mondrian's abstractions as to the cross hairs on a machine-gun). 'Sometimes it [the cross] is a global symbol of the earth. Often it is the schematic representation of natural structure, as in the *Queen Bee*. When used as a Christian symbol it represents those aspects of non-institutionalized Christianity which Beuys believes to have had a powerful effect on Western thinking.'[26] But whatever its embodied form, the cross, as with Derrida's chiasmus, is finally the mark of a structuring or stricturing dynamics of creativity ('X: not an unknown but a chiasmus. A text that is unreadable because it is *only* readable'[27]). In a session

recorded at *Documenta 5,* Beuys, drawing the cross, stated that it symbolized 'a square into which one can introduce value'[28] (recalling the 'square mouth' of enframing in *Dissemination).* Again, the cross marks human creative potential – 'That means, as a plus + that is a plus', signifying individual human freedom (Ritter, 72) – the cross as 'plus' being associated with Derrida's compositional '+ L'. By the sixties, then, the cross in Beuys' work had become 'the general medium of marking: cross as crossing two lines, defining a point. It serves as the distinguishing mark of a place ... for example the "shooting post in the woods" (perhaps a stag memorial) ... as shorthand for a compilation, cross-like, covering storehouses ("information theory").'[29] Whether chiasmus or cross, *x* or +, the dynamics of creativity in theoretical and applied grammatology alike involves the taking place of the place itself, teaching invention by displaying and deconstructing the metaphorics of creativity.

The grammatological import of the methodology explored in *How to explain pictures to a dead hare* is also apparent in the emphasis it gives to the *step* (the 'strange limp and clank of iron on the stone floor'). Derrida has applied his special techniques to an interrogation of the steps or step *(pas)* as a methodological term ('step by step'), which is the 'theoretical' version of Beuys' performance movements. 'It is the unimaginable logic, unthinkable even, of the *pas au-delà* ["step beyond" or "no beyond"] which interests me.'[30] Derrida experiments with the step at two levels – as homonym and as 'story'. (1) The term *pas* exemplifies a colossal homonym, moving undecidably between noun and adverb, between *pas* as step and *pas* as negation *(ne pas),* summarized in the phrase *pas au-delà.* The phrase refers to his revised notion of speculation – his homophonic operation – which displaces all logic of denial and disavowal, all dialectical opposition, thus enabling him (in the service of *copia)* to proceed without taking a step: 'The entire system of limits (faux pas) which prohibits putting one *pas* in the other finds itself surmounted in one single step *(pas),* without the step, the activity of walking, what one does with the legs, taking place ... The *pas de plus* ['no more' or 'one more step'] works its homonym silently, surmounting the two senses, at one stroke, the two limits. Its transgression is not therefore a work or an activity, it is passive and transgresses nothing.' Such is the step

with which Blanchot proceeds.[31]

(2) The other level at which Derrida experiments with the step of method, in a way that more directly resembles Beuys' performance, involves a narrative dramatization of walking with a limp (the metaphorics of method). In 'Envois', that is, 'Derrida' falls and fractures his ankle, forcing him to walk with a limp and lean on a crutch or cane, so that the 'story' repeats the methodological metaphors. The pun is still at work here as well, since 'Envois' is preface to a study of the '*legs*' – legacy – of Freud. The scene of 'Derrida' hobbling around with a cast and cane prepares the way for – or performs, mimes – the method to be followed in 'Speculer – sur "Freud,"' a piece that itself mimes Freud's own speculative method. Freud, both in his letters to Fliess and in *Beyond the Pleasure Principle,* refers to his speculative procedure as an impeded walk, using a phrase cited from another author: 'What we cannot reach flying we must reach limping.'[32] We are reminded, of course, that Oedipus limped, as did all the males of his line (as Levi-Strauss pointed out).

Derrida mimes this limp in his own essay, trying to capture just the right gait, since its effect, as exercised in *Beyond the Pleasure Principle,* is similar to that of the *pas sans pas* (step without a step) achieved by Blanchot – an interminable detour that transgresses passively.[33] Reading *Beyond the Pleasure Principle* as a 'discourse on method', Derrida finds that the pleasure of method is the repetitive return of the question – rhythm. '*Fort: da.* It is necessary that the most normal step allow disequilibrium, in itself, in order to carry on ahead, to be followed by another, the same again, but as another. It is necessary that the limp be above all the rhythm of walking, *unterwegs.* ... If speculation remains necessarily unresolved because it plays on two *tableaux,* band against band, losing to win, winning to lose, how be surprised that it [*ça*] proceeds badly? But it has to advance badly in order for it to work. It rightly limps, isn't that so?'[34]

Noting that *Beyond the Pleasure Principle* ends with the citation about limping mentioned earlier, Derrida remarks that its last chapter, in view of its uselessness to the argument, is a kind of 'club foot'. Yet it is effective in its own way, because it manifests the methodological value of the prosthesis. Beuys also dramatizes this methodological step, with his canes and shepherd crooks (present in many drawings and Actions) standing for the

prosthesis – for the simulacrum replacing the thesis in the deconstruction of dialectics.[35] Beuys refers explicitly to his legs in several Actions, partly with respect to the shuttle sewing them into his signature: in terms of the anagram with 'bee' (*die Beine* = legs; *die Biene* = bee) and in terms of *die Beuge* (*bend* – Kniebeuge = knee bend). The following event from the Action *Eurasian Staff* is relevant: 'Beuys again went to the felt sole [on the floor] and this time placed his iron-soled foot over it at right angles. Then he put a lump of fat in the right angle behind his bent knee and crouched down sharpening this angle until the fat was squeezed out on to the felt sole.'[36] And in a version of the Action *Celtic* performed in Basel, home of Paracelsus, Beuys highlighted 'with flashlights the back of the leg above the knee, located in alchemy as a potentially powerful zone.'[37] Such works embody his slogan, 'I think with my knee.' Discussing *The Pack* (the VW bus loaded with sleds) – which reminds us that the methodological analogy actually includes the metaphors of transport as such (method's root metaphors being derived from the history of travel, messengers, the to and fro, or *fort: da*, rhythm) – Beuys states: 'I compared it [the Volkswagen motor with the sled's runners] to a person who, finding himself in an emergency, says, if I cannot run any longer, I can at least still crawl.'[38] The methodological message of *The Pack*, in other words, is conveyed by the same slogan of speculation Freud cites at the end of *Beyond the Pleasure Principle*.

Keeping in mind the importance for Derrida of the shoes and their laces as methodological models in 'Restitutions' ('the shoes or stocking with which thought advances, walks, thinks, speaks, writes, with its language provided with shoes (or as road)'),[39] we may include as an experiment with the step of deconstruction Beuys' concert in Wuppertal (1963): 'Dressed like a regular pianist in dark grey flannel, black tie and no hat, I played the piano all over – not just the keys – with many pairs of old shoes until it disintegrated.'[40] His intention was 'homeopathic', indicating a 'new beginning, an enlarged understanding of every traditional form of art'.

The steps of grammatology itself are the issue here, finally. The difference between Beuys and Derrida is the difference between applied and theoretical grammatology. The interrogation of metaphors and models which Derrida addresses in his texts

(using the performance capacities of literature), Beuys carries beyond the Book into literal action. Although the difference in their content or subject matter seems at times to be extreme, much of the difference may be attributed not only to the differences between their respective points of departure (philosophy and sculpture) but to the division between text and Action. *Putrefaction* is just as important to Derrida's Writing (the epithymics of decomposition) as it is to Beuys' *Plastik (Fat Comer),* but the *word* and the *thing* affect people differently. Beuys' performance mode similarly leads him to adopt certain formats that may seem alien to Derrida's position-alchemy, Kabala, or the prophet motive in general [...]. But scrutiny of the Actions reveals within them, operating as their organizing principles, the pedagogy of invention and the metaphorics of Writing – grammatology, in short.

The method of grammatology, then, shared by Derrida and Beuys, is the display and displacement of the literal sense of the root metaphors of western thought – dialectic and rhetoric, science and art. At the same time that this analytical function is at work, a further pedagogy of creativity is also set in motion, intended not only to show people the principles of creativity and how to put them into practice but also – and here is the particular power of the new pedagogy, beyond deconstruction – to stimulate the *desire* to create (not necessarily in 'art', but in the lived, socio-political world).

The image of the nomad summarizes the steps of grammatology (the nomad wanderer who crosses all boundaries), with Derrida using the image analogically, while Beuys literally enacts the shamanistic practices of the nomadic civilizations (associated with the Russian Steppes). 'Ever since the very first texts I published,' Derrida remarks, 'the motifs of the "margin" and of "nomadism" are very insistent,' although, he adds, their operation in his thought should be distinguished from the ideology of nomadic margins which was fashionable in Paris intellectual circles.[41] Perhaps, too, it is justifiable to include 'margarine' in that series of terms Derrida generates around *marges,* including *marche* and *marque.* [...]

NOTES

* Excerpt from *Applied Grammatology: Post(e)-Pedagogy from Jacques Derrida to Joseph Beuys* (Baltimore: Johns Hopkins University Press, 1985), pp. 225–64.

1. Allan Kaprow, 'Manifesto,' in *The Discontinuous Universe*, Sallie Sears and Georgianna W. Lord (eds.) (New York, 1972), p. 292. Cf. Kaprow, 'The Education of the Un-Artist III,' in *Esthetics Contemporary*, Richard Kostelanetz (ed.) (Buffalo, 1978), pp. 398–410.

2. Michel Foucault, *Language, Counter-Memory, Practice*, trans. Donald F. Bouchard and Sherry Simon (Ithaca: Cornell University Press, 1977), p. 50.

3. Anecdote told by Derrida in a letter to the author.

4. Lothar Romain and Rolf Wedewer, *Über Beuys* (Düsseldorf, 1972), pp. 36–7.

5. Caroline Tisdall, *Joseph Beuys* (New York: Guggenheim Museum, 1979), p. 101.

6. Götz Adriani, Winfried Konnertz, Karin Thomas, *Joseph Beuys: Life and Works*, trans. Patricia Lech (Woodbury, N.Y.: Barron's, 1979), p. 130.

7. Tisdall, p. 105.

8. Rainer Rappmann, Peter Schata, and Volker Harlan, *Soziale Plastik: Materialien zu Joseph Beuys* (Achberg, 1976), p. 61.

9. Adriani, Konnertz, and Thomas, p. 132.

10. Tisdall, p. 105.

11. Romain and Wedewer, p. 31.

12. John Layard, *The Lady of the Hare* (1944; reprinted ed., New York, 1977), p. 138.

13. Layard, p. 156.

14. Layard, pp. 142–3, 151.

15. There is a certain *Moira* effect – the destiny of wordplay – having to do with the 'hare' as 'copula'. I am thinking of the shuttle joining the vulgar *foutre* ('fuck') with *feutre* ('felt' – which as Beuys points out is made of animal hair, often hare's hair). In any case, not only does Beuys deliberately associate the felt materials with the hare symbol, he also identifies the energy or force represented by the felt and the fat as 'love' (hence the series *foutre-feutre* could be expanded to include *foudre – Coup de foudre*, love at first sight).

16. Sister Joan Marie Lechner, *Renaissance Concepts of the Commonplaces* (New York, 1962), p. 147.

17. Lechner, p. 137.

18. Lechner, p. 144.
19. Lechner, p. 138.
20. Lechner, p. 140.
21. Jacques Derrida, *Dissemination*, trans. Barbara Johnson (Chicago, 1981), 42.
22. *Dissemination*, p. 47.
23. *Dissemination*, p. 213.
24. Adriani, Konnertz, and Thomas, p. 41.
25. Tisdall, p. 44.
26. Tisdall, p. 108.
27. *Dissemination*, p. 362.
28. Clara Bodenmann-Ritter, *Joseph Beuys: Jeder Mensch ein Künstler: Gespräche auf der Documenta 5, 1972* (Frankfurt a.M., 1975), p. 71 (excerpt from this book is in the present volume). In addition to the association linking Derrida's chiasmus with Beuys' cross, there is also an interesting convergence of 'corners' in the respective texts. See especially Derrida's discussion of the corner in *Numbers*, which suggests that the enframing fourth side could be for Derrida what the fat is in Beuys' *Fat Corner*: 'Hazarding themselves out into that night, pressing into the corners of that squarely relate the three surfaces of the imperfect to the single surface of the present, our superadded inscriptions will only, in the end, have succeeded in remarking the passage itself in its own insistence, repeating the square by the closing of the angle, fictively loosening the rigor of the text through the opening of another surface of writing to come, in a certain play of the cardinal points of the hinges (*cardo* = hinge) that has been triggered off. What sort of angle is this angle writing? Concave? Projecting? An angle of reflection? Because we cannot yet know what that will all have meant, let us put 'this' writing forth as a kind of *angle remark*, considering all lines broken' (*Dissemination*, p. 295). This angle shuttles to Lacan's angel. Geoffrey H. Hartman, *Saving the Text* (Baltimore, 1981), p. 85, discussing the meanings of '*je m'éc* ...' – '(*EC: Ecke*, the German word for *carré*). *Ecke* also means corner, or (French) coin, which is what circulates in an economy. But *Ecke* is also the word for angle.'
29. Ingrid Burgbacher-Krupka, *Prophete rechts, Prophete links: Joseph Beuys* (Stuttgart, 1977), p. 55.
30. Derrida, 'Ja, ou le faux-bond,' *Digraphe* 11 (1977), p. 101.
31. Derrida, 'Pas I,' *Gramma: Lire Blanchot I*, no. 3–4 (1976), pp. 147, 152.
32. Sigmund Freud, *The Origins of Psychoanalysis: Letters to Wilhelm*

Fliess, Drafts and Notes: 1887–1902, trans. Eric Mosbacher and James Strachey (New York, 1954), p. 130.

33. Derrida, *La carte postale: De Socrate à Freud et au-delà* (Paris, 1980), p. 287.

34. *Carte*, p. 433.

35. *Carte*, p. 414.

36. Tisdall, p. 130.

37. Tisdall, p. 199.

38. Wulf Herzogenrath, *Selbstdarstellung: Künstler über sich* (Düsseldorf, 1973), p. 31.

39. Derrida, *The Archeology of the Frivolous: Reading Condillac*, trans. John P. Leavey, Jr. (Pittsburgh, 1980), p. 21.

40. Tisdall, p. 87.

41. Derrida, 'Entre Crochets,' *Digraphe* 8 (1976), p. 108.

15. IN THE SHADOW OF JOSEPH BEUYS
Remarks on the Subject of Art and Philosophy Today*
PETER BÜRGER

I. Philosophy and Art: After Utopia, the Battle of Extremes

Since rare birds are beginning to die out in our highly industrialized societies, theoreticians are also beginning to suspect that Hegel's owl of Minerva could be a stuffed bird in whose plumage the dust of centuries is collecting. If even the past has frozen into an object of display, how much worse must things be for a theory of the present age. Who would dare today to conceive of it as a constellation together with a past epoch which one is to grasp in a tiger's leap?[1] While it's popular to quote this Benjaminian sentence, the words have lost their pathos, since entire packs of tigers – or should they be hares? – leap into all possibly imaginable past epochs to return from their plunderings, rich with clichés.[2] In contrast to the grand projects of Herbert Marcuse at the periphery of the student movement of the late 1960s, theory has grown modest.

> If, then, the legitimacy and truth of fantasy become the demands for political action, if surrealist forms of protest and resistance become widespread within the rebellion of the young intelligentsia, this apparently meaningless development could mark a groundbreaking change of conditions.

Today, Marcuse's lines from *An Essay on Liberation* smack of nostalgia. Not surrealist forms of protest, but Gorbachev's election as General Secretary of the Communist Party of the

Soviet Union, while not a 'groundbreaking change of conditions', has raised hopes in this direction …

In spite of this, the accusation that aesthetics serves political ends here is unjustified; far more credit is due to Marcuse for having made the political dimension of historical avant-garde movements apparent. When Marcuse writes that art 'would have become a productive power of material, as well as cultural, transformation', when he announces 'the end of the separation of the aesthetic from the real, but equally the end of the commercial unity of commerce and beauty, exploitation and joy',[3] he continues the utopian hopes of the surrealists. In the context of the student movement, understood as a 'present' in the emphatic sense that Benjamin associated with the concept, Marcuse actually achieves a 'tiger's leap into the past'. In May 1968, the hopes of the surrealists appear to be fulfilled; of course they only appeared to be. Already in 1972, in *Counter-revolution and Revolt*, Marcuse retreats from this rapturous position, criticizes the 'desublimation of culture' as the 'destruction of aesthetic form', and subsequently argues for the preservation of bourgeois art since it opposes the reality of bourgeois society; in short, he approaches Adorno's position without of course adopting the latter's strict notion of the modern.[4]

Today it appears that little remains of the great reconciliation of art and theory under the banner of utopia. Habermas assigns art a place next to science and ethics as one of the spheres of differentiated reason, but he has decided reservations about the blending of aesthetics and politics. Because he understands the separation of the spheres of science, ethics and art as historical progress and as a contrast to pre-modern societies, any attempt to put this separation in question is for him suspect and betrays a desire for regression. For this reason he obligates art, defined as a radical expression of the subject, to recognize the autonomy of the other spheres. Consequently the social pretensions of art become restricted, since this demand can only be raised when art impinges on other areas. Habermas certainly has a life-practical and consequential critique of art in mind, thereby legitimating a method of critique Adorno would have considered lowbrow. But this critique can only be realized when the work violates aesthetic immanence and incorporates the extra-aesthetic into itself.

If one asks about the counter-position to Habermas, one comes upon the post-structuralist philosophers. If any similarity exists in the thought of Foucault, Derrida and Lyotard, it is in that they practise a type of dedifferentiation of the spheres of reason (although to varying degrees and in different ways) Habermas argues against. At first glance, Foucault's monumental work *The Order of Things* seems only to take up the older scientific tradition of *Geistesgeschichte*, but the work isn't exhausted in a reconstruction of epochal patterns of thought. Rather it has as its goal a critique of modern philosophy from German idealism to Sartre. The point of departure of this critique is Mallarmé's conception of literature. Foucault makes the thinking through of this concept the mission of postmodern philosophizing, and thereby grants the philosophical concept a non-discursive understanding of language as pure self-referentiality. Derrida's *Grammatologie* at first appears to be engaged with an extremely strict (specific) scientific claim; however, it is rescinded over the course of the argument through the use of poetical language techniques. It is therefore not surprising that Habermas accuses Derrida 'of leveling the genre distinction between philosophy and literature'.[5] Finally Lyotard's notion of 'théorie fiction' most plainly reveals that he no longer trusts rational construction but rather a mode of thinking which consciously adopts artistic methods.[6]

Habermas and the French post-structuralists reach opposing conclusions from the failure of the hope for a radical social revolution tied to the student movement. Habermas creates a critical social theory that provides the framework for a political reform which grasps the 'pathological consequences' of the modernization process; therefore the most extravagant positions of older critical theory must be abandoned. The French philosophers retreat to a certain extent from social theory, but seek to transport the destabilizing undertakings of the historical avant-garde movements into the realm of philosophical theory. The avant-garde project of a revolutionizing of everyday praxis therefore splinters into a reformatory part which pursues the question of how the 'colonialization of the life world' can be checked, and into an anarchistic-revolutionary part which understands the revolution as the aesthetic subversion of prevailing concepts (such as subject and truth), a purely theoretical undertaking. A theory of the present age thus sees itself

confronted with the hardly resolvable task of conceptualizing a unity between these divergent and opposing theories.

Art and Theory: Obligatory Reflection

We have observed the relation of philosophical theory to art, but what is the relation of contemporary art to theory? Above all one must take into account that any discussion of contemporary art implies an historical construction that is in no way securely grounded. Contemporary painting – this designation includes not only the *Neue Wilden*[7] but also Emil Schumacher and Klaus Kröger[8] (Documenta 3, 1964) who, in spite of having worked through part of their material in the late 1950s and early 1960s, are painting their strongest works today. Contemporary painting is embodied by divergent authors who advance such differing traditions as surrealism, constructivism and the neorealism of *Neue Sachlichkeit*. Here the concern is with another matter: the present as construction. Let us again begin with extremes: Beuys and the *Neue Wilden*. Many of Beuys' works are thought pieces (*Gedanken-Werke*); this is not to say that the work's content dissolves in the author's commentary, but that this commentary is a part of the reception process. How can the utopian project of the historical avant-garde be revived – this is Beuys' question, which Breton had formulated as the creation of a 'finally liveable world' – although that project has collapsed? Beuys knows that the avant-garde attack on the institution of art could not free the potential for creativity and imagination contained there, but he also knows that the return to the painted canvas would be wrong for him. Painting is sacrificed for the hopes the avant-garde once maintained. He answers the contradictory determination of the situation with a consciously contradictory self-definition as simultaneously artist and non-artist: 'I really have nothing to do with art – and this is the only possibility of achieving anything for art'.[9] The avant-gardist impulse becomes reflexive, absorbs the impossibility of its realization into itself and yet still holds to its envisioned goal. The individual work (the drawing, the performance) doesn't only speak for itself in sensual immediacy, but it is also part of a whole to which the commentary refers. The content of the work nests in the aporia between commentary and the sensually given, which always exceeds the intentions of the author.

Theory is an integral component of the work for Beuys. In contrast, the *Neue Wilden* have forgotten the avant-garde problematic and it may be for this reason, as we will see, that they are able to reconnect with the procedures of the avant-garde. They don't want to improve the world like the ascetic Joseph Beuys; they want to paint pictures. This appears not to require theory. But theory takes its revenge; it enters the matter through the back door. Immediacy that wants to be immediate is experienced as mediated, that is, as the opposite of what it means to be. Immediacy in painting is almost always staged immediacy. 'The picture,' says Norbert Prangenberg, 'must be hermetic, may not have any ruptures, neither through the title nor through any explanation from me. It is my silent and wordless declaration which only gains power through its colour, form and existence.'[10] Commentary seeking to guard the picture against assignments of meaning functions as interpretation. Silence and wordlessness become programmes which the interpreters can adopt and vary. The return to the pure painterly is an illusion. Reflexivity cannot be skipped over. In a world in which the objects of daily use are only available through mediation (we no longer produce the goods necessary for life ourselves), unmediated art is only possible at the cost of a total break with society, which would necessarily end in madness or death. However, authors who do not pursue this path cannot be faulted.

II. Broken Sense, Modest Theory: The Postmodern

In contrast to the late 1960s, theory has become modest; it has largely abandoned the demand to continue lines of development from the past into the future. A symptom of this modesty is the semantically empty notion of the postmodern, which designates the present only as an afterwards. But it is precisely due to its haziness that the concept is apparently indispensable as a surface of projection for groping attempts to comprehend the present. The question of whether we are presently living a radical change of epoch or if we are merely witness to a multitude of unfinished, small and overlapping changes is what keeps the postmodernism debate alive. The question we pose for ourselves is fairly paradoxical. Epoch is an historical category with whose help we seek to bring order into the plenitude of what is past; a radical change of epoch is an historical construct. When we

ask ourselves if we are presently living through a radical change of epoch, we connect two mutually exclusive perspectives: the experiential perspective of the participant, and the ordering of the narrator who surveys a past event. We want to live in the present and at the same time see that present with the simplifying gaze of the historian, whereas the historian's task is to heighten the intensity of our experience. We can examine the paradox of this approach yet we can't cast it off. With the weakening of traditional alliances comes the need for self-constructed orientations. The question of the radical change of epoch which irrepressively resonates within the concept of the postmodern elevates our need for orientation in a present whose most striking characteristic we find to be the speed with which it transforms itself into the past.

When one leaves the relatively safe terrain of architecture, where the concept signified a departure from the functionalist mode of building of modernism, one encounters lack of clarity, discrepancy and unanswered questions everywhere. Does it make sense to designate the neo-expressive painting of the *Neue Wilden* as postmodern, since it connects with expressionism, considered a movement in artistic modernism? Should one designate an author like Michel Tournier as postmodern since he reaches back to the traditional narrative form of the auctorial novel? The criterion seems inapt in view of the fact that, particularly in France, there exists an uninterrupted tradition of realistic narration in the twentieth century which even criticism acknowledges.

There are obviously more complex qualifications of the postmodern than these but significantly most have to do with theoretical postulations and not with artistic techniques and modes of representation. A central thesis of postmodern thought is that in our society the sign no longer refers to a signified but only to other signs; our speech no longer achieves anything like meaning, and we move within an endless chain of signification. According to this thesis, the sign that Saussure had still described as a unity of signifier and signified would be broken. A programmatic drawing by Francesco Clemente speaks to the Italian painters' familiarity with this idea. The drawing shows two figures striding in opposite directions, each holding half of a broken ring, on which 'symbolon' is written. In fact, in

comparison to Informel painting of the 1950s and 1960s, one can observe since the end of the 1970s a return to meaning-suggesting signs in painting whose uniqueness consists in refusing any ascription of meaning. In many pictures by the young Italians, and also by the *Neue Wilden*, the signifier which is granted autonomy is merely the trap the painter sets for the viewer so that he loses himself in the whirl of possible iconographic meanings. In this context Stephan Schmidt-Wulffen speaks rightly of an interpretation blockade.[11] Of course this procedure is already encountered with the surrealists. In Magritte's *The Museum of a Night* (Fig. 15.1, 1928) four boxes are arranged next to each other; three of these hold an object (a hand, an apple, and an amorphous form, respectively); a view into the fourth box is locked out by a pattern placed before it. The viewer is challenged toward meaning, not least through the suggestive title of the painting, but the viewer's attempt toward meaning meets with the void. The signifiers reveal no signifieds; the open boxes with their symbols are as locked as the fourth box with its covered interior. Surrealism already knew the (postmodern) sabotage of meaning.

15.1. René Magritte, *The Museum of a Night* (1928); © 2006 C. Herscovici, Brussels/Artists Rights Society (ARS), New York.

If the first attempt cannot determine whether the talk of postmodern art also squares with artworks, then the next thought is that the concept merely renews old strategies of culturally conservative authors who have repeatedly pronounced the death of the modern. In *Minima Moralia*, Adorno tells of his first composition teacher, an enemy of atonal music, who sought to lead his students back to tonality by presenting atonality as outmoded. 'The ultramodern, his argument went, is already no longer modern, the fascination that I searched for has become

dull, the figures of expression that had excited me belonged to an old-fashioned sentimentality, and the new youth, as he liked to call it, had more red blood corpuscles'.[12] Therefore by the 1920s the argumentary trope of the dismissal of the modern was already developed. Around 1960 the sociologist Arnold Gehlen would take it up with the thesis that artistic modernism had entered the state of 'crystallization' before the First World War and was therefore no longer capable of renewal.[13] Of interest in these early critiques of modernism is that they consistently argue within the attitude of the modern when they designate the new, i.e., the capacity for renewal, as the criterion for judgment. The often raised accusation of inhumanity within architectural criticism in the culturally conservative anti-modernism of the 1950s originates in opposition, and was effectively represented by Hans Sedlmayer, who denounced artistic modernism in toto as the renunciation of humanity contingent upon the 'loss of the reality of God'.[14] Volker Tannert continues this polemic today with his programmatic painting *Posing for Tatlin II*. It shows a human figure whose excessively long limbs follow the spiralling turns of the famous tower created by the constructivist Tatlin as a monument for the Third International in 1920. Its head resting on the ground, the figure holds a shovel whose blade rises above this monument of human flesh. The painting is a repudiation not only of the optimism of the revolutionaries who saw in the machine an instrument for the construction of a better society, but also of constructivism as a modernist principle of production. The constructivists' enthusiasm for technology is charged with the rape of humanity. The rational project of liberation has reversed itself into its opposite. Barbarism lurks behind the self-empowerment of humanity; it is intimately connected to constructivism.

New Sensibility and the Farewell to a Work-Centred Modern

The battle for intellectual power positions moves into the foreground if one places the current postmodernism debate into the context of the confrontations with modernity carried out in the 1950s and 1960s. This didn't have to do with art but with intellectual ascendancy. This viewpoint has its justification but also its limitations. Since the analyses of Pierre Bourdieu and his school we know that questions of power play an essential role in

intellectual arguments, but that these are not entirely devoted to power struggles. The critic who is capable of seeing nothing save a conservative strategy of cultural roll-back in postmodernity gives up all claim to decipher the signs of the times in it. Paradoxically he unwillingly confirms the postmodern thesis of the independent signifier when he exposes postmodernist discourse as singularly power-oriented. One might express this differently: he who analyzes the postmodernity debate exclusively in terms of intellectual power foregoes the possibility of understanding the changes in aesthetic sensibility that surface in that debate as an expression of the changed engagement of intellectuals with social reality. Even if an independent – not based on the modern – postmodern art could not be established, this would not mean that the talk about the postmodern has no object of reference. Its object would not be a new art, but an altered attitude toward art as well as society. The changes that the postmodernity debate seeks to comprehend would not be on the level of the works but on the level of the institution, i.e., the normative discourses that first make artworks into artworks.

The shift in attitude in regard to historic architecture of the nineteenth century indicates that over the last fifteen years a not insignificant change may have taken place in aesthetic sensibility for those interested in artistic matters. What in the 1950s and 1960s was held in contempt, the arbitrary recourse to past styles and the preference for ornament, has been revalued and recognized as an expression of a comprehensible effort toward a humanistic method of building. A colourful coat of paint over previously whitewashed façades and the accentuation of ornament through a darker colour tone announced the change in attitude which continues in the growing refusal of modernist glass and concrete architecture. Something similar may be observed in painting, where the interest in painters like Bonnard, who did not participate in the stormy developments of art of the twentieth century, is growing; the realistic painting of *Neue Sachlichkeit* and, most recently, even salon painting of the nineteenth century – one thinks to the Musée d'Orsay in Paris – experiences a revaluation. On the other hand, many Informel works of the 1950s and early 1960s appear merely decorative and pleasant to the contemporary viewer. A conformity, once not perceptible, stands out in them. The moving pictures of

certain kinetic artists which at the time seemed to point to a unification of art and technology, today produce an impression merely of the obsolete without showing any sign of the aura of the obsolete apparatus. And the flattened, often vegetative forms which were perceived at the time as rigorous now allow a recognition of their secret relation to the kidney-shaped table.

If one understands the postmodernity debate as a by no means completed effort to assimilate these changes in aesthetic sensibility into the concept of the postmodern, the question arises of what the new sensibility continues. My thesis is as follows: it does not reconnect to pre-modern art, but to the movements of the historical avant-garde, without of course adopting their radical questioning of the institution of art. Postmodernity doesn't dissociate from modernity in its entirety but from the shape modernity took in the 1950s and early 1960s. If one tries to ascertain what unites the various artistic statements of this period one encounters a specific pathos of purity, an emphatic concept of the artwork, and the delineation of artistic production from the everyday. Just as architecture had freed itself from ornamental building elements, so painting freed itself from its confinement to depiction, as the *Nouveau Roman* freed itself from the categories of traditional narration (trope and plot). If painting saw its task in freeing the viewer's gaze from the constraints of an object- and goal-oriented perception, then the novels of Robbe-Grillet wanted to present the bare existence of things in lieu of a universe of subjectively fixed meanings. The purity of the artistic medium appeared not as raison d'etre but as a decisive precondition for the success of the work. The modern art of this time defines itself by a series of taboos: artist and art audience know what is no longer acceptable. It is no accident that Adorno takes up Valéry's notion of the 'refus' and gives it a central place in his aesthetic. Although the historical avant-garde movements had placed the category of the artwork into question, it again attains an unchallenged validity in the 1950s and early 1960s. Adorno's aesthetic, which can be considered *the* modernist aesthetic of this period, is so exclusively formulated around the notion of the artwork that the notion absorbs, as it were, the authority of the author and the recipient. The work and only the work is the site of a truth which transcends discursive knowledge. Such an emphatic concept of the artwork

can stand only if the work remains separated from everyday extra-aesthetic production and also from trivial art by means of insurmountable barriers. Adorno's aesthetic delivers the epoch-making formulation for this as well.

This work-centred Modern could only become culturally dominant at the expense of that modern which cuts across it, that is, the historical avant-garde movements (Dada, Surrealism, Futurism). These had elevated the impurity of the artistic medium to a principle, its blending with the depths of psychology (in 'ècriture automatique') or in the play of the intellect (in paintings by Magritte). They didn't want to capture the aesthetic within the artwork but wanted to free it from its limitations and release it into the everyday as a life-altering potential. The avant-garde movements had long since broken through the strictly observed barrier against trivial art through impudent borrowings and provocative familiarity (one has only to think to the Dadaists' advertising gesture [*Reklamegestus*]). In short, the artistic modern of the 1950s and early 1960s which sought to realize the hermetic as the harmonized artwork, which had the everyday as its exterior and trivial- and entertainment-art as its enemies, was only possible on the basis of an anti-avant-gardism, whereby it is of little consequence whether the producers themselves were aware of this or not.[15]

The Return of the Avant-Garde

What we have tried to understand here with the rather awkward concept of the postmodern might be evidenced in the breakthrough of the avant-gardist problematic into modern art. The taboos established by the work-centred modern have lost their validity. Where the modern of the 1950s and early 1960s was formed through the struggle for purity of the artistic medium, it appears that exactly the impure has achieved programmatic importance today. This extends from the thoughtless return to the object in painting, to the ease of anecdotal narration, to the joy regarding 'quotation', and to the ironically displayed avoidance of aesthetic composition. If the modern had discovered the everyday as object early on (Flaubert), then it had also given the border of the artwork with reality the meaning of a metaphysical principle which could not be violated under any circumstances. Lately this border appears to have become permeable again.

Already Pop Art had put the boundary with the everyday into question in an enigmatically playful manner, again confronting art with its fathomlessness (Warhol's Brillo boxes resemble – Brillo boxes). The increasingly encountered practical tendency of works that Adorno would have considered lowbrow also belong to this context. Where the strict modern finally excludes the semantic as an element foreign to the purity of the aesthetic and entrusts form alone as the residual element of meaning, we experience today a rapturous return of meaning-carrying signs, which, nevertheless, and in a confounding manner, leave their promise of meaning unfulfilled.

Of course one must also acknowledge the differences with the historical avant-garde movements. These were informed by the notion of a great social utopia: not only forms of political power but also the relations of everyday life were to be revolutionized. In the context of the student movement it appeared, for a short while, as though the hopes of the avant-garde had a chance of realization. Today we know this was not the case. The great utopian perspective retreats back into what Manfred Schneckenberger calls the 'small Art-Life-Utopia', the interiorizing of everyday objects as representative of life in art.[16] The attack on the institution of art has become an artistic procedure.

The historical avant-garde movements had conceived the overcoming of the autonomous work as the liberation of the creative potential of art from the jurisdiction of the institution; it mattered, as Breton's rule from the first surrealist manifesto reads, 'to practise poetry'. When the work is put in question today it is no longer carried by the pathos of the revolutionizing of everyday life but rather by a pathos of disappearance. Renate Paulsen allows the wind to tear her six-metre-high paper towers, stretched between the ground and a horizontal branch, and documents the stages of the destruction in a tiny series of photos. Norbert Radermacher's work, inconspicuous interventions in the materiality and structure of our everyday environment, wants merely to be perceived. Not recognizable at first glance as artworks, they depend on the intensity of the incidental. The artist does not impose himself on the viewer by means of a space-seizing shape (be it an equestrian statue or an abstract form), but rather by means of the intensity with which he conceives of his

own disappearance. The modern has generally made available for everyman – in reality, of course, only the small audience for art – a sensibility for aesthetic material which questions where the particularity of the artist's activity lies. Answers given today range from the monumentality of many works from Documenta 8 to the pathos of the incidental. Theory, which has retreated from the great utopia, returns as a component of the work itself. We are still standing in Beuys' shadow.

NOTES

* 'Im Schatten von Joseph Beuys', *Kunstforum* 90 (1987), pp. 70–79. Translated by Claudia Mesch.

1. Ed. note: The reference here is to Walter Benjamin's 'Theses on the Philosophy of History': 'The French Revolution viewed itself as Rome incarnate. It evoked ancient Rome the way fashion evokes costumes of the past. Fashion has a flair for the topical, no matter where it stirs in the thickets of long ago; it is a tiger's leap into the past. This jump, however, takes place in an arena where the ruling class gives the commands'. In *Illuminations*, trans. Harry Zohn (New York: Schocken, 1969), p. 261.

2. Ed.note: The hare is an iconographical element throughout the work of J. Beuys, from its corporeal manifestation in performance as a carcass to its representation in drawings and watercolours.

3. Herbert Marcuse, *Versuch über die Befreiung* (Frankfurt: Suhrkamp, 1969), p. 54. Translated as *An Essay on Liberation* (Boston: Beacon Press, 1969).

4. Herbert Marcuse, *Konterrevolution und Revolte* (Frankfurt: Suhrkamp, 1973), pp. 97ff; the American edition was published in 1972.

5. Jürgen Habermas, *Der philosophische Diskurs der moderne: Zwölf Vorlesungen* (Frankfurt: Suhrkamp, 1985), p. 246.

6. On the previous points, see the essays on Foucault and Lyotard in Ch. and P. Bürger (eds.), *Postmoderne: Alltag, Allegorie und Avantgarde* (Frankfurt: Suhrkamp, 1987), pp. 114 ff. and 122 ff.; in the same volume I have attempted to make recognizable the significance of J. Beuys' position to present aesthetic debates. [Ed. note: This essay has been translated and published in English: 'Everydayness, Allegory and the Avant-garde: Some Reflections on the Work of Joseph Beuys', in Peter Bürger, *The Decline of Modernism* (London: Polity Press, 1992), pp. 147–61.]

7. Ed. note: The *Neuen Wilden* or the 'New Savages' were a group of figurative painters who began exhibiting as a group in Germany in 1980. These painters have been classified as 'neo-expressionist'; the work attracted a great deal of attention in the art market and in critical discourse as evidence of the return to figurative gestural painting in western art.

8. Schumacher and Kröger are German painters who worked in large-scale abstraction in the 1950s and 1960s.

9. J. Beuys, *Drawings*. Exhibition catalogue, Nationalgalerie Berlin (Munich, 1979), p. 31.

10. Marianne Stockbrand, 'Gespräch mit Norbert Prangenberg...', in *Norbert Prangenberg*. (Krefeld: Museum Haus Lange, 1984), p. 82.

11. Stephan Schmidt-Wulffen, *Spielregeln. Tendenzen der Gegenwartskunst* (Köln: Dumont, 1987), p. 72.

12. Theodor Adorno, *Minima Moralia* (Frankfurt, 1969), p. 291. [Ed. note: This passage is drawn from the appendix of the German edition, which is not included in the English translation.]

13. A. Gehlen, *Über kulturelle Kristallisation* (Bremen, 1961), passim.

14. Hans Sedlmayr, *Verlust der Mitte. Die bildende Kunst des 19. und 20. Jahrhundert als Symptom und Symbol der Zeit* (Frankfurt: Ullstein Bücher, 1956), pp. 137 and 101 ff.

15. The talk of the anti-avant-gardism of the work-centred Modern (as represented by Adorno's theory) naturally only makes sense if one uses the notion of the avant-garde not as a symptom of the modern but as a designation for a multitude of artistic movements that were formed at the periphery of the First World War, and that had as their goal the liberation of the creative potentials encapsulated in the institution of art into reality.

16. 'Sie dürfen es ruhig schon knistern hören. Ein Gespräch zwischen Manfred Schneckenberger, Leiter der Dokumenta 8 und Stephan Schmidt-Wulffen', *Kunstforum* no. 88 (March/April 1987), p. 337.

16. LETTER TO JEAN-FRANÇOIS CHEVRIER*

Peter Bürger

DEAR JEAN-FRANÇOIS CHEVRIER,

When I attempt to talk about my own work I am always overcome by a feeling of apprehension. I think of La Rochefoucauld, who is known to have assumed that it is not possible to speak the truth about oneself, that everything connected with that subject cunningly evades our understanding. Lacan hardly thought differently. What is more, there is at present no common horizon for a European conception of self. While it is true that Benjamin and Adorno have been received in France, and Foucault and Derrida in Germany, I am not certain whether, when we mention these names, we mean the same thing. Did we not notice right at the start of our conversation that the political concepts we presuppose are completely different? Whereas you, citing Hannah Arendt, limit politics strictly to the area of action, I base my thoughts on a much more comprehensive concept of politics, discernible, for example, in the early writings of Jürgen Habermas.

If I endeavour to say something about my works despite these misgivings, it is because I have always had an awareness of their historicity. It was never my ambition to speak eternal truths, but rather historically feasible realizations. He who deems himself the owner of truths is compelled to defend those truths, thus promptly revealing their untruth. He who formulates a realization containing a 'temporal core' (Benjamin) is not unacquainted with the thought that historical development will change that realization.

I will begin with surrealism, about whose immense significance – not only for the art of the twentieth century – we apparently

agree. When I try to reconstruct the train of thought on which I based my surrealism book in 1969–1970, I am confronted with a peculiar schism. On the one hand there was the fascination brought about by the Utopia of another life, the will to bring the potentials of the imagination and dreams back to real life after their progressive isolation in the course of modernism and their encapsulation in the autonomous work of art. On the other hand I had developed quite a critical attitude towards the irrationality of surrealist politics. For the author who, during his childhood, had experienced the masses as they thronged to catch a glimpse of the Führer, the thought that it is imperative 'to win the forces of intoxication for the revolution' (Benjamin) was unbearable. Back then, quoting from memory, I wrote 'to win the forces of intoxication for politics', thus becoming conscious of the fact that I believed neither in the possibility nor, apparently, in the desirability of a revolution. Nevertheless, in my own way I took part in the student movement, for it seemed to open up the possibility of a non-archival means of perceiving history for political purposes. Indeed, the book begins with this sentence: 'Since the events of May 1968 at the latest, the current relevance of surrealism is obvious.' Here 'current relevance' does not mean the adjustment of works from the past to the fashions of the present, but rather *Jetztzeit* (now-time) in Benjamin's sense: the palpably sensory impression that one's own time has entered into a unique constellation with a past era. And this constellation made two things possible. It finally revealed the socio-critical dimension of surrealism, an aspect overlooked by Hans Magnus Enzensberger in his essay 'Aporien der Avantgarde' in the early sixties, when he deemed it necessary to denounce the surrealists as heralds of fascism. At the same time, it finally allowed an exit from the grey of the 1950s and early 1960s in the Federal Republic of Germany and the thought, inspired by the surrealist impulse of a radical critique of alienation, of the possibility of a different life not primarily concerned with increasing one's wealth and planning one's career. But this double movement found no correspondence in the everyday life of the assistant (professor) in the Department of Romance Languages at the University of Bonn – except a negative one, namely, that he was personally experiencing the expropriation of life, addressed by the opening words of the first surrealist manifesto.

You were surprised that the author of *Theory of the Avant-Garde*, writing in 1974, should so totally and uncompromisingly direct his gaze towards the past and interpret the historical avant-garde movement as the vanishing point of the history of autonomous art, without considering the neo-avant-garde movements of the sixties and early seventies. This, it seems to me, can be explained by the book's stance within the theoretical debates of the time. The book was conceived as a counter-argument to the widespread practice of popular materialism, which traced every work back to its societal basis. It intended to lay the foundations for a critical study of literature and art capable of producing knowledge and not merely of applying a system. To achieve this it was necessary first of all to find a historical place from within which the history of art in bourgeois society could be constructed. If the critical study of literature and art refused to be merely a field of application for materialistic historical science, then it could not let historical science dictate the location of this place, but had to find it in its own field. This was essential for posing and possibly answering questions regarding the connection between art and society. These intentions were also the source of the ambitious claim to a scientific approach, which alienated me a little when I reread the introduction to *Theory of the Avant-Garde* more recently. Reflection ascends in a spiral motion, every solution tearing open an entire new complex of problems. Here speaks the furore of the theoretical, also to be found in the early texts of Habermas and in Althusser – a nearly unlimited trust in the power of theory to reveal worlds and to shape worlds. It can be an expression of the will to possess power oneself, but the author was not aware of that at the time, perhaps because he regarded Nietzsche all too one-sidedly as the pioneer of fascism and not the conclusion of the enlightenment which in fact he was. The theoretical tension later slackened, so that a (masculine) power fantasy is now easily detectable behind the theory discourse of the sixties and seventies. Whereas back then, theory appeared to us to be *the* key to the actual reshaping of societal reality, we seem to have lost that key in the meantime. Having become distrustful of our own tools, we watch as the society we live in staggers toward ecological, social and – ultimately – economic disaster, unable to do anything but take notice of the circumstances. However exaggerated the belief in theory might have been, our

present renunciation of it is not one iota better, for the fantasy of power has become one of powerlessness. Sometimes it almost seems to me that we intellectuals still have not found our place *in* society.

Some time ago now, Ben Morgan, working in Bremen on a thesis on Adorno, confronted me with an entirely new interpretation of *Theory of the Avant-Garde*: the book as an expression of resignation, seeing the failure of the surrealist project reflected in the failure of the '68 generation. I suppose this analysis strikes true in some ways. It is certainly no coincidence that the theory of the failure of historical avant-garde movements – implying a clear rebuff to all neo-avant-gardes as well – met with the fierce resistance of those who intended to latch onto the revolutionary hopes of the avant-gardes. To be sure, this was a naive idea to the extent that it was blind to the realities of the Federal Republic. But to say that the avant-garde project of revolutionizing all forms of communal life was a failure was also somewhat misleading, as it suggested a dismissal of the avant-gardes altogether. Jürgen Habermas, as you know, in his Adorno Prize lecture 'Modernity – An Incomplete Project', adhered to this conclusion. Yet I was unwilling to understand the theory of the failure of the avant-garde in this way, being concerned with linking preservation and criticism in the sense of Benjamin's 'rescuing criticism'. And I soon explained the theory, saying that the failed endeavour had by no means been dismissed but reserved for the present as something uncompleted.

It seems to me that this thought closes the gap you discovered between *Theory of the Avant-Garde* and my Beuys essay in the book on postmodernism co-edited with Christa Bürger. Only if one conceives this theory of the failure of the avant-garde rationalistically does one detect a break between the two texts. To a dialectical view, however, which perceives the unfinished aspect of the problem, the transition from the first position to the second is logical, providing it emphasizes the other side of a contradictory relationship.

As I write this I begin to suspect that in my attempt at self-explanation I might be suffering from a compulsion to exhibit continuity, instead of just admitting the break and explaining it on the basis of historical changes. To be honest, in the mid-eighties, when I wrote the essay on Beuys, my exuberant trust

in theory had dwindled. I could not manage to immobilize the present, in Benjamin's view the prerequisite for attaining historical knowledge. I no longer sensed the present as the 'rock' referred to by Horkheimer and Adorno in *Dialectic of Enlightenment,* the mainstay from which the past and the future could be recognized, clearly outlined. The present was now nothing more than a surface of infinite expansion, onto which the media cast its images, in which the past became blurred, a mere quotation, and the future was the unending extension of the present. How could one react to such circumstances, to this 'new incomprehensibility' (Habermas), which pulled the rug out from under the theory approach? The only possibility I saw was to reverse the dispositive designed by Benjamin: rather than using the construction of a *Jetztzeit* as an outlook to the past – a past throwing light on the present – one had to relinquish the protection of a theoretical construction and risk exposing oneself directly to the work of an artist who was dealing with the avant-garde issue under changed conditions. The result shows that we have entered an epoch of ambivalences, no longer to be overcome by means of the either/or logic. Beuys, by defining himself in one situation as an artist and thereby taking advantage of the protection offered by art as an institution, and rejecting this designation in another situation in order to emphasize the social aspect of his actions, takes on the avant-garde challenge of unifying art and life, but does it in such a way that the failure of this project is acknowledged. In the shadow of a society which is on the verge of putting the neoliberal market economy into effect without any ifs, ands, or buts, it is no small accomplishment to preserve at least the thought of the possibility of a different life.

As you can see, in recent years I have reconciled myself in many ways with Adorno's position, after having followed in Habermas' footsteps in the seventies and confessed my faith in the still-to-be-constructed theory. Let me conclude with a quotation from my latest book, *Tränen des Odysseus* ('Tears of Odysseus') which is concerned with critical theory and post-structuralism and ends with a fictive monologue by the dying Adorno:

> The tricky thing about the future situation of art, which he suddenly thought he saw clearly before his very eyes – so there was something like intellectual

contemplation after all – the tricky thing was that to all appearances everything would stay as it had been in the era of modernism. There would be non-representational painting and twelve-tone music. But the images would lack something; the only word he could think of for it was that old-fashioned word "soul". It suddenly no longer mattered how one painted and how one composed; the pathos of the modern had become as hollow as that of a ceremonial speech. There was nothing offensive about it anymore. It had become consumable, Duchamp had become comical, one could have fun with it, just as one could have fun with bouquets of dried flowers. Art could no longer be distinguished from that which already existed and therefore, despite its great liveliness, was dead. The clarity of his thoughts frightened him. Maybe it was the influence of the moon, shining large and round into his room. The idea amused him. His pains were becoming more frequent and he began to suspect that this night might be his last, but he was not afraid. No, he would not be taken in by the philosopher of death. Only one thought troubled him – that he might not have enough time to conceive of art's rescue. He felt a strange lightness. Nothing was impossible; one had only to think the logic of reversal through to the end, without fear. Modernism had protested against the claim to sense – Beckett. But where the negation of sense had become the principle of society as a whole, the search for a non-trivial cipher for sense could be an act of resistance. In the final analysis it was all a question of temporal dimensions. The Moloch of the present had to be destroyed by figures transcending the limits of Now.

Early November 1996

NOTE

* In Catherine David, et al. (eds.), *Documenta X* (Ostfildern-Ruit: Hatje Cantz, 1997), pp. 379–80.

17. THE AESTHETICS OF POST-HISTORY

A German Perspective*

IRIT ROGOFF

OURS IS A GRAVE dilemma, situated in the West at the end of a millennium. We stand in the shadow of numerous traumas of holocaust, genocide and erasure, and we are faced with a series of moral deliberations concerning the relation between memory, testimony, and the task of living out our histories in a vaguely responsible manner. Those who perpetrated crimes against the innocent in the names of political ideologies or political expediencies are now confronted with the need to remember as part of some form of reconciliation with history. At the same time, the victims, or what remains of them in altered forms, are simultaneously confronted with the spectre of their reinscription into history as a potential healing of the very trauma of their initial excision. It is the discourses of such notions of responsibility, the questions of whose convenience they serve and of what they ultimately mask and contain, which constitute our dilemma. I would like to engage with the way in which they have been problematized in the work of several German artists who have been producing work within the frameworks of postmodernity. The discourses of memory and commemoration within German cultural life entail questions regarding historical practice, responsibility and testimony which are linked to certain moralizing positions, all of which claim that to produce some concrete manifestation that marks loss, even in a negative form, is the appropriate response.

I would like to take issue with such moralizing discourses, though that does not mean that I would wish to dispense with the necessity of a morality. The issues I would like to take up

result from a perception of such moralizing as an essentially comforting discourse which identifies right and wrong positions with great ease and rapidly suggests an appropriate gesture of response and reconciliation. These gestures serve to reproduce the binary structure which has for so long dominated western modernist consciousness and in which trauma, manifested as loss, is forever addressed by processes of concrete objectification. Victims are faced with perpetrators, ruins with some form of (even partial) reconstruction, silence with narrativity, and erasure with reinscription.

We are all familiar with the history of Germany in the twentieth century, a history so spectacular that it has become the very index of western horror. However, the invocation of horror functions in several ways and an attenuated and accountable historical reading would also dictate that we see the consequences of this history beyond legacies of guilt and burdens of remorse, beyond the endless, tortuous ways in which guilt becomes a saturation of banal sign systems. We must also mark the ways in which such invocations of spectacular history serve as a device for establishing a cohesion, a myth of nation and a unifying narrative in terms of which everything is interpreted. The responses to the political events of 1992–1993 in Germany were a recent case in point. While thousands of racist German thugs brutalized foreigners, refugees and guest workers throughout the land, millions of other citizens demonstrated against such racism and xenophobia in the name of 'the good Germans'. Such a division between 'good' and 'bad' Germans can only resonate if read against the background of the spectacular histories and horrific legacies of National Socialism. Certainly the world's press received the events in such a spirit, and sensationalized them by invoking the old model of Fascism rather than viewing the events as the inevitable clash between the collapse of state Communism and the transitions taking place within late capitalism. The recuperation of such old models of understanding is one of the many ways by which the boundaries of national narratives are policed and reinforced. So the issue at hand is nationalism and its ubiquitous and insistent presence at the heart of cultural histories which attempt to deal with trauma as a relation between victims and perpetrators, as a legacy of guilt. What, then, is the fate of narratives of nation

which are founded on notions of unique and discrete histories at moments of post-history, when a rapid succession of events serve to undo totalizing historico-political movements and identities? Ironically, it is my contention that nothing establishes the boundaries of nation better than so much of the visual, cultural work which is motivated by the desire to be anti-nationalist. In Homi Bhabha's words:

> To study the nation through its narrative address does not merely draw attention to its language and rhetoric; it also attempts to alter the conceptual object itself. If the problematic 'closure' of textuality questions the 'totalization' of national culture, then its positive value lies in displaying the wide dissemination through which we construct the field of meanings and symbols associated with national life.[1]

I must forewarn our readers that this effort at reading and undoing the cohesive narratives of German cultural legacies will be a long and circuitous journey. My aim is to avoid the concept of *Wende* (turning point) which has so dominated discussions of German culture in recent years, to avoid the concept of new beginnings and to see how a succession of linked visual art practices deal with the problematic of memory in the public sphere.

Since subject position is central to my analysis, I must declare that I am hardly a disinterested party in a discussion which attempts to loosen the national boundaries of particular given histories. I have long been interested in the process of attempting, to paraphrase Palestinian writer Anton Shammas, to 'unGerman German History'.[2] As an Israeli and a Jew it is clear to me that the events that took place in Germany in the 1920s, 1930s and 1940s were equally central to the shaping of our culture in the Eastern Mediterranean in the 1950s, 1960s and 1970s, and in ways which extend far beyond simple demographic issues of immigration and cultural displacements. Therefore I offer the following thoughts in the name of exploring a broad intertextuality of historical trauma which has worked to inform all our cultures in odd and diverse ways and in opposition to a view of culture contained within a a singular national history. To this purpose I shall look at a series of works by German male artists, which

touch on issues of the relations between history, memory and fantasy. (There is another essay waiting to be written, forming itself at the margins of this particular piece. This second essay has to do with the relative absence of women artists from the visual discourses of national memory and from the rituals of public commemoration. The essay-waiting-to-be-written would reflect on this absence as a critical one, in which women artists have chosen to fragment concepts of totalizing history and its concomitant memories, in the name of difference and through an insistence on multiple, concurrent histories which embrace the mundane quotidian and the obliquely subjective. The visual work of Rebecca Horn and the writings of Ingeborg Bachmann or Christa Wolf might serve as examples for such alternative explorations.)

For the moment, however, let us remain with the artists who have positioned themselves in the middle of a public discourse aimed at stimulating and activating a cultural imagination as a way of questioning how these political memories operate at the level of a cultural subconscious. Of all the artists who began to work after 1945, it is clear that Joseph Beuys alone attempts to come to terms with the experience of the war and its consequences and to find a new visual language which would combine past, present and future. Beuys' position as the most prominent artist in West Germany has come as a result of his ability to combine critical issues, exceptionally innovative artistic procedures and an engagement with national politics. It is his unique ability to combine such opposite extremes as tactile and suggestive sensations which engage the viewer on a personal and physical level with complex concepts and ideas, which engage the viewer's intellect to create succinct and striking images.

Although the language pioneered by Beuys is radical, experimental and exploratory, its roots lie in the familiar concepts of crisis which have typified much twentieth-century German art. Thus, for example, we find in his works and teachings an insistence upon freedom from middle-class social and economic beliefs, on the central role of art in any fundamental and regenerative social change and as an investigation of the future in terms of the past. 'Every human being,' he says, 'is an artist who, from his own state of freedom, a state determined by the individual's personal experience, learns to define his contribution

to the total work of art; this total work of art is the social order of the future.' Despite its commitment to the future, Beuys' work contains an exploration of the past. This is conveyed through a reference to subliminal subjects in which past and present merge and in which autobiographical experience and national myth are subtly linked. Beuys substitutes symbolic language for the more familiar formal language of politics.

Contexts

Since the end of the Second World War, West German cultural discourses have been dominated by the tensions inherent in the construction and reconstruction of successive and conflicting narratives of its own history. The present moment is characterized by the contradictory mode in which local historical narratives are framed by wider theoretical developments. On the one hand we find the *Historikerstreit,* the German historical debate, in which the neo-Conservative historians in Germany (Nolte, Hillgruber, Sturmer, Broszadt and Kokca) have sought to relativize the Fascist era by stressing those aspects in which other countries have undergone so called 'comparable experiences' (for example, totalitarianisms and genocides). The West German historian Wolfgang Mommsen has characterized the opposing views in this debate as primarily modes of and attitudes to relativization. Instead of bracketing Nazism out of German historical continuity, as does the school of historical thought and method which looks at German history as following in a *Sonderweg,* a unique path, the neo-Conservative historians in Germany have sought to relativize it by stressing in what respects other countries have undergone comparable experiences. The opposing argument is put by the proponents of the *Sonderweg* who have emerged from the post-1968 neo-Marxist schools of history, and who refuse the introduction of such notions of historical relativization and insist on looking at the Nazi state's activities as institutional continuities located within a specific development of German history. The political implications of this debate are immense, and the responses which the West German philosopher Jürgen Habermas has made to neo-Conservative historians, charging them with the attempt at the construction of a usable past within present day Conservative politics, have illuminated their full complexity.[3] As West German economic prosperity has

continued to develop in the relative calm of strife-free labour relations and official denial of increasing racial exploitation and stratification, as West German cultural practices have gained critical cachet and market clout, so the revisions of historical narratives have emerged with greater strength to frame and envelop these developments with greater comfort and ease. It is important to mention in this context that the *Historikerstreit* was not an esoteric debate among scholars, but a fully fledged political campaign carried out by both factions within the national press and media which has continued for the best part of four years.

More recently the collapse of the Communist state of the German Democratic Republic and reunification with West Germany have once again served to rewrite dominant histories. The resultant economic destabilization of the western part of the new nation and the economic disadvantage of the eastern part have resulted in disillusionment, violence and an alarming swing to the political right, to a politics of law and order and economic stability haunted by ancient ghosts of the 1920s, of extreme chaos on the one hand and of an even more extreme terror of imposed order on the other.

However, the collapse of the GDR and the concomitant reunification have also brought Germany to an exceptionally interesting historical impasse. Every single event, every historical narrative, every biography, political movement or geographical site, is contested and disputed, pulled back and forth between competing historiographies. And these traditions are no longer upheld by state structures but by personal memories, by oral histories, by photograph albums and dream landscapes; these are sites of memory which cannot be effaced by the introduction of a new school curriculum, the denunciation of recent political leaders or the introduction of new manufacturing methods. The most spectacular of Western Europe's modern histories is at present also the most fragmented, a template of fractured nationalisms at an impasse.

At another level, the wider theoretical one, we inhabit the moment of post-history, that moment in late bourgeois development in which historical movement seems to be arrested despite many hyper-accelerated processes. The theoretical framework which has emerged from post-structuralist discussions

of historical practice is at present at a stage which negates both the positions described above. It is both anti-Hegelian and anti-Marxist by definition since it is the rejection of the search for an overall theory of history. To complicate the picture even further, if that is possible, all of these historiographic debates as well as their theoretical frameworks have had substantial counterparts within the institutions and discourses of representation. Simultaneously with these political/historiographic debates, several museums devoted exclusively to the construction and display of German history are being opened (Frankfurt, Berlin, wings of museums in Osnabruck, Munich, Nuremberg and other cities) in the near future and heated public discussions have ensued concerned with precisely which version of history they are going to represent.[4] The emergence of Berlin as the resurrected capital of the new united Germany, the efforts to re-establish its national institutions and to re-write its awkward and interesting marginality as a triumphant spectacle of continuous history, continues to erupt in stormy debates and protests. If there are processes to be charted within these post-historical waters, they are those of recuperation, a rhetoric of nostalgia put forward by a weak government and seemingly ignored by most of the embarrassed population.

Within visual culture, during the 1980s certain West German painting practices, operating under the generally inappropriate title of 'Neo-Expressionism', captured the popular imagination as *the* European school of history painting. For me the fascination with these works and their relation to their articulating context has been precisely the *absence* of any traditionally serious, conceptual or problematized discussion of history. Were they putting forward a world of sign and simulacra entirely divorced from any historical narrative? Were they discoursing on the impossibility of a discourse of history? Were the cynicism and irony apparent in every thematic and formal aspect of the work directly related to the sacrifice of a grounding narrative and its fragmentation into an endless array of free-floating signifiers? Increasingly it seems to me that, in the effort to find ways of approaching the unapproachable taboo of history within West German culture, an alternative discourse (a discourse of collective memory), has been opened up. My comments, then, are an attempt to understand the shift from a discourse on history to an

alternative discourse of memory and the visual representations of this emergent and politicized understanding of memory as seen in some of the work of Joseph Beuys ...

It is important, even within such a very brief discussion, to clarify that by memory I do not mean the notion of individuated, private recollection and neither do I view it, in this context, as a resource of the individuated psyche embedded in the unconscious, but rather as the concept has emerged through the debates on history and collective memory launched by Maurice Halbwachs, Phillipe Aries, Herbert Marcuse and Michel Foucault over the past sixty years.

The main tenets of this debate and as much as I can reiterate here are Halbwachs's argument (formulated in the interwar years in a series of important books and brought to a premature end by his death in the Nazi death camps) that collective memory is related to deep social structures which shape all conscious human endeavour.[5] The social foundation of all processes of recollection, memories are formed out of the imagery of shared experience. By lifting memory out of the unconscious psyche and into a conscious and readily identifiable realm of social understanding, Halbwachs sought to weave individual recollections into the cultural fabric that gives them their broader design.[6] Equally, Halbwachs claims, memory is paradigmatic; it does not resurrect the past but rather it reconstructs it in a plurality of coherent, imaginative patterns. In fact Halbwach's theory of the adaptation of specific memories to the design of a general cultural scheme is close to Levi-Strauss's later structuralist notion of *bricolage*; the same artefacts may be appropriated for unrelated purposes in different cultural milieux.

In the context of the present discussion, Phillipe Aries' problematic (and far more conservative) contribution to this body of thought is that, for all of memory's vagaries, it is still our initial point of entry into the past. Memory then proceeds to have its own history conditioned by its role as a *route* to historical understanding. Aries sees the twentieth century as one in which counter-memory and the history of collective mentalities dominate. This is couched in a deeply conservative argument against the growing authority of the public, political world to which memory serves as a private counter-measure. While the politics of this argument is hardly scintillating, he does, however,

offer some useful thoughts, primarily his discussion of the modern passion for public commemoration which he links to the anxiety wrought by modernity's ever-increasing temporality. This passion, he states, has led to a process in which history has begun to shape memory; translated into our parlance this can be read as an observation on representation's ability to construct meaning.[7]

* * *

Invoking Memory

While memory is undoubtedly a form of entry into a discourse of history, it is not necessarily voluntary.[8] I would like to suggest that some of the early work of Joseph Beuys, in its conscious resistance to simplified forms of historical signification, touches off an involuntary collective memory. His point of entry, along the lines of Aries' argument, is a thematization of the tension between collective and individuated notions of 'The Wound'. As a case in point I would like to look at Beuys' 1955 entry for a public competition of a memorial for Auschwitz. Its components, blocks of tallow on a rusted electric plate, forms alluding to chimney stacks, electrodes and wires, maps of railroad tracks leading into the death camp, drawings of emaciated young women, rows of sausage-shaped matter alluding to waste and organic debris, repeated references to his declared desire to 'show your wound': all of these form an allusion, rather than a set of specific references, to concrete historical components. 'I do not feel,' said Beuys in an interview,

> … that these works were made to represent catastrophe, although the experience of catastrophe has contributed to my awareness. But my interest was not in illustrating it. Even when I used such titles as 'Concentration Camp Essen' this was not a description of the event but of the content and meaning of catastrophe. The human condition is Auschwitz and the principle of Auschwitz finds its perpetuation in our understanding of science and of political systems, in the delegation of responsibility to groups of specialists and in the silence of intellectuals and artists.[9]

Pathos aside, what strikes me as interesting about his analysis is the way in which it negotiates visual codification for two of Herbert Marcuse's most salient contributions to the history/ memory debate: those in *Counter-revolution and Revolt* which posit knowledge as recollection and science as rediscovery. The form of the Auschwitz piece provides its grounding in an alternative form of historical narrative. Unlike any conventional commemoration, this is not heroic, monumental, present or possessed of a coherent narrative; rather it is a testament to absence, being small, fragmented, humble and requiring a prolonged process of reading and reconstituting. In its understanding of the absence at the heart of the taboo – after all, what was being commemorated here, the technology and efficiency of mass murder? – it is a commemoration of what is no longer and what cannot be recuperated in direct historical narrative. Shoshana Felman's recent work on what she terms 'bearing witness' (the ability to site oneself outside of a paradigm in which a course of action took place and 'testify' as to its workings, the space between 'engaged activity' and critical judgment) [...] also has relevance to Beuys' position in the West German cultural scene in the moment preceding the dramatic events of 1968. Echoing the end of *Erfahrung* (that formulation of the concept of *experience* which dominated German philosophy until the end of the 1930s) Beuys was able to touch off a notion of involuntary collective memory and lead it in the direction of language, thereby facilitating some entry, however inadequate, into the hitherto taboo notion of narratives of the past.

In a speech which he gave in 1974 at the opening of an exhibition of his drawings, Beuys advanced the following observations:

> These drawings show innumerable aspects of a theme. But I have tried to arrange those which are backward-looking concepts as shamanistic concepts so that all these constellations are arranged in purely formal fashion and can awaken interest in the consciousness of the spectator. They should be of interest in respect to a total vision of man in time, not only for the present, not only looking backward, i.e. viewing history anthropologically, but also offering solutions for the

future and offering them in the sense of opening up
the problems.

The programme seems to consist of eternal time, historical time
and personal time. These are not arranged in linear progression
but as parallel, interconnected measure of time. In addition, he
would appear to be making a reference to both the fat and felt
in which he was wrapped to prevent frostbite when shot down
over Siberia as a Luftwaffe pilot in the Second World War, and to
the need to relate this personal experience to common cultural
myths.

Beuys set his art within the sphere of a specific crisis which
he discusses in terms remarkably similar to those used by social
and political critics. In a text written for Documenta 7 in 1982,
entitled 'An Appeal for an Alternative' and aimed at 'All people
belonging to the European cultural sphere and civilization', he
addresses himself to the main issues of the crisis:

A. The relationship between East and West, e.g. that
 between communism and capitalism.

B. The relationship between North and South which
 is based on separate production and consumption,
 and on extremes of famine and glut.

C. The military threat of increasing nuclear
 rearmament.

D. The ecological crises threatening to destroy nature.

These must be re-examined in terms of co-existence and
cooperation and the degree to which the social organism which
we maintain interacts with the natural order – 'whether these
have led to the appearances of a healthy existence or have made
humanity sick, inflicted wounds on it, brought disaster upon it
and are today putting its very survival in jeopardy'. The only
way out is a conceptual revolution which would embrace the
individual's opportunity to develop his faculties freely and put
them to constructive use. Here again we find that characteristic
of art which the National Socialists tried to eradicate and
discredit, namely a personal artistic vision put at the disposal of
an ideological programme.

This manifesto for a comprehensive cultural revolution is part of twenty five years of direct action by Beuys which included the formation of the German Students Party and the takeover of the Düsseldorf Academy in 1967. As a bid against authoritarianism and in favour of creativity this takeover consolidated Düsseldorf's position as the new capital city of German post-war art. Not since the early days of Dada had art so totally reflected every facet of the contemporary cultural and economic debate. The Students Party manifestos and Jorg Immendorf's 'Lidl Actions' were complemented by Beuys involvement in the creation of the Green Party, with its radical ecological platform, which has now gained representation in the West German Federal Parliament.

Although condemned as anarchic, Beuys has remained at the centre of several successive generations of cultural engagement with politics. This unique position has been due primarily to three factors: a disdain for traditional modernism, a turning of political rhetoric to his own personal ends, and an integration of historically unpalatable subjects into a new vital visual language. Images made up of fat, blood, bodily excretions and everyday objects are personal reflections of the experience of birth, death, fear and destruction as well as an exploration of experiences within the recent German past. So, for example, the predominance of such images as wounds in his work provides a subconscious response in which personal experience, for example, birth, merges with the corporate experience of political upheaval. *Tram Stop* (1976; Fig. 17.1) is described as that singular artefact: a monument to the future. There are three dominant elements in *Tram Stop*, all made of iron and describing three main directions that relate to air, earth and water. Originally the monument rose vertically out of the ground. Round the upright barrel of a field cannon are clustered four primitive seventeenth-century mortar bombs. Emerging from the cannon is the head of a man with a pained, elusive, expression. His identity too is elusive, part Celt, part martial Roman, part ordinary worker, simultaneously heroic, archaic and anonymous. Past the monument runs the tramline, a horizontal element along the earth's surface and a link to the landscape of Beuys' youth in Cleves. The image evoked by the work includes autobiography and history and brings together experience of the past, pain of the present and aspirations towards a balanced future.

17.1. Joseph Beuys, *Tram Stop*, 1976 (Kröller Müller Museum, Otterlo); © 2006 Artists Rights Society (ARS), New York/VG Bild-Kunst, Bonn.

'Images of the past,' wrote Walter Benjamin, 'are the spoils of war carried on behind the winner's triumphal chariot.'[10] What then is to be said of the post-war German situation in which there were no triumphal factions? In fact the greater the historical distance, the greater the overall perception of loss: Socialism lost, Fascism lost, representative democracy lost, the entire gamut of German modernism has been lost and exists only within museumified mythical constructions that posit objects which have been wrenched out of their discursive spheres. Who then has the traditional privilege of constructing the dominant narrative of the past?

Within this increasingly apparent demise of traditionally perceived and overtly articulated triumphant ideologies, we are faced with another problem of disarticulation. The true victors, the dominant forces which structure western society, patriarchy and capitalism, utterly refuse their own construction as subjects of discourse. While they define everything around them they themselves refuse definition and insist on their own standing as normative values and codes. Their strength lies in their resistance of articulation and therefore their evasion of visual codification. How do you visually signify patrimony or capitalism overtly? There are no sign systems such as Hitler's moustache, the swastika, or crematoria chimneys which work towards a kind of reductive pornography of Fascist evil. Long, elaborate and analytical projects (such as those of Hans Haacke or Hannah Darboven) provide close readings of particular processes but do not produce an easily readable or reproducible sign system. Furthermore, even if we had an overt and visible victorious faction, the moment is one of the implausibility of putting forward any coherent theory of history which would provide a master narrative in which these could be placed. Instead we are all much preoccupied with fragmenting that narrative into more

representative narratives, and even more with problematizing our own positionality towards them. [...]

NOTES

* This essay is a revised verion of essays that have been published previously. The essays first appeared in Stephen Melville and Bill Readings (eds.), *Vision & Textuality* (Durham: Duke University Press, 1995), pp. 115–42; and as 'Modern German Art' in Eva Kolinsky and Wilfried van der Will (eds.), *The Cambridge Companion to Modern German Culture* (Cambridge: Cambridge University Press, 1998).

1. Homi K. Bhabha, 'Introduction', *Nation and Narration* (London: Routledge, 1990), p. 3.

2. Anton Shammas, in P. Mariani (ed.), *Critical Fictions* (Seattle, 1991), p.77.

3. Charles Meier, *The Unmasterable Past* (Cambridge, 1989) and *New German Critique*, Special Issue on the *Historikerstreit*, Summer 1988.

4. Deutsches Historisches Museum, Berlin, Round Table Discussion, Berlin Senate, 1986.

5. *La Mémoire Collective* (Paris, 1945); *Les Cadres Sociaux de la Mémoire* (Paris, 1925).

6. Patrick Hutton, 'Collective Memory and Collective Mentalities: The Halbwachs-Aries Connection', paper delivered at Center for European Studies, Harvard University, by permission of the author, p. 5.

7. Hutton, 'Collective Memory and Collective Mentalities', pp. 18–25.

8. Paolo Jedlowski, 'Modernisation and Memory', unpublished manuscript, with kind permission of the author.

9. Quoted in Caroline Tisdall, *Joseph Beuys* (New York, 1979), p. 23.

10. Walter Benjamin, 'Theses on the philosophy of History', in *Illuminations* (New York: Schocken, 1969).

Section VI

ISSUES OF RECEPTION

18. THE RECEPTION OF JOSEPH BEUYS IN THE USA, AND SOME OF ITS CULTURAL/POLITICAL AND ARTISTIC ASSUMPTIONS*

Dirk Luckow

I. American 'art chauvinism' in the 1960s
and the awareness of a failing independent German sculpture

Through 1969, Beuys was not discussed in any of the major art journals in the USA, nor was he discussed within the official American art world. This is verified by not only the Documenta-organizers Jan Leering and Hein Stünke, who travelled to the USA in December of 1967, but also by Franz Dahlem, who was in New York at the time because of the acquisition of the Kraushaar Collection for [the German collector] Karl Ströher. Dahlem recalls the situation in relation to Beuys in the States:

> Zero. He was not discussed. At the time I had the Mönchengladbach Beuys catalogue with me [the exhibition *Joseph Beuys* was shown at the Municipal Museum in Mönchengladbach in 1967]. The only one who had heard of him was Jan van der Marckt, who first learned of Beuys at the time and who also spoke German.[1]

Not only Beuys but the entire contemporary European art scene, and particularly (West) German art, had no or few advocates in the USA in the late 1950s and 1960s. One searches this period in vain for an important American exhibition that offered a view of German art. The sole contemporary European artist who received a museum exhibition was the Frenchman Yves Klein, in 1966 at

the Jewish Museum. In this retrospective of the artist, who had died four years earlier, the great majority of American critics saw their disdainful view of European contemporary art confirmed and proven. Klein was categorized as a European 'parvenu' whose work was somehow derivative of American art.[2] This judgment encompassed not only Klein but European contemporary art in its entirety, which was assessed in the USA as derivative.[3]

The often-cited American 'art chauvinism' of the 1960s was based on two central points. First it was grounded in an art-political pragmatism that concentrated on domestic products; it was also based on the ideological demarcation of American artists from European art. Ideological demarcation grew continuously for Pop Art and Minimalism, the leading directions of American art of the 1960s, but also for Fluxus. An identification of the leading role of the USA in contemporary art internationally, established after the Second World War, set the standard for both US artists and critics.[4]

Pop artists concerned themselves, in both affirmative gesture as in an ironic distance, with the American metropolis and its cultural products: advertising, the trademark, commercial art, media, comics, the world of 'corporate identity' and the mass-produced. Pop derived considerable influence from New York City, where it was also most commercialized. Robert Indiana considered the American mythos as foundational for all forms of Pop Art. Touching upon the 'American dream', Indiana said, 'It started from the day the Pilgrims landed, the dream, the idea that Americans have more to eat than anyone else.'[5] The signs, symbols and images of Pop Art depicted American culture. There was no booming urban life in Germany after the Second World War that formed the premise for the emergence of an urban art like Pop. Quite the opposite; the influence of the victorious power of the USA was mirrored in a unanimous enthusiasm for American Pop Art.

While the origin of Pop Art in American culture was immediately evident in terms of content, the demarcation of American from European art was more strongly verbalized and theorized in Fluxus, for example, by George Maciunas, and in Minimal art by Donald Judd, among others. At the Fluxus Festival at the Kunstakademie in Düsseldorf in February of 1963, the organizer of Fluxus threw copies of his Fluxus-manifesto into the audience,

where one could read: 'Purge the world of Europanism, bourgeois sickness, intellectual, professional, commercial culture. Purge the world of dead art, imitation, artificial, abstract art, serial art, etc. etc.'[6] And Judd justified the characteristic, industrially produced objects of Minimal art as having cast off the principle of composition in art, which 'tend[s] to carry with them all the structures, values, feelings of the whole European tradition'.[7] Many works by minimal artists consisted of gleaming materials such as sheet steel, aluminium and moulded synthetics, from which one could discern the air of American industrial modern design. In early 1968 the 'official' American art world was far away from reacting to a European artist whose ideas and art did not derive from American modernism. However, the artists of anti-form art to be discussed here, such as Morris, Hesse, Nauman and Serra, measured themselves against Europe.

An example of the pragmatic art-politics I've already cited in relation to other countries can also be traced in the reaction to the attempts by Documenta advisors to secure financial backing in the USA for Documenta in 1968, specifically, for having the exhibition travel to the USA after its showing in Kassel. One considered the USA in Kassel since 'there has already been so much accomplished for American art at the second, and especially at this fourth, Documenta.'[8] Without doubt it would have been the most sensational German cultural export of the 1960s. This plan was, to be sure, quickly scuttled. The USA was not interested. Stünke sums it up:

> It remained an idea. This was never really thought all the way through. Leering and I always had strong reservations. When it comes to money people won't of course be particularly friendly. While one suggests something, that is well and good, it makes curators and artists happy. The whole character of American art patronage, it seemed to me due to my experience – we knew a lot of people over there in the market as well as in the museum, who would have said this – is that it was a utopian thing. And so that's what it remained.[9]

In the same way the attempt to secure financial support in the USA failed. The reactions to Willi Bongard's petition throw

significant light upon on the indifference shown in regard to the support of foreign art.[10] The responses of influential industrialists and other highly placed Americans cite ongoing American commitments which would bump up against the borders of neighbouring countries. The 'philanthropic circles' showed very little interest on anything happening outside of the USA.[11] Besides, as Gertrud Mellon wrote, one could not deduct contributions to foreign countries from taxes in the USA.[12] In addition to this, the commercial 'outflow' of the dollar was so strong that Americans travelling to Europe in this year had to pay travel taxes. It was simply 'unpatriotic' to support foreign cultural arrangements within the then-current economic crisis in the USA. In addition there was an American aversion to underwrite the activities of foreign governments with private funds. The entire campaign solicited contributions of 500 German Marks. The coming together of Germany and the USA remained one-sided. American gallerists, museum professionals and artists travelled to Germany because they had discovered a burgeoning market for their art here. There was little interest in cooperation with West German cultural representatives.

In their firm conviction about the quality of their own art, the Americans' ignorance in regard to German contemporary art was not based in American chauvinism alone. There was a parallel lack of self-assurance on the part of German cultural representatives, as well as a lack of conviction, in recognizing at an early stage the specific forms of independent developments. The difference in quality between US and German art of the post-war period continued to have too much influence. Stünke, who founded the Cologne Kunstmarkt in 1967, said in this regard:

> Who was among us, Baumeister, Nay, Trier, Trökes, Winter, all laudable people and fantastic artists, but one has to be unrealistic not to recognize that this could not to be equated with what the 'new wave' could offer. German standing within world art production was provincial. This held for painting and sculpture. All attempts to bring German art to the USA remained episodic. Schumacher at Koonz (gallery), the Zero-artists at Howard Wise, Baumeister never again saw the works he gave an American agent for an entire exhibition.[13]

Correspondingly, the transcripts of the 1967 planning meeting for Documenta of the following year give a picture of the most difficult situation of German sculpture. Under the leadership of Eduard Trier the organization considered American and British sculpture the 'standard for new tendencies.' In the minutes of the 24 April 1967 meeting the Documenta advisory board members Gerhard Bott and Klaus Gallwitz determined that German sculpture could offer 'nothing corresponding to the newness and unified endeavour of the Anglo-American artists.' German sculpture was considered uncompetitive.

Uncertainty also entered into the question of how one could define German sculpture; one saw Horst Antes, Erwin Heerich and Beuys as its representatives.[14] But it seemed more of a stop-gap measure, as Gallwitz intervened against these names as 'representative of sculpture in Germany'. In his view, Beuys and Heerich belonged to the medium of 'objects' and Antes to painting.[15] In their tendency to categorize contemporary art within classical categories of art, painting and sculpture, the Documenta administrators saw themselves confronted with the situation that 'sculpture' presented a vacuum in the German art landscape. Resigned, Trier asked his colleagues, 'Could we honestly say that they (the German sculptors) don't exist, at least not in comparison to the Americans and British?'[16]

Because the Documenta committee's definition of sculpture was measured according to the formalist school of Anthony Caro and David Smith, it existed in Germany in their view only as a kind of plagiarizing of Anglo-American 'world art'. With such self-doubt, which was no less strongly articulated within painting, the dissemination of German art abroad on the part of German art and cultural politics, particularly in the USA, was not conceivable. Therefore one year before Documenta 4 a tense uncertainty existed on the question of what might represent German sculpture. In 1967 in Germany, one did not imagine, and of course much less so in the USA, that this question would emerge from the field of experimental or avant-garde art or that, as of 1968, it would be connected with the name of Beuys.

II. The American avant-garde in the late 1960s in Germany

New York Fluxus artist Dick Higgins noted, in a comment on American 'chauvinism' in his *Postface* of 1965, that artists who

'went to Europe did not become any less American by it, but their thinking became more universal'.[17] This was particularly true of younger artists such as Eva Hesse (born 1936), Richard Serra (born 1939) and Bruce Nauman (born 1941), who at the time were at the beginning of their careers. During her stay in Germany in 1964–1965, Hesse worked toward a transition from painting to relief and to sculpture, as did Serra, who found his way from painting to his early sculptural works in Florence in 1965. In 1968 Nauman showed his body sculptures at Leo Castelli in New York, while in the same year he first publicly presented a room-centred multimedia installation at the Galerie Konrad Fischer in Düsseldorf. Morris, who arrived in Düsseldorf in 1964, showed his felt works, which in Europe are considered a high point of his *oeuvre*, in Eindhoven and in Paris in 1968; that is, before he showed them in the USA. Not only Morris, Hesse, Serra and Nauman travelled to the Rhineland through the year 1968, but also other American artists of their generation, such as Keith Sonnier, Walter de Maria, Michael Heizer or Robert Smithson. It is characteristic of them that 'the artists themselves here were travelling and becoming more open; that is what was really important, that the artists were more open to what was going on.'[18] During this time they all visited Düsseldorf or Cologne, that is, they showed work where 'without the ideas that bubble forth from Beuys' original intellect, the geographical area that is bounded by Düsseldorf and Cologne would hardly be Germany's most vital and productive artistic centre.'[19]

In part these younger artists, for example Richard Serra, were only later shown in New York, and primarily in group exhibitions in the winter of 1968–1969. The public recognition of their generation therefore happened chronologically after Beuys' breakthrough in Europe, and both sides profited from this. Beuys profited from the recognition of the American artists and Americans from the climate which he helped establish in Germany; their stays in Europe in part worked to tailor artistic developments. Sonnier and his fellow sculptor Gary Kuehn described the inspiring effect of the climate in Germany at their exhibition at the Galerie Rolf Ricke. Kuehn, who was invited to Germany by Ricke in 1966, recalls: 'I often risked things working in Germany that I would not have attempted so easily in the USA.'[20] Sonnier emphasizes the recognition he found

in Germany; he cites artists such as Beuys or Blinky Palermo as specific reasons for this recognition, artists who had already established an atmosphere which accommodated Sonnier's own aesthetic.[21] His art was first recognized in the States in ensuing years. Sonnier notes that he learned of Beuys in the context of Fluxus through Robert Watts, during his time at Rutgers University around 1966. Sonnier saw original Beuys works for the first time in 1968 during preparations for his exhibition at the Galerie Ricke in Cologne. Walter de Maria also speaks of his unreserved admiration of Beuys in 1968 via Willi Bongard. He considered Beuys the 'most important European artist of the present', as cited by Bongard during his meeting with de Maria in an exhibition of Beuys works from the Ströher collection at the Hamburg Kunstverein. De Maria worked extensively with Beuys supporter and gallerist Heiner Friedrich.[22] Both artists underscore in hindsight the support their work received early on and continuously in Germany. The at-that-time unknown Elaine Sturtevant travelled in 1968 to Düsseldorf during a stay in Paris, and met Beuys at the Düsseldorf Art Academy. Beuys' works and actions are then cited in her own work in 1973 in New York. Andre, who emphasized to the author that Beuys did not influence him, met him for the first time in 1967 as he showed his work at Fischer. His relation to Beuys was clouded on the occasion of Beuys' 1979 retrospective at the Guggenheim Museum, when Beuys appeared to him to have conducted himself as a star instead of a colleague.[23]

The effect of longer stays in Europe was not admitted by any of the American artists who I examine, neither Morris, Hesse, Nauman nor Serra. In relation to Beuys, Hesse never cites him in her journal entries from her stay in Germany. Morris makes a great effort to minimize his significance; in a conversation with the author, Serra noted Beuys' marginal position for American artists of the 1960s. Nauman takes up Beuys' *Fat Chair* only once in an interview from the late 1980s, without mentioning that it had any influence on his own work. And Beuys is of no consequence either to the already-cited Sonnier, as revealed in early interviews and statements.

III. The differentiation of American anti-form artists from European artists, and their contradictory relation to Germany

While the younger generation of the American art scene of the 1960s sought out personal contact with Europe far more frequently than its artistic predecessors, it never particularly stressed its European connections and residencies. For example, Nauman names, as important sources for his art, Marcel Duchamp and Man Ray. Both lived in the USA at that time. In addition he accords to Johns a stronger influence, as his work contained 'a kind of restraint and morality' which is typically American. He realized that Man Ray and the Dada artists did not live off of their art and therefore could afford to be particularly provocative. This position contradicted Nauman's idea of the 'artist as worker', as he identified himself. Art always contained for him a 'moral value, a moral stance, a position' which Nauman traced back to his Wisconsin origins: 'So there were a lot of people who thought art had a function beyond being beautiful – that it had a social reason to exist.'[24] In the same way Serra established the American origins of his art in connecting it closely to American heavy industry. Steel architecture can be read as an Ur-American 'tool' with which Americans asserted themselves over a superior nature; in steel he found an ally. Serra's steel and early lead works can also be read as metaphors for the tense relations between human technology and its challenge of nature.

In Andre's flat 'metal plates' the experience of the extension of the American land is mirrored. Just as Serra cited his activity in the steel industry as a student, so Andre cited his employment with the Pennsylvania Railroad between 1960 and 1964. The railroads also mastered the wide-reaching American landscape. A sculpture such as Andre's *Stone Field Sculpture* (1977) points to the pre-urban, agrarian America and thereby has a typical New England character.[25] These artists' basic ethical attitude and the experience of material that is carried over into the work is tied at its core to American society, its history and geographic conditions.

Equally, Land Art, developed around 1968, has as its basis an originally American experience of the splendor of the landscape. De Maria's *Lightning Field* (1977) stages the wide, very flat plains of New Mexico, afflicted with sudden changes of weather, as a theatre for nature as overpowering and energy-laden. The coming together of a romantic sense of nature and technology

in Smithson's American-originated works is similar in that they allude to the expansionist goals and exploitative methods of American industry. Why then should these artists have referred to European precedents?

Smithson only speaks of one European in more detail in his writings, Duchamp, who he, like Nauman, disapproves of as an 'artist-aristocrat'. Smithson endorses Judd's argument; he understood his art to be tied to a dialectical method which was to reject every form of transcendence in art, which Smithson further regarded as characteristic of European traditions.[26] Smithson directly connected the overcoming of European art, which he saw as exhausted, with artistic independence in the years 1964 to 1966.[27] He disliked the hidden but underlying European anthropomorphism of the abstract expressionists, Jackson Pollock, Willem de Kooning and Barnett Newman. His art was to be more American than theirs. He countered the idealist traditions of European art theory with a change toward crystalline structures, as 'elements of material itself', abstract and free of mythological content, and with his interest in an 'archetypal situation that was based on primordial needs and the unconscious depths'.

IV. The anti-German reception of Beuys in the USA

American artists and critics retained a bias against Germany, and not only in the immediate post-war period.[28] During Hesse's stay in Germany in 1964–1965, the critic Lucy Lippard wrote ironically in a letter to Hesse, who was an orthodox Jew, and to her husband the sculptor Tom Doyle, about the 'fatherland'; Sol LeWitt spoke sarcastically in a letter about the 'German swines'.[29] In his early drawings Smithson integrated images of Adolf Hitler, while the protagonist of Minimalist Art, Frank Stella, in titling works such as *Reichstag* (1958) *Arbeit Macht Frei* (1958) and *Die Fahne hoch!* (1959), kept memories of National Socialism alive in darkly ironic gestures.

The image of Germans in the USA was, during the 1960s and to this day, closely tied to the image of the National Socialist past. The New York critic Donald Kuspit, who in the USA paid particular attention to German neo-expressionism of the 1980s and thereafter also to Beuys' art, sees Americans' main problem with German identity as the contradiction between

German intellectual history, philosophy and music, and then Hitler. They don't know how to put them together. [...] How can Germany produce Kant, Hegel, Fichte, how can Germany produce Goethe, Schiller, Nietzsche and how can Germany produce Kaiser Wilhelm, Hitler, the Nazi? [...] That's the paradox[...] After World War II everything became tainted by the resentment against the Nazis, which spilled onto Germany, this whole issue of collective guilt [...] I know people still to this day when more than half the people that are alive in Germany were born after World War II, who still have reluctance about Germany: mixed feelings. They cannot deal with the contradiction. [...] Particularly such extreme contradictions. They can't accept complexity, they just label everything one way. And Germany becomes a kind of scapegoat.[30]

The fact that Beuys became more well known in the USA and that hostility toward him simultaneously swelled is grounded in this uncertainty. Already the first sentences formulated about him in the USA, in an article that appeared in the New-York-published magazine *Time* of 2 June 1967, depict him as a German phenomenon, as a Hitler youth and a Stuka pilot who underwent a characteristic post-war metamorphosis.[31] The article described the Düsseldorf art scene as 'Paris on the Rhine' to the American public,[32] a flowering art scene within which the artists of the Zero group, Günther Uecker, Heinz Mack and Otto Piene, shared the highest international reputation. The article claimed that avant-garde activity in Düsseldorf began with Beuys' arrival at the art academy, and he is otherwise given the most attention. In seven colour photos from the Düsseldorf studios of Uecker, Norbert Tadeusz, Gerhard Richter, Konrad Klapheck, Winfred Gaul and Peter Brüning, Beuys is positioned at the top left corner. Unlike the other artists he did not pose in his studio next to his artworks. Beuys instead is depicted sitting up, in full uniform with fisherman's vest, Homburg hat and jeans, in a dark brown, old-fashioned wood bed, the bedding pushed to one side. In his left hand he holds a longer plaster roll, out of which a small barb protrudes, reminiscent of a prosthesis. A felt roll is wedged behind the artist, between the wall and the edge

of the bed, which sticks out diagonally over the bed: Beuys sits enthroned in the bed, surrounded with attributes of wax, felt and the plaster roll. He looks forward motionlessly, in thought or fixed upon something. A light bulb wedged in at the edge of the bed is turned off, while a candle burns next to it. The subdued, shadowy colour of the photo approximates a painting. The scene appears cave-like, serious, anachronistic.

The caption describes Beuys as a 'meditating guru'. He is further described in the text as 'reigning neo-Dada hero', with a characteristic 'Chaplinesque' smile and 'battered Homburg', indications of his theatricality. The 'octopus-like' drawings and works made of chocolate and fat are only briefly cited. It is emphasized that his happenings are regarded as 'splendid' and that a creative chaos reigns in his classes.[33] In the article the art of Beuys withdraws behind the persona Beuys and his past as a German.

There is no question that the *Time* author's fascination with Düsseldorf artists began with Beuys. The larger part of the article is devoted to him, and two of three subtitles refer to him: 'Chocolate & Chaos' and 'Forward to Zero'; at the end of the article he is presented as a spokesman for the Düsseldorf scene. The article does not describe any connection to American art, and it is doubtful that the article inspired anything other than mockery in American art circles. The photo of Beuys could remind one of an arrogant country preacher or of Carl Spitzweg's nineteenth-century painting, *Der arme Poet* ('The Poor Poet').

American art critics repeatedly present the image of Beuys as a soldier and connect his work with the attempt to come clean of the past.[34] So for example the New York critic Thomas B. Hess writes in 1973 in *New York Magazine*, 'As a matter of fact, Beuys was on the other side of the barbed wire, in the Nazi army...'[35] Another well-known critic from the American metropolis, Robert Hughes, pointedly noted in 'The Noise of Beuys' in 1979, 'If one would maintain that Beuys' art had to do with earth and race one would come quite close to the truth.'[36] Similarly Kim Levin in her article in *Arts Magazine* of 1980 emphasized this view:

When Beuys speaks of the transformation of humankind and of the necessity to create a higher level of consciousness, to shape a new world and prepare

'new soil', he echoes the idea of the Volk – the 'folk', the essence of the German people – a romanticized concept of the healthy peasant and the native soil that was popular in the 1920s and 1930s.[37]

This view of Beuys still holds.[38] This is substantiated in many of the interviews I conducted. In a conversation, Carl Andre cited the roots of Beuys' aesthetic in the German middle ages and its revival in National Socialism.[39]

Beuys is particularly condemned for his inclination toward the mythologizing of his own persona. More grave however is that he refers to Celtic and Nordic mythology in his art in order to keep alive the idea of Aryan ancestry. Beuys' titles such as *Siberian Symphony* and *Eurasian Staff* are connected directly to expansionist desires of the National Socialists in the east.[40] Americans see these themes addressed by Beuys in connection to his education as a Hitler youth during the Nazi period and identify them with National Socialist mysticism, Rosicrucianism and occult belief systems of the 1920s and 1930s. The first title published in the USA about Beuys is *Occultism in Avant-Garde Art: The Case of Joseph Beuys* (1988). It investigates among other things the influence of the 'anthroposophical guru' Rudolf Steiner on Beuys, to which the author connects National Socialist and pseudo-scientific textbooks that Beuys may have read while in school. He compares these with Steiner's and Beuys' statements. Moffitt's book deepened the bias towards the artist. Beuys is to have taken from the National Socialists whatever was considered positive and 'noble' in the German past at the time, particularly German militarism as well as *Blut-und-Boden* (blood and soil) ideology.[41] No point is more incendiary in the American debate around Beuys than the question of his ideological origins; on no other point is the rejection as unanimous and seemingly insurmountable. A direct line is drawn between Beuys and National Socialist ideology without any recognition of his artistic complexity and disturbing imagery. Simultaneous with this negative reception, Beuys becomes the most popular German artist in the USA after 1945.

NOTES

* 'Die Rezeption von Joseph Beuys in Amerika und einige ihrer kulturpolitischen und künstlerischen Voraussetzungen', in *Joseph Beuys und die amerikanische Anti Form-Kunst* (Berlin: Gebr. Mann Verlag, 1998). Translated by Claudia Mesch.

1. Author's interview with Franz Dahlem, 29 October 1992.

2. Larry Rivers, 'Blues for Yves Klein,' in *Artnews* 65: 10 (1967), p. 32, 75 ff. Rivers points to himself as one of the few Americans who could appreciate Klein's art.

3. Grace Glueck, reporter for the *New York Times*, asks in the heading to her 1968 article in *Die Zeit*, 'Is there really nothing going on in Europe?' Glueck focused on European painting, which in her view was 'fashionable and uninspired', often an imitation of American tendencies. French works were for example 'for someone coming from New York, a genuine déja-vu experience'. Grace Glueck, 'Is there really nothing going on in Europe?' *Die Zeit*, 26 July 1968.

4. As the first American stylistic direction, abstract expressionism of the 1940s and 1950s definitively demarcated itself from Europe. Greenberg, the leading critic of abstract expressionism, placed Pollock at the zenith of American art, because 'the feeling [his art] contains [is] radically American'; see also Steven Naifeh and Gregory White Smith, *Jackson Pollock an American Saga* (New York, 1989), p. 552. For Hilton Kramer, David Smith was characteristic of American sculpture of this period, as an artist who traded '... the rhetoric of the School of Paris for the vernacular of the American machine shop.' See also Lucy Lippard, '10 Structuralists in 20 Paragraphs', in *Theories of Contemporary Art*, Richard Hertz (ed.)(New Jersey, 1985), pp. 207–14; 209.

5. Indiana qualifies his remark in saying that this dream was not necessarily realized, which introduced an element of cynicism into the myth. See Mario Amaya, *Pop Art... and after* (New York: Viking, 1965), p. 85.

6. George Maciunas, letter to Tomas Schmit, 'Fluxus manifesto', Silverman no. 240. XVII, June/July 1963, reprinted in *FLUXUS etc./Addenda II. The Gilbert and Lila Silverman Collection* (New York: Ink &, 1983), p. 161.

7. Bruce Glaser, 'Questions to Stella and Judd', *Artnews* 65:5 (1966), pp. 55–61; 56.

8. Due to the high cost of transport and insurance, Documenta was in serious financial difficulty. Arnold Bode saw the possibility of

profit in having the exhibition travel. In this manner, though, doubled income and budgets and through shared transportation costs, costs could be lowered. Author's interview with Stünke, 24 October 1991.

9. Author's interview with Stünke, 24 October 1991.

10. Willi Bongard, who wrote his book *Kunst und Kommerz* during his two-year stay in New York, contacted in writing 'multimillionaires and friends of art' with the knowledge of the other Documenta advisors in order to seek funding for Documenta. He based his request on the international reputation of Documenta and the argument that American artists would comprise the overwhelming majority of art represented in the coming Documenta. Letter from Bongard to Gertrud A. Mellon dated 13 February 1968, Special Collections, Getty Center for the History of Art and the Humanities, Los Angeles, California.

11. Philip Johnson, letter to Bongard, dated 21 February 1968: 'Alas there is very little interest in philanthropical circles for anything that happens outside our country.' Special Collections, Getty Center for the History of Art and the Humanities, Los Angeles, California.

12. Gertrud A. Mellon response of February 24, 1968 to Bongard, Special Collections, Getty Center for the History of Art and the Humanities, Los Angeles, California.

13. Author's interview with Stünke, 24 October 1991.

14. It was determined in the first meeting of the sculpture committee on 30–31 January 1967 at the Galerie Der Spiegel in Cologne that as the only German sculptor in addition to Norbert Kricke and Günther Uecker, Beuys would contribute a 'cabinet'. The chair in Stünkes' gallery was Trier. The sculpture committee was also comprised of Bott (Darmstadt), Gallwitz (Baden-Baden), Dietrich Helms (Hamburg), Stünke, and Bode as chair of the Documenta council, as well as members of the painting committee, Freiherr von Buttlar, Jan Leering and Arnold Rüdlinger. A short-list was determined on the basis of a previously distributed list of possible candidates; one committed to those underlined in the minutes, Kricke, Beuys and Uecker. All three artists came from Düsseldorf. Kricke and Beuys taught at the Academy. Uecker was known as a member of the Zero group among other things. Trier's influence asserted itself here. Beuys' participation was temporarily planned in conjunction with Hans Hollein; Documenta Archive, Kassel.

15. Gallwitz letter to Harten, the former secretary of Documenta, 8

August 1967. Documenta Archive, Kassel.

16. Trier letter to Gallwitz of 10 August 1967. Documenta Archive, Kassel.

17. Dick Higgins, *Postface* (New York: Something Else Press, 1965), Eckart Rahn (trans.) in Jürgen Becker and Wolf Vostell (eds.), *Happening. Fluxus. Pop Art, Nouveau Réalisme* (Reinbek: Rowohlt, 1965), p. 186.

18. Author's interview with Kynaston McShine, 17 August 1992.

19. Robert Kudielka, 'Documenta IV: The German Contribution,' in *Studio International* 176:902 (1968), p. 29. There were additional reasons for the appeal of West Germany to American artists. The American critic Phyllis Tuchman reported 'During the past three years, certain galleries have assumed leadership; prominent collectors have bought art on a grandiose scale; Cologne has emerged as a powerful art center. [...] many artists are not only traveling to Germany to work, but they are leaving their best efforts there; and much of the most interesting recent New York painting and sculpture is not there and prominently available.' As exponents of the 'flourishing art scene' in Germany, Tuchman cites the gallerists Alfred Schmela, Rudolf Zwirner, Franz Dahlem, Heiner Friedrich, Rolf Ricke and Konrad Fischer as well as milestones of private collecting, the collections of Wolfgang Hahn, Karl Ströher and Peter Ludwig. These collections point to the activity of the Cologne art market. For Tuchman this was also about the missed opportunities of American cultural politics; see Phyllis Tuchman, 'American Art in Germany. The History of a Phenomenon', in *Artforum* 9:3 (1970), p. 58; and Wibke von Bonin, 'Germany. The American Presence', in *Arts Magazine* 44:5 (1970), pp. 52–5.

20. Cited in Marianne Stockebrand (ed.), *Rolf Ricke* (Cologne: 1990), p. 44.

21. Telephone interview with the author, Summer 1993.

22. Willi Bongard, 'Gebissabdruck in Talg. Gebrauchsanleitung zu Joseph Beuys', *Die Zeit*, 6 September 1968. Along with de Maria, Michael Heizer was also supported by Friedrich and realized his first outdoor project in 1968 in Munich. In the same year he showed his work at the Düsseldorf Kunsthalle. Smithson was invited for a one-man show by the Düsseldorf gallerist Konrad Fischer in 1968.

23. Interview with the author, 13 January 1994, in connection with Andre's exhibition at the Cologne Kunstverein.

24. Cited by Joan Simon, 'Breaking the Silence. An interview with Bruce Nauman', *Art in America* 76:9 (1988), p. 143. Nauman also

notes that Wisconsin was the state with the most far-reaching social reforms in the USA.

25. See Phyllis Tuchman, 'Background of a Minimalist: Carl Andre', *Artforum* 16:7 (1978), p. 33.

26. Smithson reproached Andre for employing a 'metaphoric' instead of a 'dialectical materialism' in his art, and attacked Judd for a latent 'mystification of logos'. See Karl-Egon Vester, 'Zum Werk von Robert Smithson,' in *Giessener Beiträge zure Kunstgeschichte* vol. 7 (1985), p. 58.

27. In Nancy Holt (ed.), *The Writings of Robert Smithson* (New York: New York University Press, 1979), in an interview with Paul Cummings in July 1972, Smithson establishes the following as constituting his art: 'And then it became a matter of just working my way out from underneath the heaps of European history to find my own origins.' pp. 146 ff.

28. Milton Resnick, a member of the legendary New York 'Painter's Club' founded by de Kooning in 1946, offers an example of the negative view American artists held of Germany. He reported that after a panel discussion of 1963, the artists of the club strongly objected to Thomas Hess' suggestion that they call themselves abstract expressionists: 'We said we hate the dirty Germans [...] it was just after the war'; cited in 'Audience Bites Back at artists on art', in *Sister Brothers Warehouse* (Los Angeles: Rolf Nelson Gallery, 1963), p. 19. Sohm Archive, Stuttgart. This had to do with a discussion held over several days and organized by William Regelson at the Loeb Student Center at New York University, School of Education, that took place from 31 October to 2 November 1963, and where among others Harold Rosenberg, Larry Rivers and Milton Resnick took part.

29. Lippard began her letter of 26 July 1964: 'Sounds like the Vaterland is doing pretty well by you...', and Sol LeWitt ends his letter to Hesse of 20 July 1964 with the words 'Best wishes to all the German swines.' Eva Hesse Papers, 1914–1970. Microfilm no. 0623 and 0187–0189, Archives of American Art, Detroit.

30. Author's interview with Donald Kuspit, 27 April 1992.

31. Anonymous, 'Artists. Paris on the Rhine,' *Time* 89:22 (1967), p. 57.

32. Citing the director of the Neue Pinakothek in Munich, Eberhard Hanfstaengl, Düsseldorf is compared to the art mecca Paris in the title as 'one of the world centers where art is being created'. The introduction which describes Düsseldorf as 'a conglomeration of shimmering steel-and-glass office buildings on the Rhine that epitomizes the commercial hubbub of the

Wirtschaftswunder', sounds like a travel brochure for Americans in the 1960s who took advantage of the favorable exchange rate in order to travel to Europe, which was still recovering from the events of the war. Americans had never before visited Europe in such numbers or with such regularity. See Anonymous, 'Artists. Paris on the Rhine', in *Time* (1967), p. 57.

33. Beuys is characterized in the text as follows: 'A one-time Hitler youth and World War II Stuka pilot, Beuys has undergone a characteristic post-war metamorphosis to become Düsseldorf's reigning neo-Dada hero. He is celebrated for his Chaplinesque smile, battered Homburg, octopus-like drawings, sculptures made of chocolate and lard, for the splendiferous happenings that he used to stage and, above all, for the fertile chaos of his classrooms. Students in a Beuys class are permitted to build, sculpt or paint literally anything, from kinetic doodads to studies of Beuys himself.'

34. For example, the artist Mike Kelley concludes that the reception of Beuys in the USA discusses only his persona and his past. See Robert Storr, 'An interview with Mike Kelley', *Art in America* 82:6 (1994), p. 92.

35. Thomas B. Hess, 'Due Cause and Community Do's', *New York Magazine*, 31 December 1973.

36. Robert Hughes, 'The Noise of Beuys', *Time*, 12 November 1979.

37. Kim Levin, 'The New Order', *Arts Magazine* 54 (1980), p. 156.

38. See my Chapter IV in *Joseph Beuys und die amerikanische Anti Form-Kunst* (Berlin: Gebr. Mann Verlag, 1998).

39. Interview with the author, 13 January 1994.

40. Levin, p. 156.

41. John F. Moffitt, *Occultism in Avant-Garde Art. The Case of Joseph Beuys* (Ann Arbor: UMI Publications, 1988), pp. 83 ff.

19. JOSEPH BEUYS AND THE GDR
The Individual as Political*
Eugen Blume

'THERE ARE PEOPLE WHO are only good in the GDR,'[1] Beuys declared on a chalkboard on 31 October 1985, which later made a triumphant journey through the GDR as an original-print postcard. A piece of subversive irony, like his idea of raising the Berlin wall by five centimetres for aesthetic reasons. These are just two examples of Beuys' profound humour, and that recall the echo of his inimitable laugh.

But why was *Beuys* good for the GDR, or rather, what role did Beuys play in the German Democratic Republic? To formulate an answer, the question must be viewed on multiple levels. Beuys was from the start a staunch opponent of Marxism and therefore also opposed the GDR's political system. In his publicly delivered models of society he understood himself as positioned outside of capitalism as well as socialism. He was convinced of the impracticality of the socialist concept, even of a utopian variant purged of Stalinism. From his position as an artist, he rejected the one-dimensional definition of man based solely on his productivity and placed the subjective reasoning of individual freedom above the constraints of social legality.

Beuys, who incessantly urged personal discovery, was at first of little interest to the GDR's official cultural business. At most he served as an example of western decadence. Yet through his ever growing recognition, and particularly in his political activism – which lead him to become a founder of the Green party – Beuys gradually emerged in the crosshairs of ever watchful and power-stabilizing political officials. The only book published in East

Germany on West German post-war modernism was Hermann Raum's publication *Die Bildende Kunst der BRD und Westberlins* ('The fine arts in the FRG and West Berlin').[2] The author's subject matter was nothing less than:

> the entire development of the fine arts in the FRG and West Berlin, known as the 'avant garde', with which the FRG understands itself to be represented (also as a state). And in comparison, *that* art that stood and stands in its shadows, and that is part the 'elements of a democratic and socialist culture' that Lenin wrote about in 1913 and that will become unavoidable, that 'second culture', which under the conditions of real socialism as a world system will become a great power in the global-revolutionary process, amidst the unstoppable and deepening crisis of imperialism.[3]

Beuys, defined here as a 'state artist', plays only a marginal role in the 250-page text. As an ideologue, the author followed 'socialist realism' as a concept of art that views post-war modernism as a decadent waste, and as a construct of the market which should not be called art. Only those artists who worked within the realms of the GDR's controlled sense of realism could be counted as truly democratic and progressive artists. Raum does not dedicate even a single sentence to Beuys' revolutionary theory of the 'expanded definition of art', whereby Beuys defines society as a 'social sculpture'. Albeit far from the socialist idyll and heroism, the proximity of Beuys' program of 'every human an artist' to the state directive of the 'Bitterfelder Weg' in its originally conceived unification of art and life remained unexplored. Raum discarded the Fluxus movement, with which Beuys was involved for a time and which was of great consequence to the development of art and led to completely new directions in actionism (performance), as a 'product of the dominant elitist culture for a snob class'; he placed the 'props, mainly of the Beuys happenings' at the 'very bottom level of the applied arts'.[4]

Raum views the exhibition *Steel and Iron* of 1952, an exhibition where Beuys participated, as one of the industrially defined paradigm shifts from a realist to an affirmative – or at least esoteric – uncritical art. He does all this without once mentioning that

Beuys himself remained a realist artist throughout his life.[5] For Raum, Beuys is only a so-called 'realist' because this designation is based only upon a 'realism prosthetic', that is, in contrast to the supposedly integrally whole concept of reality of 'Socialist Realism'.[6] Raum's categorization of the Documenta exhibition as a vehicle of the art market is also questionable, wherein he concludes that at the third and fourth exhibitions the 'German pop variations (G. Richter, Beuys, Vostell, etc.) are brought on the market'.[7] Without really delving into the artist Beuys and his views on society, whose intellectual proximity to a 'Socialist Realism' would then at least be debateable, he understands the expanded concept of art merely as an innovation of the art market.[8] Raum argues in a petty-bourgeois manner in arguing the monetary side of the so-called art as his impetus for critique: 'Beuys' work *Flag of Genghis Khan...*, a broken spruce twig next to a lathe with a dirty red cloth, succeeded in receiving 100,000 Marks from the Düsseldorf art dealer Schmela, according to a press report. This dealer later passed it on to a wealthy collector, who donated the work to the 'Kaiser Wilhelm Museum' in Krefeld'.[9] Raum bases his opinions on critical texts published in the magazine *tendenzen*, a journal whose budget was primarily paid for by the East German state and could be ordered by special subscription by cultural academics who were true to the state, and that substantially determined their relationship towards western art. The papers published in *tendenzen* then functioned indirectly as the reception of Beuys in the GDR. He was often portrayed as a figurehead of the reactionary art business[10] and marked as a regressive idealist – an idealist whose esoteric and incomprehensible art remains, at most, useful for the dominant economic power of West Germany. There is no real discussion of Beuys' work or that of any other West German artist in Raum's book.

The journal *Bildende Kunst* published an article by Hans Platschek in 1980 with the title 'The man with the hat – Joseph Beuys'.[11] To characterize the article it suffices to quote its opening sentence: 'If I summarize a shoe brush as the mammal species, in my doing so it will still never grow mammary glands' (Engels). For Platschek, Beuys is 'less an innovator than he is a copyist. He does not embody the zenith of the art business but rather the twilight of its life'.[12]

One year later, Peter Pachnicke arrives at the same somewhat forced conclusion about Beuys in his four-part series of articles, 'Reaction and Denial: Papers on the Development of Art during the Imperialism of the Sixties'. He continues what Raum and other *tendenzen* critics had set in stone:

> 'Every human is an artist' is not however an enlightened solution, but rather a regressive utopia. For that which Beuys swears is human creativity is not a realistic and sensible activity. On the contrary, they are mostly prehistoric and archaic practices and conceptions of reality: magic, mysticism, fetish, ritual ... This irrationality has rightfully been declared through the fear and helplessness of those living in the modern bourgeois world.[13]

The accusation that the artist release himself from social responsibility – the critique of subjective atomization – is contrasted against the allegedly true position of freedom of Socialist Realism, a position based upon a misinterpretation of Engel's definition of freedom as 'insight into necessity'.[14] Related to GDR reality, this definition demanded the subordination of the artist, camouflaged as 'partisanship'. A positive judgment can only be reached when one is able to make a connection between the artwork and the ideological position of the state. The constantly propagated evidence of the allegedly reactionary positions of western art was in fact a ridiculous distortion of the truly reactionary Stalinist art ideology of the GDR. This absurd reversal established Stalinist art ideology as 'progressive' and hindered an open-minded understanding of western art.

A 'discussion' in the journal *Bildende Kunst* points to the sensitive public reaction to the Beuysian expanded notion of art. This article deals with an exhibition and performance (action) by the East Berlin artist Erhard Monden,[15] in which the authors attempt to condemn Monden's exhibition. This discussion compelled me to respond. Peter Michel, the chief editor at the time, agreed to publish only the short text that I submitted under the condition that prominent art theorists would simultaneously pass judgment on my article in print.[16] My contribution to the discussion was based on my thesis on Joseph Beuys, written

in 1981. My thesis attempted to be a theoretical base for the first waves of performance in the GDR. To summarize, it was to establish a second direction of art practice that began alongside traditional easel painting and sculpture with Dadaism and the Soviet avant-garde of the 1920s. This direction created expanded forms of art practice. The thesis argued that expanded art practices could therefore claim a legitimate place in the artistic landscape of East Germany.[17]

Although those involved with the discussion at first schematized the alleged inadequacies of my article, they nonetheless only proved what little developmental possibility they wanted to allow for this 'new' art form. In his article, Hermann Raum draws upon his already well-known position and once again brings the failure of western modernism to the fore:

> And furthermore, the definition of art is more broad than the expanders know and want! The definition of art, defined in classical antiquity as *techne*, still means the proficiency and ability to create something of specific quality, that is, the product of such activity. Keeping strictly within these categories, there will be much to sort out as far the concept of art and the fine arts are concerned – as being entirely independent of stylistic limitations, questions of the media, innovations and declarations.[18]

In another article, the contemplation of expanded art forms is dismissed as a senseless act based solely on appearances 'which even in the capitalist territory of art are still fully dependent upon the art sharks'.[19] In referring to the miniscule beginnings of performative art forms in the GDR, Peter Pachnicke's final article attempts to talk past what was at the time a turbulent East German art landscape.[20]

This rather unpleasant dialogue continued at the Ninth Congress of the Union of Visual Artists of the GDR (*Verband Bildender Künstler*) in 1983 at the Palast der Republik in Berlin.[21] Karl Max Kober, one of the leading theorists of 'Socialist Realism' and professor of art history at the Karl-Marx University in Leipzig, questioned the meaning of performance art in his oral presentation with amazing *naïveté*.[22] In viewing the artist's

portfolio *Leussow-Recycling* of 1983 and its accompanying performance, Dr Kober became quite irritated.[23] Reacting to the fear that there might be a future 'boom' of performance art in the GDR, Kober 'dared' to suggest that a section for performance art be formed within the VBK. Willi Sitte, president at the time, reacted immediately: 'As long as I am the elected president there shall be no such section!'[24]

Sitte repeatedly announced his annoyance with artists like Beuys in public. For example he threatened to leave a roundtable discussion in Oberhausen if Beuys were asked to join it. In the meantime, a western consensus formed on Beuys as one of the most important post-war artists. Only a few in the GDR shared this opinion. The art historian and gallery owner Klaus Werner belonged to this group. He distributed Beuys multiples from the Edition Staeck at the (East) Berlin Arkade Gallery. Thanks to this cooperation, these are the only originals to be found in the Graphic Arts Collection (*Kupferstichkabinett*) of the State Museum of Berlin.[25] Klaus Werner is one of the first who attempted to make the work of Beuys publicly known in the GDR through slide lectures.[26]

Beuys' death was reason enough to posthumously re-evaluate his now unquestioned contribution. It was finally decided to open the gate to the much unloved but by then benign artist. The Akademie der Künste (Academy of the Arts) organized the first Beuys exhibit, which took place in the Berlin Marstall and at the College for Graphic and Book Art in Leipzig.[27] It was dedicated exclusively to his drawings, and came from Hans van der Grinten's vast collection, located in the city of Kranenburg near Kleve.[28] Beuys' interference in politics and his expanded notion of art were hardly noticeable in the exhibition. The request of Beuys' former students Johannes Stüttgen and Felix Droese to drive the project 'Omnibus for Direct Democracy' past the State Council building (*Staatsratgebäude*), and then to park it in front of the Marstall to spread Beuysian ideas failed, despite the efforts by Manfred Wekwerth, the president of the Academy of the Arts. Wekwerth wrote a well-formulated statement in the exhibition catalogue: 'The personality and work (of Joseph Beuys) presents a position which we can divide into crucial questions and respect in other aspects'.[29] Direct democracy did not seem to belong on this list of questions, and letters addressed to the

president remained unanswered.

The exhibition proved so irritating to some conservative visitors that they exclaimed – in regard to Beuys – 'thank God he's dead'. For many, especially young artists, the encounter with the draftsman was a revelation. Beuys' characteristc style of handling material became noticeable in the works of the artists born around 1960. The formal succession of Frank Seidel, Ulrich Müller-Reimkasten, Olaf Nicolai, Jörg Herold, Kaeseberg, and Matthias Jackisch, among others, is seen at the point when their own individual development emerges. What remains important is the beginning of a sensitive devotion to reality, which could be gleaned from Beuys in the highest degree.

In spite of the numerous discussions inspired by the exhibition, which some used to correct their earlier views, Beuys remained a 'visitor from afar'. The 'contradiction-ridden oeuvre' (Peter H. Feist) was presented selectively and only with the drawings, and it hoped to remain as such. The original title for the exhibition, 'Beuys before Beuys', recovered the agreement on two fronts in a peculiar fashion: first, in freeing Beuys of the ballast of the expanded definition of art, and finally in establishing him in the museum. For 'although undeniably sensible and full of their own world view, the drawings are so unspectacular that Beuys never would have become Beuys without the arsenal of monstrosities, shocks and tirades that dominate his country. It was between this arsenal and the sensory overload, show business and mania-for-success, that he attained recognition.'[30]

By means of polemicized misunderstanding or implicit correction, Beuys' wide-ranging questioning was detached from those aspects of his art that could be comprehended as artwork in its traditional sense. In a treatise on the fine arts, Günther Regel, a professor of art education in the department of pedagogy at the Karl-Marx University in Leipzig, published among other things corrections pertaining to Beuys' work. 'Beuys understands that he himself is assigned as a "tool for mankind" with his creative abilities, which, as he says, serves "to pose the question, to all humans in their current life situation: where do they want to go?". He nonchalantly expresses what is in fact the concern of art.'[31] In his book, Regel places Beuys among other misunderstood artists such as Van Gogh, Monet, Cézanne and Picasso, and the painters of the Brücke. The crowning final

chord and actual beginning of serious publication concerning Beuys and his work was the acceptance of Heiner Stachelhaus' biography in 1987. Planned for the Berlin exhibition and edited by Klaus Werner, the book was published in 1989 by Reclam, supplemented with a significant appendix of Beuys quotations. Finally a proper publication about Beuys sat on the shelves of the GDR's peoples' bookstores (*Volksbuchhandlungen*), and hence the Wall was lowered not only out of aesthetic reasons, and not only by about five centimetres...

It is generally known that Beuys himself never set foot in the GDR with the exception of one evening at the Federal Republic's Permanent Representation office in East Berlin. This visit, however, was more of a close encounter of the third kind on an extraterrestrial planet, one that was largely forbidden to East German citizens.[32] Nevertheless there is a series of works in Beuys' oeuvre that relates to the GDR and that often uses the readymade: the installation *Wirtschaftswerte* of 1980[33] is without a doubt the main work in the series. With a fascinating and confident grasp, Beuys arranged the objects of a foreign, nearly archaic world of consumption so as to become an impressive work of art. This was not about a presentation of East economic values or about a debate between market economy and planned economy for Beuys. Rather, the makeshift product packaging of scarcity became a contrasting symbol in the West, of an economic organization based on concrete needs instead of on over-supply and advertising. Beuys thought through and commented on the former's economic organization in countless discussions. The strange aesthetic effect of these products remained unrecognized in the grey daily grind of the GDR.

Jürgen Schieferdecker's 1978 print *Beuys macht Licht* ('Beuys turns on the light') was the first work that directly referenced Beuys. The work connects Beuys with a piece of margarine from the GDR and programmatically references an orientation towards Beuys as an artist. Wolfgang Petrovsky of Dresden often incorporated Beuys into his works. It was probably (East) Berlin artist Robert Rehfeldt who first began to critically question Beuys' ideas. In addition to various prints that refer directly to Beuys, Rehfeldt's works are all concrete claims devoted to the general problem of 'social sculpture'. Through postcards and stamped prints, Rehfeldt called for a society of creative art workers. In

this sense he attempted to become active as an artist in a broader sense. His influence on younger artists was of great significance, particularly in communicating developments in western art. The first work to draw parallels to Beuys' installation *Wirtschaftswerte* as well as make associations with Schwitter's *Merzbau* was Stephan Kayser's *Environment k* at Sredzkistraße 64. Over the course of many years Kayser collected garbage, printed material, everyday objects and so forth, inside a typical Berlin loft, which he brought together into a symbolic, labyrinthine space.[34]

Parallel to Rehfeldt in Berlin, the Dresden artist Günter Hornig devoted himself to Beuys' social ideas. Hornig did not try to follow the autobiographic language deeply rooted in Beuys' persona, but rather used a language entirely of his own. In his abstract compositions, he stayed with his own language but understood them in the Beuysian sense as attempts to model a future societal structure. The open stage of agitation established by Beuys' works was not permitted by the dogmatic mentality of public art exhibitions in East Germany. Every attempted start was denounced as subversive. Hornig, who largely remained unrecognized as an artist, in part found a free space to speak because of his profession as a teacher at the School of Art (*Kunsthochschule*) in Dresden. In his penetrating lectures Hornig confronted and tried to convince his students of the expanded notion of art and its social dimensions.

Hornig's lectures were a guiding factor for the (East) Berlin artist and Hornig student Ehrhard Monden. Monden staged his first public performances (actions) already in 1978. These not only demonstrated performance art, but also had societal transformation in mind. Hornig is also the most important cornerstone for the antagonistic performance group 'Auto Perforation Artists' ('*Autoperforationsartisten*') that emerged in the 1980s, as all the members studied at the School of Art in Dresden.[35] Through their continual and spectacularly provocative appearances the group succeeded in making performance a subject of public discussion. In 1987, they brought the phenomenon of Beuys to the public in the Fluxus-hommage *Beuys, up on your feet* ('Beuys Beine machen'). They were far less interested in the theory of the social sculpture than fascinated by the irritating function of disturbance in Beuys' gestalt and work. Although they were intensively executed in concept and development,

their campaigns looked back to Fluxus-happenings and were materially based in the blood orgies of the Viennese Actionists.[36] Western art hit the generation born behind the Wall like a distant surge; a bit delayed, they had to toss something into the inflexibility of (GDR) society that already filled up books and museums elsewhere. They were adequate instruments of irritation for a closed society.

On the occasion of the '31-Day Permanent Art Conference' (*31 Tage permanente Kunstkonferenz*) organized by Christoph Tannert and myself, a joint appearence of the 'Auto Perforation Artists' with Erhard Monden at the gallery *Weißer Elephant* ('White Elephant') failed despite many shared ideals, in part because Monden did not desire to be exposed to 'almost humiliating tolerance'[37] and to the limited free space finally assigned by the state. Monden consciously positioned his contribution *We have arrived here and there* ('Wir sind angekommen hier und dort') with a clear reference to Beuys by means of Monden's chosen space for it.[38] Monden's oftentimes minimalist concept of performance was in danger of drowning in the confusion of other elaborate stagings in East Germany. For example, in 1990 he refused to participate in the celebrated exhibition project *The Finality of Freedom* ('Die Endlichkeit der Freiheit')[39] in a telegram that stated: 'Can't permit myself to decide, am currently in the deconstruction of the ego.' This logical consequence of Monden's development was set aside by the organizers of the project. In fact this consequence implied a radical questioning that would have brought an important critical dimension to the entire exhibition project.

In 1982, Monden and I tried to collaborate with Beuys. The idea was to construct also in the GDR a platform for 'social sculpture' through a parallel action that would go beyond the borders of the GDR. On April 2, 1983, the final day of the Ninth Art Exhibition in Dresden where performative art had no chance to exist, we realized our project on the fields near the Elbe, near the so-called 'Blue Wonder', the Blasewitz-Loschwitzer Bridge, in Dresden. The performance/action *Sender–Receiver* (*Sender–Empfänger*) took place between noon and 1 o'clock and was arranged with Beuys. Beuys sent his ideas from Düsseldorf to Dresden and we in return directed our antenna towards the Rhineland. This fictive transmission abolished the border for one hour and set up a

connection to a direction in art that acted more deeply upon society. It was an awakening from totalitarian structures; it was initially a clarifying process without sensationalistic ambience, a step in the direction of inner freedom.

In the action I consciously used the typical Beuysian blackboards, upon which I noted the 'transmission' from Düsseldorf. Monden worked with his typical performance materials. We were connected by rope with three trees that served as our antenna. The continuation of the action took place a year later, from 2–8 April 1984, in Berlin at Sredzkistrasse 64. For a week, we displayed the performance materials and discussed Beuys' expanded notion of art with visitors.[40] Every day we took down one of the written blackboards we had hung on the wall and rehung it with its written side facing the wall. On the final day, the no-longer legible transmission was to take new form through a discussion with Beuys. Around 2 p.m. Beuys, who took a flight from Düsseldorf to Berlin, was denied entry into the GDR. One hour later, he phoned Monden and stated that he was an undesirable person in the GDR. The State Security (Stasi) had already for a time monitored our suspect contacts with the West and, in November of 1983, had ordered a search of my home. A twelve-hour examination simultaneously took place on Keibelstrasse in (East) Berlin, an interrogation to which I was 'transported'. At first somewhat nebulous, it soon focused on the connection to Beuys and on my political views. It took place at the time of the planned stationing of missiles in both East and West Germany; State Security was to suppress any possible opposition to the stationing of the Russian SS-20. Beuys' only interview with a GDR radio station, in which he was portrayed mainly as a supporter of the German Communist Party's 'Krefelder Appell' [a call from the side of the West German people to cease the growing nuclear proliferation in Europe – ed.], and was considered a dangerous political figure whose influence on the GDR art scene should be hindered. The fear of an artist who actually took seriously the constant politicization of art that 'Socialist Realism' demanded and who wanted to free himself from more calculatable chalkboard agitations [i.e., Beuys' public discussion-performances – ed.] motivated the Stasi to place artistic processes and single artists under surveillance for years.

In many cases, there were either gestures made towards Beuys or applications that fitted fragments from afar into one's own individual (artistic) concerns. The social dimension was introduced in various projects without having as a consequence a desire to continue in such a direction (for example, the Harlass Project of Karl-Marx Stadt residents Gregor Torsten Kozik and Ralf Reiner Wasse). Only two have really tried to assess this difficult path. Hans Joachim Schulze and the group '37.2' developed an artistic training program in Leipzig that was to introduce the productive capacity of art into industrial management. After four years (1980–1984), Schulze gave up this Sisyphean labour and later left the GDR.

Acting out of a convinced sense of affinity toward the expanded notion of art, Erhard Monden in Berlin earnestly tried to reach beyond the realm of art. He organized many performances whose titles were somehow related to Beuys. These actions honoured the spiritual affinity to Beuys without seeming derivative. Their form grew entirely out of Monden's life. He understood and understands himself as being an active member of the FIU (Free International University) Beuys founded. In his studio Monden developed a drawing circle (*Zeichenzirkel*, one of the most customary money-earning enterprises for GDR artists), into a school for expanded pictorial work. As Monden conceived it, 'The school for expanded pictorial work is an organ of the expanded notion of art of social sculpture. As a performance/ action, it is a dynamic work of art, the continuation of my narrative/symbolic performance/actions.'[41] Monden consciously abandoned the hermetic aspect of his performances in order to be artistically pedagogical in its broadest sense:

> For me, it was only a question of time until I found the next form after the performance/action, which is closer to painting than one might imagine, to the possibility of truly practising a transformation, i.e., to come to the consequences and ask: what does performance/ action art generally intend? A development per se that therefore perpetually leads to the point of doing something concrete with people, not simply taking them as viewers and placing them in the role of someone who stands aside and watches in astonishment, but

rather drawing them into this process as a co-worker.[42]

When Beuys died, Monden applied for permission to travel to Düsseldorf for the funeral. During this time in history the Wall was opened more frequently for pressing familial matters. In justifying his application, Monden entered onto the official form under the question of 'degree of kinship' the words: 'spiritual relation of the first degree'.

NOTES

* In Gabriele Muschter and Rüdiger Thomas (eds.), *Jenseits der Staatskultur. Traditionen autonomer Kunst in der DDR* (München/ Wien: Hauser Verlag, 1992), pp. 137–54.

1. Original postcard no. 15 071. Edition Staeck, Heidelberg 1985.

2. Hermann Raum, *Die Bildende Kunst der BRD und Westberlins* (Leipzig: EA Seeman Verlag, 1977).

3. Raum, p. 7.

4. Raum, p. 49.

5. Raum, p. 66.

6. Raum, p. 156.

7. Raum, p. 158.

8. Raum, p. 162.

9. Raum, p. 172 (annotation 161).

10. Ulrich Krempel, 'Der Mensch muß lernen, sich über seine Wirklichkeit zu erheben', *tendenzen* 11 (1980).

11. In *Bildende Kunst,* Issue 11 (1980).

12. *Bildende Kunst,* Issue 11 (1980).

13. Peter Pachnicke, in *Bildende Kunst* 12 (1981), p. 574. Quotation from Ulrich Krempel in *tendenzen* 1: 30/31.

14. One of the essential taboos was the discussion of freedom in relation to the actions of the GDR. Engel's quote was oversimplified and put into use predominantly in education as a subordinating dictate.

15. The exhibition *Zeit-Raum-Bild-Realisation* ('Time-Space-Image-Realization'), took place in the Galerie Arkade at Strausberger Platz in East Berlin (June 1981). On 10 July 1981 from 2 p.m. to 7 p.m., the *Steh und Lauf*-Performance (standing and running performance) took place at the studio of E. Monden, Dimitroffstraße 197 and the Galerie Arkade, Strausberger Platz 4. A review of the performance by Gabriela Ivan apears in *Bildende Kunst* 10 (1981).

16. The articles appeared in Issues 4, 5 and 6/1982 in *Bildende Kunst*. Those requested to review were: Prof. Hermann Raum, director of the state gallery of Moritzburg, Halle; Hermann Peters, assistant professor at the Academy of the Arts of the Central Committee of the SED (Central Commitee of the Socialist Unity Party of Germany), Institute of Marxist-Leninist Cultural Studies and the Arts; Dr Klaus Weidner, assistant professor of artistic theory in the Department of Art History, Section of Fine Arts and Aesthetics, at the Humbolt University in Berlin; Dr Peter Pachnicke, assistant professor of Aesthetics at the Academy of Graphic and Book Art in Leipzig.

17. Eugen Blume, *Der Kunstbegriff bei Joseph Beuys (Bedeutung der Relevanzverschiebung vom künstlerischen Produkt zum 'Prinzip Kunst' als besondere Produktionsweise)* ('The Definition of Art through Joseph Beuys (The Importance of the Shift in Relevance from Artistic Product to "Artistic Principle" as a Specific Means of Production)'), Humbolt University, Berlin, 1981.

18. Hermann Raum, *Bildende Kunst* 4 (1982), p. 203.

19. Hermann Raum, *Bildende Kunst* 5 (1982), p. 255.

20. Peter Pachnicke, *Bildende Kunst* 6 (1982), p. 307.

21. Ninth Congress of the Verband Bildende Künstler-DDR, 15–17 November 1983 in Berlin.

22. Files 'Arbeitsgruppe', Berlin 1984, pp. 11–12, and cited in Günther Feist and Eckhart Gillen (eds.), *Kunstkombinat DDR* (1988; rpt. Berlin: Nishen, 1990), p. 149.

23. *Leussow-Recycling*, Portfolio no. 6, Edition Arkade no. 50; Artists: Wolfgang Biedermann, Michael Morgner, Thomas Ranft, Gregor Torsten Schade, Ralf Rainer Wasse (photography). Text: Klaus Werner. The event took place in September 1977 at a clearing five kilometres east of the village of Leussow.

24. Files (Protocoll collection), 1983, p. 42.

25. The following works were purchased by the Kupferstichkabinett in 1979: *Amerikanischer Hasenzucker* ('American Hare Sugar'), 1974, a colourful offset lithograph with a stamped candy bag in a padded cardboard box; *Vitex Agnus castus*, 1973, offset lithograph; *Dillinger*, 1974, silkscreen poster.

26. Files (Protocoll collection) of the Arbeitstagung des VBK-DDR (workshop of the Union of Visual Artists), Magdeburg, 1977; Klaus Werner, 'Beuys macht Licht', in Klaus Staeck (ed.), *Ohne die Rose tun wir's nicht* (Heidelberg, 1986), p. 12.

27. *Joseph Beuys, Early Works from the van der Grinten Collection. Drawings, watercolors, oil paintings, collages*, Berlin, Galerie der Akademie im Marstall, 15 January to 6 March 1988. Further

exhibition locations: Leipzig, Frankfurt on the Main, Hamburg, Brussels and Bonn.

28. Joachim Fritz Vannahme, 'Die Beuys-Hüter', *Zeitmagazin* 2 (1991), p. 14.

29. Manfred Wekwerth, Foreword, *Joseph Beuys, Early works from the van der Grinten Collection. Drawings, watercolors, oil paintings, collages*, exhibition catalogue (Cologne, 1988).

30. Hermann Raum, 'Messias, Schamane, Rebell', *Wochenpost* no. 4 (1988).

31. Günther Regel, 'Medium bildende Kunst', Berlin, 1986, p. 103–4.

32. The Permanent Representation of the Federal Republic on Hannoverschen Strasse in (East) Berlin staged many exhibitions, all open to the public but these were basically not accessible for GDR residents. The Günter Ulbricht Collection installed the Beuys exhibition. Catalog: *Multiplizierte Kunst 1965–1981* (Berlin, 1981). After a conversation with Eva Beuys, it came up that Beuys had already spent a day with family in East Berlin in the 1970s.

33. Joseph Beuys, in Klaus Staeck and Gerhard Steidl (eds.), *Das Wirstschaftswertprinzip* (Heidelberg, 1991).

34. The Environment was installed from 1978/1979 until the beginning of 1981. In 1982 it was dismantled and the room became the Red-Green self-help gallery Sredzikistrasse 64.

35. *Autoperforationsartisten*: Micha Brendel (1959), Else Gabriel (1962), Rainer Görß, Via Lewandowsky (1963). For a history of the group: Durs Grünbein, 'Protestantische Rituale. Zur Arbeit der Autoperforationsartisten', Eckhard Gillen and Rainer Haarman (eds.), *Kunst in der DDR* (Cologne, 1990), pp. 309 ff.

36. Eugen Blume, 'Kraftlos von der Mühe die Spirale so weiterzudrehen', *Bildende Kunst* 5 (1990), pp. 26–7.

37. Grünbein, p. 314.

38. *Permanente Kkunstkonferenz* (Berlin: Edition Galerie Weißer Elephant, 1990), p. 62.

39. Wulf Herzogenrath, Joachim Sartorius, and Christoph Tannert (eds.), *Die Endlichkeit der Freiheit, Berlin 1990. Ein Ausstellungsprojekt in Ost und West.*

40. Joseph Beuys, 'Warum sind Sie, Herr Beuys, nicht mehr in der DDR erwünscht?' and Holger Eckman, 'Fett schwimmt wieder oben, Beuys in der DDR', *Niemandsland* 5 (1988), pp. 126–8.

41. Erhardt Monden, 'Schule für erweiterte bildnerische Arbeit', Concept sheet (xerox copy).

42. 'Über die bildnerische Innovation zur Transformation des

Kunstbegriffs. Gespräch mit dem Maler/Grafiker/Performer Erhard Monden', *reiter in dresden* 5 (1990), p. 19.

20. JOSEPH BEUYS AND SURREALISM

Roundtable*

BENJAMIN BUCHLOH, JEAN-FRANÇOIS CHEVRIER AND CATHERINE DAVID

Benjamin Buchloh: In my opinion, the only artist who really continues the surrealist project after the war – except in the context of American abstract expressionism, where it's more complicated – is Beuys. He is the only artist who is a surrealist after the fact in Germany, the only artist who recovers and refashions a history that gives the notion of the unconscious a central place in the production of the aesthetic. The paradox is that he does so too late, at a moment when it is completely obsolete and impossible.

Jean-François Chevrier: Of course I see a failure in Beuys, but a romantic failure – and we know how important German romanticism was for the surrealists. Beuys links a residue of surrealism to romanticism, and through a logic of remanence, of the lingering historical echo, he reproduces the romantic failure.

B.B.: Any artist who would try to establish some kind of historical continuity with German romanticism – and I'm not even sure that's the case with Beuys – seems to me, after the advent of fascism, to be a profoundly problematic artist. In this perspective I find it surprising that a historian like Peter Bürger, who is precisely a specialist of surrealism and romanticism, should discover contemporary art through Beuys and not through Arman, or the reception of Duchamp, or Buren or Haacke, not to mention Broodthaers again – artists for whom any continuity is broken once and for all. At the initial moment

when the work is engaged in practice, the degree of alienation that is articulated in the work of Arman, by contrast to the degree of cultural continuity in the work of Beuys – even though they both work with found objects, industrial objects, etc. – seems to me to be a necessary condition for work which defines itself as contemporary after the war, whereas there is a totalizing tendency in Beuys' work which it is impossible for contemporary art to fulfill.

J.-F.C.: For me, Beuys has this remnant of romanticism through surrealism, as well as a project of reconciliation. There is also a project of totality, with the reprise of the Wagnerian model denounced by Broodthaers, and finally a geopolitical imaginary with the figure of *Eurasia*, which is close to certain German obsessions: but the totalizing project ultimately fails. It fails by the very force of the romantic reference, and in reality it culminates in extraordinary fragmentary invention. There's a magnificent phrase from Novalis about a universe made only of shards: that's Beuys. And, finally, Beuys is pathos in the positive sense, as that which differs from the rationality of the Logos: the impossibility of totality, the inevitability of the fragment. Of course one can ask whether this failure was conscious or not. In any case it is clearly legible in the work. There is none of the blurring for which Artaud reproached Breton.

B.B.: The fetish is legible, the fetishization of obsolete aesthetic concepts is always legible.

J.-F.C.: We can return to Walter Benjamin who enacts the fetish, that's what Adorno doesn't understand. Benjamin takes the mimetic risk of producing fetishes himself, that's why his thought was difficult to accept.

B.B.: Beuys doesn't produce fetishes, he practises them.

J.-F.C.: The artist who really allows for a critique of Beuys is the early Rauschenberg, particularly with the *Feticci Personali* and the *Scatole Personali* of 1952, before the *Combine Paintings*. It's extraordinary how an American artist, coming from media culture, pop culture, but working in an Italian context, can play with the archaism, the sexuality, the unconscious aspects of surrealism. Rauschenberg follows the same procedure of enacting magic as Beuys: he called his works 'personal fetishes'.

B.B.: The complexity of the Duchampian model is present for Rauschenberg and absent for Beuys. That's the difference.

Catherine David: There is also a tremendous naiveté, at the moment of structuralism and the work on ethnography, to think that one can reinstate ritual as an alternative to the commodity.

B.B.: That is effectively one of the problems with Beuys: restoring cult value – to use Benjamin's terms – at the very moment when it has become apparent that the work of art is constituted solely by its exhibition value. That's what Beuys didn't understand, unlike Rauschenberg or Johns, whose light bulb is an object stripped of its magical, fetishist dimension. The same thing is true of Arman from 1959 to 1961, with his boxes, the *Poubelles* and the first *Accumulations*. There's an important transition in those works. It's extremely cruel and crude, but that's the specific aspect of this historical moment of 1959–1961, which doesn't even try to establish any continuity with surrealism, with magic, with cult value, with an unconscious. What historical conditions disqualify the notion of the Freudian unconscious as the central notion of aesthetic production? That's what we haven't defined here.

J.-F.C.: I agree that the comparison with the early Rauschenberg is to the detriment of Beuys, but the comparison is interesting. There is a play with the fetish that is of a different nature; perhaps in Rauschenberg it is more immediately convincing for an intellectual educated in ideology critique, an intellectual conscious of the double historical mutation constituted by the rupture with fascism and the onset of the American-style consumer society. But there is a danger in discounting Beuys' actualization of this archaism by enacting it, playing it out (compare the little objects which are very close to Rauschenberg's, and strictly contemporary, from 1949–1955). I'm thinking of a text by Pierre Clastres from 1967, 'De quoi rient les Indiens?' ('Why do the Indians laugh?'). He says mythology is actually very funny. In Beuys there is a play on mythology, on an archaic element which is completely futile to cover up, because it will return by the back door, as the psychoanalysts say. That's exactly what happened in Germany in the eighties, that's what you denounced in 'Figures of Authority, Ciphers of Regression'. It happened because of the repression of Beuys.

B.B.: I understood that at the time, because I said that by comparison to Kiefer, Beuys was a fantastic artist!

J.-F.C.: I think that a certain conceptual-structuralist norm rejected surrealism and repressed Beuys along with it, producing the effects of the return of the repressed which happened after 1978, which is the turning point for the regressive art that you denounced. But could it be that by repressing surrealism – not the surrealist tradition, but its underlying stakes – and the stakes of Beuys' archaism, you are actually among the critics who allowed for the regressive return that you denounced? In any case, it should be clear by now that my concern is not the Freudian unconscious, the individualized unconscious.

B.B.: It remains to identify why this repression is specifically German – as I recognize. But beyond this post-war German tradition, it also remains to be clarified whether the scepticism toward surrealism over several generations and on several continents is always a repression. I'm thinking again about Ryman's work in the late fifties, the beginnings of Nouveau Réalisme in the early fifties, the artists of the second German generation like Polke, and even Palermo who was a devoted disciple of Beuys: they all take their distances from the history, theory and practices of surrealism.

J.-F.C.: There is a positive distancing, in the sense where there is a tradition of surrealism which is awful, that's what Artaud denounces: but this positive distancing is accompanied by a repression. I don't know why. Our earlier discussion of the irrational was a beginning, but we would have to go further to understand the whole problem.

NOTE

* From *Politics, Poetics: Documenta X, The Book, Idea and Conception* by Catherine David and Jean-François Chevrier (Ostfildern: Cantz Verlag, 1997), pp. 392–4.

KEY DATES AND EXHIBITIONS

1921	Born in Krefeld, Germany on 12 May
1940	Graduates from the Kleve Gymnasium (high school)
1941–1946	Enlists; soldier and prisoner of war
1947–1952	Trains under Josef Enseling and Ewald Mataré, sculptors at the Düsseldorf Academy of Art
1952–1954	Master student of Mataré
1953	First one-man exhibition at the van der Grinten farm, Kranenburg, and at the Von-der-Heydt Museum, Wuppertal
1961	Appointed Professor of monumental sculpture at the Düsseldorf Academy of Art
1963	Exhibition at the Haus Koekkoek Town Museum, Kleve
1963	Organizes and appears in the Fluxus Festival at the Düsseldorf Academy, 2 and 3 February
1964	Participates in Documenta III with drawings and sculptures
1965	First gallery exhibition, Galerie Schmela, Düsseldorf
1967	Co-founder with Johannes Stüttgen of the 'German Students Party'
	Collector Karl Ströher, Darmstadt, buys an entire block of Beuys' recent works
1968	Participation in Documenta IV with his installation *Room Sculpture*
	First written complaints from Beuys' colleagues at the Düsseldorf Academy, citing political

	dilettantism, arrogance and his negative influence on students
1970	Establishes the 'Organization of Non-Voters'
1971	Establishes the 'Organization for Direct Democracy through Plebiscite' and the 'Committee for a Free University'
1972	Manifesto with novelist Heinrich Böll for a 'Free International University'
	Installs the office 'Organization for Direct Democracy through the People's Initiative' at Documenta V
	Dismissed without notice from his academic post
1974	First trip to the USA, January
1975	Honorary doctorate from the Nova Scotia College of Art, Halifax, Canada
1976	Lichtwark Prize from the City of Hamburg
	Installs *Strassenbahn-Haltestelle* ('Tram Stop') at the Venice Biennale
1977	Installs 'Free International University for Creativity and Interdisciplinary Research' and the *Honigpumpe am Arbeitsplatz* ('Honeypump at the Workplace') at Documenta VI
1978	Kassel Federal Industrial Tribunal rules that Beuys' dismissal was illegal
	Thorn Prikker Medal, City of Krefeld
	Offered position in design theory at the Academy of the Applied Arts, Vienna
	Publishes his 'Aufruf zur Alternative' ('Call to the Alternative') in the *Frankfurter Rundschau*, 23 December
1979	Green Party Candidate for European parliamentary elections
	Installs *Brazilian Fond* (*Fond V*) at the São Paulo Biennale
	Retrospective exhibition, Guggenheim Museum, New York City
1980	Green Party Candidate for state elections, North Rhine/Westphalia
	Participates in occupying the law offices of WDR

	broadcasting in Cologne to protest at the lack of reporting on alternative groups by the network
1981	Exhibition at the Ständige Vertretung (Permanent representation) of the FRG building in East Berlin, GDR
1982	*Action 7,000 Oaks: Forestation of the City Instead of City Administration* realized at Documenta VII
1983	Fails to secure the Green Party's nomination as candidate for federal Bundestag (parliament) elections in North Rhine/Westphalia
1984	Is denied entry to the GDR at the border Travels to Japan
1985	Delivers lecture, 'Speaking About One's Own Country: Germany' in Munich Participates in the *German Art in the 20th Century* exhibition, Royal Academy, London; and *1945–1985, Art in the Federal Republic of Germany*, New National Gallery, West Berlin Travels to Naples; installs *Palazzo Regale* at the Palazzo reale di Capodimonte Lehmbruck Prize, City of Duisburg
1986	Dies in Düsseldorf on 23 January

SOURCES

'Exhibitions, Actions, Events', in *In Memoriam Joseph Beuys:*
 Obituaries, Essays, Speeches (Bonn, Inter Nationes,
 1986), pp. 64–5

'Biographie', in Franz-Joachim Verspohl, *Joseph Beuys*
 Das Kapital Raum 1970–1977: Strategien zur
 Reaktivierung der Sinne (Frankfurt a.M.: Fischer,
 1984), pp. 70–3

INDEX

actionism, 305

Adorno, Theodor, 15, 60, 65, 70, 200, 251, 256, 259, 260, 261, 263, 264, 267, 268, 321

alienation, concept of, 124, 138, 139, 146, 160, 265, 321

Anthony D'Offay Gallery, 30

Anthroposophical Society, 6

Arendt, Hannah, 264

Ariès, Phillipe, 277, 278, 283

Arman, 118, 122, 320, 321, 322

Art & Language, 20, 188

Art around 1800, 152

Art into Society/Society into Art, 95, 202

Arte Povera, 186, 206

Atkinson, Terry, 10, 20

Auschwitz, 70, 74, 278, 279

Baader-Meinhof, 208, 209

Bataille, Georges, 18, 170, 172, 173

Baudelaire, Charles, 82, 89, 93, 104, 136

Benjamin, Walter, 63, 73, 80, 85, 87, 124, 251, 262, 264, 265, 267, 268, 282, 283, 321, 322

Beuys, Joseph
 7,000 Oaks, 34, 82
 bee, 55, 239, 240, 241, 245
 Beuys Block, 8, 11, 25, 157
 Braunkreuz, 32
 Celtic (Kinloch Rannoch) schottische Symphonie, 78, 179, 245
 Directional Forces, 78, 95, 185
 Eurasia, 16, 180, 213, 237, 321
 Fat Chair, 118, 120, 125, 170, 293
 Fat Transformation Piece, 177, 178, 179, 180, 181, 183, 185, 187
 Fond-works, 156, 157, 158, 167
 German Students Party, 215, 281
 hare, xv, 46, 135, 235, 236, 237, 238, 239, 240, 241, 242, 243, 247, 250, 262, 317
 How to explain pictures to a dead hare, 243
 natural sciences, 155, 157, 158, 159, 160, 161, 165,

166
Office for Direct Democracy through Referendum, 96, 180, 181, 182, 189, 190, 198, 199, 209
Palazzo Regale, 12, 135, 171
Plight, 30, 43, 102
Raum 90.000 DM, 143, 144, 147
rose, 14, 47, 48, 49, 205, 206, 210, 281
Snowfall, 151
social sculpture, xiv, 10, 18, 142, 145, 146, 171, 172, 184, 198, 199, 201, 209, 211, 212, 229, 305, 311, 312, 313, 315
The Capital Space 1970–77, 99
The Pack, 33, 245
The Silence, 32, 33, 72, 74, 75
The Silence of Marcel Duchamp Is Overrated, 32, 33, 72
Thermal/plastic Primeval Meter, 37, 39
Tram Stop, 97, 281, 282
Transsibirische Eisenbahn, 33
Bhabha, Homi, 272, 283
Bildende Kunst, 305, 306, 307, 316, 317, 318
Bloch, Ernst, 111, 124
Block, René, 8, 11, 12, 13, 25, 49, 157, 168, 180
Blume, Eugen, 9, 12, 13, 23, 25, 304, 317, 318
Boccioni, Umberto, 120, 126
Bockemühl, Matthias, 8
Böll, Heinrich, 14, 84, 213, 219
Bourdieu, Pierre, 257

Brenson, Michael, xiv
Breton, André, 41, 253, 261, 321
Broodthaers, Marcel, 18, 19, 50, 52, 53, 54, 62, 63, 66, 67, 68, 69, 70, 71, 72, 73, 74, 75, 76, 77, 79, 80, 81, 82, 83, 122, 154, 202, 320, 321
Il n'y a pas des structures primaires, 79
Le Corbeau et le Renard, 67
Pense-Bête, 75
Section des Figures, 71
Brouwn, Stanley, 122
Buchloh, Benjamin, 4, 17, 18, 20, 21, 23, 25, 26, 64, 65, 68, 69, 73, 84, 85, 109, 127, 128, 129, 130, 146, 154, 168, 173, 186, 217, 320
Bürger, Peter, 7, 18, 22, 23, 26, 87, 201, 214, 250, 262, 264, 267, 320
Busch-Reisinger Museum, 12, 14
Byars, James Lee, 19, 88, 89, 90, 91, 92, 93, 94, 95, 96, 97, 98, 99, 100, 101, 102, 103, 104, 105, 106
Calling German Names, 104
The 5 Continent Documenta, 7, 97
The Holy Ghost on Piazza di San Marco, 97
The New National Flag for Italy (The Social Flag), 99
The Perfect Death in Honor of Joseph Beuys, 103
The Perfect Death of James Lee Byars, 102
The Pink Silk Airplane for 100 People, 95, 96

Cage, John, 17
Carus, Carl Gustav, 154, 155, 159

Catholicism, 162
Cattelan, Maurizio, 21, 26
Chevrier, Jean-François, 23, 264, 320, 323
Christ, 5, 135, 136
Christiansen, Henning, 11, 179, 216
Cladders, Johannes, 3, 12, 24, 66
Conceptual Art, 15, 16, 17, 29, 178, 184, 186, 188, 199, 202, 210, 212, 213, 214, 217, 233
Concrete Art, 7
constructivism, 1, 110, 120, 253, 257
Cooke, Lynne, 24, 43, 49, 216
Cornell, Joseph, xvi, 247

Dada, 1, 48, 57, 110, 117, 120, 121, 260, 281, 294, 297, 303
Darboven, Hanne, 17, 282
David, Catherine, 14, 23, 24, 45, 47, 154, 155, 179, 269, 291, 299, 320, 322, 323
de Duve, Thierry, 20, 21, 26, 134, 171, 173
de Maria, Walter, 292, 293, 301
Degas, Edgar, 120, 136
Deleuze, Gilles, 22, 26
Demarco, Richard, 44, 179
Derrida, Jacques, 22, 233, 234, 235, 236, 237, 238, 239, 240, 241, 242, 243, 244, 245, 246, 247, 248, 249, 252, 264
Glas, 240
grammatology, 18, 233, 234, 235, 236, 237, 238, 239, 243, 245, 246
Dia Foundation, 14
Documenta, 2, 11, 13, 15, 21, 29, 34, 44, 54, 70, 78, 84, 85,

89, 91, 92, 93, 94, 96, 97, 98, 99, 104, 105, 142, 189, 190, 197, 199, 201, 202, 204, 205, 206, 208, 209, 210, 211, 212, 213, 215, 216, 229, 241, 243, 248, 253, 262, 269, 280, 289, 291, 299, 300, 301, 306, 323
Duchamp, Marcel, xiii, 1, 17, 19, 22, 29, 30, 31, 32, 33, 34, 36, 39, 40, 41, 42, 43, 44, 45, 47, 48, 49, 52, 66, 72, 74, 75, 76, 86, 117, 118, 269, 294, 295, 320
50 cc Air de Paris, 41
Belle Haleine, 41
Boîte-en-Valise, 36, 45, 48
Eau & gaz à tous les étages, 42, 43
Etant donnés, 41
Fountain, 41
Large Glass, 39
Rrose Sélavy, 41, 45, 49
Trois stoppages-étalon, 40
"to have the apprentice in the sun", 36
Why not Sneeze Rrose Sélavy?, 41
Duncan, Andrea, 25
Dürer, Albrecht, 29, 209, 210, 216
Düsseldorf Academy, 11, 21, 35, 46, 67, 85, 95, 208, 281
Dutschke, Rudi, 67, 68, 84

Enzensberger, Hans Magnus, 201, 214, 265
Export, Valie, 5

fascism, 2, 59, 73, 110, 114, 115, 124, 173, 265, 266, 271, 282, 320, 322
Fischer, Konrad, 33, 215, 292,

293, 301
Fluxus, 11, 19, 20, 25, 26, 29, 32,
 37, 43, 56, 57, 58, 67, 78,
 86, 90, 117, 120, 201, 215,
 216, 242, 288, 291, 293,
 299, 301, 305, 312, 313
Foucault, Michel, 201, 214, 234,
 247, 252, 262, 264, 277
Frankfurt School, 15
Free International University, 6,
 14, 46, 95, 111, 220, 225,
 315
Frenkel, Vera, 10, 21, 23, 127, 128
Freud, Sigmund, 119, 244, 245,
 248, 249
Friedrich, Caspar David, 96, 109,
 124, 150, 151, 152, 153,
 154, 155, 159, 168, 202,
 293, 301
Furlong, William, 30, 45

Galerie nächst St. Stephan, 5
Galileo, 157
GDR (German Democratic
 Republic), 12, 13, 275,
 304, 305, 306, 307, 308,
 309, 311, 313, 314, 315,
 316, 318
Germer, Stefan, 17, 18, 26, 50,
 85, 215
Green Party, 3, 6, 16, 21, 74, 218,
 219, 220, 221, 224, 225,
 228, 229, 281
Greenberg, Clement, 13, 15, 299
Grotowski, Jerzy, 129
Guggenheim Museum, 12, 13,
 16, 46, 50, 64, 73, 84, 86,
 109, 122, 125, 147, 154,
 168, 247

Haacke, Hans, 19, 50, 52, 53, 64,
 73, 85, 122, 123, 199, 282,
 320

Habermas, Jürgen, 7, 87, 199,
 200, 201, 202, 214, 251,
 252, 262, 264, 266, 267,
 268, 274
Halbwachs, Maurice, 277, 283
Hamilton, Richard, 14, 182, 188
Harrison, Margaret, 10, 188, 212
Haus Lange, Krefeld, 100, 263
Heidegger, Martin, xv, xvi, xvii,
 xviii
Hessisches Landesmuseum,
 Darmstadt, 11
Higgins, Dick, 291, 301
Higgins, Hannah, 19
Historikerstreit (German historical
 debate), 274, 275, 283
Hockney, David, 14
Hofmann, Werner, 80, 87
Hornig, Günter, 25, 312

Imdahl, Max, 7, 8
Immendorff, Jörg, 14
Individual Mythologies, 91, 94, 202
Informel, 7, 256, 258
Irigaray, Luce, 10

Jena Circle, 161, 162

Kandinsky, Wassily, 163, 167
Kant, Immanuel, xviii, 82, 242,
 296
Kaprow, Allan, 14, 125, 201, 233,
 247
Kayser, Stephan, 25, 312
Kellein, Thomas, 19, 20, 26, 216
Kelly, Mary, 10, 212, 217
Kelly, Petra, 21, 26
Kemp, Wolfgang, 8
Kienholz, Ed, 14, 70
Klein, Yves, 69, 111, 118, 124,
 287, 288, 299
Koepplin, Dieter, 11, 24, 31, 45
Kort, Pamela, 4, 24, 216

Kracauer, Siegfried, 62, 65
Kranenburg, 20, 24, 25, 185, 309
Kraus, Karl, 115, 287
Krauss, Rosalind, 10, 17, 18, 21,
 26, 64, 132, 146, 170, 172
Kristeva, Julia, 10
Kuspit, Donald, 4, 17, 24, 103,
 104, 295, 302

Lacan, Jacques, 83, 234, 248, 264
Lacy, Suzanne, xiv
Lamarche-Vadel, Bernard, 34, 35,
 36, 45, 46, 47, 49, 173
Lebel, Robert, 32, 42, 45
Lehmbruck, Wilhelm, 29, 142
Leonardo, 15, 29, 44, 157
Levin, Kim, 44, 297, 303
LeWitt, Sol, 295, 302
Lippard, Lucy, 16, 17, 25, 188,
 213, 214, 295, 299, 302
Luckow, Dirk, 23, 287

Maciunas, George, 20, 56, 288,
 299
Magritte, René, 72, 81, 82, 256,
 260
Mallarmé, Stephane, 202, 215,
 252
Manzoni, Piero, 69, 72, 118, 122
Marcuse, Herbert, 202, 214, 250,
 251, 262, 277, 279
Marx, Karl, 12, 119, 125, 134,
 137, 138, 139, 140, 141,
 142, 144, 145, 146, 171,
 308, 310, 314
Mathieu, Georges, 111
Mauer, Otto (Monsignor), 5
McLuhan, Marshall, 200, 214
Messer, Thomas, xv, 51, 64, 122
Michelson, Annette, 17, 26, 64,
 146
Minimalism, 15, 206, 288
Mitscherlich, Alexander, 116

Modern Art Agency, Naples, 178,
 185, 217
Mönchengladbach, 11, 12, 76,
 77, 156, 168, 188, 213,
 287
Monden, Erhard, 13, 307, 312,
 313, 314, 315, 316, 318,
 319
Morris, Robert, 119, 121, 289,
 292, 293
Museum Schloss Moyland, 9, 24,
 103

National Socialism, 183, 271,
 295, 298
Nauman, Bruce, 46, 119, 121,
 289, 292, 293, 294, 295,
 301
Neo-Expressionism, 276, 295
Neue Wilden, 253, 254, 256
Nietzsche, Friedrich, 109, 119,
 124, 125, 154, 266, 296
Nisbet, Peter, 3, 4, 24
Nitsch, Hermann, 172
Novalis (Georg Philipp Friedrich
 Freiherr von Hardenberg),
 81, 141, 154, 155, 159,
 161, 165, 321

October, 12, 14, 16, 17, 18, 21, 26,
 40, 45, 47, 50, 54, 63, 64,
 65, 72, 84, 85, 104, 105,
 124, 132, 146, 173, 180,
 186, 217, 227, 299, 300,
 302, 304
Offenbach, Jacques, 53, 54, 62,
 63, 65, 72, 73, 123, 154
Oken, Lorenz, 155, 159
Omnibus for Direct Democracy,
 309

Paik, Nam June, 11
Permanent Representation, East

Berlin, 12, 311, 318
Petrovsky, Wolfgang, 25, 311
Phillips, Christopher, 20, 26
Picasso, Pablo, 1, 23, 26, 136, 310
Pictures, 17, 129
Platschek, Hans, 306
Pollock, Jackson, 29, 295, 299
Pop Art, 29, 200, 261, 288, 299,
 301
Prigogine, Ilya, 37
proletarian, 18, 135, 137, 138,
 139, 140, 141, 143, 144,
 145, 146, 171

Raphael, 29
Rau, Johannes, 14, 25
Raum, Hermann, 12, 14, 45, 86,
 105, 143, 144, 147, 305,
 306, 307, 308, 316, 317,
 318
Rauschenberg, Robert, 201, 321,
 322
Ray, Gene, 18
Ray, Man, 48, 49, 294
Regel, Günther, 310, 318
Rehfeldt, Robert, 25, 311, 312
Reithmann, Max, 18, 86
Richter, Gerhard, 14, 17, 83, 206,
 296, 306
Ritter, Johann Wilhelm, 45, 48,
 159, 160, 161, 169, 189,
 197, 213, 215, 243, 248
Robertson, Clive, 10, 129
Rogoff, Irit, 22, 26, 270
Romanticism, 21, 24, 80, 81, 82,
 87, 152, 153, 154, 155,
 162, 164, 165, 167
Ronald Feldman Gallery, 13
Rose, Bernice, xvi
Rosenbach, Ulrike, 10, 212
Rosenblum, Robert, 152, 153,
 168, 169
Rosso, Medardo, 120, 126

Rothko, Mark, 152, 153, 167, 168
Runge, Philipp Otto, 155, 159,
 161, 162, 163, 164, 165,
 167, 169

Sacks, Shelley, 10, 212
Saussure, Ferdinand de, 117, 255
Schellmann, Jörg, 8, 45, 105, 168,
 169, 216
Schieferdecker, Jürgen, 25, 311
Schiffer, Irvine, 127, 132
Schily, Otto, 218, 225, 229, 230
Schlegel brothers, 159
Schneede, Uwe M., 8, 32, 41, 44,
 45, 46, 47, 48, 86, 186,
 187
Schulze, Hans Joachim, 315
Sculpture Chicago, xiv
Selle, Gerd, 8
Serra, Richard, 7, 119, 120, 121,
 289, 292, 293, 294
Seven Exhibitions, 179, 180, 182,
 186
Sieverding, Katherina, 10, 96,
 105, 212
social sculpture, theory of, xiv,
 10, 18, 142, 145, 146, 171,
 172, 184, 198, 199, 201,
 209, 211, 212, 229, 305,
 311, 312, 313, 315
socialist realism, 12
Sonnier, Keith, 292, 293
Springer publishing, 196
Stalinism, 304
Steiner, Rudolf, 55, 56, 57, 58, 64,
 78, 79, 81, 111, 112, 130,
 131, 132, 167, 202, 203,
 204, 212, 219, 229, 298
Stella, Frank, 295, 299
Sterbak, Jana, 10
Storr, Robert, 4, 20, 303
Strauss, Franz Josef, 220, 228,
 244, 277

Ströher, Karl, 11, 70, 287, 293, 301
Stünke, Hein, 287, 289, 300
Sturtevant, 10, 293
Stüttgen, Johannes, 20, 34, 35, 46, 47, 84, 147, 203, 215, 216, 218, 309
Surrealism, 26, 253, 264, 265, 320, 321, 322, 323
Syberberg, Hans-Jürgen, 131, 215
Szeemann, Harald, 11, 15, 45, 47, 66, 82, 86, 153, 179, 186, 187, 202

Tannert, Christoph, 257, 313, 318
Tate Gallery, 176, 177, 178, 179, 180, 181, 183, 185, 186, 188, 202
Tatlin, Vladimir, 121, 257
Temkin, Ann, xvi
tendenzen, 306, 307, 316
The Finality of Freedom, 313
Tisdall, Caroline, 4, 17, 64, 68, 84, 86, 113, 125, 126, 147, 187, 235, 247, 248, 249, 283
Troeckel, Rosemarie, 10, 212
Tyson, Keith, 21, 26

Ulmer, Gregory, 18, 22, 233

Union of Visual Artists, GDR, 308, 317

van der Grinten, Hans and Franz, 10, 11, 20, 25, 88, 158, 317, 318
VieW, 41, 42, 48
Vischer, Theodora, 8, 17, 21, 37, 47, 74, 81, 85, 86, 87, 151, 169
von Gloeden, Wilhelm, 29
von Simson, Otto, 5

Wagner, Richard, 53, 54, 59, 60, 61, 62, 65, 72, 73, 81, 109, 115, 119, 123, 124, 125, 154, 202, 215
Walker Art Center, 14, 15
Warhol, Andy, xiii, 16, 20, 69, 111, 145, 146, 200, 261
Weibel, Peter, 5
Werner, Klaus, 12, 44, 80, 87, 105, 168, 309, 311, 317
When Attitudes Become Form, 179, 187
Wide White Space Gallery, 67, 83, 84, 85, 105
Wilson, Ian, 132, 188, 210, 211, 216, 217
Woolf, Virginia, 131, 132, 133